Projecting Spirits

PROJECTING SPIRITS

SPECULATION, PROVIDENCE, AND
EARLY MODERN OPTICAL MEDIA

Pasi Väliaho

STANFORD UNIVERSITY PRESS

Stanford, California

STANFORD UNIVERSITY PRESS

Stanford, California

Printed in the United States of America on acid-free, archival-quality paper

Library of Congress Cataloging-in-Publication Data

Names: Väliaho, Pasi, author.

Title: Projecting spirits : speculation, providence, and early modern optical media / Pasi Väliaho.

Description: Stanford, California : Stanford University Press, 2022. | Includes bibliographical references and index.

Identifiers: LCCN 2021043926 (print) | LCCN 2021043927 (ebook) | ISBN 9781503630857 (cloth) | ISBN 9781503631939 (paperback) | ISBN 9781503631946 (ebook)

Subjects: LCSH: Optical instruments—History—17th century. | Camera obscuras—History—17th century. | Projectors—History—17th century.

Classification: LCC QC372 .V35 2022 (print) | LCC QC372 (ebook) | DDC 535.028—dc23/eng/20211117

LC record available at https://lccn.loc.gov/2021043926

LC ebook record available at https://lccn.loc.gov/2021043927

Cover art: Georg Philipp Harsdörffer. *Delitiae philosophicae et mathematicae, 3: Consisting of Five Hundred Useful and Funny Art Questions.* 1653

Cover design: Kevin Barrett Kane

Text design: Kevin Barrett Kane

Typeset at Stanford University Press in 11/14 Arno Pro

Table of Contents

Preface

It was commonplace in the early modern period to emphasize a distinction between the study of two types of phenomena of light. Catoptrics focused on the production of appearances by reflective surfaces such as mirrors, while dioptrics studied refractions of light on transparent bodies such as lenses.[1] These two operations of light could not be easily set apart in the design of actual optical instruments, but it serves to bear the distinction in mind to the extent that, as Siegfried Zielinski intimates in his sketch for a genealogy of projection, dioptrics and catoptrics connoted two intertwined but nonetheless distinct techno-aesthetic practices.[2] Whereas the former dealt with optical devices contrived for looking through into the world outside the apparatus, such as microscopes and telescopes, the latter implied beholding a surface inside the apparatus onto which images were projected, such as the screen of the camera obscura or the magic lantern. To put it schematically, whereas dioptric apparatuses were designed to function as "artificial eyes" (as the German Jesuit scholar Johann Zahn called the telescope) to augment reality, catoptric ones could also be fashioned for the production of artificial realities—wavering therefore, uncannily for many, on the uncertain threshold between what was in the seventeenth century called "natural" and "artificial magic."

Microscopes and telescopes put a definitive stamp on the formation of the modern scientific worldview, marking what Hans Blumenberg called a "caesura," beyond which the perceptually and epistemologically accessible reality

started to expand indefinitely.[3] They made space stretch toward the infinite and introduced a plurality of worlds alongside the actual one. Although the contribution of camera obscuras, magic lanterns, and related contrivances to the development of early modern thought has been perhaps less straightforward to assess, these devices, too, played a role in shaping ways of seeing, visualizing, and knowing during the early modern period. The Italian scholar Francesco Algarotti proclaimed in the 1760s that "painters should make the same use of the Camera Obscura, which Naturalists and Astronomers make of the Microscope and Telescope, for all these instruments equally make known, and represent Nature."[4] In this vein, historians of art and visual culture have evaluated the place of optical instruments in early modern artistic practice, as well as uncovering how the camera obscura's projections stood for a model of truthfulness and naturalness in seventeenth-century painting, and more generally for a model of the rational, disembodied intellect—even of a kind of "phantasy subject of reason"—in the early modern period.[5] Historians of science and ideas have more widely mapped the meanings and functions of camera obscuras and magic lanterns in early modern thought, encompassing such diverse fields as the development of modern optics as well as counter-reformation metaphysics.[6] Media historians, for their part, have provided detailed accounts of the generation of image projection devices along with their makers, often situated on a long lineage of "screen practices" culminating in the cinema.[7] Historians of literature and philosophy, furthermore, have traced how the magic lantern's ghost projections became key epistemic figures in Enlightenment writing, from the emergence of German idealism to new conceptions about the status of the imagination in early nineteenth-century fiction and psychology.[8]

This book's impetus is to contribute to this heritage with its own account of how optical media lent their shape to Western thought at the turn of the century. The book pursues a historical epistemology interested in the medial conditions of thinking (not only scientific but also philosophical, religious, and economic) based on the assumption that the movements of the intellect are embedded in and hinged on the objects, techniques, and visualizations that the intellect is surrounded by, and fundamentally "patched together from shifting object relations," as Sean Silver proposes.[9] The following chapters play out a media history of thought, by exploring how circa 1700 optical projections—light-borne images cast by a more or less elaborate technical

device onto a surface—gave a meaningful cognitive shape to attempts at planning and plotting how the world could, and should, turn out. The English novelist and trader Daniel Defoe famously characterized this historical moment in his native country as a "projecting age." By "projecting," Defoe, to be sure, did not primarily mean the practice of conjuring a colorful play of light and shadow on a screen—although his concept was not far removed from the aesthetics of optical projection, as we will later see. Rather, Defoe was referring to new speculative economic practices and ideas emerging within colonial trade and finance, which not only eroded older concepts of wealth but also radically challenged traditional ways of thinking about the purpose of human activity and God's place in the world. Projection meant a way of embracing the future immanently for the sake of taking risks and profiting on what was contingent and probable, instead of submitting the future to a preestablished design.[10] Defoe's "projection" was cast against more established notions of God's providential care and governance of the world and human history, quietly questioning the basic premise, critical to the Christian cognitive universe still prevalent during the period, about the presence of divine guidance in the course of events and in one's actions. Within this universe, both intended actions as well as seemingly contingent occurrences were ruled by superior causes. As Thomas Aquinas forcefully argued:

> Since man is ordered in regard to this body under the celestial bodies, in regard to his intellect under the angels, and in regard to his will under God it is quite possible for something apart from man's intention to happen, which is, however, in accord with the ordering of the celestial bodies, or with the control of the angels, or even of God.[11]

The concept of projection embraced this epistemological problematic of "ordering," which gradually shifted its meaning from predetermination and divine intervention into speculative attempts at design and control that subsumed the future, or "fortune," into monetized relations. *Projecting Spirits* takes the conceptual and cognitive reorientation illustrated by Defoe as the general intellectual background for configuring the meanings and functions performed by optical media at the turn of the century. It is here that the book's historical excursion departs from more well-trodden paths. For some, approaching the history of optical media in relation to (apparently) far removed metaphors, analogues, and practices—and, at first sight, distant

intellectual problems—might not come across as a most straightforward ges-
ture. However, the intuition guiding this book is that from roughly 1650 to
1720, the aesthetic forms embodied by camera obscuras and magic lanterns
became symbolic of a range of intellectual transitions: "symbolic" in the
sense of providing the fitting figures of thought through which a world un-
dergoing a series of changes could be made sense of, and in that respect also
rendered as operable, actionable. This book sets out to show how, circa 1700,
the projective screens of the camera obscura and the magic lantern became
critical cognitive surfaces where the world was witnessed in ambiguously
shifting shapes—where notions of pre-established divine harmony gradually
dissolved into a complex sphere of contingent events, as well as the empty
time of eternity into a future open to opportunities and risks. On these sur-
faces, furthermore, hermeneutic quests for invisible divine truths became
juxtaposed with empirical observations of "matters of fact," and the divine
management of the world anticipated the emergence of liberal, and above all
speculative, economic ideas. These shifts were by no means linear and uni-
form; they were continuous and reversible, something akin to topological
transformations where things can shift shape, bend, stretch, and twist—all
without losing their key properties or functions.

This book's take on the early modern history of projection does not
pretend to be exhaustive. It is centered on a handful of protagonists, both
humans and machines: philosophers, scholars, friars, merchants, sailors,
missionaries, and nuns, as well as the optical apparatuses they encountered
and interacted with. As for the latter—the machines—this book focuses on
camera obscuras and magic lanterns. These two apparatuses, designed for the
processing of optical signals (light waves), shared the aesthetic function of
projecting images but in symmetrically opposing ways: While the camera
obscura transmitted light rays that projected mirror images of objects in the
environment inside the apparatus, the magic lantern had a light source, such
as a candle, positioned to illuminate a figure, drawn on a transparent slide,
through a system of mirrors and lenses and to project that image outside onto
a screen.[12] As for the former—the humans—this book's historical excursion
comprises individuals who were somehow in contact with camera obscuras
and magic lanterns: those who developed new instruments or tweaked old
ones; who wrote about the machines or used them in their artistic or sci-
entific practice; who pictured the camera obscuras and magic lanterns in

illustrations—satirical, scientific, or otherwise; and who thought, or merely dreamed, about the machines and their projections and turned them into tropes and metaphors, noetic analogues, as well as figures of thought.

The diverse and sometimes disparate stories of these devices and persons are brought together to show how the main aesthetic and cognitive function carried out by optical media in turn-of-the-century thought was to superimpose the real with a perceptual frame that could render the chaos of life as a negotiable design. The first chapter demonstrates in more detail how, during this historical moment, camera obscuras and magic lanterns were varyingly associated with an intuition of the world as a continuum of movements, differentiations, and variations (rather than as something fixed and unified per se), and they were simultaneously understood as pertinent conceptual tools to rationalize and arrange these movements, differentiations, and variations into more or less durable shapes. Alongside anamorphic images, optical projections performed a play of differing perspectives—distorted and blurred, clearer and more comprehensible—that also acted out a distinction between the human and divine modes of apprehending the world. For philosophers like Gottfried Wilhelm Leibniz, projection became a critical concept as well as an optical metaphor to understand how the universe varied from one viewpoint to another but was at once unified within a single divine optic that organized things into a geometric and logical harmony. Projection signaled what Leibniz called God's "government of the universe," thereby associating optical media importantly with an older Christian concept of "economy" (*oikonomia*), or divine administration and rule.

Taking its cue from Leibniz, this book is concerned with a changing economy of projection, both in the ancient and modern senses of the word "economy." Most generally, the concept of economy is used in this book to explore how the projective screens of camera obscuras and magic lanterns facilitated drawing relations between phenomena and one's imaginations, beliefs, and reasonings and to cognitively manage those relations. In this respect, the following chapters chart the *visual economy* of early modern optical media, to borrow a concept from Marie-José Mondzain who explores how images became conceived as indispensable connectors between visible and invisible realities in the Byzantine era.[13] In its original Greek sense, *oikonomia* signified the administration of the household (*oikos*), which in Christianity shifted its meaning to designate the divine providential government of the

world and human history toward salvation.[14] In both cases, indeed, economy meant a science of relations and their management. But whereas for the Greeks economy suggested the arrangement of goods, animals, and humans into a harmonious and profitable whole, in Christianity the concept was made to account for God's organization of divine life into a trinitarian form (the Father, the Son, and the Holy Spirit), on the one hand, and the earthly, temporal unfolding of God's eschatological plan, on the other hand. Economy became reconsidered on a universal scale, encompassing the disjunctive relations between transcendence and immanence, the infinite and the finite, eternity and historical time, universal providence and human freedom, as well as concealment and disclosure. In Christianity, what is crucial is that images became considered as essential mediators of these relations, as "living linkages," as Mondzain puts it, between heaven and earth.[15]

In the later seventeenth century, optical media became critical to this Christian concept of (visual) economy, as we will see in Chapters 2 and 3. Jesuit scholars in particular—the polymath Athanasius Kircher (also famous from extended histories of audiovisual media) at the forefront—drew optical apparatuses firmly into the providential *oikonomia*. Projections of light and shadow by technological means became regarded as relays between the holy and the profane space, and hence as potent agents of the divine providence and its economic and globalizing process. "No divine power without projection," the Jesuits of the late seventeenth century seemed to think. Chapter 2 focuses on the development of the concept and practice of optical projection among Jesuit scholars against the backdrop of Catholic counter-reformation and colonial expansion, which it plots by tracing the movements of artifacts, books, missionaries, images, and ideas, not only within Europe, but also between Rome and New Spain as well as China. Among the Jesuits, optical projection became understood as natural but prodigious mediation between the spiritual and the temporal and therefore also as a potentially expansive, possessive form.

Chapter 3 studies how central to the Jesuits' concept of optical media was the association of projection, not only with the celestial but also with the phantasmatic—spirits, ghosts, and demons of all sorts. The key "property" to be annexed to ecclesiastic rule on a planetary scale was the individual soul, and the providential grasp of images cast on a screen was to expand, through homology, onto images in the mind. Immersing their beholders into a realm

of illusions and visions, projections of spirits (or, spiritual projections) were to direct individuals toward perfection—the "government of souls," to borrow a concept of Michel Foucault's.

However, during this historical period the economy of projection also played out in a different sense. While Anglican priests in England were preaching against the worship of images of all sorts (including the Catholics' relics and miraculous apparitions), seeking to lodge the holy firmly under the purview of words only, camera obscuras and magic lanterns simultaneously developed from media of theocracy and items of curiosity into experimental and exploratory devices—especially within the exploits of the Royal Society of London for Improving Natural Knowledge, established in 1660, which was a new type of public body devoted to the *corporate* pursuit of knowledge.[16] Among the Royal Society scholars—who promoted the radical reassessment of vision and cognition by Johannes Kepler at the turn of the sixteenth century and the new principles of scientific study proclaimed by Francis Bacon—devices of projection were turned toward empirical reality, to quasi-mechanically procure information about things and beings both near and distant, familiar and strange, ranging from the operations of light to flora and fauna in the West Indies, for instance. Charting these developments, Chapters 4 and 5 survey situations where established interpretations of projection and divine rule became challenged (although by no means unambiguously) within empirical investigations that sought to apprehend the world objectively as open to "chance and opportunity" (as Francis Bacon put it), sticking onto the visible surfaces of things rather than striving to interpret every contingent event as a manifestation of a deeper cosmic order.

Chapter 4 focuses on Robert Hooke's invention of a portable camera obscura, which illustrates how devices of projection participated in key epistemic developments at the turn of the century, in addition to becoming involved, at least in Hooke's imaginary, in the colonial expansion of both knowledge and trade. Crucial here was the implicit association that Hooke and his contemporaries made between the concepts of projection and property—the latter now starting to be relinquished from celestial possession in the writings of John Locke, among others, and becoming an extension of the person laboring and thereby appropriating the commons originally bestowed upon humanity by divine providence. Projection became involved in the calculation of financial gain and prospects for improvement, surplus and

growth, which, as Devin Singh notes, the notion of *oikonomia* retained histor-ically also in the Christian era.[17] Chapter 5 continues on this theme, exploring how the mixed realities of optical media—alongside practices of calculation, which emerged as key cognitive techniques of finance during the period—gave an intuitive shape to processes in which property and value lost their traditional supports and became volatile, fluctuating, and subject to the con-ceits of speculative minds. Especially the magic lantern's ephemeral images, in want of solidity and stable form, provided the effective mental analogues for the emerging speculative economy as an ambiguous and illusory percep-tual realm seemingly unmoored from material restraints. Overall, these two chapters show how in England circa 1700, optical media became cognitive relays allowing the subsumption of material relations under abstract and invisible, noetic, and even imaginary designs, facilitating thus the develop-ment of a new economic concept of the world as a *tabula rasa* for man-made projections.

Readers, be advised that this book wants to implicitly disengage, both historically and theoretically, the study of early modern technologies and cul-tures of projection from the shadows cast by film theory and its cinematic archaeologies. The historically specific economic concept of projection advanced in this book shouldn't be conflated with the psychological and ide-ological powers of optical projection explored and critiqued in (post-)1970s film theory in particular, most often from psychoanalytic and Marxist per-spectives.[18] In these debates, early modern optical devices found their place in deep histories of darkness, illusion, and influence that extended from Pla-to's cave to the movies, arguably committing to a fundamental optical and conceptual inversion whereby "men and their circumstances appear upside-down," as Karl Marx and Friedrich Engels famously put it in their metaphoric association between the camera obscura and ideology.[19] In these debates, fur-thermore, projection became primarily interpreted as a mental mechanism and associated with the regimenting of the gaze and positioning of individu-als into conformity through identification and disavowal. For Sigmund Freud, as Jean Laplanche and Jean-Bertrand Pontalis tell us, projection was "always a matter of throwing out what one refuses either to *recognise* in oneself or to *be* oneself." Psychoanalytic projection, Laplanche and Pontalis note, is partly "comparable to the cinematographic one," in the way it describes the process

in which the individual casts onto "the external world an image of something that exists in him in an unconscious way."[20]

Such "repressed" manifestations of all sorts—spirits, demons, ghosts—featured prominently in the early history of optical media, ranging from the experiments by the Jesuits, and even sometimes by their fellow Protestant scholars, to popular projected image shows organized by traveling entertainers. In this book, I have decidedly avoided interpreting such apparitions in terms of the psychoanalytic concept of projection, as "embodiments of bad unconscious desires."[21] By doing so, my aim has been not to refute this concept but to offer a historical account that doesn't employ psychoanalytic theory as an overarching narrative of modernity. Terry Castle suggests that it was not effectively until the turn of the eighteenth century that the ghosts and spirits conjured by means of magic lanterns became circumscribed as primarily inner mental phenomena, as products of the brain rather than as anything supernatural per se, and that projected images started to come across as belonging to a mental reality understood first and foremost in psychological terms.[22]

The meanings and functions of projected images circa 1700 were neither fixed nor symmetrical; the form was in flux. Furthermore, the demarcations we today draw between economy, science, religion, and (optical) media—as well as rationality, factuality and fiction, or the phantasmatic—were not yet clearly in place during the historical period studied in this book. In the original turn-of-the-century context, these meanings and functions entered into an odd but creative mix. *Projecting Spirits* hence demands its readers approach a techno-aesthetic form (now familiar to us in the more limited sense of cinematic and "post-cinematic" entertainment, or a constituent function of the modern psyche) in its former semantic openness, complexity, and strangeness.

Acknowledgments

I am very grateful for Erica Wetter at Stanford University Press for her belief in and support of this project. The support also by Cindy Lim, Emily Smith, and Faith Wilson Stein at Stanford has been extraordinary. Thank you to Jennifer Gordon for careful copy editing.

I have been fortunate to develop this work through a series of talks at various universities and in diverse academic settings: Humboldt University of Berlin; Kingston University; University College London; University of Bergen; University of Oslo; Oslo National Academy of Arts; University of Oxford; University of Potsdam; University of Sheffield; and University of St. Andrews. I would like to thank the organizers and audiences at these institutions for their invaluable feedback as well as patience with my fledgling ideas.

At the University of Oslo, the Screen Cultures initiative provided me with much needed time to finalize the manuscript. The Department of Philosophy, Classics, History of Art and Ideas contributed important financial assistance. Han Lamers and Siiri Toiviainen afforded invaluable and generous help with Latin sources. All mistakes and omissions, however, are purely mine. Furthermore, I owe particular thanks to: Carla Benzan, Chris Berry, Ina Blom, Berndt Bösel, Matthias Bruhn, Gerbrand Burger, Sean Cubitt, Kathrin Friedrich, Hanneke Grootenboer, Henrik Gustafsson, Julian Henriques, Keisuke Kitano, Trond Lundemo, Richard MacDonald, Rachel Moore, Jussi Parikka, Deac Rossell, Jukka Sihvonen, and Aron Vinegar.

Finally, a special thank-you to Rebecca for her unreserved support, and to Asta and Onni, and Leevi, for being there.

Projecting Spirits

CHAPTER 1

THE FORM OF PROJECTION

Prelude 1: At the Academy

Sébastien Leclerc's etching *L'Académie des sciences et des beaux-arts*, from 1698, was made just before the French Academy of Sciences underwent drastic changes (Figure 1a). For about thirty years, the academy had been a self-proclaimed enterprise of twenty-nine scientists who enjoyed a pension from the government and whose activities were housed in the King's Library on Rue Vivienne in Paris. Already in the early 1660s, Jean-Louis Colbert and Charles Perrault had been soliciting royal sponsorship for various proposals for a scientific academy, but it wasn't until 1699 that the Academy of Sciences received its formal status and was moved to new premises in the Louvre. Often considered Leclerc's masterpiece, *L'Académie des sciences et des beaux-arts* quite likely drew on the ambitious plan of Perrault's, devised in the 1660s, to establish a Royal Academy of Arts and Sciences, which would unite contemporary knowledges, both theoretical and practical, under a single roof for the "destruction of ignorance"[1]—a plan that was never realized as such.[2]

Illustrating an ideal space of research and learning, with diverse groups of scholars dressed in an antique style, Leclerc's engraving abounds in detail. The building on the right houses a library room dedicated for theology. An orator in the background, almost at the center of the composition, represents rhetoric; an orchestra to the left from them, music.[3] Painting and drawing are practiced under the portico, whereas in the far background two artists

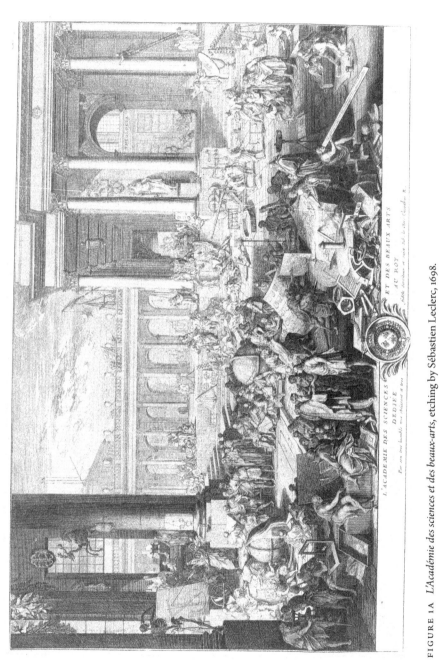

FIGURE 1A *L'Académie des sciences et des beaux-arts*, etching by Sébastien Leclerc, 1698. Courtesy of Rijksmuseum, Amsterdam.

are working on a large sculpture. Behind the colonnade on the left there is a large telescope on the roof of a building, which has been identified as the Paris Observatory.[4] Geometry is personified by a bearded man on the right-hand side who demonstrates Pythagoras's theorems; a group in the left foreground studying trigonometry stands for arithmetic. The beholder's attention is also drawn to an old magician in the center foreground reading the palm of a young student, whose manual of chiromancy is being stepped on by the students in trigonometry. This is a key image in the etching, which professes mastery over the haphazard and the conjectural and hails the establishment of a new reason taking over from the decrepit, muddled foresights and predictions; there is certainty in the timeless principles of geometry, the only science that "knows the true rules of reasoning," as Blaise Pascal praised it in 1655.[5]

Leclerc's etching unfolds an intricate diagram—"a composite play of imagery and cognition," to borrow John Bender and Michael Marrinan's definition[6]—that encapsulates this modern rationality in a series of objects and ideas. On the bottom of the pillar to the left of the engraving, which supports the academy's edifice, a poster displays a schematic drawing of the human ocular apparatus (Figure 1b). While working on *L'Académie des sciences et des beaux-arts*, Leclerc had engaged in debates about human vision in a short book on "point of view" (*Discours touchant le point de vue*), setting himself up to challenge especially René Descartes's arguments in *La dioptrique* published in 1637.

Like other pioneers in modern optics before him (most notably Johannes Kepler), Descartes compared the eye to the camera obscura and proceeded to conjecture how the slightly dissimilar images projected inside the two eyes made their way via the fibers of the optic nerve to the brain, where they were transported to what Descartes (in)famously called the pineal gland—the "seat of the common sense," or of the soul—and unified into a single mental image.[7] Leclerc, on the other hand, asserted that, while our two eyes do indeed receive two dissimilar projections of an object, we only see clearly with one eye at a time, and that the dissimilar retinal images couldn't be united. Therefore, Leclerc curiously concluded that "the soul [*l'âme*] has the perception of only one of these two images" and "sees with one eye only."[8] Presenting his arguments with a series of elaborate drawings, Leclerc sought to illustrate how one arrived at cognitive contact with the world—how the observed realm of bodies and movements became communicated to the soul

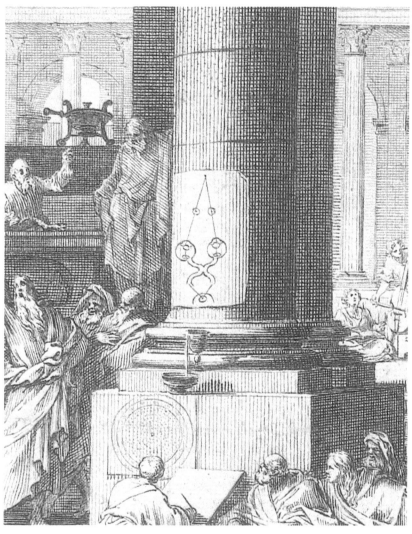

FIGURE 1B Leclerc's diagram of binocular vision. Detail from *L'Académie des sciences et des beaux-arts*, etching by Sébastien Leclerc, 1698.

Courtesy of Rijksmuseum, Amsterdam.

"with light by the channel of the eyes that are its organs."[9] For Leclerc, as for Descartes, the camera obscura provided a key analogue on which to model this process. But whereas Descartes limited this comparison to the mechanics of the eye only, Leclerc extended it to bear on the cyclopean soul, which came across as a kind of room of projection of its own, where "light, entering [the room] through a small glass, paints . . . objects on a sheet of paper."[10]

The camera obscura was an old invention, the history of which extended at least to China in the ninth century as well as to experiments by Arab scientists from the early tenth century. The latter, we are often told, laid the foundations of the modern concept of optics, including the association between the physiology of the eye and the camera obscura's operating principles pursued later by early modern Europeans. It is worth pointing out that, for the Islamic scholars, light was the primary force that governed the cosmos and made the world visible, and the camera obscura assisted in the experimental study of its mathematical laws. The figurations projected inside the device, however, bore very little significance to their pursuits of knowledge.[11] "Pictures" cast on sheets of paper and other kinds of surfaces inside the dark room did not turn into key aesthetic and epistemic curiosities until sixteenth-century Europe. The Italian scholar Daniele Barbaro outlined in his treatise on perspective, *La pratica della perspettiva* from 1569, how the camera obscura was able to visualize colors, shadows, gradations, and movements in vivid detail—water sparkling, birds flying—and how it could also be used as a drawing aid to outline, color, and shade the "perspectives" that nature displayed in the device.[12] Still about a hundred years later, the clergyman John Harris similarly praised the "admirable proportion of light and shadow" inside the camera obscura where especially "motion expressed on your cloth" made the apparatus's "lively pictures" "one of the finest sights in the world."[13] Suffice furthermore to note how in the 1760s, another Italian student of painting, Francesco Algarotti, appreciated how the camera obscura brought the "visual faculty . . . wholly to bear upon the object before it," marveling at the effects of the apparatus in a beautiful prose that deserves to be quoted at length:

> There results . . . a picture of inexpressible force and brightness; and, as nothing is more delightful to behold, so nothing can be more useful to study, than such a picture. For, not to speak of the justness of the contours, the exactness of the perspective and of the chiaroscuro, which exceeds conception; the colors are of a vivacity and richness that nothing can excel; the parts, which

stand out most, and are most exposed to the light, appear surprisingly loose and resplendent; and this looseness and resplendency declines gradually, as the parts themselves sink in or retire from the light. The shades are strong without harshness, and the contours precise without being sharp. Wherever any reflected light falls, there appears, in consequence of it, an infinite variety of tints, which without this contrivance, it would be impossible to discern. Yet there prevails such a harmony amongst all the colors of the piece, that scarce any of them can be said to clash with another.[14]

For the Europeans (Leclerc certainly among them), the camera obscura's colorful projections tending to detail and accuracy enabled a certain kind of perceptual and cognitive grasp of the world's variation within a harmonious whole. In Leclerc's *L'Académie des sciences et des beaux-arts*, this drive for optical harmony and clarity also became associated with two other key visual media of the period: first, an instrument for perspectival imaging, which is situated underneath the diagram of vision, on the bottom left-hand corner of the etching (Figure 1c); and second, a neatly decorated magic lantern on the opposite side, which looks like it has been recently used, with the slide disk in position (Figure 1d).

The former device originated from Alberti's and Brunelleschi's famous research into single-point perspective in the fifteenth century, particularly from the concept of the "veil" (*velum*) that Alberti introduced as part of his instructions on perspective painting in *De pictura* from the 1430s, for the purposes of correct outlining: a grid-structure that constituted a plane intersecting the visual pyramid and that aided in determining the positions, proportions, and scale of objects depicted by projecting and mapping them on a two-dimensional surface.[15] As such, the veil aided in securing and immobilizing the position of the viewer into a fixed point at the apex of the visual pyramid. Since systematized and popularized into various types of workable drawing aids by artists and scholars—notably by Albrecht Dürer in *Unterweysung der Messung* (first published in 1525), and later in the early half of the seventeenth century within research into perspective and mathematics, such as Jean Dubreuil's[16]—the perspectival grid, notably, contributed to the program of rearranging space according to geometrical rules.

In this purpose, the mechanics of perspective projection amounted to much more than merely automating hand and eye movements in replicating appearances. For one thing, it made the observer in principle superfluous

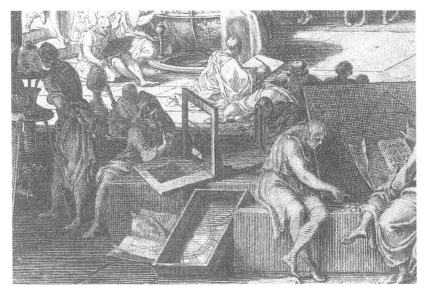

FIGURE 1C A perspective machine. Detail from *L'Académie des sciences et des beaux-arts,*
etching by Sébastien Leclerc, 1698.

Courtesy of Rijksmuseum, Amsterdam.

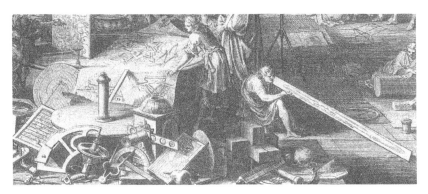

FIGURE 1D A magic lantern and anamorphic devices. Detail from *L'Académie des sciences et
des beaux-arts,* etching by Sébastien Leclerc, 1698.

Courtesy of Rijksmuseum, Amsterdam.

in the production of pictures, as one of Dürer's perspective instruments suc-
cinctly illustrates (Figure 2): This simple but cumbersome invention uses
pieces of string to simulate visual rays, which allows the projection of individ-
ual points in three-dimensional space onto a two-dimensional surface. This
early instance in the genealogy of raster graphics "eliminate[d] the human
eye altogether," Erwin Panofsky pointed out.[17] Perspective's instrumental
purpose was not to represent things as seen by the eye but according to "order
and reason," as the French engraver and architect Abraham Bosse praised
perspective projection in the 1660s.[18] Bosse made the important observation
that what he called perspective's "compass and rule" did not just operational-
ize the gestures of painters and draughtsmen, but imposed themselves onto
the imagination and the mind[19]—they functioned as cognitive screens with
their own "logical scheme or grammar of thought."[20] While offering only a
partial and essentially delimited view onto the world, perspectival presenta-
tion's shortcomings were balanced out by the universal mathematical laws

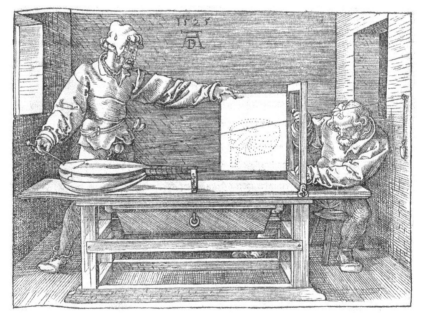

FIGURE 2 A perspective machine. Illustration from Albrecht Dürer's *Unterweysung der Mes-
sung*, 1525.
Courtesy of Saxon State and University Library Dresden.

according to which the world could be reproduced into a coherent mental shape.

A key figure in formalizing perspective projection in geometrical terms in the first half of the seventeenth century was Abraham Bosse's master, the architect and engineer Girard Desargues. Desargues demonstrated linear perspective as a subset of a more general program of projective geometry, a "post-Euclidian geometry full of irregularities and exaggerations," which, although originating in research on central perspective, simultaneously challenged its grid-based visuality.[21] In a short tract from 1636 Desargues significantly improved the techniques of perspective projection by removing the "distance point" (used to measure and ideally fix the distance of the eye of the spectator from the picture plane) from his construction, and he developed a method allowing multiple viewpoints from various distances and basically from any type of angle on a virtual object constructed on the picture plane (Figure 3).[22]

Desargues started from a fixed viewpoint but then moved this viewpoint around and through the scene, so as to rationalize distortions of perspective (convergences, shrinking, etc.) according to measurable values.[23] Investigations into perspectival modeling anticipated Desargues's groundbreaking work on conic sections from 1639, which developed the notion of invariance, referring to the internal coherencies of figures undergoing changes in different projections; for instance, the circle becoming an ellipse, a hyperbola, a parabola, and so on, on different intersections of a "cone" projected from a point.[24] Desargues dealt with changes in scale, distortions, bending, and (even more radical) "becomings" that took place in the process of projection, and he explored how the apparently disordered series of transformations were subject to inherent regularities: The lines extending from different sides of a triangle, say, would converge at a point (even if they were parallel, as they would curve at a point in infinity), sharing the same "axis of perspectivity." Here, Desargues's contribution was two-fold. On the one hand, he showed how objects were essentially shaping and reshaping depending on a point of view. On the other hand, he demonstrated how variability, diversity, and contingency could be mapped and ordered within a system of laws and regularities. Desargues's gesture was in a sense to both affirm and rationalize transformation by emphasizing the importance of the point of view, which both embraced variation and facilitated its harmonization.[25] Projective

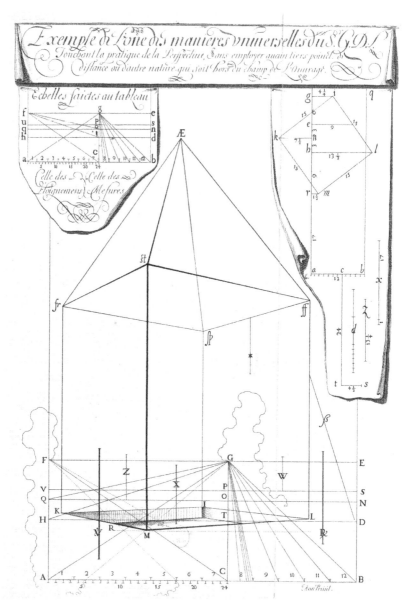

FIGURE 3 Perspective projection. Illustration from Girard Desargues's *Exemple de l'une des manieres universelles du S. G. D. L. touchant la pratique de la perspective*, 1636.

Courtesy of Bibliothèque Nationale de France.

geometry, in Michel Serres's words, put forward "a space organized in rela-
tion to a point of view from which the random variety of the former becomes
ordered"[26]—a point we shall come back to.

Returning to Leclerc's etching, it is plausible that the engraver was, to a
degree at least, cognizant of the developments in projective geometry dur-
ing his time. In the early 1670s, Leclerc became a professor in geometry
and perspective at l'Académie Royale de Peinture et de Sculpture, where
Bosse had caused controversy a bit over a decade earlier by seeking to turn
the mathematical methods of perspective construction adapted from De-
sargues's investigations into aesthetic criteria.[27] It is likely no coincidence
that Leclerc included in the right foreground of the etching—under the
plans for fortifications à la Vauban unfolded on the table and behind a heap
of instruments—two optical apparatuses that both emphasized visual varia-
tion and change and challenged the world's rendering within perspective
pictures' static geometrical structures (see Figure 1d): a round table for view-
ing anamorphic images by means of a mirror positioned in the middle of the
table (anamorphic images that a man sitting on the floor also spectates from
a slanted angle) and, below the table, a magic lantern (a version of which
Leclerc also had in his extensive collection of scientific instruments).[28]

Anamorphic images twisted perspective's "rules and compasses" from
within. While experiments with anamorphic pictures date back to Leonardo
da Vinci, if not earlier, it was a Minim friar based in Paris, Jean-François Nice-
ron, who came up with a key theoretical formulation of anamorphic practice
in the 1630s (although the term "anamorphosis," Greek for "forming anew,"
was not used before the Jesuit scholar Gaspar Schott's *Magia universalis*
published in 1657).[29] Niceron called his invention a "curious perspective"
(*perspective curieuse*). Anamorphic images were "lacking reason" (*sans raison*),
as opposed to ordinary perspective's "straight vision" (*vision droite*).[30] The
monk's approach was to manipulate the perspective grid by conflating the
vanishing point with the point coordinating the position of the (ideal) viewer,
which radically distorted scale and proportion causing figures to stretch,
bend, and blur, and above all, eradicated the illusion of distance (Figure 4).
As a result, the space between the viewer and the picture plane was collapsed,
and pictures no longer appeared to recede away but to extend toward the
viewer.[31] This marked an important conceptual shift where distinctions be-
tween visual clarity and confusion, ultimately between the subject and object

FIGURE 4 Anamorphic grid. Illustration from Jean-François Niceron's *La perspective cu-rieuse*, 1651.

Courtesy of Bibliothèque Nationale de France.

of looking, became obscured. Uncertain and ambiguous shapes did not find coherence and pattern until the viewer moved around or manually manipulated the picture plane. A sense of perceptual and cognitive mastery was only possible from within an embodied viewpoint as a kind of trick effect to be discovered hidden in the picture's composition, which itself played an active role in decentering and repositioning its beholder. Anamorphic projection, as Lyle Massey emphasizes, introduced temporality, contingency, and performativity into the act of looking—a degree of immanence that challenged perspective's transcendent overview of a homogeneous, infinite expanse. Therefore, crucially, it questioned "the seemingly ironclad claim that perspective unambiguously rationalizes space through mathematics."[32]

Anamorphosis disclosed how contingency and order depended on one another, emphasizing how their borders were uncertain and under constant variation. To that effect, it converged closely with the magic lantern's key aesthetic principles. In the 1650s, a member of the French Academy of

Sciences, the Dutch scientist Christiaan Huygens, came up with a device for reflecting, transmitting, intensifying, and amplifying light, which could cast magnified shadow projections onto a surface by means of a system of mirrors, lenses, and a candle.[33] The slide projector, called *laterna magica* in Latin by its inventor, quite likely grew out of Huygens's investigations into the properties of light (Huygens became famous for his wave theory of light, among other things), although in the scientist's own assessment, his contrivance was a mere "bagatelle," something of less value and significance, as we read in Huygens's letter to his brother Lodewijk.[34] Huygens was, for some reason, oblivious to how his contrivance put forward an original regime of images—images that were not exactly unheard of, considering how similar but less elaborate effects had been previously contrived by means of camera obscuras, but nonetheless distinct. The magic lantern's images were "lightsome Object[s] of distinct Colours and Parts," as Huygens's contemporary William Molyneux put it.[35] They were, in other words, light-borne, becoming visible only in the dark. They were temporal, potentially animated (as Huygens seems to have intended with his famous sketches of skeleton slides from 1659), and flickering. They would distort depending on the positioning of the light source; they would bend and stretch if one tilted the projector; they would grow bigger or smaller if one moved the *laterna magica* closer or farther away from the projection surface.

The magic lantern's projections were therefore anything but stable and predictable. Like anamorphic images, they distorted perception. "'Tis that fallacious Art that deceives our Sight, and which with the Rule and Compass disorders all our Senses," the French physician Charles Patin noted in a letter to the Duke of Brunswick after witnessing a magic lantern show in the early 1670s.[36] Variations in scale and the separation of effects from their causes were particularly troubling to contemporary observers, who emphasized the apparatus's powers of magnification and often associated it with black magic and the devil's work. As late as 1728, the French priest Jean Pierquin explained away necromancers' evocations of the spirits of the dead as effects of the magic lantern, which was able to blow up "specters" in prodigious dimensions; here, "mechanics" and "optics," as Pierquin put it, were employed for the art of "evoking [*susciter*] all sorts of phantoms."[37] But rather than anything primarily supernatural per se, in its early days the magic lantern embodied the understanding of visuality under variation conceptualized in Desargues's

geometrical investigations. The magic lantern, as George Hersey cogently points out, was "a machine for projective geometry." Its design involved a light source and a set of lenses that projected an image drawn or painted on a translucent slide onto a screen—a process in which the projected image underwent a series of continuous distortions (such as enlargement) along the cone of light but exhibited nonetheless internal coherence.[38] The *laterna magica*, in this sense, grew out of the concerns of a geometrical reason that understood contingency and variability subjected to inherent rationality as essential to the formation of figures.

If media technologies are able to bear upon epistemic changes, the magic lantern, alongside anamorphosis, participated in what Michel Serres has mapped as the translation, in the Western spatial imagination, of the question of a fixed, privileged point at the center of a harmonious organization to the variable point of view as a central epistemic figure in the seventeenth and eighteenth centuries.[39] During the period, the idea of a transcendent, synoptic, and totalizing God's eye view of the universe as something unified and homogeneous became challenged, among others, by the science of conic sections explored by Desargues (alongside Blaise Pascal), which coincided with post-Copernican debates about plurality and relativism. Conic sections, as noted, emphasized the multiplicity and changeability of figures but simultaneously demonstrated how this polarized space could be rendered into a rational structure from within (and relative to) a point of view. Projective geometry showed how "there is a point from which the apparent disorder becomes organized into a real harmony," a unique point from within which a given variety folds back into order.[40] Critical here was how organization became localized; how contingency and variation were introduced into certainty and permanence; how points of reference became multiplied; and how the localized and singular point of view itself became the condition of knowledge.[41] The two devices of projection in Leclerc's *L'Académie des sciences et des beaux-arts*—the magic lantern and the anamorphic display—silently and unassumingly gesture this primacy of point of view. Leclerc's "meta-picture"—to use W. J. T. Mitchell's concept of pictures that "present a scene of depiction or the appearance of an image"[42]—diagrams what projection meant and implied at the turn of the seventeenth century: an emerging sense of perspectival dislocation from which the world started to appear as uncertain and ambiguous. Anamorphosis distorted perspective representation's rule and order, while simultaneously affirming the

possibility of their temporary recognition and reinstatement. The magic lantern presented simulated environments of movement, variation, and distortion that even more radically challenged the fixed and the permanent.

The latter optical apparatus also figured prominently in two vignettes Leclerc designed for two dissertations in philosophy almost a decade after *L'Académie*: Jules Adrien de Noailles's *Theses philosophicae* and Roger de la Rochefoucauld's *Deo adjuvante* (Figure 5), both from 1707. Both engravings portray allegories of philosophy seated among ranks of scientific instruments and illustrations, including Leclerc's diagrams of vision. De Noailles's and de la Rochefoucauld's dissertations were both written to affirm the established Christian concept of the universe whereby God "directs, conserves, and moves everything with the highest providence," as we read in de la Rochefoucauld's *Deo adjuvante* ("The helping God").[43] In Leclerc's engraving for the work, Lady Philosophy leans on a magic lantern not only for physical but also, one can assume, for cognitive support to shore up this thought. In her left hand, she holds a stick with which she traces an illustration drawn from

FIGURE 5 Vignette for Roger de la Rochefoucauld's dissertation *Deo adjuvante*, portraying the allegory of philosophy leaning on a magic lantern for support, surrounded by various scientific instruments and illustrations. Engraving by Sébastien Leclerc, 1707.
Courtesy of Bibliothèque Nationale de France.

Leclerc's own cosmological treatise on a "new world system conforming to the scripture," *Nouveau système du monde, conforme à l'écriture sainte*, from 1706. The main idea of Leclerc's lavishly illustrated book was that the sun and the earth revolve around the center of their shared "vortex." In both words and pictures, the engraver's goal was to promote an anti-Copernican view of the universe, which could reconcile with the teachings of the Bible. The result was an odd construction where the universe was understood as made up of an infinite number of vortices (*tourbillon*) housing celestial bodies. Bubbles provided the key thought-figure for explaining the composition of the vortices themselves: The universe was like a sea of bubbles that a child blows with a straw in soapy water, held together by the frozen waters of the firmament.[44] In Leclerc's universe, the complex and the contingent (vortices, the formation and movement of bubbles) were fixed and frozen into a timeless order. It is not insignificant that, in the vignette to de la Rochefoucauld's *Deo adjuvante*, Leclerc made Lady Philosophy lean on the magic lantern for support to hold together this incongruous thought, which put forward a key paradox emblematic of the era: between permanence and fluidity, contingency and organization, design and randomness.

Prelude 2: Leibniz's Lantern

In September 1675, while on a stroll on the banks of the Seine in Paris, Gottfried Wilhelm Leibniz witnessed a fantastic-sounding contrivance on display for the public: a machine that could walk on water.[45] In his notebooks, the member of the French Academy of Science doesn't expound on what he saw, perhaps more a visual trick than anything else. But the experience sparked in Leibniz what he called "une drole de pensée"—which can be loosely translated as an "amusing thought"—about a new type of academy showcasing the latest achievements in science, technology, and art. Eminent patrons were to be summoned behind the venture, which was also meant to be a commercial success. Those invited to participate were to include painters, sculptors, carpenters, clockmakers, in addition to mathematicians, engineers, architects, street performers, musicians, poets, librarians, typographers, engravers, and even charlatans. Their activities would be divided across at least four departments: "science," "representations," "exercises," and "pleasures." Leibniz's design was to be a mélange of the latest knowledge and arts akin to Leclerc's engraving on the imagined Academy of Sciences and Fine Arts,

but more focused on attraction, play, and illusion. In addition to displaying the latest technology—from telescopes to Athanasius Kircher's "cabinet," for instance—the public was to be lured in by various types of insects and rare animals, fireworks, military exercises, anatomical theaters, burning mirrors, and all other sorts of optical marvels, as well as fairground attractions, from acrobats to an English fire-eater.

Throughout the notebook tract, Leibniz was "fascinated most essentially with light and its effects, and with projection and its possibilities," as Deac Rossell points out.[46] The magic lantern was meant to play a prominent role in the show alongside camera obscuras and anamorphic displays. Leibniz, who learned about the new optical medium from the German instrument maker Johannes Franz Griendel around 1672, emphasized how the magic lantern could present "extraordinary and grotesque" movements with bespoke slide mechanisms (Figure 6).[47] At the end of his 1675 note, Leibniz included the apparatus in a design for a shadow play consisting of movable wooden figurines positioned in front of a light source and arranged on different levels so as to maintain perspective. All sorts of marvelous metamorphoses could be portrayed with the shadows of the figurines bursting onto a paper screen. The magic lantern was to conclude the show by projecting "admirably beautiful and shifting shapes."[48]

Horst Bredekamp associates Leibniz's shadow play with the Dutch artist Samuel van Hoogstraaten's print displaying a "shadow dance" (*schaduwendans*), from the latter's treatise on painting from 1678, *Inleyding tot de hooge schoole der schilderkonst* ("Introduction to the academy of painting").[49] Van Hoogstraten explained the setup as a large screen made of white paper stretched behind the curtain of a prepared theater, with a sizable candle lit at the back of the stage (Figure 7). When actors appear between the light source and the screen, with the curtains open, their shadows are cast onto the paper—those closer to the candle appearing larger, and those further away, smaller.[50] Van Hoogstraten was an illustrious perspective painter, who experimented with anamorphosis and peep shows. In *Inleyding*, he also discussed shadow projection according to perspective's rules where shadows appeared, in his words, as "actually nothing" in themselves but "absence."[51] But in the shadow theater, as van Hoogstraten's etching vividly shows, shadows carried out a more substantial purpose. The dancers were performing the mythological story of Acis and Galatea, with cyclops, fauns, and nymphs. Their shadows were growing, shrinking, and metamorphosing into one another.

FIGURE 6 Griendel-type magic lanterns with horizontal cylinder bodies. Illustration from Johann Zahn's *Oculus artificialis*, 1686.

Source: Staatliche Bibliothek Regensburg, 999/Philos.3970, urn:nbn:de:bvb:12-bsb11112062–6.

Appearances came across as ephemeral and uncertain; the projected shadow of a person dressed as a satyr turned him into a devil. Shadows suggested distortion and transformation, indeed, a certain plasticity of the real; perhaps they even possessed the power to both create and erase the real—the "powers of the false," as Gilles Deleuze called them.[52]

Both Leibniz's and van Hoogstraaten's shadow plays dealt with variations of scale, movements, and transformations. Both emphasized the fundamental contingency and manifoldness of the visible. Bredekamp rightly points out a key connection between Leibniz's shadow theater and the theory of conic sections explored by Desargues: Both dealt with apprehending figures through "movement and transformation."[53] For Leibniz, conic sections

helped to conceptualize the notions of the viewpoint and harmonious varia-
tions within and between different viewpoints that were also outside the
realm of geometry proper:

> It is true that the same thing may be represented in different ways; but there
> must always be an exact relation between the representation and the thing, and
> consequently between the different representations of one and the same thing.
> The projections in perspective of the conic sections of the circle show that one
> and the same circle may be represented by an ellipse, a parabola and a hyper-
> bola, and even by another circle, a straight line and a point. Nothing appears
> so different nor so dissimilar as these figures; and yet there is an exact relation
> between each point and every other point. Thus one must allow that each soul
> represents the universe to itself according to its point of view, and through a
> relation which is peculiar to it; but a perfect harmony always subsists therein.[54]

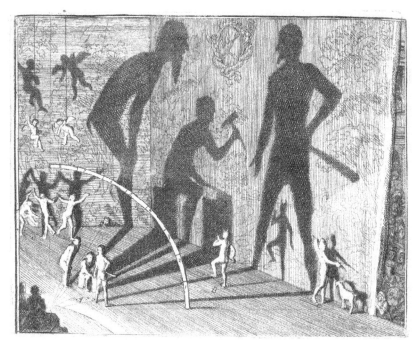

FIGURE 7 Shadow dance. Illustration from Samuel van Hoogstraten's *Inleyding tot de hooge
schoole der schilderkonst*, 1678.
Courtesy of National Gallery of Art, Washington.

Conic sections thus figured in Leibniz's sketch of his concept of the universe, which was pluralized into an infinite series of fragmented and decentered viewpoints. These "monads" were able to represent distinctly and clearly only a small part of things; the rest of the universe appeared in a confused manner, disappearing into metaphorical darkness.[55] "The same town," Leibniz explained in the manuscript on "monadology" in 1714,

> when looked at from different places, appears quite different, as it were, multiplied *in perspectives*. In the same way it happens that, because of the infinite multitude of simple substances, there are just as many different universes, which are nevertheless merely perspectives of a single universe according to the different points of view of each monad.[56]

Leibniz's concept of the monad was a question of shifting perspectives, and it carried in its composition features of the key optical media of the turn of the seventeenth century that embodied such shifts in their aesthetics. Depending on the viewpoint, vague, deformed, and confused lines and areas emerged into a shape and form with distinct properties, and vice versa, as in anamorphic images.[57] And every monad (and especially monads endowed with self-consciousness, that is to say, "minds") was in Leibniz's conception an image projection apparatus in its own right, comprehending things through projections of "shadows and fairly strong and well-handled colors."[58] Camera obscuras and magic lanterns figured prominently, especially in Leibniz's discussion of the mind in *New Essays on Human Understanding*, written in response to John Locke in the early years of the 1700s. To Locke's famous approximation of perception and understanding with the camera obscura's operations of framing and circumscribing, Leibniz responded:

> We should have to postulate that there is a screen in this dark room to receive the species, and that it is not uniform but is diversified by folds representing items of innate knowledge; and what is more, that this screen or membrane, being under tension, has a kind of elasticity or active force, and indeed that it acts (or reacts) in ways which are adapted to both to past folds and to news ones coming from impressions of the species.[59]

Whereas Locke considered the human mind as a receptive screen for recording and organizing sense data, Leibniz applied the camera obscura metaphor to the brain, which he understood as an "active and elastic" screen that

combined sensory impressions with innate ideas (universal knowledge en-folded in every monad) and produced new ones from their combinations. The mind itself, on the other hand, was in *New Essays* approximated to the magic lantern, but only on those occasions when the rational soul was not fully in control of itself but was visited by involuntary thoughts coming "from within," stirring the mind's ordinary operations. "Even when we are awake, we are visited by images," Leibniz wrote, "which come to us unbidden, as in dreams"—like the projections of the magic lantern "with which one can make figures appear on the wall by turning something on the inside."[60]

"By turning something on the inside . . ." Leibniz's somewhat clumsy explanation suggests a moment when a media apparatus, involuntarily per-haps, starts to feed back onto the originator of the metaphor. Throughout Leibniz's writings, optical projection appeared and reappeared in modeling the monadic viewpoint, providing a reflective surface for figuring and con-ceptualizing the world's manifoldness and contingency—transformations of figures, the multiplicity of shapes—and the world's variation within and between viewpoints. Yet, also important for Leibniz was to understand how seemingly ephemeral, disparate, and accidental phenomena were funda-mentally enfolded within an original harmony and order. "One must seek the reason for the existence of the world, which is the whole assemblage of *contingent* things," Leibniz wrote, "and seek it in the substance which carries with it the reason for its existence, and which in consequence is *necessary* and eternal."[61]

Leibniz aligned this quest for an underlying geometrical and logical har-mony with a particular concept of divine vision and wisdom. Fragmented, framed, and decentered monadic viewpoints, whose capacity to illuminate a portion of the world was predicated on surrounding obscurity (or, ambient darkness as in the camera obscura or the magic lantern), were united in God's omniscient and omnipotent mind—the original source of all light. God could apprehend "all things at the same time."[62] Bredekamp notes how Leibniz conceived of God as being able to intuitively envision all objects, relations, and events—past, present, and future—in the universe at a single *glance* (*coup d'oeil*), in a single visionary moment.[63] Where the world appeared as blurry and confused from an individual's viewpoint, God saw everything in proper perspective. Where relations between things and events came across as haphazard and merely probable, God was able to perceive their necessary

connections and place them within the overall design of the universe. Where earthly beings were overwhelmed by uncertainties of the future, God oversaw each individual's destiny. This divine optic concerned, in other words, the world's *providential* organization. "The foreknowledge of God renders all the future certain and determined," Leibniz wrote,

> but his providence and his foreordinance, whereon foreknowledge itself appears founded, do much more: for God is not as a man, able to look upon events with unconcern and suspend his judgement, since nothing exists save as a result of the decrees of his will and through the action of his power.

The world fell under God's "foreordinance"—that is to say, anticipatory command and care. The omniscient and omnipotent God governed every single instance in advance; God ordered "all things at once beforehand." Leibniz called this the divine "government of the universe," which was based on God's infinite wisdom and goodness, and therefore on absolute necessity (rather than being "guided by chance," which was the work of evil).[64]

Such a celestial vision, which "regards all the aspects of the world in all possible manners," could not be replicated by any earthly optical medium.[65] Yet the undertones of camera obscuras and magic lanterns became palpable also in Leibniz's attempts at grasping the larger divine organization within which the world's variability, manifoldness, and randomness settled into a harmony. Leibniz spoke about the "emanation" of things and beings as manifestations of God's "glory," which he modeled with his famous invention of binary arithmetic: Just as every number could be created out of combinations of zeroes and ones, God created the world and its unity out of nothing, Leibniz reasoned.[66] According to Deleuze, Leibniz's mathematical combinations of zeroes and ones also compared visually with projections of light and shadow, suggesting how the universe was fundamentally composed of emanations of light and its obscurities, in addition to mathematical code.[67] Overall, optical media guided Leibniz in probing the monadic viewpoint and (by implication) divine illumination, in view of understanding how the world's becoming was enfolded in a rational design and how occurrences of seemingly contingent nature gave expression to a gracious organization. For Leibniz—and for Leclerc, as we learned earlier—projections of light and shadow embodied a fundamental dilemma between contingency and providence, variation and harmony, the human and the divine. This is where

Leibniz articulated something essential about how early modern optical media became generally played out in the minds of his contemporaries.

Providence/Speculation

In Leclerc's and Leibniz's times, "projection" in the optical sense of the "presentation of an image on a surface" (as the Oxford English Dictionary today puts it) had not yet entered language; instead, the concept is much newer than its apparatuses. In the French context, *Le Dictionnaire de l'Académie françoise dedié au Roy* from 1694 tells us that the word "projection" was hardly used in any other than its archaic alchemical sense referring to the mysterious "powder of projection" that was meant to be able to change base metals into gold.[68] Antoine Furetière's rivaling *Dictionnaire universel*, published posthumously in 1690, four years before the academy dictionary, reiterates the alchemical meaning of the word but also proposes two other definitions: first, projection as the perspectival and/or cartographic practice of translating three-dimensional objects onto two-dimensional surfaces; and second, projection in the sense of a founder's "design" (as in "projection" of metal into a sculpture).[69]

In the English context, Samuel Johnson's *Dictionary of the English Language* from as late as 1755 likewise shows no awareness of projection in the optical sense (even if by the mid-eighteenth century, projected image spectacles had become standard popular entertainment, evolving from exotic shows in scholars' and collectors' cabinets of curiosities into commodities consumed by the lower classes in pubs, at home, and on the street). More detailed than its French predecessors, Johnson's dictionary gives instead four other definitions for "projection": (1) "the act of shooting forwards"; (2) "plan, delineation"; (3) "scheme, plan of action"; and (4) in chemistry, "a moment of transmutation."[70] The first three definitions describe a movement forward, in time rather than in space; indeed, they suggest anticipation and forecasting (the anticipation of the stone one throws hitting its target or one's plans becoming reality with desired results), whereas the fourth one connotes variation, mutability, and metamorphosis, and therefore also uncertainty. In all its senses, "projection" suggests a design awaiting realization—a plan for (re)shaping—therefore something virtual in the sense of existing as a possibility that is yet to be actualized. The word's roots, we recall, include the Latin *projectio*, for the act of throwing forth (from *proicere*, "to throw or propel") as well as an extension or a protrusion, and the Middle French *projetter*, meaning "to plan ahead."

The etymology also implies planning, plotting, and modeling, and by implica-
tion, the tension between one's plans and the chance events that thwart them,
between intended outcomes and random effects.

The two registers of "projection," as a visual practice and as the activity
of designing, are not necessarily mutually exclusive.[71] When projection was
developed as a modern techno-visual concept and practice at the turn of the
seventeenth century, these two aspects were in fact inseparable. Optical pro-
jection embodied a larger intellectual problem of *design*. Leclerc's *L'Académie
des sciences et des beaux-arts* thematized projection both as a techno-aesthetic
frame and a cognitive point of contact with a changing world: While the
camera obscura enhanced the observer's powers to circumscribe the world
visually, the magic lantern challenged the mind's grasp of the complexity of
things and events. Leibniz, on the other hand, considered projection as sus-
pended between the individual's perception of its surroundings alternating
between clarity and obscurity, and the emanation of God's providential plan
in the universe. Leibniz's intuition of projection as indicating an underlying
rational arrangement beneath the world's manifoldness and human history
can be traced back to scholastic theology—as well as the patristic Christian
concept of *oikonomia*[72]—where it meant the government of the world as a
whole (*gubernatio mundi*) and was considered synonymous with the protec-
tive care and direction of beings toward perfection that God exercises upon
his free will. "God, through His providence," Thomas Aquinas wrote, "orders
all things to the divine goodness, as to an end."[73] Government designated the
divine economy (*oikonomia*) and benevolent activity through which God
manages human history, contingent relations between things and beings as
its field of operation.[74]

At the turn of the seventeenth century, as we will see in more detail in the
following chapters, the optical concept of projection became activated across
several discursive fields, from (natural) philosophy to religion and economy,
against this notion of government rooted in scholastic theology. "Projection"
was variously predicated upon the problematic of world government, focused
on casting an orderly form upon contingent relations, linking with what Jona-
than Sheehan and Dror Wahrman propose as a "bigger intellectual problem
that shaped the later seventeenth century," which "converged on the problem
of order, its origins, and its dynamics."[75] Debates about and reinterpretations
of the concepts of providence and contingency—design and chance—were

at the very core of this problem.[76] In his sermon on time and chance, the Anglican priest Laurence Sterne encapsulated the existential dilemma of maintaining faith in God's benevolent direction of the world when faced with accidents that overwhelmed one's actions and reasonings:

> Some, indeed, from a superficial view of this representation of things, have atheistically inferred,—that because there was so much lottery in this life,—and a mere casualty seemed to have such a share in the disposal of our affairs,—that the providence of God stood neuter and unconcerned in their several workings, leaving them to the mercy of time and chance to be furthered or disappointed as such blind agents directed.

Sterne countered such deliberations by arguing that what appeared as accidental and arbitrary were in fact "regular dispensations" and part and parcel of the "secret and overruling providence" of a "superior intelligent Power." If God didn't introduce variation and change as part of his design, effects would follow their causes merely mechanically like in a clockwork; therefore, it would be profane, Sterne cautioned, to deem "sundry events" as "chance."[77]

Sterne sought to undermine skeptical voices that challenged the subsumption of contingency under a purportedly rational but fundamentally inaccessible and secret divine design. Consider the refutation by French Calvinist philosopher and proto-encyclopedist Pierre Bayle, in *Various Thoughts on the Occasion of a Comet* (1682), of the belief that extraordinary events could simply be regarded as signs of God's will and direction. Bayle did not go as far as to challenge the idea of general providence—that there is a "general cause that puts into action all the rest by means of a simple and uniform law"—but he dismissed the idea that God willed every particular occurrence and outcome. Apart from implementing the general plan based on impersonal natural laws, God, according to Bayle, did not decide to act externally in the course of events. Thus, rather than being guided in their knowledge by divine benevolence, individuals were left on their own in the face of the world's uncertainty, to seek to comprehend in vain the complexity of causes and effects where even the simplest movements would "no longer appear to depend on one another."[78]

Bayle was not alone in his doubts. Across the channel, John Locke, in his *Essay Concerning Human Understanding* (1689), ended up questioning the idea of God as provider of certainty of knowledge and conceded that, "in the

greatest part of our concernments," divine providence has "afforded us only the twilight, as I may say so, of *Probability*." Locke's *Essay* proposed that individuals acquire knowledge through the evidence of their senses (instead of innate ideas acquired from God, as Leibniz, among others, argued) and acknowledged that knowing in many cases was a matter of judging the "likeliness" of something being true, a matter of belief and opinion or what Locke, importantly, called "credit."[79] In this case, our access to and comprehension of the world was no longer based on "visible and certain connexion"—reality had become opaque, difficult to penetrate with the dim light of reason, and made of relations that remained invisible and virtual.

In their respective ways, Bayle and Locke articulated a loss of faith in universal harmony. This was the loss of a religious (and especially Catholic) view of the world where miracles were frequently appearing instances as well as proofs of divine presence and guidance, and where the variety and randomness of things and events could be mapped out by human eyes and ears as signs of deeper hierarchies, even if unbeknownst to us. The erosion of this view was by no means sudden or straightforward. In France in the 1670s, Nicolas Malebranche defended his famous doctrine of the vision in God, which asserted that we see all things and cogitate abstract notions as mediated by ideas in God. For Malebranche, God's presence in our souls was immediate and intimate, and as rational creatures we all participated in the infinite and universal divine reason, which guaranteed knowledge of the immutable order of the universe.[80]

In his 1662 sermon on providence, the French bishop Jacques-Bénigne Bossuet similarly defended divine wisdom against doubts that God had abandoned humankind to the blind powers of hazard and fortune. Bossuet maintained that everything in the world happened for a reason and was governed by general rules—that, even if the world could appear as "prodigiously uncertain," an "eternal and immutable" but hidden "council" presided over every event.[81] Bossuet, crucially, modeled his concept of a secret providential rule juxtaposed against the world's seeming disorder and continual change on anamorphic projection, or what he called a "perspective trick" (*jeu de la perspective*). Referring very likely to the anamorphic mural painted by Jean-François Niceron in the Minim monastery situated at the Place Royale in Paris, which presented Saint John the Evangelist emerging out of a medley of plants and flowers, Bossuet explained how, when knowing the secret of

an anamorphic picture, the visual confusion of lines and colors suddenly re-solved into a proper human shape.[82] According to the bishop, anamorphosis, presented in this way, a "quite natural image of the world." In the first in-stance, we perceive the world in a confused manner, in search of form, order, and certainty. The hidden rationale (*justesse*) of the world becomes revealed to us when we look at it from the vantage point opened up by faith in Jesus Christ.[83] Only from this oblique viewpoint are we able to appreciate how the supreme power governs the world and individual fates and how even the smallest detail fits into the providential organization where everything coincides and cooperates in harmony. Bossuet, in other words, articulated the relationship between change and order, contingency and providence, as a question of perspective and its distortions. In *Theodicy*, Leibniz in a like manner brought up anamorphosis—"those devices of perspective, where certain beautiful designs look like mere confusion until one restores them to the right angle of vision"—when discussing the divine perception where "the apparent deformities of our little worlds combine to become beauties in the great world, and have nothing in them which is opposed to the oneness of an infinitely perfect universal principle."[84] Here anamorphosis performed a parallel epistemic role with optical projection in Leibniz's thought: Apparent confusion (disorderly shapes, or the play of shadows on a screen) suggested an underlying rational operating principle.

Leibniz's notion of projection suggesting God's governance of the world resonated particularly with the ideas of the German Jesuit polymath Athana-sius Kircher, a key protagonist in this book, who affirmed divine providence with his notion of universal harmony conceptualized as an institution of light and shadow and modeled on the operating principles of camera obscuras and magic lanterns. In Kircher's hands, optical media were employed first and foremost as tools of illusion, influence, and paradox—designed to blur the real with the virtual by abstracting effects from their causes. Deceits of the senses, tricks, sudden transformations, and disappearances imposed fundamental cognitive uncertainty and indeterminacy on their beholders, which could only be reconciled as prodigious apparitions manifesting a hidden providen-tial order. Kircher understood optical projection as a matter of instituting and making present divine providence on earth: as the establishment of a system of management and administration, fundamentally, "to the greater glory of God" (*"Ad majorem Dei gloriam,"* as the Jesuit order's motto goes).[85]

Yet to many contemporary observers, the visual manifoldness and variation of camera obscuras and magic lanterns could also concomitantly suggest something other than divine glory: an emergent and discomforting feeling that the world's variation and contingency were not necessarily anchored in any overarching supernatural system. Rather, at the dawn of the eighteenth century, the effects of these apparatuses started to align with the development of a new kind of scientific and above all economic sensibility of a reality of facts and flux open to accidents and the unforeseen. This sensibility could not be separated from the rapid rise of financial capitalism in Europe in the later seventeenth century, which subjected contingencies and risks to human-made speculative designs. A key witness of the socioeconomic changes taking place during his times, Daniel Defoe, among others, (re)defined "projection" as the anticipation of economic gain through speculative ventures, ranging from stock market speculation and government credit to insurance services. Using the magic lantern's shifting and semi-illusory shapes as an important point of reference, Defoe associated "projection" with the rising dominance of monetized relations that were based, not on actual exchange, but on imaginary transactions—with the virtualization of things and beings into the anticipated realities of futures markets. Crucial here was a new anthropological concept of the future, which was gradually relinquished from divine guidance and became open-ended and indefinite, and therefore a matter of "projection" in the sense of conjecturing and speculation; a future that didn't simply fall under divine foreordinance but came across as an ill-defined mixture of human action and phantasy, and forces that fell beyond human control.

In 1712, Richard Steele articulated this epistemic opacity of prospect and probability in the figure of a "young man" who couldn't "pass his Time better than reading the History of the Stocks" and seeking to reach some purchase on "by what secret Springs" the stock market performed its "sudden Ascents and Falls in the same Day."[86] We should note how in a book on God's foreknowledge and human freedom from 1713, a certain Joseph Jackson similarly pointed out "hidden Springs of Action" and "latent Causes" in discussing contingent events, including the seemingly unfathomable and complex outcomes dependent "upon the fluctuating and undetermin'd Wills of Men." While Jackson's comforting conclusion was to acknowledge the primacy of God's prescience that "sees and knows all Things and Events,

which are to come, and not yet actually existent, with equal Certainty as if they were present," Steele, in contrast, was no longer able make sense of the speculative economy's "secret springs" through the notion of divine omniscience.[87] The movements of Steele's springs were rather subject to chance effects owing to concealed human desires and intentions, especially to the "temper of mind" that makes us dependent upon "contingent futurities," as Steele noted in discussing lotteries and other speculative ventures. "We are apt to rely upon future prospects, and become really expensive while we are only rich in possibility. We live up to our expectations, not to our possessions, and make a figure proportionable to what we may be, not what we are," Steele cautioned.[88] Steele, in other words, witnessed the rise of the imagination as a driving force of the new economy, as a power that "contracted our Desires," not to "our present Condition" but to expectations of the future—that is to say, what was merely possible or probable. Simultaneously, what is important, Steele implicitly gestured toward a fundamental problem of governability of this new "temper of mind"—and the world it grew out of and was knitted to—that had become pulled out of divine grace.

Optical media's aesthetics of variation, uncertainty, and transformation, as we will later see in more detail, provided a potent mental frame through which the new speculative economic processes and their seemingly spontaneous as well as capricious nature became assessed. But how could one aesthetic and cognitive *form*—the projected image—asymmetrically lay claim to the effects of both totality and contingency, and subscribe to God's destinal order, at the same time as embracing things and events in their apparent randomness? Overall, the main cognitive task of optical media at the turn of the seventeenth century was to tackle what eluded perceptual grasp, something that was greater in complexity than the representations one could make of it. Camera obscuras and magic lanterns indicated how appearances came about, and the rationality behind them, if any. In this respect, whether in terms of belief in divine design or in the possibility of spontaneous organization, optical projection dealt with temporal modalities—eternity or the future—that (unlike the present and the past) eluded firsthand experience and/or empirical verification. The cognitive task of projection was above all to superimpose the real with an imaginary frame that could substitute the actual for the possible and thereby render the world's variability and randomness as a negotiable mental construct.

A comparison, even if a cursory one, with two other visual modes of projection in early modernity—linear perspective and cartography—might be helpful.[89] We recall how the Renaissance resuscitation of cartographic projections developed by Claudius Ptolemy facilitated mapping out the earth onto a two-dimensional surface with a geometrical grid of meridians and parallels and produced a new kind of viewpoint that combined human, earthly agency with a panoptic overlook. The cartographic grid provided what one could call an *operational* form that, as Christian Jacob reminds us, projected "an order of reason onto the world and [forced] it to conform to a graphic rationale, ... a conceptual geometry."[90] Designed for the expansion of empires, the grid set up an intellectual frame that fostered visual harmonizing, systematization, and uniformization—indeed, "optical coherence" (as Jacob puts it) against disorder, chance, and the unforeseen. In this sense, as Sean Cubitt notes, the grid suggested "a deep structure" that cartography shares with linear perspective.[91] Both perspective and cartographic projections made spatial relations measurable. Both, essentially, reduced things and beings into purportedly objective epistemological content, which allowed the world's subsequent translation into repositories of information, or "databases." At the same time, linear perspective, if Erwin Panofsky was right, gave an intellectual expression to the rationalization and mathematization of space from a viewpoint.[92] As a treatise on perspective painting from the turn of the seventeenth century tells us, "in terms of *perspective, projection* is a certain view according to the situation of bodies, whose description is drawing on a plan such as they would appear, if the eye were in a certain point."[93] Accordingly, Hans Belting talks about perspective as "an ontological securing of the gaze, which becomes its own image," where the picture surface opens up an imaginary, symbolic space of ordering, categorizing, and narrativization.[94]

How did optical projection, in the sense of casting the play of light and shadow onto a surface, both coincide with and differ from the above projective forms, which largely defined modernity's visual culture in terms of plotting and gridding? All three forms of projection—cartographic, perspective, and optical—hinged on the fundamental concept of the *screen*: the screen as a cartographic grid on which the world's figural multiplicity is divided into regular squares; the screen as a "window," or a threshold, that is porous for the gaze to penetrate, pushed by the vanishing point toward "an infinite, unreal, numinous distance" (as Brian Rotman describes it);[95] and

the screen as an opaque surface displaying colorful, moving, and ephemeral images through which the world both reproduced itself (as in the camera obscura) and became a product of the imagination (as in the magic lantern).

These forms had several overlapping qualities, not least in the way each displayed what Panofsky deemed "the distance-denying human struggle for control."[96] But they differed from one another in terms of *how* they contributed to this struggle. The vocation of cartographic pictures was empirical (despite their complex semiotics): They translated an antecedent reality, however abstractly, into a mathematical presentation. Perspective pictures supplemented the gridding function of maps with two critical notions: on the one hand, the idea of verisimilitude (the gaze as a measure of truth)—what Roger de Piles, in his authoritative handbook of perspective painting *Cours de peinture par principes* from 1708, considered the picture's credible appearance of truth (*vraisemblance*)[97]—and, on the other hand, the notion of the picture as a stage for narrative action, or, what Alberti called *historia*.[98] Although mixing with these features, the form of projection materialized by dark rooms and magic lanterns was something different: It was not necessarily grid-driven; it did not necessitate calculation; and its major symbolic operation was not based on the concept of an open window. For instance, if the window frame in linear perspective was predicated on the concept of looking through, the camera obscura's small aperture was rather to let light into the dark room so as to allow the world's play of figuration on a surface—a diametrically opposite process.[99] In the camera obscura's visual system, the direction between inside and outside is reversed, which is something that the magic lantern elevated to a next level, severing the connection with the outside altogether.

A note on how perspectival and optical forms of projection played out a key feature of their composition—shadows—might make their differences (even if only analytical) more tractable. The proper rendering of shading and cast shadows was critical to perspective's strive for *vraisemblance*. De Piles, for instance, emphasized their importance to the expression of the unity and harmony of objects.[100] Leonardo da Vinci already pointed out how, in perspective, shadows are "of supreme importance" because "without them opaque and solid bodies will be ill defined."[101] Optically accurate visualization of shadows also served more technical functions, above all in sciography, a subgenre of linear perspective focused on the two-dimensional representation of calculated projected shadows. Michael Baxandall tells us how treatises

dealing with sciography proliferated in France in the eighteenth century as they responded to the demands of the developing technical culture of mining, engineering, architecture, and military science.[102] Precise methods of shadow projection were needed for registering spatial relations and planning distributions of light and shade.

The shadows projected by camera obscuras and magic lanterns, on the other hand, were of a somewhat different nature. Whereas sciography—like the geometric interpretation of the visual world in linear perspective, more generally—dealt with shadows first and foremost in privative terms as "holes in the light," even if essential to human perception, seventeenth- and early eighteenth-century concepts of optical projection drew effectively on older (what one might call archaic) understandings of the shadow.[103] "Archaic" refers here, following Victor Stoichita's seminal study, to shadow projections understood in terms of substitution rather than resemblance or *vraisemblance*.[104] Shadows, in this understanding, were curious animations, semi-autonomous and semi-substantial, that could reduplicate and even supersede their originals.

Consider Kircher's "playful" demonstration of the camera obscura's operating principle in *Ars magna lucis et umbrae*, first published in 1646 (Figure 8). The optical apparatus, Kircher argued, could make it appear to the beholder that specters of devils had been summoned straight from hell.[105] The demonic silhouette's frame of reference was anything but empirical. In this instance, shadow suggested the quasi-hallucinatory evocation of ghosts and spirits by technical means—what the Jesuits called "parastatic magic" that dealt with techno-mental appearances (see Chapter 3)—but also God's care and protection, the manifestation of divine providence inside the dark room. Similarly, for Leibniz, as we have seen, projected shadows suggested visual uncertainty—movement and metamorphosis—and the multiplication of perspectives, but simultaneously their possible resolution into a spiritual harmony. Consider, on the other hand, Defoe's figural use of shadows in his portrayal of the vagaries of the nascent financial capitalism a couple of decades after Kircher and Leibniz. About the "lunacy" he witnessed in speculation on colonial trade (which "carries out our Woollen to *Africa*, carries Slaves to *America*"), Defoe queried: "How did Notion drown Men's Reason, Interest shut their Eyes, positive Assertion pass for Argument, Slander for Testimone, and *Shadow* for Demonstration."[106] In

FIGURE 8 The camera obscura's "curious" (*curiosis*) realm of representation where one could evoke images of demons in the eyes of beholders. Illustration from Athanasius Kircher's *Ars magna lucis et umbrae*, 1646, page 129.

Courtesy of Bayerische Staatsbibliothek München, Res/2 Phys. Sp 11, pp. 129 and 130.

the financial economy's new ontological realm, "Substance," Defoe intuited, was "answer'd by the Shadow."[107] The vocation of shadows, in these examples, was not the reproduction of the actual, but the production of the virtual—the substitution of the real with the spiritual, the providential, or the speculative. The vocation of shadows, in other words, was to provide access, not to the empirical per se, but to the powers of its making and shaping.

The purpose of optical projection circa 1700 was to virtualize things and processes: to unlock them from the here and now and to displace them in time—in the empty time of eternity, or prospects of colonial adventures, or speculative futures. Optical projection was an expansive form that made the virtual, in the sense of what surpasses the present reality, enter into actual states of affairs, thereby also introducing the possibility of deception and illusion. This virtual could be the divine providential plan or the anticipated reality of futures markets, or something in between; it remained undetermined. But, as we will see in the following chapters, what this form primarily enabled was bringing the virtual in its various definitions to bear on the world's becoming, overshadowing the real with a transcending frame of reference—a frame within which things were not rendered as solid and stable but as plastic and prone to suddenly shift their shapes.

PROJECTION AND PROVIDENCE

Mirror Lantern

In the fall of 1661, a shipment was sent from the small city of Puebla, New Spain, to Collegio Romano, the Jesuit college in Rome. The shipment was addressed to Father Athanasius Kircher, who was at the time among the most acclaimed scholars at the college, a hotspot of Jesuit learning established by the founder of the Society of Jesus, Ignatius of Loyola, over a hundred years earlier. The shipment contained silver plates and pieces of Mexican chocolate; the latter seem to have been particularly dear to the Jesuit priest. The sender of these treasures was Alejandro Favián, a Creole cleric and an aspiring scholar deeply devoted to Kircher's teachings.[1]

Kircher was an avid writer of letters. His correspondents included emperors, queens, princes, cardinals, abbots, counts, men of science, fellow Jesuits, antiquarians, and so on, not only from Europe but also from parts of the globe by then colonized by the Europeans.[2] For Kircher, it appears, correspondence was a way of executing what Octavio Paz calls "the grand plan of the Society of Jesus," the unification of diverse civilizations and cultures under the sign of Rome.[3] Such was the political purpose of the extended and hierarchical network of knowledge that the Society of Jesus established over the globe. It was thanks to his industrious efforts in corresponding with people with a myriad of backgrounds and stature that Kircher's ideas spread around the world. His influence in the New World was notable. Latin America was largely steeped

in the neo-Platonic and hermetic doctrines of Kircher's teachings, which pictured the cosmos as permeated by hidden divine designs whose revelation necessitated elaborate exegesis.[4] Favián was one of Kircher's most fanatic followers, who, in accordance with his master's example, entertained plans for a universal encyclopedia of "absolutely everything," consisting of five volumes and thousands of pages.[5]

Favián had started corresponding with Kircher in early 1661, and a regular exchange of letters as well as goods continued for about thirteen years between the savants of the Old and the New Worlds. During this time, a good deal of money and silver, a selection of religious feather paintings by native artists, and obligatory quantities of chocolate made their way across the Atlantic from New Spain to Rome. Favián promised the "Reverend Father" the "most extraordinary things he could find."[6] Many of Favián's offerings ended up in the Musaeum Kircherianum, the famous collection of antiquities, technical apparatuses (such as clocks, hydraulic and pneumatic machines, magnetic gadgets, automata, telescopes, microscopes, and mirrors), natural objects, fossils, skeletons, and various other marvels from all over the globe that Kircher had established at the Roman college.[7] If nothing else, the items procured by Favián contributed to the father's perception of his own prestige. In return, Favián solicited the latest publications by Kircher and other (mostly Jesuit) authors, as well as scientific instruments. The latter were to be included in the cabinet of curiosities Favián was setting up in Puebla following the Reverend Father's example.[8] And similar to what things like Mexican feather paintings did in Rome, curiosities from Europe contributed to Favián's social standing. He boasted that his house was constantly full of people who came to "satisfy their desire to see and understand Your Reverence's marvels."[9]

Favián was eager, constantly demanding new items, which he learned about from Kircher's encyclopedias, his imagination fueled by illustrations of singing mechanical roosters, hydraulic devices, metamorphosis machines, and what have you. What Favián yearned for was hands-on experience of actual instruments that would help him gain practical understanding instead of merely speculative knowledge. The New World, however, was lacking skilled artisans who could complete their construction.[10] Therefore, machines needed to be imported. Kircher provided, among other things, optical gadgets of various types: microscopes (with which one could "see the fleas,"

as Favián put it), telescopes, "parastatic microscopes" (designed for the sequential viewing of virtual realities rather than empirical observation), as well as "helioscopes."[11] The latter was an astronomical instrument that combined telescopic lenses with mirrors to project the image of the sun onto a screen or a piece of paper, and in fact played a key role in the debate between Jesuit astronomer Christoph Scheiner and Galileo Galilei on the existence of sunspots in the mid-1600s—a debate that challenged the old Aristotelian view held officially by the Jesuit order that heavenly bodies were incorruptible and not subject to change.[12] Favián, for one, however, didn't seem to have known how to install the helioscope properly. Adjusting the parastatic microscope caused problems, too.[13]

In his letter from the turn of 1665–66, Favián also mentioned a curious "mirror machine" (*machina especular*) that he had requested from the Reverend Father but never received.[14] Perhaps Kircher's shipment had got lost in transit. This was nothing unexceptional; letters and shipments were regularly delayed, intercepted, or just disappeared. Favián reminded Kircher about sending a mirror machine again in the autumn of 1667 but to no avail, it appears.[15] What was this device? And why was it so important to the Creole cleric that he kept repeatedly requesting it among the various marvels for which Kircher was famous?

The mirror machine had something to do with the projection, and study, of light and shadow.[16] Before the design of a proper slide show apparatus by Christiaan Huygens sometime in the 1650s, various kinds of arrangements for the projection of shadow pictures had been contrived, which were also included in Kircher's encyclopedic accounts. Favián was familiar with the 1646 edition of Kircher's *Ars magna lucis et umbrae* ("The great art of light and shadow"); perhaps he had perused a copy already in early 1661 when he had first encountered Kircher's works in the library of the Jesuit college in Puebla set up by Kircher's friend Francisco Ximénez (a French Jesuit originally known as François Guillot who had moved to New Spain in 1635).[17] And it is quite likely that Favián paid particular attention to the section entitled "Cryptologia nova," in Book Ten, on the art of hidden writing ("steganography") by means of candlelight, the technical arrangements for which included a lantern equipped with a concave mirror, a candle, and a lens.[18] Such a contrivance would cast outside and enlarge anything that is inscribed or drawn on the mirror, making thus shadowy forms appear and disappear on a surface.

These were above all "nocturnal appearances" meant to terrify the beholder, as the Venetian engineer Giovanni Fontana described the projections of an early type of "mirror lantern" in his treatise on war machines of all sorts entitled *Bellicorum instrumentorum liber*, from around 1420 (Figure 9).[19] Kircher similarly emphasized how his lantern replaced the sun as the originator of appearances (*simulacra*). Visibility was predicated on surrounding darkness: Images would appear only upon nightfall when a part of the earth sunk to its own shadow, or in artificially dark surroundings. What used to be clear and durable under the sun's brilliance became shady and ephemeral appearances conjured by means of an artificial light source combined with an optical system. And such appearances would be much more frightening than those "made by the sun," making the apparatus a good tool for keeping impious people from vice, according to Kircher.[20]

Perhaps it was such a "steganographic mirror" that Favián referred to as a "mirror machine." The cleric could also have noticed the device illustrated in the frontispiece to the 1646 edition of Kircher's *Ars magna lucis et umbrae*, where a small, detached human hand emerges from the cloud holding a lantern that projects its message onto an open book (Figure 10). The lantern compares with the telescope on the right-hand side of the engraving, and both devices with the large concave mirror held by the angel, which reflects divine light rays onto the earth below.

The designs of the optical devices in Kircher's *Ars magna lucis et umbrae* were, as a matter of fact, copied verbatim from the frontispiece to Scheiner's *Rosa ursina sive sol* (1626–1630), an important book on observational media such as telescopes, where Scheiner asserted the epistemic divisions entertained by Jesuit scholars of the period, juxtaposing the knowledge of reason and scripture with the knowledge generated through the senses. While reason, according to Scheiner, was illuminated directly by God's glory, the senses needed optical apparatuses—such as mirror lanterns and telescopes—to translate the original divine light into intelligible shapes.[21] Kircher, on the other hand, similarly emphasized the epistemic importance of technology but didn't draw any unequivocal separation between the senses and divine illumination. Without sense evidence there would in fact be no knowledge; "nothing can belong to the intellect, which hasn't first come about through the senses," Kircher declared, following the Aristotelian doctrine.[22] The senses rather needed to be separately guided toward the divine light. "So

FIGURE 9 An early image projection device. Illustration from Giovanni Fontana's *Bellicorum instrumentorum liber*, 1420–1430.

Source: Bayerische Staatsbibliothek München, cod.icon. 242, urn:nbn:de:bvb:12-bsb00013084–8.

FIGURE 10 Frontispiece to Athanasius Kircher's *Ars magna lucis et umbrae*, 1646. Engraving by Petrus Miotte Burgundus.

Courtesy of Bibliothèque Nationale de France.

great is the deceit of our senses," Kircher announced, that the senses had to be "supported" by something so as to arrive at an understanding of the secrets of the universe. This was precisely the task Kircher assigned to various optical contrivances. Knowledge would be significantly insufficient without "the divine science of optics," which was capable of drawing what was concealed in "profound darkness out to admirable light."[23] The human sensory and cognitive apparatus needed, in other words, to be buttressed by various kinds of optical accessories that promised access to the hidden divine design of the universe.

The telescope illustrated in Kircher's frontispiece wasn't simply to provide the "certainty of the senses"—as Galileo Galilei described the observations of the moon enabled by his telescope in the early seventeenth century[24]—but to link the observer spiritually to a fundamentally *invisible* reality behind and beyond the empirical. In the publications by Jesuit savants, optical devices were often shown to project a cross, a symbol instead of figurative image, which highlighted how projections had the power to guide the beholder toward a closer contact, not with the realm of observable phenomena but more essentially with the heavenly spheres, the original divine light that, by definition, escaped visibility, thus playing with the credibility of perception. It is here that the mirror lantern appearing in the frontispiece to *Ars magna lucis et umbrae* also performed a particular epistemic role. The lantern's art of secret writing played with the nesting of linguistic or visual messages within appearances: the hidden presence of something other than what appears to be represented on the surface.

Above all, the emanations of light and the projections of shadow through optical apparatuses signaled the potential, or virtual, presence of a configuration of the universe based on the *praeconceptus divinus*.[25] Kircher's was a concept of a closed world order permeated by interconnected and relational structures, a world of divine harmony and unseen correspondences where everything was connected with everything else with secret knots.[26] The frontispiece to *Ars magna lucis et umbrae* displays how these correspondences and connections became apparent to us mortals only through various optical mediations of divine light, which associated with the hierarchy of different types of being and knowing Kircher discussed in the epilogue to *Ars magna*, on the "metaphysics of light and shadow."[27] Divine light, the "light of light" (*lume di lume*), had no corporeal presence but was dispersed in the universe through

reflections and refractions. The bodies of angels presented the first-order mirror by means of which this infinite light became reflected, the bodies of humans the second-order one.[28] Kircher also attributed to the humankind the quality of shadows (*umbrae*), which suggested the imperfections of the human intellect due to the fact that, as sentient, breathing, and mortal beings, humans were tied to earthly, finite existence. Thereby humankind partook in the animal kingdom, confined to the realm of darkness (*tenebrae*), where the original beams of light got lost. The frontispiece visualizes a universe composed of the emanation of divine light, which became distorted via a range of mediations as it traveled to earth.[29] What differentiated humans from angels was that angels were able to comprehend without resemblances (*specie*) and images (*imagine*), whereas the original divine light glimmered to human cognition only through all sorts of figurations and shadow pictures (*imaginis umbram*).[30]

Projections of light and shadow thus stood for both the separation of humankind from God's glory and the possibility of their (re)connection. In this sense, we can also appreciate Favián's preoccupation with the "mirror machine," or the steganographic lantern. Perhaps for the American, like for his fellows in Europe, the machine came across, not merely as a gadget among others, but as a symbolic apparatus, which crystallized the human condition as suspended between light and shadow, holding the promise of connecting the profane and the sacred, the senses and reason, the finite and the infinite. In the Jesuit imaginary, the mirror machine indicated how human understanding could be lifted from the dark and guided toward the divine light that was the source of all appearances: how one could *project* the mind toward greater truth. In this sense, it was devised above all as an "embodiment of transcendent truths," as Koen Vermeir points out about Kircher's optical inventions.[31] But truths about what? For Kircher, as already noted, optical media were to reach and give expression to the divine organization of the universe. Within the Jesuit scholarship circa 1700, as we will see in the following paragraphs, the practice and concept of projection was considered in relation to the omnipresence of divine providence, that is to say, the notion that the world existed "in accordance with the Intellect and that Intellect is prior to it," to borrow Plotinus's words.[32] Here, optical projection came to demonstrate the fact of divine providence on earth as part of its effects, and therefore to execute God's presence and government of the world—also in faraway places like the town of Puebla in New Spain.

Oikonomia of Projection

The optical apparatus that, for Kircher, most forcefully carried out the providential vocation of projection—of connecting the observer with original divine light by means of marvelous shadow pictures—was the camera obscura. Equipped with a small aperture at one wall through which inverted light images were projected on the opposite wall, these dark chambers had been used in the study of light and shadow at least since the experiments conducted by the Arab mathematician Abu Ali al-Hasan Ibn al-Haytham circa 1000 ce. Among Jesuit scholars, the device was firmly embedded in the study of optics. In his 1619 treatise on the "eye," Scheiner, for instance, used the camera obscura's principle of projection to model how rays of light cross through to the organ of sight.[33] However, in a short but significant passage in his major geocosmic treatise from 1664–65, *Mundus subterraneus*, Kircher somewhat surprisingly brought up the camera obscura in the context of "chymistry" rather than the optical per se, when addressing the problem of spontaneous generation and the origin and force of life. Upon Kircher's account, which followed closely the teachings of Genesis and the holy text's interpretation by Paracelsian chemical philosophers, God created chaotic matter from nothing, which he animated with a universal force of propagation of living beings, called *panspermia*, or the "universal seed": a mixture of salt, sulfur, and mercury at the origin of all extant bodies in the world.[34] "It can be established from the Sacred Book of Genesis," Kircher wrote:

> that GOD GREATEST AND BEST created nothing immediately, whether plant, animal, or any other thing of mixed species, but rather that these were drawn forth from nothingness through the Chaotic Mass (for which God simultaneously created *panspermia* and the universal seed of Nature) so that as if from a preexisting entity He produced all things: the heavens, the stars, minerals, plants, and animals.[35]

The universal seed mediated between the creator and his creatures. It organized chaotic matter into a well-ordered universe while maintaining the diversity of things and beings. It propelled the becoming of things and beings while ensuring the execution of the divine plan. The seed itself was endowed with two key powers: the plastic power (or force), *virtus (or vis) plastica*, and the magnetic power, *virtus magnetica*. The latter attracted similar bodies to

one another. Kircher understood magnetism as the virtual force in action in the universe that bound things and beings together into a harmony. The magnetic power, we are told, "pulled the stars and planets into their orbits, pulled ivy around trellises and sunflowers toward the sun; it the caused animals to mate, worms to wiggle, and human beings to love."[36] On the other hand, the plastic power provided each being with its form, figure, and color. It was a "radiating" power, which differentiated living beings according to their nature and produced the variety of things from within unformed matter. The plastic power thus concerned the actualization and individuation of form from a virtual and embryonic state to a more developed one according to a pre-established design. It explained how divine light differentiated into visible shapes and colors, and how the world's becoming followed the divine architect's blueprint—how indeed manifoldness and contingency were, fundamentally, signs of an underlying order.

The camera obscura entered Kircher's discussion in a thought experiment (*experimentum*) to illustrate how the plastic power triggered spontaneous generation. The experiment compared the optical device's operating principle with the individuation of forms.[37] When the figure of a man was exposed to sunlight outside a dark room, what Kircher called *species* propagated through a small aperture into the dark room, and the figure was projected, upside down, onto the opposite wall (Figure 11). Kircher's concept of *species* derived from medieval perspectivist optical theories, developed by Roger Bacon and his followers, to designate what was understood as emanating from objects to perceivers, something akin to "aspects," "forms," "likenesses," and even "power" and "virtue." Mediating agents between the perceiving mind and perceived objects, *species* were like phantom images or resemblances emitted by objects, which somehow successively multiplied themselves through transparent media like air and made their way to the observer's sensorium and through to the senses to the soul.[38] For Kircher, particularly significant in the experiment was the camera obscura's pinhole where rays of light united, containing the various *species* emanating from the person with their proper colors. The pinhole represented the form-generating seed (point A in Kircher's illustration), where a variety of figures and colors existed in an indeterminate, virtual state, *in potentia*. From within this virtual state, sensory and sensible forms with their individual properties became actualized, like the visible figure drawn inside the dark room as light rays spread out through the small aperture onto the screen.

branas extendet , aut inteftinorum fpiras convolvet , fed fingula fubjecti portiuncula totum quod efformandum eft , continet ; haud fecus ac in fpecierum in obfcuro loco in candidum objectum exhibitione contingere folet . Sit igitur hoc primum experimentum.

EXPERIMENTUM I.
Quo radiativa plafticæ facultatis vis oftenditur.

DEpingatur in objecto quopiam Solis radiis expofito figura hominis cum omnibus & fingulis membris. Hoc peracto, in obfcuro conclavi juxta experimentum hujus libri de Photifmo Chromatico exhibitum, per minutiffimum & punctuale foramen fpecies imaginis hominis paulo ante figuratæ intromittatur in chartam in obfcurata camera expofitam, atque experientiâ difces, fpecies imaginis unâ cum colore cujufvis membri intus repræfentari. Si verò chartam foramini applicaveris, tota fpecierum diffufio conturbabitur , nihilque , nifi circulus lucidus apparebit : quantò verò plus à foramine femoveris tabulam, tantò fpecies imaginis evolventur amplius , ufque dum naturalem fuam perfectionem nactæ fuerint. Hîc certum eft, radios ex fingulis,punctis membrorum imaginis per medium radiare , & in foramine punctuali inconfufe uniri , ubi etfi ad fenfum fimplex lucis radia-

Plaftica vis operatur eo modo quo fpecies in obfcurum locum intromiffæ forinfecum obviatum exprimunt

tio videatur , evoluta tamen aliquantulum, non fimplicem fpeciem , fed infinita quadam varietate colorum infignitam diftinctis , fingulis partibus & fine ulla confufione ωτάκλως difpartitis reperies : Videbis cum admiratione fingula membra in fingula corradiare, atque unà cum fpeciebus colores fingulorum quoque differre membrorum ; fi illa res in rerum natura incomprehenfibilem illam plafticæ virtutis fimplicem varietatem explicet, hæc fanè explicat. Dico igitur , eadem profus ratione in fpermate contineri plafticam vim five formæ opificem , ficuti fpecies colorum in aëre , femen enim ab omnibus & fingulis partibus aphrodifio motu & ἀπλανέσολισμοῦ fpermatico deciduum in uterum mulieris, ceu in locum radiationi prolificæ naturalem profufum , ibi materia quidem fimplex ac homogenea fecundum fenfum involutum, naturali tamen vafis calore promovente radiatione fua paulatim incipit evolvi , atque per hujufmodi ideas & rationes fpermaticas , partes incipiunt differre, & membra diftingui , & à fe diftare. Sicuti igitur in uno foraminis puncto omnes fpecies vifibiles virtute continentur , evolutæ tamen figuram , fitum , colores fingulorum membrorum diftinguunt,ita profus fe habet plaftica in fpermate virtus : radii enim alii, quia longiores,& extimam fuperficiem pertingunt, alii fubitò ab exortu fini- unt, alii fuperficie fphærica, alii plana, alii aliter terminantur ; ex quo omnis varietas in

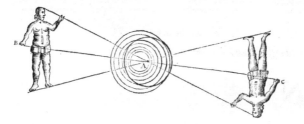

fœtum redundat, ut in Figura patet. Ubi vides fpecies ex omnibus membris B. C. ad fingula feminis in A. locum uteri projecti puncta collectas, convolutaque à puncto A, in quo indeterminatæ funt , & non nifi potentia & virtute, hinc paulatim calore uteri excitatas , primùm in membra principalia , deinde reliqua membra inæquali & tempore & motu difcriminari. Ordinis autem ratio poftulare videtur , nobiliores , & à quibus reliquæ quafi dependent partes , radiatione prius evolvi. Itaque videmus cor ante aliorum exortum fanguineis fibris etiam tum manifeftè ceu inftrumentum vitale fpiritus pulfare, deinde cerebrum, poft hoc jecur, deinde pulmo & ftomachus fua paulatim li-

neamenta oftendunt , cujus rei accipias fequens experimentum.

EXPERIMENTUM II.
Mirabilem vim plafticæ Virtutis exponens.

ACcipe ovum tertio ab incubitu die pertufum , & eâ qua par eft , induftriâ apertum fmicrofcopio diligenter infpice vitellum, & comparebit in eo manifefta cordis effigies adinftar guttæ fanguinis concretæ viva & mirifica quâdam ratione fe agitans fibris cruentis, ex eo undique tanquam è luce radiis , atque à fonte rivis deductis , & quamvis ftatim poft triduum appareat vitalis motus cordis & arteriarùm , nihil tamen reliquorum membrorum

Experimentum plafticæ facultatis ex ovi incubitu.

For Kircher, the radiation of light in the camera obscura corresponded to the radiation of the plastic power in the universe: The projection of images stood for the mediation of the divine providential design in the formation of being.[39] Projection, in other words, provided Kircher with a forceful thought-figure according to which he induced how the visible world came about. We can see here how the light metaphysics Kircher put forward in *Ars magna lucis et umbrae* also informed his explanation of embryonic formation and the creation of the living in more general terms. The camera obscura was given the task of implementing the divine architect's plan and projected images associated with the individuation of diverse forms on the planet. The metaphysical postulate that the world was essentially enveloped within projections of heavenly light became thus reworked in the thought experiment in *Mundus subterraneus*. The experiment suggested a vision of the earth as a projection surface of a kind of giant celestial camera obscura: the flora and fauna and basically everything in the universe, with their distinct shapes and colors, appearing like the colorful play of light and shadow cast inside the apparatus.

Even in its own times, Kircher's understanding of the camera obscura's meanings and functions was rather idiosyncratic. By the mid-sixteenth century in Europe, the optical device had found various purposes, ranging from the study of the properties of light (optics) to the observation of celestial bodies (astronomy) as well as the world's reproduction as its own picture by means of meticulously tracing, by drawing or painting, the projections cast inside the dark room (visual arts). A recurrent theme in the apparatus's reception was how the device opened a unique access to empirical reality. In his 1623 book *Uso de los antoios* (*The Use of Eyeglasses*), the Spanish pioneer in optometry Benito Daza de Valdés explained the camera obscura's effects to those ignorant of its principles, describing how inside the dark room, "perfectly reflected on the paper [placed in front of the hole], you'll see the figures of all the people outside. They'll be smaller, but all their colors and features will be so vivid that they will appear like a living painting."[40] Constantijn Huygens, father of the Dutch scientist Christiaan Huygens, echoed Daza de Valdés, when he famously exclaimed after witnessing a camera obscura shown to him during his trip to London in 1622, by the engineer and experimenter Cornelis Drebbel: "All painting is dead in comparison, for here is life itself, or something more elevated, if one could find the words for it."[41] Huygens gave expression to a common sentiment about how directly and accurately, beyond verbal description, the device was able to depict the

FIGURE 12 "Nature's Artistic Works" (*Naturae pictricis opera*). Illustration from Athanasius Kircher's *Ars magna lucis et umbrae*, 1646. Sheet located between pages 806 and 807. Courtesy of Bibliothèque Nationale de France.

movements, colors, and shapes of the natural world.[42] A few decades later, Samuel van Hoogstraten, Huygens's compatriot, compared the dark room's views with a "properly natural painting."[43] The camera obscura's projections equaled naturalness and "life itself," surpassing techniques of picture-making relying on the human hand in their perceptual objectivity and truthfulness. The Dutch natural philosopher Willem Jacob 's Gravesande summarized this sentiment in emphasizing how the camera obscura allowed one to grasp things and beings in their "natural disposition [*au naturel*]."[44] As such, the apparatus's screen spurred the development of a mode of knowing that wanted to rid itself of traces of the knowing subject while keeping firmly grounded in the observation of "matters of fact" (see Chapter 4). The screen instigated, to paraphrase Lorraine Daston and Peter Galison, a desire for "objective views," a mechanical way of "seeing without inference, interpretation, or intelligence."[45]

A similar interest in the autonomous as well as pictorial qualities of the camera obscura's visions shaped Kircher's considerations. Kircher praised a large (but portable) camera obscura developed by someone he called a "notable artist" from Germany, which had a room with transparent paper walls nested inside another one with lenses in the center of each wall, and which aided in painting the varying *species* (mountains, trees, animals, humans, etc.) delineated by the "machine" (as Kircher called it) on the projective screen (Figure 12).[46] Kircher understood the device's projections indeed as "truly natural paintings" in the sense that, in its mechanics, the camera obscura imitated the way nature herself operated as a painter (*natura pictrix*). In Kircher's understanding, the camera obscura's projections participated in nature's playful performance of marvels and wonders and shared their ontological import with images that Kircher considered spontaneously occurring in nature, for instance, on the surfaces of stones and in the flesh of fruit, or in the shapes of hills and rock formations. Kircher described a plethora of marvelous pictures one could find inscribed in natural objects and landscapes, which appeared to be made not by a human hand but by nature herself as signs of God's perfection.[47] These could be animal and human shapes, letters, symbols, geometrical forms, and most importantly, figures from the scripture such as Saint John the Baptist or Christ. In these images, according to a common conception during the period among the Jesuits (which was indebted to the notion of nature as artist from Pliny's *Natural History*), nature was "sporting

with beauty." But such wonders were not considered mere chance effects; as Paula Findlen notes, "the Jesuits rejected Pliny's insistence on chance as the ultimate creative force in the making of *lusus naturae*," and rather interpreted nature's spontaneous images as signaling the divine architect's plans and powers of creation.[48]

In *Diatribe de prodigiosis crucibus* from 1661, Kircher even mobilized the latest media technology, the microscope and its magnifying powers, for discerning the figures of crosses occurring in various types of fruit—similarly to what the polymath suggested as an experiment in *Mundus subterraneus*, to use the microscope to examine the plastic power at operation in an egg.[49] Such detective work caused Leibniz to later ridicule Kircher's media-driven inventory of marvelous forms, claiming that "the more one looked, the less one saw."[50] But Kircher was far from skeptical; for him, rather, as Martin Kemp points out, "optics, mystery and divine" co-existed naturally, in a manner difficult to fathom from a modern perspective.[51] Crosses appearing after the eruption of a volcano, for instance, indicated the omnipresence of divine providence. Even mere optical effects of light and shadow could amount to marvelous appearances. Kircher reported how in Chile, when the Catholic faith was spreading to a new area, a native child suddenly noticed a strange formation on the mountainside, where the landscape looked like a colorful image of a woman holding a baby in her arms. As the Jesuits heard the news, they traveled to examine the formation and concluded that the appearance of the Holy Virgin holding Baby Jesus was merely an optical phenomenon caused by rocks of different colors when seen from a particular viewpoint. Nonetheless, this did not discredit the importance of the devotional site for the effusion of divine glory, according to Kircher. "Nothing in nature," Kircher asserted, "can appear by way of chance and accidentally, which does not already lie behind the secret arrangement of divine providence that governs everything."[52]

Such prodigious apparitions were not outright miracles, something occurring outside the ordinary cause of events and crafted directly by God by supernatural means. Neither were they results of illicit magic—that is to say, to quote Gaspar Schott, "the work of Demons" by which "marvelous things are done that go beyond common deeds."[53] Instead, Kircher considered these wonders made of natural causes, occurring through "*natural* executors for divine providence."[54] The kind of providence Kircher referred to when

discussing prodigious images should be understood in terms of what was called *providentia generalis*, or *ordinaria*, meaning the "general and orderly world-governance" corresponding to the divine rational plan.[55] In this sense, prodigious images belonged to the same visual realm with the camera obscura's projections. According to Kircher, the same "plastic spirit" (*spiritus plastici*)—the spirit that generated forms and shaped organic matter, indeed, that created intelligible patterns out of the world's visual chaos—was at work in both the appearance of pictures in nature and the formation and proliferation of likenesses in the camera obscura.[56] In the camera obscura, too, God became an image-maker: the technical, projected images amounted to the same kind of "prodigious representations" that nature was capable of. In Kircher's camera obscura, in other words, projection became a matter of natural causation according to a pre-established providential design. But how could one combine natural causation with divine intention? How did God, with the cooperation of nature, actually come to produce extraordinary and/ or projected images?

Kircher tackled the issue by invoking, in accordance with the general doctrines of Jesuit natural philosophy, the Aristotelian analysis of causality, and he proposed that God himself was not directly involved in every appearance or eventuality; his omnipresence was rather mediated, derived. In a few important lines in *Mundus subterraneus*, Kircher noted that divine providence was carried out and administered (*executio*) by the mediation of several secondary, or efficient, causes.[57] This also concerned marvelous appearances—strange figurations in nature, the camera obscura's projections, even the birth of new stars and monsters, according to Kircher—which were all joined in a nexus of mediations via efficient causes that executed the divine order and accomplished its ends.[58] Kircher's musing on prodigious and/or projected images was therefore indebted to a long tradition of investigations into how the divine order is implemented and administered in the world. Perhaps of most prominent influence here was Saint Thomas Aquinas, who held a central, even if not unambiguous, place among the Society of Jesus's theological and epistemological doctrines.[59] Aquinas made a significant articulation between God's transcendent being and divine action in the world. "Looking at the world as a whole," he wrote, "there are two works of God to be considered: the first is creation; the second, the God's government of the things created."[60] How these two—the transcendent principle of creation and

the immanent implementation and government of the divine order—came together was a matter of what Aquinas called first and second causes. The first cause was "itself the pure light above which there is no light," the general principle of creation, more great and powerful than the second cause, which the first cause aided "in its activity, because the first cause also effects every activity that the second cause effects, although it effects it in another way [which is] higher and more sublime."[61] The second cause was "the effect of the first cause," and derived both its "substance" and power or potency to act from it.[62] The first and the second causes dovetailed in a hierarchical relationship where the former remained transcendent with respect to created things and acted through the mediation of the latter.

Aquinas's splitting of reality into two levels—divine being and praxis, transcendence and immanence—had its predecessors. Boethius, for one, had proposed how the acting principle could not be "located on the same level as its effects" and distinguished between the order of transcendent primary causes and immanent secondary causes, or between providence and fate. These two, as Giorgio Agamben puts it, worked like "a two-stroke machine, in which the destinal connection of the effects (fate as *causa connexionis*)" realized the "providential effusion of the transcendental good." Agamben shows how Aquinas put forward a closely similar distinction between the divine order where "God is impotent or, rather, can act only to the extent that his action always already coincides with the nature of things," and the sphere of the government of the world, "the contingent relation of things between themselves," a sphere in which "God can intervene, suspending, substituting, or extending the action of the second causes."[63] On the one hand, for Aquinas, there was the divine plan for government, and on the other hand, the execution of this plan—through the intermediary of secondary causes—in actual states of affairs. In connection with the first cause, the order of the world couldn't be changed and coincided with divine prescience and predetermination. God "cannot do things that have not been eternally under the order of His providence," Aquinas argued.[64] Eventualities and contingencies were drawn into the repetitive and empty temporality of eternity. The future followed a pre-established program, which the divine programmer could compute with a single "glance." The activity of secondary causes, however, ensured that the universe was not entirely deterministic.[65] God made every being to cause in its own way, even though ultimately moved by the primary

agent. Natural agents could influence *how* something would turn out—like random or contingent causes (earthquakes, droughts, and so on) were ordered by God to act randomly.

Secondary causes could therefore explain for events and things that appeared as accidental and inexplicable outside the ordinary course of events, bringing contingencies and miracles closely within the divine administration of the world. Let us quote Aquinas at length:

> For the order imposed on things by God is based on what usually occurs, in most cases, in things, but not on what is always so. In fact, many natural causes produce their effects in the same way, but not always. Sometimes, indeed, though rarely, an event occurs in a different way, either due to a defect in the power of an agent, or to the unsuitable condition of the matter, or to an agent with greater strength—as when nature gives rise to a sixth finger on a man. But the order of providence does not fail, or suffer change, because of such an event. Indeed, the very fact that the natural order, which is based on things that happen in most cases, does fail at times is subject to divine providence. So, if by means of a created power it can happen that the natural order is changed from what is usually so to what occurs rarely—without any change of divine providence—then it is more certain that divine power can sometimes produce an effect, without prejudice to its providence, apart from the order implanted in natural things by God. In fact, He does this at times to manifest His power.[66]

Aquinas explained how, in connection with secondary causes, the implementation of the divine order could also be subject to sudden interventions outside the ordinary course of events, *praeter ordinem rerum*.[67] Unforeseeable, unusual, and contingent occurrences (for instance, a person with six fingers) could come about that deviated from the norm but were nonetheless due to secondary causes and therefore did not require the suspension of the providential order. Lorraine Daston and Katharine Park discuss how the marvelous and the extraordinary became labeled as "preternatural" (from Aquinas's *praeter ordinem rerum*), as distinct from both supernatural (what is performed directly by God without the mediation of secondary causes) and purely natural (ordinary and conforming to the norm).[68]

The fact that Kircher situated both nature's miraculous images and technical, projected images within the sphere of secondary causes underscored a

view of such images as signs of God's omnipresence, as allusions of the divine order in things and beings. In one way or another, in the Thomist view, God was acting continuously and intimately in the world through the activity of natural agents, while essential to optical mediations was how they effected the derived or withdrawing presence of divine providence. In this sense, projected images also embodied the conundrum of knowing the divine, positing the possibility of ascending along the rays of light toward higher illumination, toward what Aquinas described as God's "glance" that is "carried from eternity over all things as they are in their presentiality."[69] In the epilogue of *Ars magna lucis et umbrae*, Kircher proposed such a metaphysical explanation of the camera obscura by approximating the device's projection of light rays to the contemplative soul's ascent toward God. Those who wanted to reach a sublime state of enlightenment, Kircher urged, should shut all the windows and doors of their soul leading to the world outside, except a tiny aperture that lets in a single ray of divine light. The light thus entering the "dark room of the heart" (*obscuro cordis cubiculo*) would represent "all in all, and all in God" (*omnia in omnibus, et omnia in Deo*).[70] By extension, Kircher's gesture suggested that the camera obscura's projections also participated in the practical execution of the divine design. They were "ordering" agents, which signaled God's sovereignty and manifested, to paraphrase Aquinas on prodigious effects, "His power." Miraculous and/or projected images derived their powers of appearance and propagation from God. They made present and put into effect a hidden rationality behind the chaotic empirical world of accidents, risks, and the incomprehensible—a rationality that ensured that the link between the present and the future was anything else but random and accidental. Therefore, we learn how, for Kircher, projection was fundamentally a matter of fate as well as faith.

Here, the history of projected images joined a broader genealogy of Christian governmentality. The question as to how secondary causes implemented God's presence in the profane and contingent world concerned above all the immanent ordering of human life—an ordering that revolved around the concept of the *oikonomia*, or "economy." Originally involving the management of the goods and wealth of the private sphere (*oikos*) of the family, *oikonomia*, as Agamben shows, acquired a new interpretation as divine power and providence as it entered Christian theology.[71] *Oikonomia* shifted its meaning from profitable housekeeping to the action and rule of God. The Christian

concept of divine economy, Agamben points out, was predicated on a distinction we have already encountered in terms of first and secondary causes, between the essence of God and his actions in the world, or between absolute power and ordered power. Critical to *oikonomia* as divine government was that it provided an image of the world as organized according to an established order and hierarchy, and of the God as the universal administrator with officers—angels, ecclesiastical functionaries and missionaries—in his service to manage the world order. The transcendent God acted as a principle of an immanent bureaucratic organization. The world fell under the dominion of a hierarchical "sacred power" that, in Agamben's words, "penetrates and traverses the divine as well as the human world, from the celestial principalities to the nations and peoples of the earth."[72]

For Kircher, mediations of light through optical media were firmly lodged within this *oikonomia*. Consider the frontispiece to *Ars magna lucis et umbrae* (see Figure 10): a small hand reaches from the heavens, holding an open book that is illuminated directly by the sun, or the "infinite light" of God.[73] This is the realm of "sacred power" (*auctoritas sacra*), the text underneath informs, a power that knows no boundaries and applies to everyone at all times. The engraving links this realm with the domain of "secular power" (*auctoritas profana*)—power over particular territories, physical or mental—which is illuminated by the hand holding the little mirror lantern. Overall, the engraving teaches us how Christian government involved reflections and projections of light, which, as secondary causes in Aquinas's sense, mediated the sacred and the profane, the transcendent and the immanent, holding the promise of coupling fallen humankind with God's glory in support of the church's claims over the souls of individuals and populations.

Government Through Miracles

The frontispiece to the German Jesuit Wilhelm Gumppenberg's book *Atlas Marianus* (1672 edition), a meticulous catalogue of 1,200 miraculous images of Mary (Figure 13), puts forward a potent allegory of optical projection as divine government. The engraving made by Melchior Haffner (who also provided illustrations for several of Kircher's books) is based on an old story of how a group of angels airlifted the Virgin Mary's dwelling from Palestine and moved it to Loreto, Italy, after the fall of the Christian crusader state in the Holy Land in the thirteenth century.[74] Beams of light emanate from the bottom of the house, which is covered by Virgin Mary's images. The Mother

FIGURE 13 Heavenly projection of miraculous images onto earth. Frontispiece to Wilhelm
Gumppenberg's *Atlas Marianus*,1672. Engraving by Melchior Haffner.
Source: Staatliche Bibliothek Regensburg, 999/2Hist.eccl.268, urn:nbn:de:bvb:12-bsb11054554–2.

of God herself is seated on the roof. Mediator between the heavens and the earth (*mediatrix caeli et terrae*), the Virgin radiates divine light, and projects her presence onto the European continent below through her images. Each light beam carries a particular image, whereas on the map below, a dot indicates the location of a picture of reputedly miraculous nature. Here, visual emanations became associated with cartographic projection; the illumination and embrace of the earth's surface under divine rule worked hand in hand with modern visual techniques of navigation and expansion. The reach of these emanations, like the cartographic project, was to be global and cover every continent.

The Mother of God's light-borne images were strange forces of attraction, whose powers, according to Gumppenberg, were comparable to magnetic transmission. "The magnet transmits its power to the iron ring in such a way that the ring can transmit it to another ring, and so on, like in a chain," we read in the preface to *Atlas Marianus*: "It is certain that the miraculous force that resides in Mary's image comes from Mary herself and true believers know through long experience that this power also extends to images that have had contact with the original image."[75] Miraculous images diffused from the heaven, propelled by something like magnetic energy, Gumppenberg surmised, referring in particular to Kircher's notion of magnetic power (*virtus magnetica*) as a power of attracting similar bodies.[76] For Kircher, we recall, the magnetic power itself was an expression of the universal seed, *panspermia*, as the mediator between the creator and his creatures. The plastic power (*virtus plastica*)—the generation of sensible and sensate forms—provided another type of manifestation of this universal mediation. Gumppenberg thus combined the latest conceptual tools from natural philosophy to account for miraculous images as kinds of contact surfaces with the holy.

Gumppenberg's project expressly linked Kircherian metaphysics with divine government. *Atlas Marianus*, Olivier Christin and Fabrice Flückiger suggest, was part of a vast program of promoting Marian devotion in Catholic countries fostered by the papacy in Rome to combat the Protestant Reformation.[77] The meticulous mapping of Virgin Mary's apparitions was a matter of spiritual reconquest, of re-establishing the *oikonomia* as an attempt to manage disjunctive relations between the terrestrial and the spiritual realms.

In its governmental vocation, Gumppenberg's *Atlas* restated an older economic concept of the image that, as Marie-José Mondzain demonstrates,

goes back to Byzantine debates about the iconic picture as a formal resemblance between the visible image and its invisible origin. In these debates, the Christian concept of *oikonomia* was applied to the problem of visual incarnation and interpreted in terms of the management of relationships between "the natural image" (the Son as the living image of the Father) and "artificial images" (icons as the Son's image).[78] "God, through his providential will," Mondzain explains, "set in motion the economic power of his iconic nature and decided to renew the only covenant possible with humans, the inherent covenant of the creation, similitude."[79] Iconophiles like Nicephorus I, Patriarch of Constantinople, conceptualized icons as formal resemblances of their holy archetype, which operated, in Mondzain's terms, as "structural relays" connecting the earthly and the divine, the temporal and the spiritual. "An icon is a likeness of the archetype, and on it is stamped, by means of its resemblance, the whole of the visible form of which it is a likeness of, and it is distinct from its model only in terms of a different essence because of its material," Nicephorus reasoned.[80] Therefore, as Mondzain points out, images could be considered truthful demonstrations of something that, without them, could not be thought about without contradiction (the visibility of invisibility, the presence of absence). Therefore, also, by relaying the holy and the profane space in their form, images could take up the function of abstraction and incorporation of new physical and mental territories under divine management, across spatial and temporal boundaries. "No power without an image," Mondzain describes the authoritarian and expansive nature of the Christian visual economy, where artificial icons could transport holiness to all places by communicating divine presence—the "gaze of God"—and bringing the divine into existence "invisibly and with supreme power." Images became "centrifugal and invasive," Mondzain remarks. Everywhere the icon invaded could be turned into divine *property*—part of the Christian system of illumination where Christ the King rules over territories through his "brilliant light, glory without limit and without borders" (to borrow Nicephorus's words).[81]

Artificial images thus carried out the functional organization of the relations of similitude whereby God's sovereign authority could be mediated in secular space. This notion of visual governance was by no means foreign to the Jesuit order during the Catholic counter-reformation, which interpreted the question of incarnation and expansion of authority in terms of projections of light as the most effective medium to carry God's similitudes, as well

as in terms of optical appearances and transformations (indeed, "miracles") playing with visibility and invisibility. Furthermore, new concepts from natural philosophy were brought into the mix, as Gumppenberg exemplifies: Relations of similitude and resemblance were now explained away in terms of magnetic attraction and *panspermia*. Yet for the Jesuits, one word crystallized this economic concept of projection: "glory." The frontispiece that opens onto the first volume of Daniello Bartoli's monumental history of the Society of Jesus (*Istoria della Compagnia di Gesù*, 1653) illustrates the concept: Ignatius of Loyola is sitting in the heaven accompanied by putto angels, his right arm stretched toward the sun, which is marked by the order's emblem *IHS* and which illuminates the four females representing the four continents below (Figure 14). The terrestrial globe links the cartographic projection with a divine radiating power embodied by Ignatius. Both are mobilized for "the greater glory of God" (*ad majorem Dei gloriam*), as the order's motto inscribed on the book that Ignatius holds with his left hand tells us.

The frontispiece to Bartoli's book, we should recall, was likely the inspiration for Andrea Pozzo's famous illusionistic ceiling fresco in the Chiesa di Sant' Ignazio in Rome from the early 1690s (Figure 15), a major visual testimony of the Jesuit counter-reformation culture. Without doubt familiar with Kircher's instruments and ideas, Pozzo mobilized techniques of perspectival and anamorphic projection to create a realm of immersion and incarnation, where the beholder was to stand at a specific spot and to occupy the ideal viewpoint situated vertically beneath the Christ, from which the visual spectacle opened up in the beholder's eyes in its full powers, perspectival illusions drawing the beholder toward what Pozzo called "that true Point, the Glory of God."[82] Divine glory unfolded from an intimate first-person viewpoint within which the real, lived space almost dissolved into phantasmatic, quasi-hallucinatory spiritual visions. By means of anamorphic projection, figures appeared hanging in mid-air, immaterial but real; the gestures of angels and saints drew the beholder upward to the celestial theatre, whereas the church's architectural space seemed to merge seamlessly with the painting's universe. Felix Burda Stengel observes how Pozzo's composition staged a "miracle of transformation" where divine merged with secular space, exemplifying the visual economy of the Catholic counter-reformation where the "very experience of being" (if Yves Bonnefoy is right) took place through illusory abstractions.[83] The Jesuit General Giovanni Paolo Oliva, who summoned

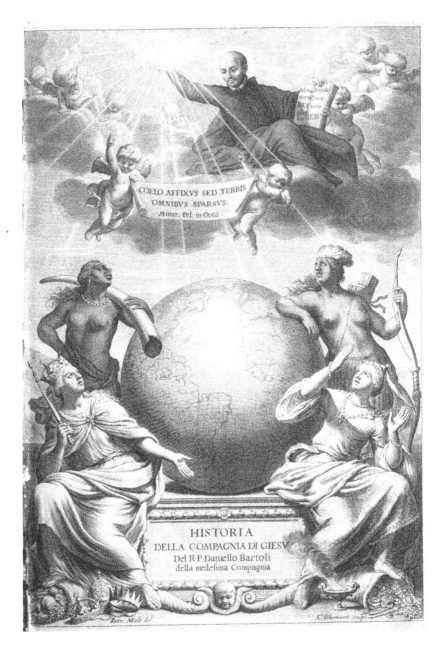

FIGURE 14 Frontispiece to Daniello Bartoli's *Istoria della Compagnia di Gesù*, 1653. Engraving by Jan Miel and Cornelis Blomaert.

Source: Staatliche Bibliothek Passau, urn:nbn:de:bvb:12-bsb11348602-9.

FIGURE 15 Andrea Pozzo's *The Triumph of St. Ignatius of Loyola*, 1691–1694. Detail of ceiling fresco, Chiesa di Sant' Ignazio, Rome.

ItalyTarker / Bridgeman Images.

Pozzo to Rome to design the visual edifice of the Chiesa di Sant' Ignazio, crystallized the role of images in the manufacture of such an experience: "In our churches both Ignatius, our father, and all of us, who are his sons, try to reach up to the sublimity of God's eternal omnipotence with such appurtenances of glory as we can (to the best of our powers) achieve."[84] Images, Oliva suggested, worked as "appurtenances"—or, rather, *apparatuses*, as Oliva's original Italian term *"apparati di Glorie"* suggests—by means of which the earthly spirit could ascend toward divine illumination (and vice versa).

Perhaps nowhere else was this economy of light and glory more palpable in the later seventeenth century than in Latin America, which in many parts was turned into a symbolic projection screen for the Catholic Church's proselytizing efforts, and especially the Jesuit order's program of *propagatio fidei per scientia*, the missionary work of propagating faith through knowledge—a program celebrated in Pozzo's fresco where Ignatius's body provides a mirror that reflects and directs the rays of divine light to reach all the four continents: Europe, Asia, Africa, and the Americas.[85] Consider, for example, the frontispiece located on the opening pages of the Mexican Jesuit Francisco de Florencia's book on the history of the Society of Jesus in New Spain from 1694 (Figure 16): Francisco de Borja, the Spanish Jesuit general who initiated missions in Latin America, radiates divine light that is reflected from the saintly offices of Ignatius of Loyola and Francis Xavier, the founders of the society, and cast onto what appears to be a congregation of kneeling indigenous people. The engraving is modeled on the frontispiece to Kircher's *Ars magna lucis et umbrae* (see Figure 10) but translates the baroque metaphysics of light and shadow into the context of colonial expansion[86]—a context where the kinds of prodigious images conceptualized by Kircher as natural indicators of God's sovereignty became instruments of spiritual conquest. Kircher, we recall, reported about the Virgin Mary's miraculous apparitions as optical effects of light and shadow in Chile, following the arrival of Jesuit missionaries into the area—an incident that, according to Kircher's Italian colleague Gregorio Rosignoli, came "upon divine providence" to facilitate the conversion of "infidels."[87] Such apparitions by the Mother of God did not focus on Chile only. In his compendium on Marian images in New Spain from the 1690s, which was both inspired by Gumppenberg's work and aimed to challenge its limited focus on Europe, de Florencia listed over a hundred miraculous images of the Virgin venerated across the country.[88]

"The apparent that we see encloses in itself the mysterious that we do not see," the Mexican historian Augustine de Vetancurt noted in his discussion

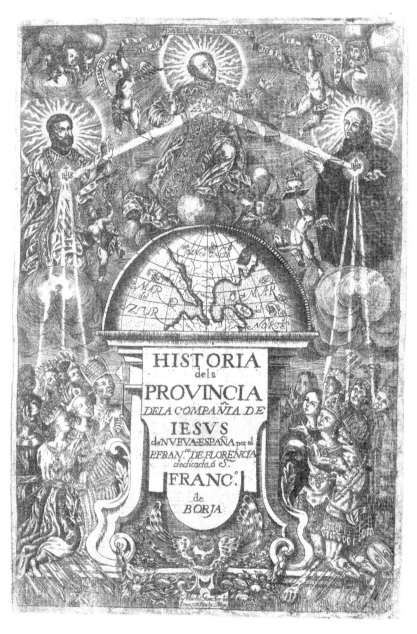

FIGURE 16 Frontispiece to Francisco de Florencia's *Historia de la provincia de la compañia de Jesus de Nueva-España*, 1694.

© The British Library Board. General Reference Collection. Source: C.36.g.5., frontispiece.

about miraculous images at the close of the seventeenth century.[89] The Franciscan's focus was on the apparitions of Virgin Mary, who provided the "most perfect image" for rightful worship. The Virgin held a special place in the Christian visual economy as the one who embodied and gave birth to the only natural image of God; it was the Virgin's flesh that "brought God's imaginal manifestation into the world, his perfect resemblance, with no discrepancies," as Mondzain points out.[90] Therefore, the Mother of God's more or less thaumaturgic manifestations played an unparalleled role in giving form and presence to the divine. A key point of reference for Vetancurt was the famous painting of Our Lady of Guadalupe, a popular object of worship that was reputedly made in 1531, just over ten years after the conquest of Mexico.[91]

One day, the story behind the painting goes, the Virgin appeared to a poor Indian named Juan Diego at the top of the hill of Tepeyac, located north of Mexico City, instructing the Indian to go and tell the bishop of Mexico that she wished to have a shrine built in her honor on the hill—a site where the natives had previously worshipped their "pagan" goddess Tonantzin.[92] Turned away by the bishop, Juan Diego encountered the Virgin again, who told him to climb the hill of Tepeyac where he would find precious flowers blossoming. Juan Diego collected the flowers in the folds of his cape and returned to the bishop's palace, where the priestly ruler's dependents saw a glimpse of Juan Diego's cape—something painted or sewn on the cloth. The Indian was taken to see the bishop himself, and as he spread out his cape, "all the different kinds of Spanish flowers scattered to the ground, the precious image of the consummate Virgin Saint Mary, mother of God the deity, was imprinted and appeared on the cloak." As soon as it was revealed, the Virgin Mary's image transfixed its beholders with a spellbinding force of attraction, and "their spirits and their minds were transported upward."[93]

"I am within the painted or sculpted images, so I am certainly present through them when I work miracles," Vetancurt ventriloquized the Blessed Virgin's visual manifestation.[94] Similarly, in his 1648 tract of the Guadalupean legend, Miguel Sánchez, a preacher from Mexico City, celebrated the painting: "I do not doubt that the Blessed Virgin is here, with her image, on this canvas."[95] Sánchez's account drew the painting into a system of mediations of the original (primary cause) and its similitudes (secondary cause)—a visual economy at the heart of Christian governmentality. "The earthly image constituted the miraculous copy, the *transunto por milagro* of the celestial

original," Serge Gruzinski clarifies: "Miguel Sánchez recaptured a theology of the image which made God the primary creator of images, since he was the creator of man. The Virgin was the most perfect image since she was 'copied from the God's original,' 'a privilege that was always hers in all of her images.'" Gruzinski points out how this theology of the image enabled Christian divinity "to establish and make concrete absorption of pagan space" that had been previously devoted to what were deemed as idolatrous cults. Through the intermediary of the Blessed Virgin's miraculous images, the "form of God" could be stamped onto profane space, facilitating the expansion of the divine providential rule on a potentially planetary scale by anchoring beings and processes "into the time of Christianity."[96]

In one curious and idiosyncratic but also significant and revealing account of the Guadalupean Virgin's apparition, penned by the Creole cleric Luis Becerra Tanco, this theological problematic of mediation of the invisible in a visual image—and by consequence, of the institution of divine government in New Spain—became specifically a matter of optical projection. Becerra Tanco, who briefly held a chair in mathematics and astrology at the University of Mexico, was concerned with how the Blessed Virgin's image could have been painted on Juan Diego's cape as if by itself, without any human intervention. He presented his explanation in a 1666 deposition on the Virgin of Guadalupe, which was included in a petition addressed to the pope in Rome for the canonization of the miraculous image in Mexico; before his death, Becerra Tanco also completed a revised version of his account that was published posthumously under the salutary title *Felicidad de México* ("Mexico's Happiness") in 1675.[97] Briefly put, Becerra Tanco's proposition was that Juan Diego's cape must have functioned like a mirror, or another kind of reflective surface, onto which the Virgin Mary's holy image was cast.[98] As an anonymous woodcut accompanying the 1675 edition of *Felicidad de México* illustrates, Becerra Tanco surmised that the formation of the miraculous painting must have taken place when the Virgin appeared to Juan Diego at the foot of the hill of Tepeyac, during the time of day when the sun was behind the Virgin (Figure 17). Illuminated by the rays of the sun, which was equated here of course with divine illumination, the Virgin's appearance was cast as a reverse picture on the Indian's clothing.

To substantiate his claims, the Mexican drew on a famous treatise on optics, *Perspectiva communis* written by John of Pecham, the Archbishop of Canterbury, in the late 1270s—a key contribution to medieval perspectivist

FIGURE 17 "Apparition of Our Lady of Guadalupe to Juan Diego." Illustration from Luis Becerra Tanco, *Felicidad de México en el principio, y milagroso origen, que tubo el Santuario de la Virgen María N. Señora de Guadalupe*, 1675.
Provided by Harvard University.

optics that the English scholar conceived of as a compendium to the discoveries by Alhazen over a couple of hundred years earlier.[99] Becerra Tanco cited in particular the parts of Pecham's treatise that discuss image formation on mirrors and the principles of transformations and deformations occurring on curved reflective surfaces. Based on the observation of Pecham's that "straight things usually appear curved in convex spherical mirrors," the Mexican inferred that the folds of Juan Diego's cape made the right-hand side of the Virgin Mary's tunic look folded.[100] Likewise, Pecham's premise that "the smaller a convex [spherical] mirror is, the smaller is the image that appears on it," explaining why the hands of the Virgin seem somewhat smaller with respect to the rest of her body in the painting.[101] Overall, Becerra Tanco conjectured that the image of the Virgin of Guadalupe resulted from perspective projection and that the laws of reflection accounted for its partial distortions.

Apart from convex mirrors, the correspondences Becerra Tanco drew between the Virgin Mary's miraculous image and the optical media of the later seventeenth century also went further. Above all, the way the cleric envisioned the Virgin's apparition was cast, with the sun as a light source, as a reverse picture on the cape that functioned as a projective screen, tallied with the camera obscura's key functions. The camera obscura, we should note, wasn't an entirely new invention on the Mexican soil—bespoke underground caves with pinhole apertures at the top had already been constructed (at Xochicalco) for the observation and measurement of the movements of celestial bodies during the classical Mayan period.[102] But most likely Becerra Tanco learned about the image projecting device in Pecham's treatise where we read how rays of the sun are "received" or "captured" (*excipio*) inside the apparatus through "a hole of any shape."[103] Becerra Tanco furthermore developed the notions of the "trace" and "impression" to describe how the Virgin's image appearing on the surface relayed and translated the presence of its original.[104] He even envisioned that the Virgin Mary herself had sent an angel to outline and paint the projection cast on the cape with beautiful colors—without this heavenly agency, the final painting couldn't have materialized.

Here, Becerra Tanco reiterated the use of the camera obscura as a drawing and painting aid, which had become common practice (at least in Europe) since the seventeenth century.[105] Assuming the cleric was familiar with Kircher's works—which he quite likely was, given Kircher's intellectual influence in New Spain[106]—he would have encountered an illustration of a room-size camera obscura in *Ars magna lucis et umbrae* (see Figure 12). Kircher's engraving, we recall, appears in *Ars magna lucis et umbrae* in the context of nature's marvelous figurations, those "natural executors for divine providence," as Kircher called them. Becerra Tanco likewise situated the Virgin's miraculous apparition within an optics of divine government. The cleric called the Virgin's projections on Juan Diego's cape "*especies*," drawing on the concept of *species* critical to Pecham's perspectivist optical theory.[107] Pecham understood *species* as the "power" (*virtus*) that natural agents propagate from themselves to surrounding bodies.[108] "Every natural body, visible or invisible, diffuses its power radiantly into other bodies," Pecham wrote, aligning his ideas with the neo-Platonic concept of emanation.[109] This power was fundamental to explaining efficient causality in the universe; the *species*, as Bacon put

it, "produces every action in the world, for it acts on sense, on the intellect, and on all the matter of the world for the generation of things."[110] For Becerra Tanco, the idea of *species* suggested an understanding of the formation of the miraculous image as an emanation of divine powers that need not be captured by a human agent; instead, *species* moved and propagated on their own accord, propelled by a divine force, and carrying a holy form that became imprinted on a screen—on a cape, on a mirror, on the camera obscura's wall—and painted by an angelic hand.

Coda: "A Rat Peers Out"

Becerra Tanco envisioned the Catholic Church's planetary mission as a gigantic optical show, a glorious visionary spectacle from the sky. His account of the Guadalupean Virgin presented a particular colonial interpretation of projection in support of the centrifugal Christian visual economy where prodigious apparitions of all sorts labored to expand the reach of divine government across the globe. Here, he joined his contemporaries like Alejandro Favián, who also understood the providential import of optical apparatuses as relays between the sacred and the profane.

What happened in Mexico was unusual in that it gave rise to such an experimental and idiosyncratic concept of projection. Yet it wasn't unique. The missions of the Knights of Jesus reached the whole known world, and technical-miraculous images (as apparatuses of divine government) often preceded or followed the Jesuit missionaries' travels. Kircher discussed the appearance of crosses on the backs of river crabs in China shortly before the "Gospel of Christ" was introduced into the empire; in Japan, mysterious but miraculous figures of crosses were found on cuttings from trees upon the arrival of Christian preachers.[111] On occasion such manifestations of God's providential presence were also aided by optical devices—the key earthly media of prodigious apparitions—which traveled with missionaries on trade ships or were embodied in evocative illustrations in Jesuit scholars' publications taken on long journeys. But only a few traces remain that allow us to conjecture where these instruments advanced, and to what extent. In addition to the Viceroyalty of New Spain, most sources relate to China where the Jesuits had established a permanent presence in the later sixteenth century, spearheaded by the Italian Jesuit Matteo Ricci who ultimately became an advisor of the imperial court.[112]

In China, the Jesuit missionaries addressed themselves to the literate elite, showcasing latest innovations in science and technology, in addition to Christian icons and other kinds of sacred images, in an attempt to convince the locals about the superiority of European culture and the Christian god.[113] Optical devices manufactured in Europe made their way into the imperial court sometime in the late 1660s and early 1670s. Ferdinand Verbiest, who served as private tutor to the Kangxi emperor, described briefly in his memoirs how he initiated the Chinese ruler into the parastatic magic of dark rooms and "wonderworking" (*thaumaturgum*) lanterns (as Verbiest put it, following Kircher's terminology).[114] The Flemish Jesuit was not operating alone. In his widely read description of the Chinese empire compiled of letters and unpublished reports by Jesuit missionaries from 1735, Jean-Baptiste Du Halde relates how another Jesuit scholar, the Italian Claudio Filippo Grimaldi, who had arrived in Beijing in 1671, utilized a gamut of optical media (perhaps in cooperation with Verbiest) to impress the emperor, from telescopes and microscopes to the camera obscura, the magic lantern, and even anamorphic murals.[115] Du Halde narrates how, after seeing Grimaldi's portable camera obscura, the emperor ordered a dark room built in his garden where he could observe, unnoticed and invisible, what was happening on the street across the wall. The dark room triggered the pleasures of distant, hidden observation, while the anamorphic painting in the Jesuit garden solicited the displacement and virtualization of vision. The emperor studied the mural "a long time with Admiration," witnessing "Mountains, Forests, Chaises," and other such things turn into the "Figure of a Man" (a religious character such as a saint, one can safely assume). Finally, the magic lantern epitomized such visual thrills and delights:

> They shewed him a Tube with a Lamp in it, the Light of which came through a little Hole of a Pipe, at the End whereof was a Convex-Glass, then moving several small Pieces of Glass, painted with divers Figures, between the Light and the Glass, the Figures were thrown upon the opposite Wall, appearing either very large or small in Proportion to the Distance of the Wall; this Spectacle in the Night, or in a very dark Room, frightened Persons ignorant of the Artifice, as much as it delighted those who were acquainted with it.[116]

We are not told how the emperor reacted to this nocturnal spectacle of projected images. Certainly, from the Jesuits' viewpoint, devices of projection

FIGURE 18 Optical apparatuses in the service of divine enlightenment. Frontispiece to Johann Christoph Wagner's *Das mächtige Kayser-Reich Sina*, 1688. Engraving by Melchior Haffner.

Source: Staats- und Stadtbibliothek Augsburg, 2 Gs 885, urn:nbn:de:bvb:12-bsb11119738–5.

were to contribute to the order's evangelical program where knowledge was seen as a path to salvation. G. W. Leibniz, who was in correspondence with several Jesuits stationed in China, including Grimaldi, was frustrated that the missionaries sought merely to propagate European religion and science rather than to learn the native culture; their actions were far from the kind of exchange of knowledge, a "commerce of light," that Leibniz had envisioned the encounter between the Europeans and the Chinese to have produced.[117] In theological and metaphysical terms, from the Jesuits' viewpoint, true light shone only from one direction: from the Christian god through the mirrors and lenses of optical devices onto profane spaces and souls.

Consider the frontispiece to *Das mächtige Kayser-Reich Sina*, a compendium of intelligence on China from 1688, by Johann Christoph Wagner, a Protestant scholar from Germany who never traveled to China himself (Figure 18). Wagner's book compiles stories and visual information—maps, pictures of landscapes, cities, and local inhabitants—deriving mainly from Jesuit sources. The engraving by Melchior Haffner presents a triumphal arc for the European arts and sciences located somewhere in China, surrounded by a group of locals admiring its composition. Above the arc, a group of cherubs support four oval-shaped picture screens sitting on clouds, which represent the gradual advancement of knowledge toward divine glory in terms of a hierarchy of optical apparatuses.[118] The first stage involves a mirror lantern that is shut, the caption telling us that "it does burn but gives no light" ("Es brennt zwar aber leuchtet nicht"). An exemplar of this device, we recall, was also found in the frontispiece to Kircher's *Ars magna lucis et umbrae*, held by a hand emerging from the clouds. The lantern is shut, Wagner explains, because, even if natural light emanating from the "true God" burns for everybody on earth, including the Chinese, its brilliance is occluded by the superstitions of the non-believers. In the second illustration—stage two—the mirror lantern is opened as the non-believers become exposed to divine illumination through scientific knowledge. "In this way, truth enlightens vision," the caption reads ("so leuchtet Wahrheit das Gesicht"). In the third stage the mirror machine grows into a magic lantern, named by Wagner "optical" or "art-lantern," which magnifies the light of reason, leading to knowledge of the creator of all things. The fourth and final stage is explained in terms of the camera obscura's principle of functioning; just as the figure of a cross is projected through a lens onto a surface, divine sovereignty will be instituted in the hearts and souls of people on the earth as a play of light and shadow.

Wagner gained firsthand experience of camera obscuras and magic lanterns from his tutor Johann Christian Sturm at the University of Altdorf, and likely also from the instrument-maker Johann Franz Griendel's demonstrations in Nuremberg[119]—the magic lantern in the frontispiece to *Das mächtige Kayser-Reich Sina* reproduces Griendel's original and distinct design with a cylinder-form body (see Figure 6).[120] Yet much of Wagner's understanding of the symbolic import of projection technologies as inspiring demonstrations of Christian science and religion was adopted from his Jesuit contemporaries—Kircher and Johann Zahn in particular.[121] Wagner's optical devices, like Kircher's, belonged to an economy of government where projections functioned as providential relays between spatial and mental territories and celestial truths. Unlike in Mexico where the colonial economy of projection took up the hallucinatory and thaumaturgic form of miraculous apparitions, in China, following Wagner, the effects of optical media were premised on scientific demonstration leading to salvation. It was through "mathematical arts and sciences" that the Chinese could be directed to and enlightened by knowledge of the "Creator himself." Just as the magic lantern's lens magnifies and intensifies the light rays shining on a semi-circle from which lines lead to the triangle in the middle, Wagner mused, the arts magnify the light of reason that leads to knowledge of the true God and the Holy Trinity at the origin of all things, through the contemplation of the wonders of nature. By means of optical media, the light of divine wisdom and salvation shall shine so brilliantly, and acquire such a glorious representation, that infidels could only hold it in highest esteem and veneration. Thus, according to Wagner, the Chinese nobles and state servants could not help but adopt the teachings of the Europeans.[122]

Among the Chinese themselves, however, such demonstrations of professed European supremacy seem to have been met with somewhat different effects. The Chinese painter and poet Wu Li, who converted into Catholicism and became a member of the Society of Jesus, provides a rare testimony in a poem entitled "A Western Lantern":

> This lantern from distant parts is strange:
> its flame has been lit from Cold Food fires.
> I try viewing the scenes of Rome;
> > (—The name of the place where the Church
> > has its headquarters.)
> horizontally read the Latin characters.

(—The West's ancient writing.)
Moths flit about the light but can't approach;
a rat peers out, his shadow all alone.
Startled, I read the missive from the West:
all these affairs, have they been heard of before?[123]

Wu Li wrote these allusive lines likely after he entered the Jesuit College in Macao in the 1680s where a magic lantern had been sent from Rome with an accompanying note. The atmosphere of projection described in the poem is curious and mysterious yet somehow impenetrable; rather than enlightened, Wu is "startled." Seemingly unimpressed with the contents of the projection, he turns to look at the lantern situated in its environment, moths fluttering about the machine's light source. Then, we read a curious line: "a rat peers out, his shadow all alone." Perhaps Wu is describing how the images appear and disappear on the screen, enticing curiosity but also fundamentally fleeting and ungraspable. The reader gets a sense of the momentary and ephemeral nature of the optical spectacle, yet very little of any kind of wonder let alone miraculous experience or divine illumination.

The last line in Wu Li's poem ("all these affairs, have they been heard of before?") suggests the centuries-long native tradition of optics among the Chinese, rich in its own right in experimenting with light-borne images.[124] Among a myriad of contrivances, suffice to mention the "pacing horse lantern" (*zouma deng*), which, even if not as technically erudite as the Europeans' "wonder-working lamps," made "shadows move, circling and leaning, on a silk gauze screen" by means of a mechanism consisting of paper-cut figures inside a box moved by the convection currents caused by a candle.[125] In his *New History of China* (John Ogilby's English translation published in 1688), the Portuguese Jesuit Gabriel de Magalães chronicled the zoetropic device in considerable detail:

> They are twenty Cubits and sometimes more in Diameter: and the Lamps and Candles of which there are an infinite number in every Lanthorn, are intermix'd and plao'd within-side, so artificially and agreably, that the Light adds beauty to the Painting; and the smoak gives life and spirit to the Figures in the Lanthorn, which Art has so contriv'd, that they seem to walk, turn about, ascend and descend. You shall see Horses run, draw Chariots and till the Earth; Vessels Sailing; Kings and Princes go in and out with large Trains: and great numbers of People both a Foot and a Horseback, Armies March-

ing, Comedies, Dances, and a thousand other Divertisements and Motions represented.[126]

The pacing horse lantern's rapidly moving and distorting shadows alongside "mobile lines of sight and vantage points," as Jennifer Purtle points out, would have come across as unfamiliar to European observers more accustomed to visual fixity and geometric order.[127] Indeed, the magic lantern of the Europeans didn't quite succeed in giving "life and spirit" to images as forcefully as its Chinese counterpart, which encircled observers with continuously recurring animated and shifting shapes. Placed in this context, Wu Li's hesitation when facing what he emphasized was a *Western* contrivance might make more sense. The apparatus shipped from Rome came across as exotic and intriguing, to be sure, but far from anything aesthetically or intellectually superior. The providential promise of optical media, Wu Li's poem implies, didn't necessarily have much purchase in those parts of the world where projected shadows had already been attuned to other kinds of meanings and functions—even among those like Wu Li, the convert, who would have been most curious about and sympathetic to their purported powers.

In China, too, optical media promised illumination, but in a different sense than that intended by the Knights of Jesus. The presentation of the camera obscura in Sun Yunqiu's *A History of Lenses* (*Jingshi*, 1681), an important Chinese-authored study on optical devices, provides a case in point.[128] Sun's treatment of the "lens that absorbs light" (*sheguang jing*), as he called the dark room, did not delve in technical detail but presented a vivid phenomenological account of the device's effects: "A plain screen is positioned facing the lens, then what is outside the room both far and near, above and below, the movement and stillness of all things great and small, all enters onto the screen. With the subtle details of form and color, all will appear as if real."[129] Sun's description appears at first to gesture toward the perceptual veracity of the dark room's projections, yet the "as if real" that Sun refers to does not align with the empirical reality, pure and simple. In his treatise, Sun also provides an illustration of the camera obscura's screen on which the following Buddhist verse ("gâthâ") of "reflected light" is inscribed:

An aperture in the room
Returns the light [*huiguang*] and traces the picture.
The master is positioned inside,
And a multitude of mysteries comes in great profusion.

In this way, he can sit in meditation;
In this way, he can attain the Way.
[signed] "Quiet Amusement" [seal] Quiet observation brings things
 about of their own accord[130]

The camera obscura's main purpose, the verse tells us, was to enable a space of observation and reflection, to trigger a mental process. The second line of the verse ("Returns the light"), as S. E. Kile and Kristina Kleutghen observe, can be understood in terms of the introspective movement of the mind away from external objects toward inner enlightenment.[131] The device's purpose, Sun's *A History of Lenses* suggests, was above all to assist the soul's reach of higher truths by detaching the observer from the world's sensory immediacy. Here, in a sense, Sun's description of the camera obscura was not far removed functionally from Kircher's musings about the contemplative soul's ascent toward God in the dark room, or from Wagner's different stages of techno-intellectual illumination.

Displacing the mind from actual objects toward something that could not by definition be represented in any image—the virtualization of the real as a meta-physical construct—seems to have been a key operational goal of optical media during the period. Yet, this operation simultaneously challenged the notion of projection as purveyor God's grace. This is what the Knights of Jesus found difficult to fathom, reluctant as they were to engage in genuine cultural translation: that rather than being suitably amazed by what the Jesuits had to display, the Chinese had their own apparatuses of projection and enlightenment, ones that perhaps shone more brilliantly with more powerful and enticing effects than those in service of the Christian god.

GOVERNMENT OF SOULS

Parastatic Magic

On Tuesday May 9, 1656, the French poet Jean Loret visited the Hôtel de Lian-court in Paris. In the townhouse of Roger du Blessis, Marquis of Liancourt and Duke of La Roche-Guyon, and his wife Jeanne de Schomberg, "a quantity of great things" was displayed. Or so Loret reported in his gazette written in easy verse for the noble and the noteworthy in the French capital to quench their curiosity for news and gossip.[1] The hôtel of the duke and the duchess, follow-ers of the controversial teachings of the Dutch bishop Cornelius Jansen, was designed by the architect Jacques Lemercier, who was commissioned to dou-ble the size of the existing building on the site, located on Rue de Seine almost opposite the Chateau du Louvre across the river. The building work started in 1623 and, among other things, a small court and a garden were added on the left in front of the main block.[2] It was perhaps in this new extension that Loret witnessed a curious spectacle, which involved a canvas (*toile*)—or in modern terms, a screen—that a "beautiful charmer" had hung in the air.

A series of apparitions suddenly unfolded on the screen: beautiful pal-aces, human figures dancing and fighting, even fireworks. Something in these apparitions—"slightly dark glimmers" and "light bodies like shadows"[3]—made Loret suddenly jump away in fear; the realization, the poet explained in retrospect, that the light-borne figures had their feet upside down and made "no hullabaloo nor noise." The "innocent magic" of these projections, the

secret of which, Loret said, escaped him, made the poet cross himself several times, believing he was in Bicêtre (the hospital, which subsequently became a famous mental institution), where beggars, tramps and "undesired" ones were confined, and where Loret could have joined several others possessed by dreams and apparitions caused by (as Loret's contemporary across the English Channel, Thomas Hobbes, put it) "the distemper of some of the inward parts of the body."[4]

In Loret's memoirs we encounter an early account of the common trope of projections of light and shadow having the power to take hold of the observer to the point where external images become blurred with the psyche's internal productions—how optical media are able to shake, shatter, and take over our faculties. It is not certain, however, what kind of optical spectacle Loret was taken in by. The description does resemble a magic lantern show with the canvas and the orchestrated play of colorful shadows, but the fact that the figures were inverted does not support this.[5] It is more likely that Loret witnessed a room-sized camera obscura exhibition, something akin to what the Italian polymath Giambattista Della Porta had already envisioned in his famous *Magiae naturalis* (*Natural Magic*) from 1558:

> Nothing can be more pleasant for great men, and scholars, to behold; That in a dark Chamber, by white sheets objected, one may see as clearly and perspicuously, as if they were before his eyes, Huntings, Banquets, Armies of Enemies, Plays, and all things else that one desireth. Let there be over against that Chamber, where you desire to represent these things, some spacious Plain, where the Sun can freely shine: Upon that you shall set Trees in Order, also Woods, Mountains, Rivers, and Animals, that are really so, or made by Art, of Wood, or some other matter. You must frame little children in them, as we use to bring them in when Comedies are acted: and you must counterfeit Stags, Bores, Rhinocerets, Elephants, Lions, and what other creatures you please: Then by degrees they must appear, as coming out of their dens, upon the Plain: The Hunter he must come with his hunting Pole, Nets, Arrows, and other necessaries, that may represent hunting: Let there be Horns, Cornets, Trumpets sounded: those that are in the Chamber shall see Trees, Animals, Hunters Faces, and all the rest so plainly, that they cannot tell whether they be true or delusions.[6]

Della Porta provides a rare, early script for an entertainment show with props and live actors moving outside a darkened room with an aperture on

one wall, whose shadows were projected and animated inside the device, their silent gesturing accompanied by music. Della Porta's shadow projections were rooted in movement and metamorphosis—human bodies assuming a range of animal shapes, for example. Such transformations anticipated subsequent projected image spectacles, as we learn from the German scholar Daniel Schwenter's 1636 description of a camera obscura show organized by the then-famous Dutch inventor Cornelis Drebbel. In Drebbel's show, kings suddenly metamorphosed into beggars or adopted the shapes of wolves, bears, and horses.[7] Schwenter emphasized how optical projection submitted forms to variation and becoming, crossing conceptual boundaries. In *The Anatomy of Melancholy* from 1621, Robert Burton underscored the aspects of deception and fallacy in such catoptric shows. "Who knows not that if in a dark room," Burton pronounced,

> the light be admitted at one only little hole, and a paper or glass put upon it, the Sun shining, will represent on the opposite wall all such objects as are illuminated by his rays? With concave and cylinder glasses we may reflect any shape of men, Devils, Anticks, (as Magicians most part do, to gull a silly spectator in a dark room), we will ourselves, and that hanging in the air, when 'tis nothing but such an horrible image as Agrippa demonstrates, placed in another room.[8]

Burton, importantly, situated such deluding and "gulling" apparitions partly inside the observer's brain, and inside the imagination in particular, which, located in the "middle cell of the brain," received images (*species*) communicated by "the common sense," and by comparison "feigned infinite others unto [itself]." Yet Burton remained undecided whether the device's projections should be understood in terms of inner mental visions, or whether they were caused by otherworldly forces. "But most part it is in the brain that deceives them," Burton asserted and hesitated, "although I may not deny, but that oftentimes the Devil deludes them, takes his opportunity to suggest, and represent vain objects to melancholy men, and such as are ill affected."[9]

The entertainers at the Hôtel de Liancourt clearly took up some of the ideas about staging live-action performances with the camera obscura from their predecessors like Della Porta and Drebbel. These shows exhibited imitation and deception, as well as perceptual confusion as to the boundaries that distinguish the inside of the apparatus (and its visions) from the outside world and the apparatus' visions from the products of the beholder's

imagination. "For what is without will seem to be within," Della Porta ob-
served about images "hanging in the air" that came across as "Spirits of vain
Phantasms." Della Porta described an optical illusion produced by means of
a concave mirror that subverted both its origin and medium, "the visible Ob-
ject" and the "Glass seen." The substance of such images was not light, but
"spirits." Here, Della Porta crystallized something essential about the culture
of projected images around 1700, as we will see throughout this chapter—
indeed, projections as experiments on the "imaginary conceits of the mind,"
as Della Porta put it.[10]

The optical projection witnessed by Loret at the Hôtel de Liancourt had
an eerie atmosphere, which involved perceptual dislocation, disjunction, and
deception. What matters most in Loret's account is the "cut" the poet felt
within his bones, an anthropological interval, if you will, between embod-
ied reality and projections on the screen. The shadows seemed cut off—or
perhaps better put, freed from—the bodies that cast them. What gave the
apparatus's projections this power to trick and to fool, and to substitute for
the original? In his 1688 treatise on sculpture, *Traité des statues*, the French
lawyer François Lemée observed how shadows, like phantoms, appeared
unmoored from anything firm and stable. Mere fleeting projections, lacking
fixed referents, Lemée compared shadows to the idolater's items of worship.
Idols, Lemée tells us drawing on his knowledge about the image practices
of ancient as well as non-European cultures, are mistaken for what they are
images of.[11] They are given the powers of living beings or deities; they kneel,
walk, talk, and run away. Importantly, they are animated with "deregulated
affections." The idolater's emotions and ideas unpredictably fly out of critical
control and judgment. Yet Lemée didn't regard such practices as entirely alien
to the ideals of Enlightenment rationality—and the reasoned individual—
growing during the period. Every image, according to him, could partake the
powers of life, and share a portion of its referent's "substantial form."[12] There-
fore it made sense, for example, to bow one's head and take off one's hat in
front of the statue of King Louis XIV on the Place des Victoires in Paris.

Lemée pointed out how the relationship of images to their originals was
more definitive than mere likeness; it was based on metonymy and contiguity,
even substitution, which warranted authenticity and authority.[13] Perceptual
submission to such substitutive powers might also clarify Loret's sudden urge
to jump away in fear from the projection screen at Hôtel de Liancourt. For the

poet, the "magic" of projection was acting with "so much energy."[14] Projections of light and shadow performed their agile spectacle in silence, as if on their own accord, severed from the noisy flesh-and-bone humans but reanimating their "substantial form." They were like semi-autonomous doubles that confused distinctions between animate and inanimate, original and copy. Not surprisingly, the French physician Pierre le Lorrain (Abbé Vallemont) called the camera obscura's projections "little phantoms" (*petits fantômes*) that imitated the movements of their objects—"phantoms," we should note, was also how Lorrain characterized the figures painted on magic lantern slides.[15]

While Loret's account discloses how one could witness such animations of light and shadow in private performances in French aristocratic houses, it was above all in the centers of learning established by the Knights of Jesus (the Collegio Romano as their apex) where experiments with the powers of optical projection and illusion—indeed, what Della Porta called the "imaginary conceits of the mind"—were carried out to their fullest. In the latter half of the seventeenth century, the Jesuits took up optical investigations pioneered by Della Porta with particular determination and enthusiasm, spearheaded by Athanasius Kircher and his disciple Gaspar Schott who coined a term critical to understanding the history of projection in the modern age, as the production of simulated environments, a term that was inspired by the work of their Renaissance predecessors: *magia parastatica*, or "parastatic magic."[16] Kircher defined this magic as the secret science of light and shadow by means of which "wonderful shows" (*mira spectacula*) could be staged to an audience.[17] Schott, for one, pointed out how parastatic magic was practiced by "God himself, the author of nature, who plays on the earth" (*ipse Deus, Naturae Auctor, ludat in orbe terrarum*), referring to the passage in Proverbs that discusses the role of Wisdom in "forming all things" and "playing in the world."[18] The effects of this playful magic could be found everywhere in natural media—from air, water, and earth to mountains, rocks, stones, and other kinds of objects—but its primary field of application consisted of "mixtures of light and shadow" effected by optical media, Schott emphasized.[19]

The term *parastatica* itself, however, remains enigmatic. One possible definition could be "wondrous," given how both Kircher and Schott related *magia parastatica* with miracles (*rerum prodigiosis*) and, more precisely, the manufacture of prodigious images with optical media—images that, as we saw in the previous chapter, connected the profane and the sacred and

participated in the execution of divine providence on earth. But the term also suggests a more psychological character. According to the *Oxford English Dictionary*, "parastatic" relates to "what is presented to the mind," to "appearance, virtual." In this sense, *magia parastatica* involves the production and administration of endogenous appearances by technologically mediated means. Hence, this magic could also involve deception and manipulation.

Not coincidentally, the German poet Georg Philipp Harsdörffer revamped the purposes of the portable camera obscura presented by Kircher in *Ars magna lucis et umbrae* to this effect in his book *Delitiae philosophicae et mathematicae* ("Philosophical and mathematical pleasures") from 1653. Harsdörffer, who was in regular correspondence with Kircher, introduced an aspect of artifice, illusion and the supernatural to the original design (Figure 19):

FIGURE 19 Illustration of a camera obscura from Georg Philipp Harsdörffer's *Delitiae philosophicae et mathematicae*, 1653, page 230. Harsdörffer added the Grim Reaper holding an hourglass to the camera obscura design that Athanasius Kircher presented in *Ars magna lucis umbrae* (Figure 12). Note that the Grim Reaper reappears in one of the famous illustrations of the magic lantern in the second edition of Kircher's *Ars magna lucis et umbrae* (Figure 20).
Source: Staatliche Bibliothek Regensburg, 999/Philos.2181/2182, urn:nbn:de:bvb:12-bsb11110929–0.

In addition to natural objects and landscapes, one could project images of "old emperors, ghosts, and death," the poet suggested, onto the translucent paper walls set inside the room as screens.[20] Inspiration for Harsdörffer here likely came from traveling camera obscura performances, such as the one Schott described in *Magia Optica*:

> Then they sharply advise one to be as silent as a mouse . . . as if one was waiting for the sermon in church. While waiting for the apparition they say that the devil will be here soon. In the meantime one of the assistants puts on the mask of a devil . . . and walks around as if in deep thought towards a place from where his color and figure can shine through the sheet of glass into the chamber. . . . After that someone brings in a large board made of paper [*Papyrne Tafel*] and positions it in the ray of light that has been directed into the chamber. Then there appears an image [*Bildnuss*] in the shape of the devil walking up and down, which they [the audience] look at, inspect and view with fear. Thus the poor and inexperienced people waste their time and money viewing the shadow of a traveling entertainer.[21]

Schott's account was drawn from the Jesuit mathematician François de Aguilón's denunciation of traveling camera obscura shows set up by "charlatans" to "hoodwink the uneducated rabble" from the early seventeenth century.[22] Kircher, likewise, referred to Aguilón's account in *Ars magna lucis et umbrae*, emphasizing how some viewers turned pale while others started to sweat, fearing that suddenly "some God" might "come forth from the machine."[23] Parastatic magic could, in other words, prove to be mere trickery profiting on the credulity of the underclass, the Jesuits lamented, observing how the organizers of these shows capitalized on otherworldly emanations pretending to black magic. The Jesuit scholars wanted to expose the foolishness of such attitudes, to falsify the projected image's seemingly supernatural powers. Schott's and Kircher's gesture was to rid the traveling showmen's projections of their metaphysical weight and to make devilish occurrences and apparitions a matter of the mind, as their choice of words to describe light-borne images illustrates: Both called the animated projected image in this instance a *simulacrum*, meaning an apparition or phantom imagined in the mind[24]—something akin to Della Porta's "Spirits of vain Phantasms." *Simulacra* did not amount to the metaphysical status of *species*, which were likenesses that shared the powers of their origins. *Simulacra* were phantasmatic; they belonged to the imagination because they were appearances that

were conjured up having never been perceived by the senses.[25] Rather than assuming a metaphysical connection between optical projections and what surpassed human faculties, Schott and Kircher, in this context, shifted the problematic toward the beholder's soul, and above all the affective and emotional effects of projected images on their spectators.[26]

Here, the Jesuit scholars were evidently indebted to the principles of the order to which they belonged. The founder of the Society of Jesus, Ignatius of Loyola, posited the imagination as pivotal to instituting Christian faith and administering its effects. One of the main pedagogical and missionary concerns of the order was how one could produce desired results by controlling the mind's powers of visualization. In this respect, it was Kircher who developed a unique concept of optical projection as a psychic space of its own kind. Kircher described the imagination as a dark place (*obscuro loco*) where a "radiant power" brought forth appearances and played a trick on perception. "The material radiation of phantasy," Kircher surmised, could cause one to "apprehend external things through vehement imagination."[27] The imagination partook in the form-generating plastic power (*virtus plastica*) at operation in the universe (see Chapter 2), but its special quality was to agitate the rational soul and to endow things and beings with a phantasmatic outlook. Marina Warner points out how Kircher's imagination was an "active agent, with strong—indeed, even autonomous and ungovernable— powers not only to shape the fantastic lineaments of objects as they appear on the screen of the inner eye but also to change the person's own perception of self."[28] For Kircher, as Warner also suggests, the key media apparatus that both symbolized and operationalized the imagination's dark place was the magic lantern. Unlike the camera obscura, which the Jesuit associated first and foremost with divine government through the planetary effusion of appearances, the magic lantern was directed toward the soul, particularly the flights of fancy, which the device was designed to capture and control.

Techniques of the Imagination

Since its invention sometime in the mid-seventeenth century, the magic lantern became a true technology of parastatic magic—the creation of phantasmatic virtual realities—a "lantern of fear," as the French scientist Pierre Petit dubbed it.[29] The device was "magic" in the sense that its effects defied comprehension. Antoine Furetière's *Dictionnaire universel*, published in 1690,

advised its readers how the lantern could "make appear" (*faire voir*), in a magnified dimension, on a white wall "so frightful ghosts and monsters that whoever doesn't know its secret will believe it is made by magic."[30]

From early on, the lantern was associated with testing and shaping, even perverting, the limits of what could be imagined and believed. The Royal Society fellow Robert Hooke provided a somewhat strange account of an image projection device of his own design:

> Had the Heathen Priests of old been acquainted with [the device], their Oracles and Temples would have been much more famous for the Miracles of their Imaginary Deities. For by such an Art as this, what could they not have represented in their Temples? Apparitions of Angels, or Devils, Inscriptions and Oracles on Walls.[31]

Hooke seemed unaware of the experiments carried out during the same period across the channel, by Johann Franz Griendel (or Gründel), a former Capuchin who had turned to the Lutheran faith and opened a shop of optical curiosities in Nuremberg. Griendel was one of the most celebrated projectionists in Europe, "Master of the most abstruse Secrets in Opticks . . . capable of fixing half the World in a Point," as the French physician Charles Patin put it, who witnessed a magic lantern show set up by Griendel in May 1672. With his portable magic lantern, Patin tells us, Griendel could "remove Ghosts from their Stations at his pleasure, without any assistance from the Infernal Regions." Patin narrates how captivating the apparatus's visions were—even though, he cautions, they lacked solidity:

> For it seem'd to me as if I had a sight of Paradise, of Hell and of wand'ring Spirits and Phantoms, so that altho' I know myself to be endu'd with some measure of Resoluteness, yet at that time I would willingly have given one half to save the other. All these Apparitions suddenly disappear'd and gave place to Shews of another Nature. For in a moment, I saw the Air fill'd with all sorts of Birds, almost after the same manner as they are usually painted round about *Orpheus,* and in the twinkling of an Eye, a Country-Wedding appear'd to my view, with so natural and lively a representation that I imagin'd myself to be one of the Guests at the Solemnity.[32]

"I imagin'd myself . . . ," Patin described an uneasy and self-contradictory feeling of how the magic lantern enveloped him into a kind of daydream with

his eyes open. The physician clearly struggled to pinpoint the psychological status of the sudden apparitions, transitions, movements, and disappearances of both earthly and otherworldly beings on the screen.

Griendel, we should note, was a friend of Johann Zahn's and very likely familiar with the Jesuit scholars' experimentations on parastatic magic. Indeed, the ex-monk's spectacles were not far removed thematically from the magic lantern shows organized by Kircher at the Collegio Romano. The two illustrations of what Kircher called the "magic or wonderworking lamp" (*lucerna magicae seu thaumaturgae*) that were published in the second edition of *Ars magna lucis et umbrae*, from 1671, have attracted much attention (Figures 20 and 21). Media historians have questioned why the illustrations appear to be incorrect (at least if we regard them as technical drawings): The unknown author of the woodcuts places the disks of transparent glass slides in front of the lens rather than between the candle and the lens mechanism; thereby they seem to portray a point light-source projection system rather than a magic lantern proper.[33] This has caused doubt among historians about how well versed Kircher actually was in the laws of optics—doubt that, in fact, is not new. Around 1660, John Bargrave, an Englishman who traveled widely across the European continent, noted about a certain Westleius, "an eminent man for optics at Nuremburg," who had tried to implement some of Kircher's designs: "The gentleman spoke bitterly to me against Father Kercherius, a Jesuit at Rome (of my acquaintance), saying that it had cost him above a thousand pounds to put his optic speculations in practice, but he found his principles false, and shewed me a great basket of glasses of his failings."[34]

We are not told if any early type of image projection apparatus was to be found in Westleius's basket of failed experiments. Nevertheless, in the 1671 edition of *Ars magna lucis et umbrae*, Kircher claimed that his original idea for a magic lantern had been taken up and improved by a certain Danish mathematician Thomas Walgenstein. Walgenstein had indeed constructed an optical projection machine at some point in the 1660s and was touring with his invention across Europe, including Rome, where (by Kircher's account) he had been selling his devices to Italian princes in such amounts that they had become everyday commodities.[35] Kircher's colleague at the Collegio Romano, the mathematician Francesco Eschinardi, mentioned in his study on optics, published in 1668, a "lantern, which they call magic."[36] In his technical description of two types of magic lantern designs, Eschinardi didn't divulge

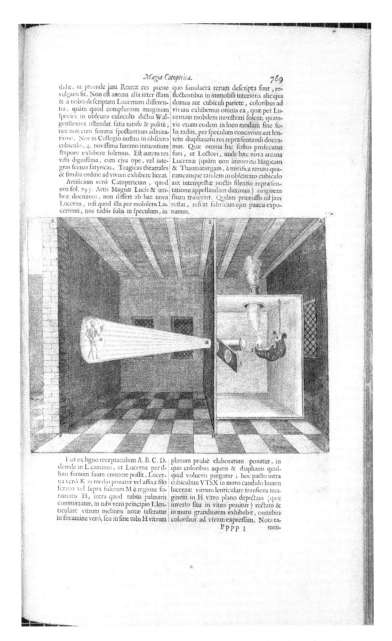

didit, ut proinde jam Romæ res pœne vulgaris fit. Non est autem alia inter illam & a nobis descriptam Lucernam differentia, quàm quod complurium imaginum species in obscuro cubiculo dictus Walgenstenius ostendat satis nitidè & politè, nec non cum summa spectantium admiratione. Nos in Collegio nostro in obscuro cubiculo, 4. novissima summo intuentium stupore exhibere solemus. Est autem res visu dignissima, cum ejus ope, vel integras scenas satyricas, Tragicas theatrales & similia ordine ad vivum exhibere liceat.

Artificium verò Catoptricum, quod nos fol. 793. Artis Magnæ Lucis & umbræ docuimus, non differt ab hac nova Lucerna, nisi quod illa per mobilem Lucernam, nos radiis solis in speculum, in quo simulacra rerum descripta sunt, reflectentibus in immobili interioris alicujus domus aut cubiculi pariete, coloribus ad vivum exhibemus omnia ea, quæ per Lucernam mobilem monstrari solent; quamvis etiam eodem in loco modum sine foliis radiis, per speculum concavum aut lentem diaphanam res repræsentandi doceamus. Quæ omnia hic fusius prosecutus sum, ut Lectori, unde hæc nova arcana Lucernæ (quàm non immerito Magicam & Thaumaturgam, à mirifica rerum quarumcumque tandem in obscurato cubiculo aut intempestæ noctis silentio repræsentatione appellandam duximus) originem suam traxerint. Quibus præmissis nil jam restat, nisi ut fabricam ejus paucis exponamus.

Fiat ex ligno receptaculum A. B. C. D. deinde in L caminus, ut Lucerna per illum fumum suum emittere possit, Lucerna verò K in medio ponatur vel affixa filo ferreo vel supra fulcrum M è regione foraminis H, intra quod tubus palmaris committatur, in tubi verò principio I.lenticulare vitrum melioris notæ inferatur in foramine verò, seu in fine tubi H vitrum planum probè elaboratum ponatur, in quo coloribus aqueis & diaphanis quidquid volueris pingatur; hoc pacto intra cubiculum VTSX in muro candido lumen lucernæ vitrum lenticulare transiens imaginem in H vitro plano depictam (quæ inverso situ in vitro ponitur) rectam & in muro grandiorem exhibebit, omnibus coloribus ad vivum expressam. Nota tamen-

FIGURE 20 The magic lantern projecting a Grim Reaper with an hourglass. Illustration from the second edition of Athanasius Kircher's *Ars magna lucis et umbrae*, 1671, page 769. Courtesy of the Smithsonian Libraries and Archives, Washington, DC.

Problema III.

Lucernam artificiosam construere, quæ in remota distantia scripta legenda exhibeat.

Fiat lucerna, ea, qua hic factum esse vides figura cylindracea, in cujus basi AB speculum concavum, quod parabolam quantum fieri potest, adectet, erigatur.

Lucerna Catoptrica. Intra hujus speculi focum applicetur F flamma candelæ, habebisque quæsitum. Nam tam inusitato splendore fulgebit, ut noctu etiam minutissimas literas ope te-

lescopii inspectas nullo negotio exhibeat. Remotè verò flammam intuentes, ingentem ignem esse existimabunt ; augebunt lumen, si latera cylindri interiora ex fulgido stanno in ellipsin elaborata fuerint. Sed inventum figura appofita satis declarabit. E manubrium, D feneftram, C tintinnabulum defignat.

Problema IV.

De Lucerna Magicæ seu Thaumaturgæ constructione.

Quamvis in arte Magna Lucis & umbræ folio 767. hujusmodi Lucernæ mentionem fecerimus & fol. 793. modum per solem simulacrorum in obscurum locum tranfmittendorum, una cum coloribus ad ea depingenda requisitis tradideri-mus: Quia tamen in citatis locis, inventionem hanc prorsus fingularem ab aliis majoribus inventionibus adornandam reliquimus, accidit, ut multi rei novitate

allecti ad eam excolendam animum adjecerint, Quos inter primus fuit Thomas Walgenftenius Danus, haud infimæ notæ Mathematicus, qui recolens meas in defcribendis iis inventiones Lucernam fol. 767. à nobis defcriptam, in meliorem formam reduxit, quam & poftea magno fuo lucro diverfis in Italia principibus vendidit ;

FIGURE 21 The magic lantern projecting a person burning in purgatory. Illustration from the second edition of Athanasius Kircher's *Ars magna lucis et umbrae*, 1671, page 768.

Courtesy of the Smithsonian Libraries and Archives, Washington, DC.

where his knowledge of the device originated from, but we can assume that a projection apparatus had been developed at, or made its way to, the Collegio Romano in the early part of the 1660s. Magic lantern projections, we know, were among the curiosities displayed at the Musaeum Kircherianum for the enjoyment of nobles and other noteworthy. These included a certain "Prince of Neuburg," who arrived at the college in 1676 with twenty courtiers. In addition to enjoying lunch, music, and singing, the prince, we are told, was taken to the loggia to try out "various telescopes" as well as to see the magic lantern (*lucerna magica*).[37]

The illustrations published in Kircher's *Ars magna lucis et umbrae* suggest how, at the Collegio Romano, the magic lantern was enclosed in a box hidden from the beholder rather than being displayed as a wonder of its own. Spectators entering the dark room were meant to encounter projected images coming and going as if by themselves, endowed with their own fledgling powers. "Who or what is at work should not be recognizable," as Siegfried Zielinski notes about Kircher's setup.[38] The "magic" of the lantern was a matter of effects that "go beyond the sense and comprehension of common people," as Schott tellingly put it.[39] Kircher emphasized how the device's projections were to come across varyingly as delightful, gloomy, dreadful, frightening, and (for those who didn't know what caused them) miraculous (*prodigiosa*). With the lantern's arrangement of light and shadow, one could incite wonder (*admiratione*) in beholders; or, as Kircher's colleague Johann Zahn put it, even deepest awe.[40] The Jesuit father, in other words, envisioned the magic lantern above all as an instrument for the manipulation of how representations and emotional effects were created, which drew its beholders into an uncertain and ethereal visual realm where a person howling in the flames of purgatory could quickly turn into a crucified body (or vice versa), into a world of movements and becomings without fixed points of reference. Importantly, Kircher called his lantern "wonderworking" (*thaumaturga*); its "transforming images" (to borrow a concept of Tom Gunning's), like the imagination's radiating power, were designed to have the power to twist and shape the ways the mind was able to picture the real.[41]

For Kircher, the magic lantern was thus generally situated among phenomena deemed as "rare, curious, paradoxical and prodigious," and joined a range of other optical apparatuses designed to both expand and control the boundaries of the imagination.[42] An avid reader of *Ars magna lucis et umbrae*

notices how transforming images of various kinds were the particular scope and aim of what was called "catoptric art." This "secret knowledge" (*scientia secreta*) as Kircher's colleague, the Austrian Jesuit Zacharius Traber called it, concerned "monstrous mirror apparitions" produced by means of reflections of "rays of luminous bodies": in other words, apparitions caused by means of mirrors and lenses.[43]

In addition to the magic lantern, the pages discussing catoptric art in *Ars magna lucis et umbrae* are populated by devices with exotic names and designs—"parastatic microscopes," cylindrical anamorphosis devices, "catoptric theaters," metamorphosis machines (*proteus catoptricus*)—which represented a whole repertoire of visual media effects. The catoptric theater, basically a box of mirrors, multiplied the objects put in it, causing its beholders to try in vain to touch what they saw inside it until they realized that the device's projections were mere insubstantial phantoms. The parastatic microscope was a handheld device presenting pictures painted on a rotary disk and peeped through a "viewfinder." While the cylindrical anamorphosis device conjured appearances hanging in the air as if of their own accord, the metamorphosis machine, so we are told, achieved the transformation of the beholder's self-image in the mirror with the head of a donkey, deer, or hawk, or whatever was painted in the drum that remained invisible to the viewer.[44] Sudden appearances, multiplications, animations, and mutations—such were the attributes of the projections thus contrived, whose primary task was to betray God's mysterious workings. Critical to catoptric art was the transformation of one's surroundings into something other than what it was—into a religious phantasm; the beholder would not know where the phantasm came from nor how to distinguish it from reality. On the one hand, as Barbara Maria Stafford points out, Kircher's optical media worked like "spiritual tools" that "demonstrated the fickleness of the human mind, the duplicity of the sensory appearances, and the convertibility of the physical universe in contrast to the immutability of an immaterial God." As such, on the other hand, they also worked as tools to "bridge the gap between God and his imperfect, composite creatures"[45]—in other words, as pedagogic contrivances.

Kircher's apparatuses grew out of a pastoral imperative to bind the individual's sensorium and imaginings into a set of attitudes and meanings. The magic lantern was designed to cast the sudden appearance of the Grim

Reaper with an hourglass, or a person burning in purgatory. The parastatic microscope would conjure a scenario of the Passion of Christ in a proto-movie. The cylindrical anamorphosis machine, so we are told, would portray the Ascension of the Lord so vividly that the figures seem to be hanging in mid-air.[46] Life, passion, death, and the resurrection of Christ—these were key materials from a specific source very close to every Jesuit's heart: the manual of mental drills, also known as the spiritual exercises, that Ignatius of Loyola had come up with in the early sixteenth century. The spiritual exercises were the means by which novices were trained to become true *milites Christi*, by "preparing and disposing the soul" for "the glory of God our Lord."[47]

For Ignatius, God's glory was to be encountered in solitude, locked inside one's cubicle. And it was to be received in the dark. "I will deprive myself of all light, closing the shutters and doors when I am in my room," the exercises suggest in the first person. In this artificial night, the projection of mental images—sensations, appearances, and scenarios—could begin. Ignatius's drills include the imperative "imagine," the call to picture something as vividly as possible, drawing on one's powers of visualization and fabulation: "Imagine Christ our Lord before you, hanging upon the cross. Speak with Him of how from being the Creator He became man, and how, possessing eternal life, He submitted to temporal death to die for our sins." Ignatius's exercises targeted the production and use of images, both internal and external. While they encompassed all the five senses, from vision and hearing to touch, taste, and smell, the exercises were plotted to take charge of how and what one is capable of "seeing with the imagination's eye." The exercises, in other words, were designed to harness one's capacity to *animate* mental imagery of particular places, situations, events, and dramas. Such animations would help the soul to reach divine presence—to *be* with the Virgin or the Christ—above all, to see them with the "sight of the imagination," then to "hear what they are saying," and to "smell and taste with the sense of smell and taste the infinite fragrance and sweetness of the Divinity."[48]

Ignatius's exercises were particularly designed for the discipline of such mental dynamic. The exercises determined "less what has to be imagined than what it is not possible to imagine—or what it is impossible not to imagine," as Roland Barthes puts it.[49] Barthes implies that power, for the Jesuits, was above all an issue of the allocation and distribution of dispositions, the "cans" and "cannots" that define individuals. In this purpose, not only the

possibilities of fantasizing, but also the retention of images, fell under scrutiny. Ignatius's drills were aimed at divesting the exercitant's memory of its habitual contents, at making one forget through the concentrated repetition of select imagery.[50] The spiritual exercises were meant to colonize the possibilities of imagining and remembering, to "occupy the totality of mental territory," as Barthes put it.[51] The exercises were devised as techniques of the soul, which sought to institute Christian government deeply within the individual's mental apparatus.

We should therefore consider Ignatius's drills as part of a larger historical transformation that, according to Michel Foucault, took place in the sixteenth and seventeenth centuries, whereby the notion of *oikonomia* started to apply to the Christian problem of the salvation of souls by the Christian pastorate.[52] The original concept of *oikonomia* as the profitable management of a household acquired a new set of references where it designated the "government" or "conduct" of souls (*oikonomia psychôn*) as impacting simultaneously on the whole Christian community and on each Christian in particular. A new kind of primarily psychic economy emerged with beneficial mechanisms devised to direct individuals to conduct themselves properly and to allow them "to advance and progress on the path of salvation," as Foucault puts it.[53] Confessionals, self-examinations, and the spiritual techniques of the Jesuits, among other modes of "psycho-power," fell within these mechanisms of the government of souls. As a Catholic cardinal proclaimed about secret confessions to a single priest in the latter half of the sixteenth century: "It is a custom which is to be recommended highly, not so much because it conforms to the law of God and Christ, as because it is by itself highly praiseworthy and also according to human and natural reason most useful for the good government of the Christian republic. *No other republic, however well organized, ever developed such an excellent way of governing.*"[54]

Among sixteenth-century moral theologians, such methods of behavioral monitoring were based on an elaborate psychological theory according to which the human faculties of perception were, as Wietse de Boer puts it, "capable of transmitting not only aesthetic and intellectual qualities, but virtues and vices as well."[55] The eyes provided gateways or windows into the body and the mind; they could introduce "great mischief into the soul," and therefore needed to be guarded with diligence.[56] Ignatius's exercises sought to expand the reach of this *oikonomia* from the windows of the soul to its very

heart, that is to say, the mind's eye that brings the world, *qua* images, to life and invests the self in it.

"The Jesuits," Mark Waddell notes, "were early modern experts in transforming what could not be sensed by the eyes into something that could be seen by the mind, and thereby understood."[57] However, external pictures also played an important role in administering the production of inner mental imagery. Ignatius had suggested that one of his disciples, Jerome Nadal, illustrate the passages from the Bible that the spiritual exercises ordered its readers to visualize and meditate upon, which resulted in the 1593 publication of *Adnotationes et meditationes in Evangelia* (also known as *Evangelicae historiae imagines*), consisting of 153 engravings depicting scenes from the New Testament. Text and pictures were tightly linked in Nadal's illustrations, with legends recounting key events in the engravings and indicating memory points to serve as the basis for meditations and the mind's animations. Words to a large extent presided over pictures. The movements and flights of images were firmly positioned under the reference of the scripture, the divine *logos*. At the same time, however, what made Nadal's *Imagines* unique, according to Samuel Edgerton, "was its absolute dependence on images for meditational inspiration."[58] Pictures were given the critical task of projecting their beholders' imaginations and emotions onto scriptural events, and of serving as mediators between the sensible and the supersensible.

For the Jesuits, in other words, the capacity to create, animate, retain, and examine images held the key to the government of souls. Optical media, too, were variously employed to capture, orient, and administer the imagination's powers to project and animate the divine. Friedrich Kittler makes the important observation that the illustrations in *Ars magna lucis et umbrae* place Kircher's optical devices precisely within such a framework of administering and programming the psyche.[59] Kircher's contribution here was above all to introduce the question of technology to the old Jesuit techniques of discipline and contemplation. So strong was the force of the imagination, Kircher suggested, that it could make even the rational soul see illusions[60]—therefore, the imagination needed to be "propped up" and secured by media machines, by more or less idiosyncratic phantasy-producing apparatuses that sought to blur distinctions between images projected on the outside and those appearing from within. In a dark room, the wonder-working lamp was to conjure apparitions that reproduced key scenes from Ignatius's instructions using the

projection screen as a quasi-material, quasi-mental surface where indeed in-visible realities were contemplated as visual events. The person burning in purgatory's flames, for instance, recalls the fifth exercise of the first week, the "meditation on hell":

> *The first prelude* is the composition of place. Here it will be to see in imagina-tion the length, breadth, and depth of hell.
>
> *The second prelude* is I will ask for what I desire. Here it will be to ask for a deep awareness of the pain suffered by the damned, so that if I should forget the love of Eternal Lord, at least the fear of punishment will help me to avoid falling into sin.
>
> 1st. The first point is to see with the eye of the imagination the great fires, and the souls enveloped, as it were, in bodies of fire.
>
> 2nd. The second point is to hear the wailing, the screaming, cries, and blasphemies against Christ our Lord and all His saints.[61]

Souls burning in purgatory provided also a valuable visual trope in the sermons of Jesuit preachers. Giovanni Pietro Pinamonti's devotional publi-cation originally from the 1680s, *L'inferno aperto al Cristiano* ("Hell opened to Christians"), which was composed like a printed sermon, evoked similar imagery to Ignatius's meditational exercise in an attempt to allow its read-ers visualize the Inferno. The 1693 edition of the book even included a vivid engraving of a body burning in flames (Figure 22), with close resemblance with the magic lantern's projection in Kircher's second edition of *Ars magna lucis et umbrae* (see Figure 21).[62] The latter, as this haphazard but nonetheless telling figural coincidence suggests, grew out of a specific pedagogic economy of images. Like preached exercises of the imagination, Kircher's slide designs were meant to light the fires in their beholders, burning their skin and their bones. In this purpose, the magic lantern could in principle revive any scene from Ignatius's scrapbook of imaginings, not just "souls enveloped in bod-ies of fire." Such was the task of Kircher's catoptric devices in general. Seeing Christ ascending in mid-air in the cylindrical anamorphic device approxi-mated hallucinating the event in solitary confinement. Different scenes on the slide disk of the parastatic microscope replicated the contents of the third week of the exercises, focused on visualizing the Passion. More than a mere aid of visualization, the archaic movie-machine was to perform a particular examination of what one desires to feel and to be affected by: "In the Passion the proper thing to ask for is suffering with Christ suffering, a broken heart

FIGURE 22 "The pain of damnation."
Illustration from Giovanni Pietro Pina-
monti's *L'inferno aperto al Cristiano*,
1693. Sheet between pages 60 and 61.
Source: Bayerische Staatsbibliothek
München, Asc. 3783.

with Christ heartbroken, and inner pain because of the great pain the Christ
endured for me."[63] We learn how the primary task of Kircher's optical inven-
tions was to fill "the spirit with images," to quote Barthes, to "inject images"
into the "dull, dry and empty spirit," and so seize the beholder's imaginary in
both form and content.[64]

The magic lantern's projections were "parastatic" in the sense that they
made a virtual reality (a reality lacking extension and materiality) tangible
to the senses. In their ambiguity, they were, in Kircher's words, "frighten-
ing" (*formidanda*) and "prodigious" (*prodigiosa*).[65] In Kircher's vocabulary,
"frightening" did not designate psychophysical interiority—that is to say, a
subjective feeling. The inner space of affects, we are told, was not in Kircher's

thought separated from the world by a person's skin but porous and pierced by influences from the divine cosmos.[66] Affects were media through which the divine power could enter into individual souls—and the fear of God, in particular, was instrumental to the salvation of souls from misconduct. It is important to understand Kircher's magic lantern in this context: Its beholders were to enter a dark realm of projections, the origins of which were inexplicable and seemingly miraculous, and which, owing already to their very inexplicable nature, generated fear and anxiety in their beholders, thereby preparing individuals to enter a scriptural order and reach toward the Holy Word, or the divine light.[67]

The Governing Hand

Some contemporaries responded with a mixture of both fear and ridicule to the Jesuit order's optical inventions, which claimed to be capable of plugging one's soul into an apparatus. An obscure fictional memoir written for a popular audience (sometimes attributed to a certain Abbé Jean Olivier), published in French in 1708 and a year later as an English translation, contains a scene where the protagonist Signor Rozelli, known for his collection of curiosities among the locals in Utrecht, shows a magic lantern to an unnamed duchess. He introduces the lantern briefly, but significantly, as one of the "artifices made use of by the popish priests, to terrify the common people," before he conjures the device out of his pocket:

> I pull'd out my magical lantern, and having lighted the candle, the chamber was immediately fill'd with monsters; which so frightened the duchess, that she was about to run away. As soon as I perceiv'd her fright, I assur'd her, that she need not fear any thing; for, all that she saw, was done by meer trick: and, to convince her of the truth of what I said, I open'd my lantern, and shew'd her the whole invention.[68]

It is unknown the extent to which the Catholic clergy actually took advantage of the magic lantern in their proselytizing efforts, but the symbolic import of this scenario is noticeable. In order to set oneself free of the apparatus's terrifying visions, and by extension the influence of "popish priests," a gesture of disillusionment was needed: the opening up of the black box and consequent profaning of its effects. A Dutch engraving from 1701 (Figure 23) was designed for a similar iconoclastic exposure. The engraving shows the

King of Spain, Charles II, on his deathbed (he died in 1700 at the age of 39), accompanied by Cardinal Louis Manuel Fernández de Portocarrero, member of the Council of State, who is wearing a Jesuit hat, and a monk, the king's confessor, who operates a magic lantern hidden from the king behind the head of the bed.[69] While the cardinal mimics a magician's performance, the king raises his head anxiously in response to the projection of an angel holding the cardinal's hat, the king's crown, a scepter, and an order of the Golden Fleece positioned under the hat. The illustration is a title page to a satirical pamphlet, which relates how the cardinal subjected the king to an hour-long magic lantern show in the middle of the night, with the aim of influencing the king's decision about who should inherit the throne of the Spanish empire. Suddenly, an image of his father, Philip IV of Spain, appeared in front Charles II's eyes, like a spirit, growing bigger and bigger. Then the figure of death, then some soldiers, monsters, and the devil, until the show ended with the apparition of an angel, and the cardinal freed the king from these visions

FIGURE 23 Charles II of Spain on his deathbed. Vignette to *De Toverlantaaren* ("The Magic Lantern"), pamphlet no. 2 in the series entitled "Esopus in Europa." Engraving by Romeyn de Hooghe, 1701.

Courtesy of Rijksmuseum, Amsterdam.

with a prayer. The contents of the cardinal's lantern spectacle could have been copied, almost verbatim, from the optical treatises of the Jesuits, especially the sections in Kircher's *Ars magna lucis et umbrae* that envisioned projection screens as a semi-material, semi-spiritual folds where the object world came into contact with, and became twisted and shaped by, the creatures of our most intimate nightmares.

Such critical reflections sought to lay bare the Jesuits' optical media as instruments for the government of souls. One should simultaneously note, however, that, although born in the Collegio Romano's eclectic culture of experimentation fused with the Society of Jesus's scholarly as well as pros- elytizing pursuits, the machinations conjured by the Jesuit scholars were not entirely idiosyncratic in their own times. As a final case in point, let us have a look at a small booklet published in Jena in 1713, bearing the Latin title *Novum et curiosum laternae magicae augmentum* ("New and curious augmentation of the magic lantern"), which described the then relatively new innovation of movable magic lantern glass slides. The author of the text remains unclear; the title page identifies the booklet as a dissertation by Samuel Johannes Rhanaeus, a student (of Latvian origin) at the University of Jena, submitted "under the presidency" of Bonifacius Heinrich Ehrenberger, who was at the time assistant professor of philosophy. But, as was common practice during the period, dissertations that were not doctoral theses could be mere tran- scripts of professors' lectures scribed by the student by command, or even written by the professor himself and handed over to the student to be de- fended publicly.[70] Whoever its maker, the tract describes innovations with slide mechanisms, which in the context of the University of Jena had been carried out since the last decade of the seventeenth century, with indirect influence from Christiaan Huygens himself.[71] The reader is given a detailed visualization of moving slide mechanisms contrived for a Griendel-type lan- tern (Figure 24) and descriptions of ten different designs for slide paintings.

"On the white wall," the tract tells us, "we project":

1. The three main vices of mankind rising out of hell as out of the under- world and, when the projectionist decides, returning to their home while hell remains unmoved, as long as it pleases him.

2. Christ rising out of his sepulchre and ascending to heaven, leaving behind the sepulchre and the guards beside it.

FIGURE 24 Moving magic lantern slide mechanisms. Illustration from *Novum et curiosum laternae magicae augmentum,* 1713. Engraving by Samuel Johannes Rhanaeus.

Source: Staatliche Bibliothek Regensburg, 999/Philos.3117.

3. A windmill with arms rotating in the wind while the mill stays still. Like the foregoing, this spectacle stimulates the admiration of the spectators.

4. A hand coming from heaven out of the skies, with the name of His Highness the Sovereign written on it.

5. An apocalyptic animal rises out of the sea and stands on the beach. Like the preceding and nearly all the following, it is presented by the hand of the artist.[72]

Nearly half the slides were about biblical themes, and half were profane illustrations including "a woman curtseying in a way typical of the weaker sex."[73] The religious themes set the Jena scholars' innovations apart from other contemporary (and still surviving) mechanical movable slide designs, such as those of the Dutch scientist Pieter van Musschenbroek from the 1730s (depicting windmills with rotating arms, trapezists, and even erotic scenes).[74]

Ehrenberger's and his student's interest focused partly on the animation of the Christian imaginary as an orchestrated spectacle of moving images—even if one might assume that experiments of this kind would have been more fitting within the Catholic parts of the Holy Roman Empire than Jena, which was a firm stronghold of Lutheran Protestantism. Luther's program of reformation, concerning the meaning and status of images in religious practice, was nonetheless not as radical as the competing French reformist John Calvin's, who proclaimed that individual souls needed to be purged of all sorts of "phantoms and delusive shows," such as murals, paintings, relics, sculptures, and imposing ceremonies.[75] In the Lutheran baroque, church walls were by no means simply whitewashed; images rather served a complex of functions that could be confessional, devotional just as well as "magnificent," seeking to captivate, as Bridget Heal points out, "Christian's heart and minds through their eyes as well as through their ears."[76]

Ehrenberger seems to have studied optical effects of various types in order to beguile eyes and minds and lectured, among other things, on "catoptric deceptions" in the 1740s (when he was professor in mathematics and metaphysics at the Academic High School in Coburg), covering topics such as anamorphic projection and illusions produced by means of mirrors.[77] His studies were firmly situated within the tradition of Jesuit scholarship on optical media. For example, the objective of animating Christ's ascension to heaven by means of an elaborate mechanics of cogwheels, rods, and slides replicated the key objectives of Kircher's parastatic art purposed to render

scriptural events as quasi-miraculous apparitions. Essential to the Jena schol-
ar's innovations was how they associated projected images with a providential
economy of faith. The appearance of God's hand as a moving projected image
was a direct reference to the Psalms, for instance, where we read: "Now I
know that the LORD saveth his anointed; he will hear him from his holy
heaven with the saving strength of his right hand."[78] God watches and guards
over his flock; those in his faith can trust their lives are governed with care—
"casting all your care upon him; for he careth for you."[79]

It might be apt in this context to also cite the *Heidelberg Catechism*, from
1563, that discusses precisely the "saving strength" of God's hand:

> Q. What do you understand by the providence of God?
>
> A. God's providence is his almighty and ever present power, whereby, as with
> his hand, he still upholds heaven and earth with all creatures, and so gov-
> erns them that leaf and blade, rain and drought, fruitful and barren years,
> food and drink, health and sickness, riches and poverty, indeed, all things
> come not by chance, but by his fatherly hand.[80]

The catechism raises the issue of immanence and transcendence in divine gov-
ernment, God's potential presence in every individual soul and occurrence,
yet his transcendent nature above all creation. It is precisely this withdrawing
virtual presence that Ehrenberger's and Rhanaeus's movable slide wanted to
ascertain, as the inscription "His Highness the Sovereign" doubly affirms. The
Jena scholars wanted to place the products of their new media apparatus within
the same register as the Jesuits' parastatic machines. Ehrenberger's and Rhanae-
us's magic lantern, a curious passage in the tract tells us, could even make angels
and specters appear to have a visible body or shape.[81] Just like the magic lan-
tern's projections, angels and specters came about by the movements of rays of
light in the ether and affected the eye; variations of color and shadow gave such
ghostly beings visible presence. And just like projected images, Ehrenberger
and Rhanaeus mused, these specters couldn't be touched, because they did
not have a body. They were ephemeral animated shadows, occurring spontane-
ously in the ether and causing visions. The Jena scholars thus approached the
magic lantern's new visual forms by comparing them with spectral or angelic
apparitions, and they simultaneously explained how such apparitions occurred
according to the projection apparatus's operating principles.

Since such appearances were divorced from the direct materiality of touch,
and consequently from one's experience of one's own body, they seemed to be

coming from nowhere, as if on their own accord, as signs of God's inexplicable workings. In the magic lantern's dark exhibition chambers, "one watched the images come and go without producing them in oneself. Never before had pictures come into existence without the participation of a human subject," as Hans Belting aptly encapsulates the apparatus's phenomenology.[82] The appearance and movement of figures on a screen was, in this sense, not guided by a human hand but by "his fatherly hand," projections equaling providential signs in their apparent mediation of transcendence in the world of mortals. Projected images could signal the presence of God in the everyday; their appearance could remind us about the divine design we were all part of; and they could bring about a psychic economy of care—the government of souls—whereby each individual soul could be folded into the flock.

Coda: "Ghostly Figures"

Sor Juana Inés de la Cruz, a Mexican nun and poet of Creole origin, who lived her life at the convent of St. Joseph in Mexico City, must have closely perused the pages discussing the magic lantern and other catoptric devices in Kircher's *Ars magna lucis et umbrae*, before she penned her major poem entitled in Spanish as "Primero Sueño" (which can be translated as either "First Dream" or "First I Dream") in the early 1680s. We know that she held a copy of *Ars magna* at her private library, provided probably by Francisco Ximénez, Kircher's old friend, who played an important role as mediator between the Jesuit master and the community of Mexican scholars following his teachings.[83] Quite likely she had also seen the magic lantern in operation—or even had one within her collection of scientific instruments, musical instruments, paintings, and other curiosities at the convent[84]—so vividly did she describe the smoke coming out of the device and its projections flickering in candle light:

> And from the Brain, thus liberated,
> the ghostly figures fled
> and, as if composed of misty vapors
> or blown away like wind or smoke,
> forms dissipated.
> In this same way, the magic lantern throws
> on a white wall
> the contours of delineated figures
> in thrall as much to shadow as to light,

trembling reflections maintained by guarding
a proper distance
according to the precepts of perspective
and precise measurements
derived from various experiments:
this fleeting shadow
dissolved by day's illumination
feigns solid form
as if adorned with all dimensions
though not deserving claim even to one.[85]

The Viceroyalty of New Spain, as we saw in the previous chapter, provided a fertile symbolic testing ground for new media of projection circa 1700. Kircher traded optical instruments with New World scholars, and his concepts were used to articulate the church's providential—or, otherwise put, spiritual and colonial—program of expansion as a system of divine projection. In this context, Sor Juana stood out in the way she mobilized the magic lantern as a technology of ephemeral, semi-hallucinatory appearances in her quest for epistemic revelation, a cosmic vision. The protagonist of "Primero Sueño" is an entity called the soul, who falls asleep upon nightfall and begins to fabricate imaginings of its own making. Thereby, a spiritual journey begins. "Freed from governing the senses," as Sor Juana writes, the soul travels through the cosmos, ascending from the mineral and the natural realms to celestial spheres, striving to reach the apex of the pyramid of wisdom where the human and the divine are meant to merge. Sor Juana describes the soul's journey as the fantasy's production of mental imagery, or *simulacra*. Using her "fictive brush," the imagination, Sor Juana writes, composes "images of all being" and brings the universe to the reach of the intellect in "brilliant colors"—just like the "glossy surface" of the "mirror of Pharos" reflects "farthest distances."[86]

The "mirror of Pharos" suggests the legendary lighthouse of Alexandria, which had a miraculous mirror that could reflect ships sailing beyond the horizon line—yet it could just as well indicate the concave mirror that intensifies light inside a magic lantern. Neither surface merely mirrored reality in terms of reproducing empirical information, but rather both stood as intermediaries, like the imagination did, according to Sor Juana, between the spiritual and the sensible. For Sor Juana, the imagination in fact worked "more freely

and less encumbered" during sleep, "collating with greater clarity and calm" the different images (*especies*) gathered during the day.[87] The imagination's task was ideally to guide reason to comprehend the unity and harmony of the universe, disclosing the "hidden links that were placed in this universal chain by the wisdom of their Author."[88] All things in the universe, Sor Juana had learned from Kircher, were connected with one another by forces of attraction, and all things issued "from God, who is at once the center and the circumference from which and in which all lines begin and end."[89] The soul's nocturnal journey was purposed to reach the "circle joining Heaven and Earth" where "Man, through loving Union," could "join with the Divine."[90]

Sor Juana's intuition, however, was simultaneously imbued with a fledgling skepticism about the powers of the intellect in reaching this goal. The soul could be "dazed by the enormity of all that lay before her eyes." The imagination was only able to sketch the "disorienting chaos of the confusing images" of the universe's "innate variety" and diversity, which the mind was "far too small" to contain. There was something terrifying about the thought of infinity—the divine circle—that forcefully reminded Sor Juana about the "limitations of human intellect" when facing the complexity of being.[91] In "Primero Sueño," the magic lantern was brought to bear on this skeptical perception. The apparatus embodied the soul about to wake up, still half asleep, soon to become trapped in corporeal life again. The brain's *simulacra*, which were designed to guide the reason toward divine wisdom, escaped like the "fleeting shadows" emanating from the magic lantern's cavern and disappeared into thin air. Half corporeal, half spiritual, these projected images did not have the power to guide the soul toward heavenly illumination; the universe rather slipped away from attempts at holding it in an image, "dissolved by day's illumination." The magic lantern was therefore accompanied by a particular experience of non-revelation at which the dream one was immersed in, instead of reaching its apex, began to obstinately unravel and lose its epistemic and theological gravity. This was an experience of fundamental disillusionment and doubt, based on the uneasy feeling that the visions that only a moment ago were to lift one's soul toward heavenly truths were nothing but the imagination's ghostly projections—indeed, merely just a dream.

Sor Juana's "Primero Sueño" put forward a saliently modern experience associated with the magic lantern where the world's organization in thought started to lose its traditional supports—its providential guidance, one could

argue. The Mexican nun's cosmic vision did not simply lend itself to harmony and organization but was disturbed by difference and variation, ending up with the soul losing control of the colorful but ephemeral images fluttering about in its obscure inside. Here, Sor Juana suggested a fundamental metaphysical dilemma inherent in any act of "parastatic magic" (a dilemma, as we will see in Chapter 5, that gained particular purchase in addressing the epistemic challenges posed by the nascent financial capitalism a couple of decades later): Were these visions indeed true miracles, or mere tricks?

PROJECTING PROPERTY

The Birth of *Picturae*

August 19, 1666: The English naval administrator and diarist Samuel Pepys spent the day with Richard Reeves and John Spong, makers of scientific instruments, exploring the latest optical gadgets Reeves had brought over to Pepys's house. Reeves was a prominent glass grinder who had a shop in Long Acre in London; he supplied many of the fellows of the Royal Society of London for Improving Natural Knowledge, Pepys among them, with instruments of empirical investigation. Reeves initiated Pepys into a variety of optical experiments. They studied how "the rays of light . . . cut one another" by means of a "frame" (most likely a prism of sorts) "in a darke room with smoake." With a "twelve-foote glasse," they inspected "Jupiter and his girdle and satellites," wondering "why the fixed stars do not rise and set at the same houre all the yeare long."[1] Pepys, even if not a scholar himself, showed considerable interest in the study of natural phenomena as well as in the vision machines contrived for that purpose. Already in 1664, Reeves had sold a microscope to Pepys, "the best in the world." In February 1666, Pepys had discussed instruments for drawing with his Royal Society fellow Robert Hooke at Gresham College. An eminent natural philosopher famous for his work on optical instruments and the study of light, among many other things, Hooke advised that a "darke roome," a camera obscura, was most fitting for the purpose.[2] And among the gadgets Reeves brought to Pepys on that Sunday in 1666 was

also "a lanthorne with pictures in glasse," which was devised to "make strange things appear on a wall." The magic lantern, Pepys noted three days later, when he and Reeves tested it again, was indeed designed to "show tricks."[3]

No longer did these tricks come across as hermeneutic riddles alluding to God's hidden presence within things and beings: They were just optical effects toying with the eye and its makeup. Pepys's diary chronicles a secularly conceived collection of new optical media of the later seventeenth century brought together into a kind of private cabinet of curiosities. The apparatuses were, in Pepys's words, "curious curiosities" that the virtuoso collected into a repository of display and delight.[4] His interests were closely aligned with the pursuits of the Royal Society, which was in the vanguard of experimenting with new technology alongside new scientific methods in England during the period, and perhaps even in the whole of Europe. On June 9, 1670, John Evelyn, Pepys's friend and a fellow member of the Royal Society, noted in his diary: "There was this day produced in the R[oyal] Society, an invention by intromitting the Species into a large dark box, to take the profile of ones face as big as the life; which it did perform very accurately."[5] Evelyn was referring to the demonstration of a camera obscura designed to function as a drawing and painting aid by Robert Hooke, who throughout his career worked closely with instrument makers, Richard Reeve among them, to improve the device. Hooke had trialed several versions of a camera obscura purposed as a drawing aid in the spring and summer of 1670, improving his initial design so that the sights projected wouldn't be inverted at the expense of their brightness.[6]

Evelyn's choice of words to explain Hooke's contrivance is noteworthy. To "intromit," Samuel Johnson's dictionary of English tells us, means to "allow to enter; to be the medium by which any thing enters."[7] And what the camera obscura allows to enter through the pinhole, we read in Evelyn's diary, are "species"—something that Johnson's dictionary characterizes, among other things, as "appearance to the senses," "visible or sensible representation," or "representation to the mind."[8] Evelyn, to be sure, was not alone in using the term in conjunction with Hooke's camera obscura; for instance, Richard Waller, the editor of Hooke's posthumous works, wrote how the scientist introduced "the Species into a dark Room for Painting, and contriv'd a Box for that purpose."[9] The term, we recall, originated in medieval perspectivist optics where the status of *species*—not quite material, not quite spiritual—was

difficult to pin down.[10] They even carried "intentions," which communicated an object's characteristics to conceptual understanding.[11]

Even in Evelyn's and Pepys's times, however, the concept was already becoming outdated. While *species*, as we saw in Chapter 2, held sway in contemporary accounts of the emanation of the divine in optical apparatuses by Jesuit scholars, the concept's powers of explanation were waning. Among others, René Descartes ridiculed and rejected "all those small images flitting through the air, called *intentional species,* which worry the imagination of Philosophers so much."[12] Descartes insisted that images in the brain did not resemble the external world. Here, he was drawing on the important new ideas about optics and visual perception proposed by the German astronomer and mathematician Johannes Kepler, who worked in Rudolph II's imperial court in Prague at the turn of the sixteenth century[13]—ideas that were born out of experiments with the camera obscura.

Like Alhazen more than half a century before him, Kepler employed the camera obscura in the study of optics, in addition to the astronomical mapping of the heavens. In a key passage from his 1604 work in optics, *Ad Vitellionem paralipomena* (Paralipomena to Witelo[14]), Kepler reports about examining a camera obscura in Dresden:

> A disk thicker in the middle, or a crystalline lens, a foot in diameter, was standing at the entrance of a closed chamber against a little window, which was the only thing that was open, slanted a little to the right. Thus when the eyesight travelled through the dark emptiness, it also, fortuitously, hit upon the place of the image, nearer, in fact, than the lens. And so since the lens was weakly illuminated, it did not particularly attract the eyes.[15]

The experiment took place, Kepler tells us, in the "Elector's theatre of artifices," a *Kunstkammer* (cabinet of curiosities) that was housed in seven rooms within the Palace of Dresden, an abundant collection of mathematical instruments as well as tools from different trades and crafts. One of the rooms had been turned into a camera obscura with a lens placed in an aperture in the wall through which light was able to enter the dark chamber. There Kepler witnessed images being formed in "mid-air":

> But the little window and the objects standing about it, which had the benefit of much light, lying hidden beyond the lens, set up a bright image of them-

selves in the air (between me and the lens). And so at first glance I perceived this aerial image, but with repeated gazing, gradually less and less.

Such images might not have been purely the intent of the experiment, however, as Kepler notes: "But what I, steeped in demonstrations, stated that I had seen, the others denied. I therefore attribute it, not to the overseer's intent, but to chance."[16]

It was such coincidental apparitions—part of what Sven Dupré argues were ludic experiments in the dark room, conceived as something that had epistemic weight but didn't need to work as "proof" in any strict sense—that gave Kepler the motive to rewrite the very concepts of image and vision. The "experiment" in the dark room, Dupré notes, "allowed Kepler to contextualize projected images . . . in a new theory of optical imagery."[17] Notably, what Kepler witnessed in the camera obscura gave rise to a new concept of the picture (*pictura*) as the replica or, better yet, the trace of objects projected onto a screen—a concept that Kepler introduced in *Ad Vitellionem paralipomena* so as to challenge medieval perspectivist theories revolving around the concept of *species*.[18] Kepler's gesture was to rid optical theory of ontological speculation on the emanation of likenesses in favor of a geometrical account, which was based on the premise that light was the only agent of optical phenomena—a point that was taken up a couple of decades later by the Jesuit scholar Christoph Scheiner, who also drew a potent analogue between the eye and the camera obscura's operating principles.[19] For Kepler, images were products of light, including images on the retina. "Since hitherto an Image [*imago*] has been a Being of the reason, now let the figures of objects that really exist on paper or upon another surface be called pictures [*picturae*]," Kepler wrote, making an important distinction between *pictura*, a projected image that "really exists," and *imago*, an image existing in the mind; between optics and psychology, or the material and the mental image (which the Scholastics' *species* had confounded). The *imago*, in Kepler's words, was "practically nothing in itself, and should rather be called imagination." Kepler described in detail how light rays project an inverted image on the retina (understood as a kind of projection screen) but refrained from arguing anything about what happens when this image meets "the tribunal of the soul or the visual faculty," which was a matter he wanted to leave to "the natural philosophers."[20]

Kepler's distinction between *pictura* and *imago*, as Svetlana Alpers emphasizes, "deanthropomorphized vision."[21] The retinal picture, like any projected image, was a causal effect of light and had in principle nothing to do with how

the world became eventually interpreted and judged. An autonomous "what-ness," it was the result of the propagation and projection of light rays onto the (retinal) screen according to physical laws, which could be described math-ematically. Conceptually, medieval *species* gave way to projected pictures and the mathematization of being, which presented "the first genuine instance in the history of visual theory of a real optical image within the eye," according to David C. Lindberg. Retinal images were modeled on the dark room's oper-ating principle, as Lindberg observes: "An inverted picture is painted on the retina, as on the back of the *camera obscura*, reproducing all the visual features of the scene before the eye."[22] For Kepler, indeed, the eye was basically a cam-era obscura, and vice versa, and both were "screens" on which the accidental effects of purely causal processes were inscribed.[23]

Kepler's invention of *pictura*, and his refusal to assert anything about what happens when a picture meets "the tribunal of the soul," attested to a na-scent separation between the objective and the subjective. On the one hand, Kepler's distinction between *pictura* and *imago* found its epistemological ful-filment in Descartes's skeptical anxiety about the trustworthiness of vision, which radically questioned the connection between the eye of the mind and the eye of the flesh, between mental images and visual perception.[24] On the other hand, *pictura* also served as basis for an emerging concept and practice of scientific observation, an emerging sensibility of "objectivity" (for want of a less anachronistic term), which was based on the ideal of witnessing the world as its own trace untainted by the human observer's interpretations. Raz Chen-Morris observes how a new kind of "visual economy" emerged from Kepler's rewriting of optics where instruments of observation were made to reduce physical phenomena to "insubstantial, yet perfectly measur-able shadows and stains of light"—an economy that, Chen-Morris adds, was "fully played out within the camera obscura, where instead of focusing on the contact between the corporeal visible object and the eye, the observer con-centrates on shadows as the embodiment of imaginary mathematical entities artificially produced by the instrument."[25]

This visual economy pertaining to the geometrical regularity of phe-nomena became palpable in Kepler's own use of the camera obscura for the world's reproduction in pictures, as reported by the British ambassador Sir Henry Wotton in a letter from December 1620. Wotton visited Kepler at his home in Linz and was fascinated by a landscape drawing he saw in Kepler's

study. To Wotton's query about how he had made it, Kepler replied: *"Non tanquam pictor, sed tanquam Mathematicus"* ("not as a painter but as a mathematician"). The secret behind the drawing, Kepler explained, was a portable camera obscura. "He hath a little black Tent," Wotton wrote:

> which he can suddenly set up where he will in a Field, and it is convertible (like a Wind-Mill) to Quarters at Pleasure, capable of not much more than one Man, as I conceive, and perhaps at no great ease; exactly close and dark, save at one hole, about an Inch and a half in the *Diameter*, to which he applies a long perspective Trunk, with a Convex glass fitted to the said hole, and the concave taken out at the other end, which extendeth to about the middle of this erected Tent, through which the visible Radiations of all the Objects without, are intromitted, falling upon a Paper, which is accommodated to receive them, and so he traceth them with his Pen in their natural Appearance, turning his little Tent round by Degrees, till he hath designed the whole Aspect of the Field.[26]

Kepler did likely make more than one sketch of the landscape, crouching uncomfortably in his dark rotating tent, to attain a comprehensive view of the field. Instead of relying on direct perceptual contact and what one might want to designate as artistic skill, the scientist insisted on staring at mechanical *picturae* projected inside the tent onto a screen, which he meticulously traced onto a sheet of (most likely oiled) paper with his pen. Kepler, in his own words, didn't consider himself a painter but a mathematician—in this case, someone who merely operated with causal effects of light, with what struck Wotton as "natural Appearances" as effects of "visible Radiations." The world's visual interpretation by the naked eye was taken over by what Kepler in the subtitle of *Ad Vitellionem paralipomena* called "technically sound observations" (*artificiosa observationes*). As Chen-Morris emphasizes, "Keplerian optics would prefer indirect visual experience of shadows and virtual images over direct experience of tangible entities."[27] The draughtman's vision was replaced by an optical system, interpretation by the recording of visual facts, actual objects by their shadows.

Wotton's letter was written to Francis Bacon, chief proponent of experimental science in England. The ambassador wanted to relate the story about Kepler's rotating camera obscura, because he saw it as fitting with Bacon's general interest in "Philosophical Experiments."[28] As is well known, Bacon's "new science" emphasized the importance of observation and sense data in

extracting "facts" from the world. Such facts were by no means unambiguous, and they often concerned singular cases—what appeared as wondrous and miraculous. Yet their main thrust was to challenge explanations of nature refracted through the lens of theoretical suppositions relying on Aristotelian metaphysics.[29] The systematic collection and weighing of facts were above all to be disentangled from abstract notions, interpretations, and opinions: "fictions of the imagination" to be "removed and separated from the evidence of facts," as Bacon put it in *Novum Organum*, published in 1620. Bacon promoted an inductive method that "should separate by proper rejections and exclusions, and then conclude for the affirmative, after collecting a sufficient number of negatives." This method dealt with facts that arose out of "chance and opportunity," Bacon wrote, "of a nature most heterogenous, and remote from what was hitherto known."[30]

For Wotton, Kepler's tent-model camera obscura clearly spoke to this sensibility of the factual, a sensibility that strove to generate perceptual order immanently out of the random flux of experience, by embracing the contingent *qua* contingent. In this sense, Kepler's camera obscura, as reported by Wotton, made reality legible in a rather different way from Kircher's dark room we encountered in Chapter 2 (see Figure 12): Both opened up "nature," but whereas the latter's figurations were actualizations of the plastic power (*virtus plastica*) that executed the divine architect's pre-established plan in the generation of shapes and forms, the former was devised to be an observational apparatus for discovering facts emerging from "chance and opportunity." The *picturae* projected inside the device were matters of fact arising out of multiple and contingent refractions, reflections, and intersections of light rays. They were natural creations plain and simple, which didn't allude to a deeper reality behind their surface; that deeper reality was rather the domain of *imagines*, or the imagination, which now started to become divorced from the visible.

By associating Bacon's yearning for facts with Kepler's concept of techno-visual observation, Wotton anticipated what was to take place during the latter half of the seventeenth century among the pursuits of scholars gathered around the Royal Society of London. The Royal Society famously took up and developed Bacon's experimental program and positioned the imperative of data collecting—observed particulars ideally divorced from interpretation and bias—at the heart of its rationale. Thomas Sprat, in his *History of the Royal*

Society from 1667, described "collecting divers patterns of all *Natural*, and *Artificial* things" as the society's main purpose, with the aim of penetrating "the naked and uninterested Truth."[31] Camera obscuras were the ideal instruments of visualization in this purpose, given how they promised to bring the empirical world directly under perceptual scrutiny. The Royal Society fellow William Molyneux emphasized how in the camera obscura equipped with a convex glass, "the Eye must necessarily perceive on the Paper the lively Image of the Object, being it is affected in the same way by *This*, as by the Object itself."[32] Among those most systematically spearheading the improvement of optical instruments with the purpose of amassing visual facts about the world was Robert Hooke, who served, among other things, as the Royal Society's Curator of Experiments and was famous for his studies with the microscope, published in the best-seller *Micrographia*, from 1665. Camera obscuras, too, as noted, were among the instruments with which Hooke frequently experimented. Hooke's interest was focused on the dark room as a drawing aid in the sense that Kepler intended it: as a device for observing and recording *picturae*, or, matters of fact.[33]

The remaining parts of this chapter will explore Hooke's work on the camera obscura, which discloses an emerging sense of objectivity attached to a machinic vision supposedly untarnished by imaginations and interpretations. On the whole, Hooke's experiments with the dark room continued the Keplerian attempt for a de-anthropomorphized and mechanized mode of seeing and knowing based on (ideally measurable) projections of light and shadow. But as we will see, Hooke's imaginary of the device also extended beyond what was professed, overlapping with the colonial conquests and economic developments within the Kingdom of England at the turn of the seventeenth century. In addition to signaling changing understandings of visuality of knowledge during the period, Hooke's camera obscuras associated projected images with the kingdom's growing networks of possession, travel, and trade. What was professed as a quest for truth was also one for domination, associating optical media with "the Power of using, directing, changing, or advancing all the rest of the Creatures," to use Sprat's words.[34]

The Picture Box

On December 19, 1694, Robert Hooke presented a paper to the Royal Society, on "An Instrument of Use to Take the Draught, or Picture of Any Thing."[35] The 59-year-old "England's Leonardo" had, basically, just tweaked an ancient

invention. What he presented to his fellows—a congregation of physicians, clergymen, noblemen, academics, and businessmen—was a portable camera obscura. Hooke himself was quick to acknowledge that his invention was not exactly a "thing that [had] never been done before." Around 1670 in England, Robert Boyle, for whom Hooke had worked as an assistant during the period, had already described his "portable darkened roome," a box camera, which was equipped with an adjustable lens, and which afforded sharp projections of "Motions . . . Shapes and Colors of outward Objects" onto a sheet of paper.[36] Across the channel, Johann Zahn provided the readers of his 1685–86 book *Oculus artificialis* with a range of technical illustrations of portable camera obscuras (Figure 25).

These designs, however, were not exactly what Hooke had in mind. Instead of serving as an aid for making fine arts or as an instrument of scientific scrutiny, Hooke's invention was to gain particular advantage among "curious navigators and travelers," whom it would help to represent:

> true Forms and Shapes . . . not only of the Prospects of Countries, and Coasts, as they appear at Sea from several Distances, and several Positions; but of divers In-land Prospects of Countries, Hills, Towns, Houses, Castles, and the like; as also of any Kind of Trees, Plants, Animals, whether Birds, Beasts, Fishes, Insects; nay, of Men, Habits, Fashions, Behaviours; as also, of all Variety of Artificial Things, as, Utensils, Instruments, Engines, Ships, Boats, Carriages, Weapons of War, and any Other Thing of which accurate Representation, and Explanation, is desirable.[37]

The "picture box," as Hooke called it, would allow potentially anything to be recorded by lay artists in an appropriate manner. Hooke described how the box was meant for "tracing profiles," for "running over the outlines" of things with one's pen, indeed, for making drafts. These sketches would be available for future modifications and could later be complemented with "proper shadows and light."[38] But above all, the device was to facilitate the abstraction of the world to its outlines: It would translate complex forms—landscapes of distant locations, coastlines, basically any visible appearance on the earth—into visual "data" consisting of lines and zones.[39] Unlike the whimsical drawings and stories of excursion by sailors, merchants, and other travelers, which generally raised hills to "extravagant heights" as Hooke contended, the picture box was to allow visual information to be produced according to proper proportions and perspectives.[40]

FIGURE 25 Portable camera obscuras from Johann Zahn's *Oculus artificialis*, volume 1, 1685, page 181.

Source: Staatliche Bibliothek Regensburg, 999/Philos.3970, urn:nbn:de:bvb:12-bsb11112062–6.

We don't know if the design for a camera obscura that Hooke intro-
duced to his fellows was ever actually built and used—quite likely not. Yet
it is the imaginary of the apparatus that counts here more than its realiza-
tion, an imaginary that can be witnessed in the anonymous woodcut of the
picture box that was published posthumously by William Derham, editor of
the collection of Hooke's papers (Figure 26). The illustration's origins remain
unknown, and they quite likely have little to do with Hooke himself.[41] The
engraving presents Hooke's model of the camera obscura as a curious kind
of ergonomic design—as a not merely portable device but as a "wearable"
wooden box that could be positioned over the observer's head and shoul-
ders to facilitate drawing the sights projected inside it. This "head-mounted
display" would rotate and move with the observer like a semi-natural, even
if doubtless uncomfortable and awkward, extension of her or his body. A
draughtsman encased in the picture box surveys a seaside landscape with
hilly islands and a castle, tracing something with his pen onto a paper sup-
port. The exotic flora suggests a distant location, a faraway place indeed likely
to be observed by "curious navigators and travelers" on their excursions. The
illustration's portrayal of the picture box coincides with what Henri Wot-
ton envisioned Kepler's tent-model camera obscura could be of service to:
chorography, that is to say, the detailed description of the characteristic prop-
erties of a particular location.[42]

The imperative of Hooke's 1694 model of the camera obscura was that, by
drawing the outlines of things and beings, instead of relying merely on ver-
bal expression, one could attain "the true Form of the Thing describ'd."[43] The
echoes of Kepler's concept of *pictura* are evident in Hooke's wording: *picturae*
as naturally formed and untainted visual images unfolding for the observer's
scrutiny to allow an epistemically firm grasp of things as they "really are."

Furthermore, Hooke's words mirrored the sentiments of his Dutch
Calvinist contemporaries in whose appreciation of visual and descriptive
knowledge Kepler played a decisive role.[44] Constantijn Huygens famously
credited the perceptual naturalness and epistemic directness of the dark
room's projections ("life itself, or something more elevated," as Huygens put
it; see Chapter 2). Huygens's son, Contantijn Jr., utilized the camera obscura
in producing topographical drawings while serving with Willem III on his
campaign against the French in 1672, which emphasized images as surfaces
on which the natural world could be inscribed *qua* distributions of light and

FIGURE 26 Illustration of Robert Hooke's picture box by an anonymous artist. Woodcut published posthumously by William Derham, editor of the collection of Hooke's papers, in *Philosophical Experiments and Observations*, 1726.

the Draught of any Thing. 295

Iᴛ is, therefore, the Intereſt of all ſuch, as deſire to be rightly and truly informed for the future, to promote the Uſe and Practice of ſome ſuch Contrivance as I ſhall now deſcribe ; whereby any Perſon that can but uſe his Pen, and trace the Profile of what he ſees ready drawn for him, ſhall be able to give us the true Draught of whatever he ſees before him, that continues ſo long Time in the ſame Poſture, as while he can nimbly run over, with his Pen, the Boundaries, or Out-Lines of the Thing to be repreſented ; which

being once truly taken, 'twill not at all be difficult to add the proper Shadows and Light pertinent thereunto. By the ſame Inſtrument alſo, the Mariner may very eaſily and truly draw the Proſpect

U 4

shade (Figure 27).[45] In the vanguard of operationalizing vision for military purposes by means of optical media—including the defects and shortcomings of these media such as the blurry foreground in the drawing on the Ijssel due to the camera obscura's focus—the sketches by Huygens Jr. instantiated what Alpers calls the "art of describing," an art that wanted to arrive at epistemic certainty about appearances through attentive observation as well as by blurring "distinctions between measuring, recording, and picturing."[46] Here, the camera obscura contributed especially to reproducing uneven and varying shapes and surfaces that did not lend themselves to being traced with rulers and compasses. As the surgeon William Cheselden noted in the

FIGURE 27 Military topographic drawing by means of camera obscura. Contantijn Huygens, Jr.'s *View of the Ijssel*, 5 June 1672. Pen and ink, watercolor.
The Courtauld, London (Samuel Courtauld Trust). Photo © The Courtauld.

preface to his famous atlas of skeletons, *Osteographia* from 1733, the camera obscura aided in overcoming "difficulties of representing irregular lines, perspective, and proportion," and provided an indispensable epistemic safeguard that helped him and his engravers to correct their previous visualizations and even to discard inaccurate ones.[47]

Hooke, for one, had something similar in mind when designing the picture box. The box did grow out of the specific concerns of observing, recording, and classifying distant "matters of fact" related to the Royal Society's epistemic conquest over foreign and hitherto unexplored parts of the world. Not only people closely associated with the Royal Society but ordinary travelers, seamen, and merchants were turned into intelligence gatherers and charged with procuring reports of their journeys worldwide.[48] In addition to written reports and oral accounts extracted from returning travelers, crucial data included objects and artifacts—specimens, raw materials, and all sorts of curiosities that arrived for the naturalists' perusal in the cargo of ships returning from overseas—as well as, in some cases, drawings, even if the travelers' picture-making skills were particularly questionable.[49]

Overall, in the Royal Society's accumulation of knowledge of natural history, things, pictures, and words came together in an epistemologically vital accord.[50] Any "facts" of the parts of the world that remained to be fully explored and scrutinized were to be collected and preserved, so as to come up with "as full and compleat a Collection of all varieties of Natural Bodies as could be obtain'd," as Hooke put it in relation to the Royal Society's repository of specimens of which he was appointed to be the keeper in 1663.[51] The key aim of the society, we are told, was thereby to establish an "epistemic empire" alongside the political and economic one, an empire founded upon the empirical method of extracting knowledge, based on observation, inductive reasoning, and experimentation with nature by means of technology.[52] Joseph Glanvill's apologetic proclamation of the advantages of the new type of science spearheaded by the Royal Society disclosed the close ties between the expansion of the British empire and the development of empirical science:

> And that there is an *America* of secrets, and unknown *Peru* of Nature, whose discovery would richly advance them, is more then conjecture. Now while we either sayl by the *Land* of gross and vulgar Doctrines, or direct our Enquiries by the *Cynosure* of meer abstract *notions;* we are not likely to reach the Treasures on the other side the *Atlantick*: The directing of the World the way to which, is the noble end of true *Philosophy*.[53]

Glanvill's unrestrained enthusiasm about the "treasures," both epistemic and economic, awaiting on the other side of the Atlantic indicated how the Royal Society was operating in a world of expanding horizons. The Kingdom of England had been growing as a maritime power during the seventeenth century, and a motley group of trading companies had started to establish themselves as global powers—even if at this point, the British empire's reach over the globe was a question of interlinked island and coastal settlements rather than of centrally governed occupation of vast areas of territory.[54] During the latter half of the seventeenth century, England's re-export trade—that is, the trade of goods imported to London from the colonies in America and India and then exported from London to continental Europe—grew exponentially. Fellows of the Royal Society of London were by no means disentangled from the empire's economic pursuits. Boyle, one of its founding members, for instance, owned shares in the Hudson's Bay Company and served on the board of the English East India Company.[55] The latter was a leading financial-military complex of its times, which made extensive profits

and growth with its trade in cotton, silk, and tea and had been granted semi-sovereign privileges to autonomously acquire and rule territories with its private army.[56] Profits within the East India Company, we should note, were not made by means of traditional trade alone; the company also played an important role in the development of financial economy in England during the period, and investment in as well as speculation with the company's shares were as lucrative as actual commerce.

Upon Boyle's own account, however, it was the "desire of knowledge, not profit" that drew him to the board position at the East India Company, along with, as Boyle expounded elsewhere, the desire to propagate "the gospel among the natives."[57] Boyle crystallized how the authority of scripture, generally speaking, provided a moral foundation for the Royal Society's epistemic (and the Kingdom of England's financial and military) pursuits. For Boyle, natural philosophy obeyed as its final cause, and was thus legitimated by, God's original directions to Adam to establish an empire over the earth and its creatures. Boyle announced:

> It is recorded in the Book of Genesis, the design of God in making man was, that men should subdue the earth (as vast a globe as it is) and have dominion over the fish of the sea, and of the fowl of the air, and over the cattle, and over all the earth, and (to speak summarily) over every living thing that moveth upon the earth.[58]

This was a rather different kind of "design" from what we have encountered previously. For the Royal Society fellows, God no longer revealed himself in marvels and ambiguous signs but ruled the world through universal, rational, and empirically comprehensible laws. Francis Bacon had warned about "absurd mixture[s] of matters divine and human" in an attempt to purify natural philosophy from the influence of all sorts of "idols," including "religious and theological considerations."[59] God initially set the universe in motion, so to speak, giving it reason and purpose, but then left it for humans to scrutinize and experiment with, and to improve by means of technology. "Divine Providence," Hooke observed, "adapted every Thing to its proper Use and End," which could be known and also exploited.[60] Foucault described this general epistemic change taking place concerning the concepts of nature and providence in the latter half of the seventeenth century as the "de-governmentalization of the cosmos," summarizing it as the "unfolding of

an intelligible nature in which final causes gradually disappear and anthropo-centrism is called into question, of a world purged of its prodigies, marvels, and signs, and of a world that is laid out in terms of mathematical or classifica-tory forms of intelligibility that no longer pass through analogy and cipher."[61]

Accordingly, collecting "data," rather than deciphering every eventuality as a possible signal of divine presence, became critical for those pursuing Ad-am's task of planetary rule: the imperative to "have dominion . . . over all the earth, and over every creeping thing that creepeth upon the earth," as it reads in Genesis.[62] Following this imperative, Hooke announced how descriptions of "parts and Regions of the Earth, whether Inhabited and Cultivated, or not Habitable or unfrequented" were "highly necessary to the augmenting and perfecting of Naturall philosophy."[63] Yet how these written and oral accounts connected observation, description, and matters of fact remained a signifi-cant epistemic concern. Pivotal to the fellows of the Royal Society was where their "informants" were to travel and what was to be observed, and the proper direction and framing of the inquiries made.[64] The astronomer Lawrence Rooke, for example, produced a set of directions to "*Sea-men* going into the *East & West-Indies*, the better to capacitate them for making such observa-tions abroad."[65] Boyle, for one, urged travelers to note details of longitude and latitude, temperature, tides, currents, and the formation of plains, valleys, hills, and mountains. The particularities of flora and fauna, as well as natural resources such as minerals, metals, and stones, were important; furthermore, Boyle noted,

> there must be a careful account given of the *Inhabitants* themselves, both *Na-tives and Strangers*, that have been long settled there: And in particular their Stature, Shape, Colour, Features, Strength, Agility, Beauty (or the want of it) Complexions, Hair, Dyet, Inclinations, and Customs that seem not due to Education.[66]

Boyle anticipated what Hooke pointed out in his preface to seaman Rob-ert Knox's *Historical Relation of the Island of Ceylon* from 1681 (a book that was financed by subscribers from the East India Company and produced in cooperation with the Royal Society scholars, Hooke in particular): the prob-lem of regulating what was perceived as fact, as well as how these facts were gathered.[67] Hooke did praise that "Truth will be pleas'd" by Knox's memoirs, which were written after the seaman was released from his nineteen-year

captivity on the island, but more often than not the flights of the informants' imaginations had the tendency and power to overshadow actual states of affairs. Seamen and travelers, Hooke contended, needed instructions as to "what is pertinent and considerable, to be observ'd in their Voyages and Abodes, and how to make their Observations and keep Registers or Accounts of them."[68] Above all, at issue was the truthfulness and integrity of the observers' accounts: that the accounts were "worthy of Credit," as the secretary of the East India Company suggested in his foreword to Knox's book—a point we shall return to.

In the 1694 note on the picture box, Hooke elaborated on these particular concerns:

> I lately saw a Book containing the Prospects of all the Western Coasts of *America*; but any one, that understands Prospects, will easily discern, how rude, imperfect, and false a Representation, all such Books contain of the Places themselves: For, not to mention the Impossibilities they often represent, as the Over-hanging of Mountains for half a Mile, or a Mile, which, tho' the Mountain were made of cast Iron, were impossible to be sustain'd in such a Posture.[69]

Surely, as Hooke affirmed, imperfections in visualizations were often due to unskilled hands with little training in the "Art of Delineation" (unlike Hooke himself, who was well versed in drawing).[70] But it is possible that illustrations published in travel books were actually made by draughtsmen in England, based merely on verbal accounts, or previous imagery—such as those produced for Knox's *Historical Relation*, which seem to have been composed from a variety of sources, or the ones published in John Ogilby's *America* from 1671, which were reproduced from the Dutch original (and to which Hooke is probably referring in the above quote).[71] Such processes of mediation were unacceptable, Hooke objected, because the pictures could "misguide our Imagination, and lead us into Error, by obtruding upon us the Imaginations of a Person, possibly, more ignorant than ourselves."[72]

This is where Hooke's portable camera obscura was to perform an epistemically vital corrective operation. For Hooke, the device was to function as a mechanical eye, which, like the physiological one, received "Representations of the outward Objects very perfect," but unlike the human one, was not misguided by the mind's whims.[73] The picture box was above all to

diminish the imagination's potential for distortion by disciplining the acts of both looking and drawing, hedging against people's inabilities in visualizing and verbalizing their encounters. Hooke's 1694 design for a portable dark room should, in this sense, as Matthew C. Hunter suggests, be considered in relation to the devices of "machine-assisted drawing" that the Royal Society fellows were innovating—devices that, by programming lines of sight and mechanizing the user's hand movements, helped schematize the world into grids and outlines.[74] "Operative and Mechanick Knowledge" could only be achieved by "a sincere Hand and a faithful Eye," as Hooke put it in the preface to *Micrographia*—something that the machine was to facilitate, offering "remedy" for the "dangers in the process of humane Reason."[75] In other words, the picture box was purposed to regulate and standardize knowledge production, by controlling what and how one was able to see, imagine, and draw.

Enclosures

On September 22, 1683, a few months before Robert Knox was to sail off to Madagascar to deliver a shipload of enslaved people to St. Helena in the service of the East India Company, Hooke noted in his diary that he was "to present Capn Knox a perspective. A picture box, an azimuth perspective [and] a longitude clock."[76] The latter two were instruments of surveying and navigation, while the "picture box" in question was quite likely a version of a portable camera obscura designed to be used as a drawing aid—something that Hooke had developed and presented to the Royal Society in the early summer of 1670, adjusting the device's design to his fellows' suggestions over the course of a few trials.[77] The final model of the "darkened box," we read in the minutes, was deemed "proper for the hand to draw a picture conveniently by a metalline speculum and a moveable bottom, whereby the picture appeared both erect and direct."[78] At the turn of 1683–84, a box assumedly of this kind was to join devices of mapping and delineation on a long journey overseas purposed for the accumulation of both information and capital, contributing thus to an emerging infrastructure of colonial trade, occupation, and violence.

The message from Hooke to Knox seems to have been that visualization was to be taken seriously during Knox's adventures; its epistemic value was guaranteed by optical projections capable of restraining the mishaps and flights of "Mr. Engraver's fancy" (as Hooke put it in relation to his 1694

camera obscura model).[79] The point of departure for systematizing seeing and knowing (and, by extension, capital accumulation) was a reality projected on a screen instead of the reality opening up to so-called natural perception—a mechanically "objective" reality in the sense of being ideally "unmarked by prejudice or skill, fantasy or judgment," to paraphrase Lorraine Daston and Peter Galison.[80] The screen itself was, in appearance, nothing complicated: a translucent waxed paper surface on which the observer witnessed the world becoming its own image. Like in any dark chamber, these images were born of light and shadow going through lenses, bouncing off mirrors (if any), and shrinking or expanding on conical paths. We should recall that the camera obscura's projections were dynamic and "live" instead of being static, made of "Motions, Changes, and Actions," as Hooke emphasized.[81] A dark environment would be necessary for these moving pictures to become visible. What the apparatus necessitated was a strict separation between the system and the environment in terms of levels of ambient light and dark. Thereby, the projective screen came to impose itself between the observer and the environment. The screen, or *tabula*, as it was called in the seventeenth century, turned the world into a flat, two-dimensional plane.[82] It rendered the environment as projected images, which embodied the outside as a virtual reality inside the machine—"virtual" because the images were deprived of physical existence but possessed full color, form, and motion in appearance. Or, more exactly, the screen facilitated the production of *hybrid images* that blended semi-automatic projections with drawings and paintings made by human hand.[83]

The screen of Hooke's picture box, as Sean Silver describes it, was "the critical thing, serving, like a slash, as the figure for separating then linking subject and object, thinker and thought"—a surface on which the observable realm of things and processes interfaced with the mind's desire for knowledge as well as the imperative to shape and improve.[84] The screen provided an auxiliary perceptual and cognitive mechanism by means of which the world could be outlined, surveyed, and designed—a mechanism akin to a grid that discloses things and beings by abstracting, systematizing, and operationalizing them according to a coordinated framework. In Hooke's times, to be sure, several other *tabulae* carried out similar operational as well as epistemic roles, among them, most crucially, cartographic pictures. The Renaissance resuscitation of the cartographic projections developed by Claudius Ptolemy was, as known, imperative to Europe's colonization of the globe. The expansion

of empires overseas relied on the projection of the earth's spherical volume onto a flat surface and the introduction of the geometrical grid of meridians and parallels. Now, the surface of the earth could be graphically coded— gridded, structured, and schematized—under a disembodied gaze, which combined human, earthly agency with a panoptic overlook. Gone were the days of medieval *mappae mundi*, which represented a symbolic universe based on mythical and biblical narratives; what emerged instead were "planetary projections," even if unfinished and incomplete, that sought to conquer the unknown and the undiscovered in *this* world rather than reaching toward a heavenly beyond.[85] Mapmaking hence fulfilled an imaginary of expansion whereby the earth could be spread out, within the projected image, like a surface to be occupied. With their grids and schemas, modern maps rendered territories as "suitable for administrative operations, for control, for management, for fiscal and economic planning."[86] They would serve not only as aids for navigation, but as graphic inventories of, say, flora and fauna or native inhabitants, in addition to marking the boundaries of property.

Should we consider the projective screen of Hooke's picture box in similar terms, as extending, like cartographic projections, toward possession through visualization? Did "projective" here mean "possessive" in the first instance? At a minimum, Hooke envisioned his device as facilitating the production of recordings and measurements by means of perspective projection; perhaps he even had in mind the surveying and plotting of distances, heights, and shapes from pictures, thus conceptually linking optical and cartographic projection. This was something that Hooke had already implied in the short diary entry from 1683 where he included the picture box with measuring devices and mapmaking and navigation techniques ("a tangent projection from a projection on a sphere, but only great circles which passt the centre with the straight lines. Others will be conicall curves," Hooke noted to himself in the entry from September 22, 1683, his mind having clearly been preoccupied by cartographic projection).[87] The anonymous engraver's interpretation of Hooke's design (see Figure 26) also implies a similar preoccupation: The picture box appears to be purposed, like the maps, to mobilize the gaze and to incite action, simultaneously letting its observer lay claim to the landscape through framing, looking, and drawing.[88]

Even if merely a footnote in history, buried in an old publication of Hooke's "philosophical experiments," the portable camera obscura did

become an important witness to the Kingdom of England's program of economic expansion. If not by any real deeds, it operationalized an imaginary—of colonial conquest, to be sure, but more specifically, an imaginary that linked optical projection with the pursuit of property and profit. We recall how the secretary of the East India Company expected descriptions to be "worthy of Credit"—the kind of knowledge that John Locke deemed probabilistic, that is to say, not grounded in "visible and certain connexion" but rather rooted in the authority of the source of information, indeed, what Locke, too, called "credit."[89] For Hooke, his picture box was to procure such authoritative, credible views. But the secretary's use of the word "credit," considered in its context of the East India Company's pursuits, did not merely connote images as worthy of trust, but first and foremost perhaps, as worthy of investment. The secretary's phrase divulged how natural philosophy—the screening and outlining of "matters of fact"—was to provide the required background knowledge for scouting out new prospects for colonial settlement and trade, and thereby speculation on yields to come. Corporate commerce needed practical knowledge for its expansion—for setting up new bases, prospecting for natural resources, transplanting crops and people, and so on.[90]

The English, generally speaking, saw the colonies as profit-returning property. "The Plantations are the Property of English Men," asserted the English commissioners negotiating for a union with Scotland in the early years of the eighteenth century, "and that this Trade is of so great a consequence & so beneficial as not to be communicated, as is Proposed, till all other Particulars which shall be thought necessary in this union be adjusted."[91] In advancing and expanding this "so beneficial" trade, the borders between knowledge and possession became effectively blurred. For some of the Royal Society's fellows, like John Locke, the concerns of natural philosophy were primarily economic and governmental. From "rational and regular experiments," Locke argued, "we may draw advantages of ease and health, and thereby increase our stock of conveniences for this life."[92] Knowledge, for Locke, was purposed to accumulate one's possessions but, furthermore, to restore (as stipulated by the Old Testament) mankind's original dominion over the globe, and to render the earth as fruitful and lucrative.[93]

Empirical investigations were, in other words, needed for new invasions and for securing investments. This somewhat utilitarian conception of

knowledge was complemented with Locke's theory of property, which the philosopher formulated while involved with the proprietors of the Carolina Company and managing the colonial affairs of his patron Lord Anthony Ashley Cooper, Third Earl of Shaftesbury.[94] "*As much land* as a man tills, plants, improves, cultivates, and can use the product of," Locke wrote, "so much is his *property*. He by his labour does, as it were, enclose it from the common." Through labor, property is established, boundaries and rights of ownership are drawn, and the fruits of the earth are reaped. Wealth and possession boil down to "the labour of [man's] body, and the work of his hands" that are "properly his." Or, as Locke expounded, "God gave the world ... to the use of the Industrious and Rational, (and *Labour* was to be *his Title* to it)."[95]

So, Locke theorized his notion of property, which tallied with the British colonial project of occupying, cultivating, and privatizing foreign territories purposed to be "enclosed" and "improved" into sources of profit. One of the founders of liberalism—a critic of slavery and absolutist forms of rule; a proponent of a natural right to health, liberty, life, and possessions (indeed, someone who wrote that "God ... hath given the World to Men in common," all "men" being naturally rational, self-governing creatures[96])—saw no contradiction in the appropriation of colonial peoples and their lands into the production of surplus. As Crawford Macpherson demonstrates, Locke's doctrine of property *qua* labor was premised on the primacy of capital accumulation over moral claims of the society.[97] While "the chief end" of the civil society, Locke famously propounded in *Two Treatises of Government*, was "the preservation of Property," the appropriation and accumulation of property itself was something that preceded the very institution of civil society: a natural disposition, or right, of each individual that owed no debt to civil society but rather found its social expression in the invention of money. "This partage of things," Locke wrote, "in an inequality of private possessions, men have made practicable out of the bounds of Societie, and without compact, only by putting a value on gold and silver and tacitly agreeing in the use of Money."[98]

Monetized relations based on the enlargement of one's possessions and the hoarding of wealth for further investment became considered primary, and imperative, to "civilization" and its expansion. "For I ask," Locke queried, "What would a Man value Ten Thousand, or an Hundred Thousand Acres of excellent *Land*, ready cultivated, and well stocked too with Cattle,

in the middle of the in-land Parts of *America*, where he had no hopes of Commerce with other Parts of the World, to draw *Money* to him by the Sale of the Product?" Locke replied that this land "would not be worth the inclosing, and we should see him give up again to the wild Common of Nature."[99] Therefore, the cultivation of land and the establishment of property depended on the introduction of markets in commodities, capital, as well as labor. Even if these markets were "out of the bounds of Societie," the idea that societal structures were established to safeguard property and wealth meant, in turn, that now market economy was considered the very foundation of civil society. Here, we should note, Locke was by no means alone. For example, his contemporary, the Dutch-English political economist Bernard Mandeville professed how market relations were indeed "the cement of civil society."[100]

A key idea for Locke (and the beginnings of liberal political economy) was the notion of enclosure. On the one hand, enclosure meant the civilizing operation of appropriation whereby property boundaries were drawn, an operation that allowed the development of the economy of accumulation and exchange and provided the foundations of civil society. On the other hand, enclosure defined the new liberal, or "possessive," individual—someone who had "a *Property* in his own *Person*," and therefore in principle owed nothing to the society for his/her person.[101] This was an individuality, as Macpherson describes it, that could "only fully be realized in accumulating property, and therefore only realized by some, and only at the expense of the individuality of the others."[102] The possessive individual, in this sense, found fulfilment in the very operation of the enclosure. But this individual was also enclosed in another sense: cognitively drawn apart from the environment, contemplating views of the external world from within the dark room of the mind. "The Dominion of Man," Locke wrote in his *Essay Concerning Human Understanding* (1689), "in this little World of his own Understanding, being much the same, as it is in the Great World of visible things."[103] The philosopher famously compared human understanding with the operations of the camera obscura, the media apparatus that put on display what Locke considered the "inner space" of the rational mind reflecting on the representations brought from the world by the senses:

> External and internal sensation are the only passages that I can find, of knowledge, to the understanding. These alone, as far as I can find, are the windows

by which light is let into this *dark room*. For, methinks, the *understanding* is not much unlike a closet wholly shut from light, with only some little opening left, to let in external visible resemblances, or ideas of things without.[104]

The camera obscura crystallized the personal enclosed space—the fundamental property of every individual—and facilitated thinking about how this space matched with the observable realm of things and processes. Locke's passage, however, also hastened to undo similarities between the camera obscura and the intellect as soon as the media metaphor was evoked. "Would the pictures coming into such a dark room but stay there," Locke continued, "and lie so orderly as to be found upon occasion, it would very much resemble the understanding of a man, in reference to all objects of sight, and the ideas of them."[105] The dark room became quickly replaced with another kind of apparatus, which resembled a *Kunstkammer* of a sort displaying an orderly connection of items arranged under concepts and categories. Yet the camera obscura persisted as a tangible double metaphor for the possessive individual. First, it stood for the circumscribing of the person's inner space as a simultaneous process of inclusion and separation. Second, it demonstrated one of the principal cognitive operations of capitalism: the operation of enclosure where the external world became appropriated, *qua* its shadows, as a (potential) object of possession and profit. If we can assign a specific visuality to liberalism (the protection and enhancing of property and market economy) and the colonial project of the Commonwealth, it evidently was embedded in the optical media of the times. Namely, what else could Locke's notion of property entail, especially if we think about it in cognitive terms, but the act of optical projection as screening, outlining, framing, and circumscribing?

Locke's implicit association of the dark room with the notions of property and enclosure resonated closely with the concerns about the portable picture box envisioned by Hooke. The camera obscura, as the latter pronounced, was to allow travelers to "*take* the draught or picture of any thing."[106] "Taking" a picture came across as a cognitive act of appropriation. We can surmise how the picture box's hybrid images were meant to be more than mere description of foreign things and beings. They were purposed to operate as acts of enclosure precisely in the sense that Locke intended: acts that designated and outlined the things and beings—fruits, trees, birds, hills, rivers, natives, you name it—meant to fall under one's ownership and care.[107] In Hooke's

picture box, projection became a way of sketching the things and beings "worthy of Credit," things that were evaluated as objects of appropriation and investment.

Coda: "A Kind of Property"

"In the beginning all the World was *America*," Locke famously proclaimed, picturing the planet as a vast open territory to be seized and enclosed for the production of wealth.[108] In England at the turn of the seventeenth century, projection held a particular role in upholding this picture. It stood for a new scientific as well as economic sensibility of the world as open to "chance and opportunity," promising to procure the required data for the advancement of knowledge, on the one hand, and to provide the perceptual and cognitive means to translate things and beings into potential objects of possession, on the other hand. Inherent to its aesthetic was thus a tension between (mechanical) reproduction and (cognitive) spontaneity in the world's visualization—in other words, the mind's spontaneous ability to picture the opportunities or "prospects" presented to it by contingent occurrences.

This theme was taken up by Joseph Addison in a set of essays on the "Pleasures of the Imagination" published in *The Spectator* in 1712 where the poet discussed the mind's power "to enlarge, compound and vary" ideas.[109] "A Man in a Dungeon is capable of entertaining himself with Scenes and Landskips more beautiful than any that can be found in the whole Compass of Nature," Addison surmised. "The Colors paint themselves on the Fancy, with very little Attention to Thought or Application of Mind in the Beholder."[110] Addison's imagination was nonetheless not allowed to roam totally free and unchecked; its operations were ultimately moored to empirical evidence provided by the senses. One could not "have a single image in the fancy that did not make its first entrance through the sight," Addison cautioned. Rather than creation *ex nihilo*, the imagination's duty was to "retain, alter, and compound" images from sensations and perceptions. Crucially, Addison modeled this empirically restrained and cautious concept of the imagination on the camera obscura. "The prettiest Landskip I ever saw," he wrote:

> was one drawn on the Walls of a dark Room, which stood opposite on one side to a navigable River, and on the other to a Park. The Experiment is very common in Opticks. Here you might discover the Waves and Fluctuations of the Water in strong and proper Colours, with the Picture of a Ship entering at

one end, and sailing by Degrees through the whole Piece. On another there appeared the Green Shadows of Trees, waving to and fro with the Wind, and Herds of Deer among them in Miniature, leaping about upon the Wall.[111]

Such were the sights that Addison witnessed on a visit to a camera obscura at the Astronomer Royal's Greenwich Observatory, where these devices had been installed since the observatory's construction in the late 1670s for solar observations.[112] To be sure, the dark room in Addison's account wasn't targeted toward the skies. Quite likely Addison was referring to the two camera obscuras located in the turrets of Flamsteed House, which were "uncommonly pleasant on account of the charming prospect and the great traffic on the Thames," as the German scholar Conrad von Uffenbach's testimony of his visit to the observatory in 1710 tells us.[113]

Addison treated the camera obscura's projection surface as a canvas (a "Piece") for essentially *moving* pictures of various kinds: a common sight of ships sailing on the river Thames, deer leaping in the Greenwich park, and so on (Figure 28). The device corresponded with a view of the world preferred by Addison that was far from static, made of "perpetually shifting" scenes paying witness to "Variety, where the Mind is every Instant called off to something new."[114] The camera obscura's screen came across as a plane of representation, which delighted with its "near Resemblance to Nature" in its ambulatory dynamics. Addison spoke about the camera obscura's projections

FIGURE 28 View of Greenwich Observatory looking to the west, with the Thames leading toward London in the distance. *Prospectus versus Londinium* (*Vivarium Grenovicanum*). Etching by Francis Place, 1676.

© Trustees of the British Museum.

("pictures") in a manner similar to Kepler's *picturae* or Hooke's "matters of fact." But in addition to technical objectivity, the shadowy chamber facilitated something else: a degree of detachment from the external world, a shift in experience, which lifted the projected sights from sensory immediacy and turned them into objects of cognition.

Addison found particularly delightful how the apparatus turned objects and events into their own images "leaping about upon the Wall," and thus set the mind in motion in various ways, triggering observation, inspection, contemplation, and conjecturing. In the camera obscura, the world became arranged into a mental space with "pleasant Similitudes" and "perfect Patterns"—there one could witness the world replicated in its complexity—indeed, something as nebulous and volatile as trees swaying in the wind, miniaturized into fleeting apparitions without sound, more easily graspable and controllable than the row of the real. In the camera obscura, one could even delight in "the Effect of Design, in what we call the Works of Chance." The pleasures that the camera obscura provided involved a degree of cognitive apprehension over the unpredictable and the unruly, an assurance of thought's capacity to give spontaneous form to and manage what is lacking coherence and clarity. Spontaneity was key to the apparatus's projections, as Addison's peer Alexander Pope observed about a grotto located on the premises of his villa at Twickenham that had been turned into an optical projection device. On the walls of the dark cave, Pope wrote, "all the objects of the river [Thames], hills, woods, and boats, are forming a moving picture in their visible radiations," emphasizing the present moment ("are forming") of the apparitions' emergence.[115]

As such, the camera obscura provided a fitting embodiment of the intellect. The shadowy chamber's aesthetic of projection enabled one to intuit how the worlds within and without became both separated from, and articulated into, one another in the processes of representing and imagining, and how the mind was able to give a kind of shape—to assign some similarities and differences, however fragile and fleeting—to the flux of experience. Addison clearly took inspiration from Locke, who described how the understanding "has the power to repeat, compare, and unite" the impressions provided by the senses so as to "make at Pleasure new complex *Ideas*."[116] We recall how Locke approached this operation of the mind—the projection of resemblances to be assembled into an arrangement—with his partial metaphor of

the dark room. For both Addison and Locke, the camera obscura disclosed something essential about the composition of the mind and how the mind interfaced with reality. Previously, the dark room had served as a potent model for vision—from Kepler and Scheiner to René Descartes, who theorized the retinal image in terms of projection. But Addison and Locke stood out to the extent that, for them, the camera obscura made sense of how the individual cognitively interacted with external phenomena. Locke, we recall, deemed the mind's grasp of movements and connections thus acquired as probabilistic. Addison's experience similarly involved parsing together conjectural arrangements through the association of "similitudes."

This was a model of projection that suggested the mind's powers to picture, connect, and circumscribe the real, but it did not stipulate that such techno-mental appearances should be hailed as signs of an immutable divine structure, a timeless logical harmony. For Addison, instead, projections paid heed to the complexity of things, their self-organization, so to speak, rather than to their position in a pre-established system. Proceeding to the topic of gardening after the short note on the Greenwich camera obscura, Addison cautioned against laying gardens out by "rule and line" and "trimming" trees and plants "into a Mathematical Figure." Gardeners should rather appreciate nature's uncontrolled, spontaneous emergence ("Marsh overgrown with Willows"), which allowed the sight to "wander up and down without Confinement" and fed it "with an infinite variety of Images."[117] Crucial here was the intellectual transition that Addison gave expression to, from the notions of harmony and order—indeed, providence in the religious context—to "infinite variety," the complex and the unpredictable. One no longer appreciated events and details simply as parts of a larger rational (but hidden) design, but rather in terms of their contingent, creative emergence and in terms of the imagination's attempts at turning their movements into a speculative design.

The designs of the imagination, epitomized by complex animated patterns appearing on a camera obscura's screen, provided their beholder, in Addison's words, "a kind of Property in every thing he sees."[118] The moment a sight entered the mind—the moment, to use Addison's analogy, something was turned into its projected image, however miniaturized and distant—it became a matter of virtual ownership and valuation, the poet implied. Here, again, Addison shared his take on optical media with Locke, as well as Hooke. But Addison simultaneously expanded their association of

projection and property, to encompass "Visions of things that are either Absent or Fictitious."[119] Yoking the real with the imaginary, property with the prospective—this was a fundamentally new concept of projection emerging in English thought circa 1700. And this was a concept tied to the rise of a new speculative economy in England during the period.

SHADOWS OF EXPECTATION

Nine times a-day it ebbs and flows,
Yet he that on the surface lies,
Without a pilot seldom knows
The time it falls, or when 'twill rise.

JONATHAN SWIFT, "THE SOUTH SEA PROJECT"

The Problem of Design

Jonathan Swift's poem "The South Sea Project" (1721)[1] dealt only vaguely with large quantities of water. Written after the burst of the so-called South Sea Bubble, one of the main financial crises of the eighteenth century that shook not only England but Europe at large, the poem describes the behavior of a relatively new phenomenon in Swift's times: the stock market. When historians talk about the English financial revolution at the turn of the seventeenth century, they are typically referring to the rapid development of financial innovations, institutions, and infrastructures such as the establishment of a national bank, the creation of a system of public debt whereby individuals and companies could invest money in the government, and the expansion of speculative markets in stocks, lotteries, and insurance. Not all such innovations were new strictly speaking—joint stock companies, for instance, had already been established in the Elizabethan era for foreign trade—but the revolution, if there was one, was in how quickly this form of trade surged and how it shook the conceptual foundations of socioeconomic life. There were eleven joint stock companies in the Kingdom of England in 1689, and six years later there were about a hundred, while the capital ploughed into these

companies increased ten times over between 1695 and 1720. At the same time, the Bank of England was established to facilitate the expansion of national debt, allowing the kingdom to shape itself into a leading maritime power. Thus, the financial revolution consisted of the growth of ventures whereby economic relations became increasingly predicated on predictions about the future as well as promises to pay back. A new kind of abstract framework of accumulation based on speculation as well as credit became superimposed on material relations of production and exchange, which quickly started to acquire independence and autonomy of its own.

"All *Trade* is an Ass to *Stock*," an anonymous pamphlet from 1691 announced:

> there's more to be got by Stock in a Week, or sometimes in a Day then by other Business that ever he was acquainted with in a Year. . . . Besides East India, Africa, and Hudsons's Bay Stock, there was now Linen Stock, and Paper Stock, Copper Stock, and Venetian Mettal Stock, Glass Stock, and Wrack Stock, Mill Stock, and Dipping Stock, and almost a hundred other Stocks.[2]

The new type of trade on immaterial assets, we read in these lines, promised quick accumulation of wealth. Yet the pamphlet simultaneously portrayed the financial market as essentially capricious and volatile. The consequences of "Stock-jobbing" could be "mischievous," disregarding traditional demands and checks of profitability, being driven instead by self-fulfilling expectations based on confidence and faith. Value on the stock market, the pamphlet tells us, could "rise and fall as the humours of the Buyers increase or abate," and was driven by techniques of "forestalling" (financial instruments such as derivatives) devised by "subtile and designing Men."[3]

An ardent skeptic about the new economy, Swift similarly observed the aleatory, unexpected, and uncontrollable nature of the speculative market of shares and how it undermined familiar knowledge and understanding. The poem "The South Sea Project" continues:

> Subscribers here by thousands float,
> And jostle one another down;
> Each paddling in his leaky boat;
> And there they fish for gold, and drown.[4]

Swift's poem focused on the events that took place around the South Sea Company (more on this later), which had been established in 1711 by the

Tory government to reorganize the national debt and capitalize on public credit. In 1720, during a general speculation frenzy, the company's share price was driven—blown up "like a Bladder" by "Jobbers" (as Daniel Defoe put it)[5]—to increase seven-fold in a few months, until it collapsed toward the end of the year, mainly due to the lack of investor confidence.

For someone like Swift, such sudden rises and falls taking place seemingly by chance, beyond any individual's control, posed a serious challenge. Credulous investors were left floating at the mercy of fluctuations "without a pilot," without a (cognitive) map or a guiding hand that could help them navigate the perilous ebb and flow of the financial market. No longer did it appear, in any simple and straightforward manner, that "they are [God's] directions which *the winds and the seas obey*," to quote Laurence Sterne's affirmation of the presence of divine providence in individual occurrences.[6] The problem posed by the new economy was, in other words, one of design (or the lack thereof); above all, for Swift and other clergymen, of divine plan and guidance.

The rise of the speculative economy presented the challenge of rethinking the relationships between chance and order, contingency and form. Important here was how features of finance such as speculation on share prices were frequently associated with gambling and lotteries, and brought into the purview of probability and risk.[7] As John Arbuthnot wrote in the preface to his translation of Christiaan Huygens's important work on the laws of chance, the "Calculation of the Quantity of Probability might be improved to a very useful and pleasant Speculation, and applied to a great many Events which are accidental."[8] For Arbuthnot, who was a close friend of Swift's, the concept of probability allowed one to reassert the presence of divine power and order in the world. The mathematician proposed that improbabilities, such as the uneven distribution of gender that Arbuthnot inferred from birth tables, worked as proof of God's benevolent engineering of human affairs: Such an intervention was necessary for human survival, given the extent to which "external Accidents" made "a great havock" of males.[9] Importantly, irregularities and anomalies were no longer considered to be extraordinary occurrences; God's workings instead became comprehensible through probability figures. The Scottish philosopher Francis Hutcheson also associated divine design with probability in his *Inquiry* from 1725, but he emphasized regularity and pattern. "The recurring of any Effect oftner than the Laws of Hazard determine gives

Presumption of Design," Hutcheson wrote, arguing that it is improbable that our world is governed by the forces of blind chance alone; in other words, the likelihood that the world is the product of providential design is the highest. Above all, our appreciation of unity and regularity in variety—"the Frequency of regular Bodys of one Form in the Universe"—should be attributed to a divine cause. Hutcheson credited the mind's capacity to anticipate form in disorder and similarity in difference and thereby inferred the presence of a superlative design in how things are and come to be.[10]

On the one hand, then, the concepts of probability and un/certainty were employed to reaffirm the presence of divine design within what seemed aleatory and disorderly.[11] On the other hand, they simultaneously started to erode the theological concept of providence by supporting a secularized notion, more fitting to finance, of the future (as well as the mind's powers of imagining it) as a source of potentially infinite wealth. Fundamental to finance, as William Goetzmann summarizes it, is that it "deals with the unknown future."[12] Take, for example, financial instruments such as time bargains, which had been introduced in London by the beginning of the 1690s. By means of "puts" and "refusals"—what are today called futures and options contracts (obligations to buy or sell a security or an asset at a predetermined price at a certain moment in the future)—the investor could, "for a small hazard . . . have his chance for a very great gain," as the trade writer John Houghton explained the financial market to potential investors in his periodical.[13] Buyers and sellers of stock wagered on whether prices would rise or fall, according to "hopes and fears." By the early eighteenth century at the latest, chance was no longer simply to be written off and uncertainty explained away as effects of "secondary causes" in the providential order. David Hume encapsulated this new attitude in *A Treatise of Human Nature* (1739–40) as follows:

> Probability is of two kinds, either when the object is really in itself uncertain, and to be determin'd by chance; or when, tho' the object be already certain, yet 'tis uncertain to our judgment, which finds a number of proofs on each side of the question. Both these kinds of probabilities cause fear and hope, which can only proceed from that property, in which they agree, *viz.* the uncertainty and fluctuation they bestow on the imagination by that contrariety of views, which is common to both.[14]

For Hume, the concept of probability did not resolve the fundamental "contrariety of views" involved in it. By contrast, the future was genuinely open to possibility (that is to say, uncertainty) and the imagination strong enough to project future eventualities in vivid colors, which made one both dread and desire them. The Scottish philosopher put forward an emerging notion of human cogitative powers as divorced from divine guidance, arguing that one "must acknowledge the reality of that evil and disorder, with which the world so much abounds," instead of falling back on "general laws" that the divine ruler had supposedly "laid down to himself in the government of the universe."[15] The concept of providence in this sense came across for Hume as "entirely imaginary." Indeed, Hume asserted that "our mental vision or con-ception of ideas" was not "a revelation made to us by our Maker." One could not stipulate an underlying order of reason to guarantee necessary connec-tions between causes and effects; events, according to Hume, came across rather as "entirely loose and separate" until the mind could figure out how one thing joined with another within a temporary and fleeting design, based on the experience of recursive patterns.[16]

"After a repetition of similar instances, the mind is carried by habit, upon the appearance of one event, to expect its usual attendant, and to believe that it will exist," Hume wrote.[17] Here, it was particularly the task of the imagination to "repeat our impressions" and to furnish the mind with series of associative linkages.[18] Hume's imagination was a "contractile power," as Gilles Deleuze de-scribed it: "Like a sensitive plate, it retains one case when the other appears. It contracts cases, elements, agitations or homogeneous instants and grounds these in an internal qualitative impression endowed with a certain weight."[19] Far from haphazard and unfettered, the work of the imagination was yoked with the qualities, or modalities, of association such as resemblance, conti-guity, and causality.[20] At the same time, the imagination was also, on Hume's account, able to "transpose and change its ideas."[21] It had the power to mix, compound, separate, and divide, to anticipate future occurrences, and even to generate fictions by positing the being of that which did not exist. The imag-ination was, in Hume's words, "a productive faculty, and gilding or staining all natural objects with the colors, borrowed from internal sentiment, raises in a manner a new creation."[22] Hume conceived of the mind as a constantly reshaping configuration of a variety images coming and going—a "kind of theatre, where several perceptions successively make their appearance; pass,

re-pass, glide away, and mingle in an infinite variety of postures and situations," as Hume put it.[23]

For Hume, a more fitting metaphor for the mind might have been the camera obscura, in the sense intended by Joseph Addison, as the unfolding of an associative and conjectural pattern onto what was contingent and resisted systematization. Addison, we recall, admired how the Greenwich camera obscura modeled the aleatory and contingent movements of given variables. In this instance Addison refrained from extending the reach of the design concept outside the dark interior of the apparatus (or the human mind). Rather than suggesting any higher organizational superstructure, the "effects of design" that the apparatus enabled to plot in the "works of chance" suggested a functional relationship between knowing and imagining in the production of speculative patterns juxtaposed with the world's variability. Addison's musings on the camera obscura resonated therefore closely with Hume's intuition of the mind as "projecting" itself, as one commentator puts it, onto external objects—changing their appearance, outlook, and makeup, and taking "something mental and see[ing] it as external."[24] Hume's projective imagination, like Addison's, effected the virtualization of things and relations through their juxtaposition with the mind's designs, especially in terms of the anticipation of future events. Fundamental to the human cognition, in other words, was how it turned the world into a projected—in the sense of speculative—image.

As such, Hume's and Addison's concepts of design and imagination were purposed to fit their socioeconomic landscape. On the pages of *The Spectator*—the widely disseminated journal in London that Joseph Addison and Richard Steele published in the early 1700s—the reader encountered several attempts at grasping the vagaries of the new type of speculative capitalism booming in England during the period. In the third issue, Addison presented his gendered allegory of the "Virgin called Publick Credit," who was seated on a throne inside the relatively recent Bank of England (founded in 1694), and who, in "the twinkling of an Eye," could "fall away from the most florid Complexion, and the most healthful State of Body, and wither into a Skeleton."[25] Through credit, wealth became volatile, uncertain, and even phantasmatic, a "Dance of Apparitions," to quote Addison. Hume, for one, did not avoid showing his contempt of the new credit economy when he wrote:

> But what production we owe to Change-Alley, or even what consumption, except that of coffee, and pen, ink and paper, I have not yet learned; nor can

one foresee the loss or decay of any one beneficial commerce or commodity, though that place and all its inhabitants were for ever buried in the ocean.[26]

Referring to the South Sea Bubble, Hume noted how the newly established mechanisms of public debt were fueled by "popular madness and delusion."[27] In speculative economic activity, reason was overrun by passions of accumulation, and the imagination, in anticipation of future profit, superimposed things with qualities and relations that they did not actually have. "Men are mightily govern'd by the imagination," Hume remarked, "and proportion their affections more to the light, under which any object appears to them, than to its real and intrinsic value."[28] In Hume's phrase, one could argue, a general anthropological observation of the powers of the imagination was drawn based on the observation of speculative economic behavior where the mind's passionate expectations superseded empirical weight ("intrinsic value").

Importantly, neither Hume nor Addison lamented the lack of a providential plan or guidance but proposed an epistemic problem inherent in speculative capitalism concerning the virtualization of material relations and processes by the fancy's potentially whimsical projections. Emerging in this sense in English thought in the beginning of the eighteenth century was a new concept of projection as a speculative mental design. This concept was also vaguely indebted to the optical media of the period. The optical analogues in Addison's prose—"the dance of apparitions" within finance, on the one hand, and the "waves and fluctuations" inside the dark room, on the other hand— intimated that the poet's experiences in the Greenwich camera obscura were in fact aligned with the processes of financialization in the sense that both presented the cognitive challenge of coming to grips with the fleeting, the ephemeral, and the contingent. Peering at the screen inside the Greenwich camera obscura, Addison experienced what Hume later articulated, also in relation to finance, as the mind's challenge of finding a meaningful pattern in the flux of things, which was not given or pre-established but required the work of the imagination in conjecturing and figuring possibilities. Such associations aside, the reality of finance was nonetheless nothing visually apprehensible per se, and its abstract and stochastic movements escaped the camera obscura's screen as purveyor of mechanically objective knowledge.

As we will see in the next section, it was instead in practices of calculation that anticipations of the future could more readily be pinned down and features of finance given a fledgling cognitive shape. More or less accurate

mathematical calculations merged with imaginary prospects of all sorts, turning into key ingredients of experience. However, as we explore in the following paragraphs, the optical concept of projection returned as a potent mental analogue to make sense of the difficulties that the speculative economy's processes of accumulation and valuation posed in distinguishing the real from the virtual, perception from fantasy. Above all, the magic lantern's projections, which raised the real "into a new creation" (to borrow Hume's words), helped the contemporaries of Swift, Addison, and others to fathom how the rise of finance involved the separation of value from the reach of divine providence into an imaginary product, even mere phantasmagoria (to use a slightly anachronistic term).

Calculation and Projection

The early financial economy was materialized on paper, and particularly in print. Its expansion relied on price lists, among other kinds of information, distributed in newspapers and periodicals.[29] John Houghton, for example, published weekly listings of stock prices in his *Collection of Letters for the Improvement of Husbandry and Trade*, alongside other kind of data such as "Bills of Mortality of London" and accounts of "the Shipping into and out of the Port of London."[30] Houghton's printed tables of figures, as Miles Ogborn points out, embodied the Royal Society's ideals of data gathering and analysis: The consolidation of the circulation of reliable information was key to the improvement of the circulation of capital, including financial capital.[31] Given the extent to which the hopes, fears, anticipations, and conjectures driving the rise and fall of the stock market were fueled by interpretations of various forms of knowledge, Ogborn argues, "print was part of the workings of the stock market rather than simply a commentary upon it."[32] Catherine Ingrassia even suggests that the financial market was not strictly speaking "a 'real' event; rather it was a phenomenon that could be known primarily through print sources like newspapers or stock sheets dedicated to the listings of various values."[33]

In addition to print, the speculative realities of finance were performed, as Hume already noted, by "pen, ink and paper." Promissory notes, bills of exchange, bonds, stocks, shares, deposit receipts, and so on bound their signatories into a set of promises and obligations—into a web of credit and debt—and thereby also to one another in terms of shared pursuits and

dependencies. "They have his soul, who have his bonds," Swift lamented.[34] These documents knitted together shared imaginaries and anticipations, a shared invisible future. Furthermore, they signaled a significant change in the very concept of property, which expanded its semantic reach from real objects and relations such as land, goods, or the family tree, to imaginary ones. Pieces of paper dislodged property from its previous referents to promises about future payments. As J. G. A. Pocock puts it, "what one owned was promises, and not merely the functioning but the intelligibility of society depended upon the success of a program of reification."[35]

Capital became "fictitious," Charles Jenkinson, the Earl of Liverpool, observed in the early 1800s.[36] Jenkinson was concerned about the economic instability and volatility caused by the conversion of "almost every other sort of property" into paper notes. Such an "alchemic" practice fundamentally challenged the notion of value, which was purged of material basis and attached to shared expectations and anticipations. "For what's the worth of any thing? / But just as much as it will bring," a jingle in Malachy Postlethwayt's *Universal Dictionary of Trade and Commerce* (1774) teaches us.[37] The value of debts and shares was indexed to fluctuating loan rates and stock market prices. Financial services like insurance and futures contracts even detached the value of things from actual marketplace exchange and ascribed it to what were fundamentally imaginary transactions.[38] The value of a cargo, say, was reckoned by imagining a typical exchange that might (or, rather, will) have taken place, based on a purely speculative market. Value was thus no longer tied to literal exchange, or even the life of real bodies and things; it became free to float open ended as imaginary valuations and promises of future payment. Value, in other words, became a speculative projection. Objects and relations became referenced in relation to visualizations of what might yet be realized—to scenarios that were located, uneasily perhaps, on the ontological no-man's-land between what is merely illusory and manipulated and what is not.[39]

Unsurprisingly, the imagination—in the sense of "gilding and staining" (to use Hume's words) of things and beings with nonexistent features— arose as a critical concept in grappling with the rise of finance. Swift, for one, dismissed all other forms of property but land as "transient or imaginary," contrasting the durable and the material with ephemeral mental projections.[40] More liberal voices like Daniel Defoe's understood the imagination as

the gateway through which financialization made its way into human affairs, something indispensable to the functioning of the speculative economy, even the society at large, yet potentially pejorative and whimsical:

> Is it a Mystery, that Nations should grow rich by War? that *England* can lose so many Ships by pyrating, and yet encrease? . . . Why do *East India* Company's Stock rise, when Ships are taken? Mine Adventures raise Annuities, when Funds fall; lose their Vein of Oar in the Mine, and yet find it in the Shares; let no Man wonder at these Paradoxes, since such strange things are practised every Day among us?
>
> If any Man requires an Answer to such things as these, they may find it in this Ejaculation—Great is the Power of Imagination![41]

Defoe made his readers aware of how the imagination became a "moving force," as Colin Nicholson puts it, in human relationships and circumstances.[42] Defoe was not alone in this observation. The Tory economist Charles Davenant wrote in the 1690s how in the new economy, the realm of the imaginary stipulated by systems of credit was the "principal mover in all business," the "nerval juice" total stagnation of which would "seize the body-politic." But he simultaneously recognized the fragility of the credit economy's epistemological foundations, existing only "in the minds of men" and subject to sudden turns caused by irrational and unpredictable whims and passions:

> Of all beings that have existence only in the minds of men, nothing is more fantastical and nice than Credit; it is never to be forced; it hangs upon opinion; it depends upon passions of hope and fear; it comes many times unsought for, and often goes away without reason; and when once lost, is hardly to be quite recovered.[43]

Chains of cause and effect, Davenant observed, were complex, almost impossible to pin down, and perhaps even nonexistent.

Importantly, Davenant the economist turned to numbers as a safeguard against such random forces. Superseding his critique of the imaginary and the speculative, Davenant took as his task to "argue upon Things by Figures," which implied, not merely record-keeping but the creative use of mathematical reasoning in order to find some effects of design in what appeared as random events. In this purpose, Davenant revived the program of political arithmetic initiated by Sir William Petty, a fellow of the Royal Society, in the 1660s, to promote "the art of reasoning by figures, upon things relating to government."[44]

Petty's ideal was a governmental rationality that worked "in Terms of Number, Weight, or Measure" (something akin to what is today called social statistics).[45] The Royal Society fellow, as Mary Poovey points out, pioneered the notion of economic "facts" and the use of mathematical formulas to come up with purportedly impartial knowledge.[46] Petty's facts, however, were not quite like the observed particulars of experimental scientists but rather conjectural and abstract evaluations and estimates. Here is Petty:

> The value of people, Men, Women and Children in *England*, some have computed to be £70 *per* Head, one with another. But if you value the people who have been destroyed in *Ireland*, as Slaves and Negroes are usually rated, *viz.* at about £15 one with another; Men being sold for £25 and Children £5 each; the value of the people lost will be about £10,355,000.[47]

According to Petty's ideal of statecraft, such crude and ruthless estimations of value based on projected exchanges should drive the government of populations, drawing on gradually amassed numerical records about production, consumption, trade, longevity, and so forth. Petty based economic analysis on "aggregate reasoning" (as Jonathan Sheehan and Dror Wahrman call it), which applied itself to large data sets instead of individual cases, seeking to discern mathematical order from the multitudes of particular instances.[48] His work suggests how at the turn of seventeenth century the world became viewed and ordered through numerical *tabulae*—mortality tables, birth rates, casualty figures, quantities of livestock—through records and grids "on which lines, numbers, and changing characters [were] inscribed," as Gilles Deleuze observed about the emerging patterns of perception during the period.[49] To put it another way, Petty's work points out the importance of calculation *screens* to the governmental and economic reasoning of the period—screens in the sense of cognitive operations by means of which the material reality of things, bodies, and relations could be filtered into abstracted as well as projective patterns. Here, Petty's numerical tables echoed Robert Hooke's concept of the camera obscura's projective screen, not only in the sense that both were to serve as surfaces for the tracing and accumulation all types of facts (visual in Hooke's case, numerical in Petty's), but also with respect to their shared association with the circumscribing and administering of things and beings *qua* property.

The "data screens," if you will, of Petty's political arithmetic dealt nonetheless more explicitly with the management of fluctuations and change (Hooke's

camera obscura being focused on the visual recording of objects and shapes). They sought to give expression to the world in terms of constants and regularities, even regularities of irregularities, such as accidents. Aggregate reasoning was to provide the proper tools for this purpose. Davenant cautioned that "he who will pretend to compute, must draw his conclusions from many premises; he must not argue from single instances, but from a thorough view of many particulars." By means of the accumulation and analysis of numerical data, Davenant proposed, one was able to form "very probable conjectures," and thereby to provide a "certain footing" to "fix our reasonings upon."[50] Calculation was, first, a "framing" device; its function was to fasten "schemes," that is to say, flights of the imagination, to "practice," or empirical evidence. But second, essential here was how the strictures of numerical analysis and governmental reasoning were no longer based on demands of exactitude but rather on estimates and speculative computations. William Deringer shows how Davenant's approach represented an epistemological departure from the accounting tradition, embracing "probable, rather than certain, knowledge."[51] Speculative economy shaped knowledge into a concern of probability, while probability was to provide an epistemic counterweight to radical uncertainty. As one could no longer rely on one's judgments of the present—because the present was constantly displaced toward an uncertain future—numerical estimates, or conjectures, became the measure of knowledge.

In "An Essay upon Projects" from 1697, Defoe brought up Petty's arithmetic for calculating "probable hazards" in the purpose of designing life insurance policies.[52] While death, as Defoe noted, had appeared as the ultimately contingent event "beyond direct computation and therefore control" that surrendered investors to the forces of chance, now mathematical methods could be employed to expand the temporal reach of economic evaluations. Defoe didn't seem to have been aware of the astronomer Edmund Halley's 1693 statistical analysis of the mortality data gleaned from the city of Breslau, which perhaps best illustrated the new mode of reasoning (Figure 29). Halley—who carried out his astronomical observations at the Royal Observatory at Greenwich—used logarithms for calculating the likelihood of death among people in different age groups. These estimates became useful in reckoning insurance policies, among other things:

> By what has been said, the *Price* of *Insurance* upon *Lives* ought to be regulated, and the difference is discovered between the *price* of ensuring the *Life*

of a *Man* of 20 and 50, for Example: it being 100 to 1 that a Man of 20 dies not in a year, and but 38 to 1 for a Man of 50 Years of Age.

On this depends the Valuation of *Annuities* upon *Lives*; for it is plain that the *Purchaser* ought to pay for only such a part of the value of the *Annuity*, as he has chances that he is living; and this ought to be computed yearly, and the Sum of all those yearly Values being added together, will amount to the value of the *Annuity* for the *Life* of the Person proposed.[53]

Years.	Prefent value of 1 l.	Years.	Prefent value of 1 l.	Years.	Prefent value of 1 l.
1	0,9434	19	0,3305	37	0,1158
2	0,8900	20	0,3118	38	0,1092
3	0,8396	21	0,2941	39	0,1031
4	0,7921	22	0,2775	40	0,0972
5	0,7473	23	0,2618	45	0,0726
6	0,7050	24	0,2470	50	0,0543
7	0,6650	25	0,2330	55	0,0406
8	0,6274	26	0,2198	60	0,0303
9	0,5919	27	0,2074	65	0,0227
10	0,5584	28	0,1956	70	0,0169
11	0,5268	29	0,1845	75	0,0126
12	0,4970	30	0,1741	80	0,0094
13	0,4688	31	0,1643	85	0,0071
14	0,4423	32	0,1550	90	0,0053
15	0,4173	33	0,1462	95	0,0039
16	0,3936	34	0,1379	100	0,0029
17	0,3714	35	0,1301		
18	0,3503	36	0,1227		

FIGURE 29 Calculation of the values of life annuities contingent on the chance of mortality. Table from Edmund Halley's "An Estimate of the Degrees of the Mortality of Mankind," *Philosophical Transactions of the Royal Society*, 1693, page 609.
© The Royal Society.

Calculation of life annuities, we read in these lines, was a predictive as well as preemptive operation, devised to both forecast the future based on observed past regularities and frequencies and to hedge against risk (possible loss). In both senses, it was to deal with the new reality of property and value dislodged from the present to the future. In this way Halley did by no means undermine the fanciful aspects of speculative economy but rather operationalized the imagination as the power of turning the world into an "effect of design." Here, calculation was employed above all as a projective technique that sought to translate one's cognitive reach from the past to the future, to formalize "data" (empirical observation) into a conjectural pattern.

On the one hand, this involved probabilistic analysis developed to estimate what the unknown future might bring, to cope with the risks—in the sense of both hazards and opportunities—lying ahead. Important in this respect was how techniques such as Halley's implemented a notion of the future as a landscape of calculable risk rather than an effect of fortune.[54] On the other hand, economic calculations were also harnessed to predict hypothetical futures for different types of scenarios of action. Such use of "projective calculation," as Deringer notes, was pioneered by Robert Walpole who held the British prime minister's office for two decades starting in 1721.[55] In their attempts at managing the public debt by means of a "sinking fund," Walpole and his administration mobilized a range of computational techniques (spreadsheet models and the mathematics of compound interest) in projecting the future outcomes of particular economic decisions. Calculation was operationalized as a technique of conjecturing, not only in the sense of assessing the likelihood of something, but also in terms of presenting future possibilities that one could plot and control.

In essence, then, the world brought about by finance and its media of inscription and reckoning was no longer a steady dwelling of divine harmonies; it was aleatory, changing, and mutable, made of uncertainties and risks that posed a challenge of management by quantitative means. This involved an important shift in the concept of the future, which became divorced from a metaphysical and theological frame of reference—the realm of divine providence—and was turned instead into an anthropological question of human influence and design. The English financial revolution, according to Edward Jennings, marked a transition "from an attitude that individual and social destiny is beyond human control to an attitude that the future can be

predicted and affected by human behavior."[56] "Planning ahead" substituted for fate, risk for fortune. The future became a matter of truth in a different sense than as the instantiation of a pre-established divine plan. Probability theory in particular, as Douglas Patey notes, posed difficulties to the theological concept of providence, because, "although it did not propose to give causal explanations of phenomena, it proposed rational prediction to be possible concerning precisely the sorts of events most typically thought to be providential (plague, death by lightning)."[57] The future was hence no longer closed and emptied into eternity, nor was it inherently rational as an outcome of divine wisdom and governance. Accidents were no longer to be explained away as miracles *"praeter ordinem rerum."* Pocock suggests how speculative economy gave rise to a new type of secular future that was "open and indefinite" and where "society must go on advancing into."[58] This future was made of uncertainties and risks, but it was also, alternatively, a future of probabilities and unheard-of opportunities.

Defoe, for one, repeatedly affirmed how chance and risk became new kinds of driving forces for the accumulation of wealth; "all risk in trade is for gain," he observed. For Defoe, "hazard" was an epistemic problem and, at the same time, an economic opportunity. "I don't pretend to determine the controverted point of predestination, the fore-knowledge and decrees of Providence," the merchant wrote, noting at the same time how probabilities and likelihoods could be turned into sources of value.[59] Those who didn't "run Hazard," Defoe observed, were not to expect the kinds of gains presented by all sorts of "Gaming Projects, where a Man has the chance of doubling his Money every Year."[60] Furthermore, hazards could be acted and speculated upon, especially by means of economic "securitization": "All the disasters in the world might be prevented by [insurance], and mankind be secured from all the miseries, indigences, and distresses that happen in the world."[61] Defoe gave expression to a crucial sentiment emerging during the era that one should conduct one's life as an enterprise that calculates the future and seeks to profit on its commitments—a sentiment that, as François Ewald succinctly puts it, no longer means "resigning oneself to the degrees of providence and the blows of fate, but instead transforming one's relationships with nature, the world and God so that, even in misfortune, one retains responsibility for one's affairs by possessing the means to repair its effects."[62]

Defoe characterized this new kind of attitude based on "planning ahead" (rather than resignation to providence) with one key notion: *projection*. Projection, for Defoe, meant basically drawing the future within the reach of human imagination and action. If during the financial revolution calculation evolved into a technique for producing predictable patterns, projection evolved into a critical concept to assess the new kind of cognitive reality of speculation. Those joining in market activity—in the transmission of credit and debt, stock exchange, and so on—came across, for Defoe, as self-interested individuals endowed with a special "faculty of projecting," a faculty of speculating and scheming, which was birthed in Defoe's account in the planting of foreign colonies:

> But here begins the forming of public joint-stocks, which, together, with the East India, African, and Hudson Bay Companies, before established, begot a new trade, which we call by a new name, stock-jobbing, which was at first only the simple occasional transferring of interest and shares from one to another . . . but by the industry of the Exchange brokers, who got the business into their hands, it became a trade, and one, perhaps, managed with the greatest intrigue, artifice, and trick ever anything that appeared with a face of honesty could be handled with.[63]

While "stock-jobbing nursed projecting," as Defoe put it, the extension of the latter was wider. Projecting meant the imaginary creation of possible futures—many of which never came into being. In Defoe's use, the verb derived from the noun "project," which meant the design of a future with desired outcomes but also connoted, to this effect, deceit, and trick.[64] "The diver shall walk at the bottom of Thames; the salpetre-maker shall build Tom Turd's Pond into houses; the engineers build models and windmills to draw water, till funds are raised to carry it on by men who have more money than brains," Defoe noted about the fanciful undertakings proposed by fraudsters who walked away with their investors' money.[65] Generally speaking, a project was a way of framing the future as a probabilistic object of speculation and a source of opportunity. "A Project is a Notion," Defoe's contemporary writer Aaron Hill noted, "which, having no real or visible Existence, the issue subsists at best upon a precarious Probability."[66] Defoe himself associated projects with "conceptions which die in the bringing forth, and (like abortions of the brain) only come into the air and dissolve." Defoe's times were

"swarming" with such conceptions to the extent they merited the title "Projecting Age."[67]

"Projection," in Defoe's phrase, stood for the liberation of the imagination toward the not-yet-realized, to generate all kinds of "shadows of expectation," as the merchant called the mental entities (or, "abortions of the brain") driving the speculative economy.[68] From where did such shadows originate? What were their medial underpinnings (if any)? Defoe's concept of projection, as we will shortly see, was knitted to the optical media of his times, most notably the magic lantern, which emerged as an important analogy for fathoming the vagaries of finance in the early 1700s. If "data screens" such as Davenant's or Halley's functioned as operative techniques for mooring the speculative imagination within the empirical, the magic lantern's projective screens, in contrast, symbolized another side of finance predicated on (optical) illusion and paradox.

The Devil's Lantern

A dwarfish figure, named "Night-Wind Singer of Shares," tramps ahead with his walking stick, his mouth open as if about to shout something, and carrying a magic lantern on his back (Figure 30). This is one of the satirical illustrations the reader encounters in *The Great Mirror of Folly* (*Het groote tafereel der dwaasheid*), a Dutch folio of engravings made during a major financial crisis that shook Europe in 1720.[69]

In England, the crisis had started with the bursting of the South Sea Bubble—a scheme made to privatize the massive debts that the English government had run up by 1719, after three decades of waging war. It was concocted that the creditors who held almost a third of the debt in government bonds were to exchange their long-term annuities for shares in the newly founded South Sea Company, with the incentive of making better returns.[70] South Sea Company had risen to prominence after it had been granted a monopoly contract with the Spanish government to supply South America with slaves (even if the trade itself, the little there was, wasn't profitable). For the scheme to work, the company's share price needed to be driven up. With false promises spread about the profitability of potential pursuits overseas, and in the midst of a general speculation frenzy catapulted by fantasies of fortunes made by "stock-jobbing," the value of the company's share rose from 130 per share in January 1720 to the peak of 950 in June, only to plummet a few

FIGURE 30 Savoyard entertainer carrying a magic lantern. *Actieuse nacht-wind-zanger met zyn tover slons* (The Night-Wind Singer of Shares, with His Magic Lantern). Anonymous engraving from *The Great Mirror of Folly* (*Het groote tafereel der dwaasheid*), 1720.

Courtesy of Rijksmuseum, Amsterdam.

months after.[71] The fall was precipitated by new government measures against financial speculation and declining confidence among both English and foreign investors. The consequences vastly exceeded the fortunes lost, or made, in investing in South Sea Company's shares alone. A general crisis in the stock market and a fall of the price of securities spread from London to Paris and eventually from Paris to Amsterdam, where similar projects of restructuring government debt through speculation with the promises of colonial exploits collapsed simultaneously.

The "Singer of Shares" in the illustration seemingly roamed the streets of Amsterdam selling shares to credulous investors, before the bubble's burst, trading when others had already gone to sleep. Amsterdam had been the financial center of Europe before London took over at the close of the seventeenth century; it was where the backbone of the speculative economy was laid out, from forward trading with the value of shares and commodities to

investment in public debt, among other things.[72] To many contemporaries, such forms of trading came across as perplexing and difficult to pin down conceptually. "The seller, so to speak, sells nothing but wind and the buyer receives only wind," a French observer pointed out about the futures trading practiced in the city.[73] The wind metaphor reappears also in the little windmill that decorates the singer's walking stick. *The Great Mirror of Folly* reiterated the common phrase "wind trade" (*windhandel*) used during the period to account for the transitory, immaterial, uncontrollable, as well as whimsical nature of speculation. As we read elsewhere in the folio:

> Wind is my treasure, support, and foundation.
> A master of wind, I am the master of life.
> A monopoly of winds currently presents itself
> as an adorable subject of rich idolatry.[74]

Speculative economy, these verses contend, bordered on idolatry: the worship of likenesses as if they were real. The text warns against projections of the imagination taking on a life of their own, endowed with unusual vital and occult powers, and blowing through people's minds as powerful yet essentially insubstantial substitutions for the real. One is reminded of Charles-Louis Secondat de Montesquieu's parodic allegory of financial markets, which pictured a person "accompanied by the blind god of chance" and trained in the secret of trading with balloons full of wind. "Imagine that I am very rich, and that you are very rich," the person urged. "Get yourselves into the belief every morning that your fortune has been doubled during the night: rise, then, and if you have any creditors, go and pay them with what you have imagined, and tell them to imagine in their turn."[75] Montesquieu's target was the notorious Scottish banker and gambler John Law, who imported novel financial mechanisms to France in the 1710s and facilitated the development of a state monopoly of commerce in which credit became the "unique source of circulation and abundance," as Abbé Jean Terrasson, apologist of Law's new economic realm, described the "System."[76] Above all, Law was in charge of the central bank (Banque Royale as of 1718) that introduced paper notes and public debt, alongside the Mississippi Company, a joint-stock enterprise (similar to the South Sea Company) that enjoyed a trade monopoly in the French colonies but was primarily devised to incorporate the entire national debt into its capital stock.

In addition to the atmospheric medium of wind, *The Great Mirror of Folly* modeled the new world of finance on types of optical phenomena fluttering in the air: projected images. The folio abounds with allusions to the practice of optical projection. In a scene on Rue Quincampoix, Paris, where a chariot is pulled by two toads and driven by a female figure of Deceit, the hunchback Bombario sitting on the top of the chariot next to a devil who blows with bellows into the anus of John Law who is vomiting shares, there is also a frail-looking elderly man at the forefront who carries a magic lantern on his back (Figure 31). The man with the magic lantern appears in several other scenes: among a rowdy crowd rushing to catch the seemingly worthless stock distributed by the commedia dell'arte character Harlequin from a chariot (Figure 32); in the crowded coffeehouse Quincampoix near the Amsterdam Stock Exchange where stock traders rush to register the deals struck with brokers (Figure 33). A note in the latter's left hand reads "it's magical" (*"'tis toveragtig"*), linking the speculators' "idolatry" of their schemes with how the optical projection machine turned its pictures into something ephemeral and intangible yet intensely powerful and lively.

Who were these lanternists populating the pages of *The Great Mirror of Folly*? Most likely Savoyards, members of a group of itinerant performers who came from a small mountainous region between France and Italy, but were visible and audible virtually everywhere in Europe, in the streets, at fairs, and in inns.[77] With their mechanical instruments, magic lanterns, peep show boxes, dancing dolls, and other technical wonders, the Savoyards possessed, we are told, "a virtual monopoly on the display of optical and mechanical curiosities" until the late eighteenth century.[78] The Savoyards governed the entertainment media environments of their times, producing multi-sensory spectacles that combined machine-made sounds with optical projections, and projections with more or less hyperbolic story-telling. At nightfall, the lantern entertainers were usually invited to people's homes to perform their shows with "amusing effects"[79]—comic scenarios, satiric tales, tidbits about nobles and noteworthy, ghost shows, even scenes of erotic nature.

Jean Ouvrier's engraving from the mid-eighteenth century provides a vivid view into a magic lantern show by two itinerant entertainers (Figure 34). The two youngest children react in fear while the chaperone and the older boy are amused by what appears on the hurriedly hung white sheet: a group

FIGURE 31　Man with a magic lantern (*front middle*) within a crowd on Rue Quincampoix, Paris, jostling for shares vomited by John Law. Detail from *De Kermis-kraam, van de Actie-knaapen, Schaft vreugde, en droefheid, onder 't Kaapen* (The Share Boys' Fair-Booth Gives Pleasure and Sorrow in Stealing). Anonymous engraving from *The Great Mirror of Folly* (*Het groote tafereel der dwaasheid*), 1720.

Courtesy of Rijksmuseum, Amsterdam.

FIGURE 32 Man carrying a magic lantern among a crowd (*lower left*). Detail from *De vervallen Actionisten, hersteld, door den Triompheerden Arlequin* (The Ruined Share Traders, Restored by the Triumphant Harlequin). Anonymous engraving from *The Great Mirror of Folly* (*Het groote tafereel der dwaasheid*), 1720.

Courtesy of Rijksmuseum, Amsterdam.

FIGURE 33 Man carrying a magic lantern, with a note reading "it's magical" ('tis toveragtig)
in his hand, among speculative traders in a coffee shop in Amsterdam. Detail from De grote
vergaderplaats van de windverkopers, 1720 (The Great Meeting Place of Wind Traders, 1720).
Anonymous engraving from The Great Mirror of Folly (Het groote tafereel der dwaasheid), 1720.
Courtesy of Rijksmuseum, Amsterdam.

LA LANTERNE MAGIQUE

FIGURE 34 *La lanterne magique.* Engraving by Jean Ouvrier, after Johann Eleazar Schenau, ca. 1765–1767.
Courtesy of Yale University Art Gallery.

of half-animal and half-human monsters dragging a captive female figure—to the netherworld, one can assume. The light emanating from the magic lantern casts the crucifix-wearing chaperone's shadow onto the screen, and her profile turns into what resembles a devil's silhouette, despite the crucifix's promise of God's presence and protection.[80] Thus, within the projected image's luminous circle, all sorts of shape-shifting and grotesque figures could roam free, and continuous transformations could take place that translated humans into demonic shadows.

In *The Great Mirror of Folly*, the Savoyard entertainers with their optical tricks became witnesses to the beginnings of modern finance capitalism. The magic lantern's uncertain and volatile projections—which emanated from inside the apparatus as if out of nowhere, unfixed from any material referent, constantly moving, growing, shrinking, and transforming—provided an apt analogy for the imaginary objects of speculation freed from the constraints of actual bodies and things. What the magic lantern projected were "disgusting bubbles" (*misselijke Bobbelen*), the inscription below "The Night-Wind Singer of Shares" advises us. The shadows of expectation animating finance, the illustration suggests, were like the shadows cast by the device. Both the credit economy and the magic lantern were operationally premised on the projection of virtual realities onto things and relations. Both financial and optical projections were fragile, ephemeral, and volatile like a bubble—prone to suddenly burst and disappear at any moment.

Such analogies between the magic lantern's perceptual environment and the cognitive reality of finance were also visualized in the French engraver Bernard Picart's illustration commemorating "the incredible folly transacted in the year 1720," which was included in some versions of *Great Mirror of Folly* (Figure 35a). The engraving portrays a chaotic scene where figures representing French, English, and Dutch financial enterprises (the Mississippi Company, the Bank of England, the Dutch West India Company, the South Sea Company, etc.) drag a chariot driven by Folly with the goddess Fortune as passenger, who is throwing shares, bills, and bonds to the rowdy crowd. Picart draws a compelling picture of what Anthony Ashley Cooper dubbed as "modern projectors," new types of individuals in pursuit of imaginary gains who "wou'd new-frame the human Heart; and have a mighty fancy to reduce all its Motions, Balances and Weights, to that one Principle and Foundation of a cool and deliberate *Selfishness*."[81]

Almost hidden behind a group of these "projectors," on the far left, there is also a young man holding a magic lantern (Figure 35b). The optical apparatus aligns with the promissory notes with which people are trading, as well as with the soap bubbles blown by the devil sitting in the clouds. The magic lantern plays a rather minor role in the illustration; for instance, the vignette does not mention the apparatus, which itself is barely noticeable. Yet the lantern's anecdotal appearance suggests an emblematic object through which the cognitive reality of speculation, especially the phantasm of boundless accumulation, became mirrored. The engraving's composition even implies that it is from within the small box's dark interior that the scene itself, and especially the contrast between light and shadow, or Fortune and the devil, in fact originates.[82] It is in this sense that the optical apparatus triggers the action of a new kind of economic apparatus, embodying the epistemic dilemma about an invisible agency that truncates the real into a mere play of appearances.

This mirroring wasn't limited to *Great Folly* alone; it became manifest in discourses that drew on optical metaphors and analogues in tackling the new economic realm. In *An Essay upon Publick Credit*, Defoe tellingly described credit as "the essential Shadow of Something that is not," providing a verbal counterpart to Picart's illustration. Credit, Defoe asserted, operated like a form-giving but reality-defying force that was nearly impossible to pin down. We read Defoe struggling with definitions:

> *Like the Soul* in the Body, [credit] acts All Substance, yet is it self Immaterial; it gives Motion, yet it self cannot be said to Exist; it creates *Forms*, yet has it self *no Form*; it is neither Quantity or Quality; it has no *Whereness*, or *Whenness*.[83]

Credit rested on uncertain ontological grounds, unmoored from substance or spatiotemporal coordinates; it was first and foremost paradoxical by nature.

Defoe employed the sexualized allegory of "Lady Credit" to account for its autonomous but irrational, even deluded agency that needed controlling.[84] At the same time, Defoe also mobilized an important optical allegory to describe credit's trick nature as "the lightest and most volatile Body in the World," visible only as a fleeting appearance. "As Light vanishes into Darkness; [Credit] comes with surprize, and goes without Notice. . . . What has this invisible Phantom done for this Nation," Defoe queried.[85] Later, in

FIGURE 35A *Monument consacré à la postérité en mémoir de la folie incroyable de la XX année du XVIII*, 1720.

Engraving by Bernard Picart.

Courtesy of Rijksmuseum, Amsterdam.

FIGURE 35B A young man holding a magic lantern among a crowd of speculators. Detail from *Monument consacré à la postérité en mémoir de la folie incroyable de la XX année du XVIII*, 1720. Engraving by Bernard Picart.

Courtesy of Rijksmuseum, Amsterdam.

Defoe's assessment of the collapse of financial markets in France entitled *The Chimera*, from 1720, this allegory evolved into

> an inconceivable Species of meer Air and Shadow, realizing Fancies and Imaginations, Visions and Apparitions, and making the meer speculation of Things, act all the Parts, and perform all the Offices of the Things themselves.[86]

The implicit reference in Defoe's phrasing, calling forth shadows and phantoms, was the new medium of the magic lantern capable of casting ephemeral imaginary realities. Defoe's formulation of "a species"—which we can read here in terms of both money and a visual image—made of "air and shadow," capable of effecting imaginations, visions, and apparitions—did rather strongly suggest the magic lantern's projected images as their key point of reference.

To be sure, such isomorphism between the apparatus's aesthetics and the writer's use of figurative language could be considered mere conjecture. A rare direct mention of the new medium (and perhaps the only one) by Defoe, which appeared in *The Political History of the Devil* from 1726, suggests nonetheless a deeper connection. In the esoteric treatise written late in his life, Defoe conceived of the perceived world as uncertain and prone to machinations by the devil, who enjoyed the "liberty of residing in, and moving about upon, the surface of this earth." Ordinarily, Defoe reasoned, the devil acted in the world by possessing persons or agitating objects, but on occasion he could also take appearance "in borrowed shapes and bodies, or shadows rather of bodies, assuming speech, figure, posture, and several powers."[87] The magic lantern makes an entrance where the means by which the devil propagates "his interest and kingdom" are discussed. Defoe described the lantern as

> an optic machine, by the means of which are represented on a wall in the dark, many phantasms and terrible appearances . . . by the help of several little painted pieces of glass, only so and so situated, placed in certain oppositions to one another, and painted with different figures.[88]

Defoe's description of the lantern resonated with how the devil could appear as shadows of bodies. Yet Defoe was quick to note that, although the device's projections were capable of "terrifying the spectators," there was "no devil in

all this." The magic lantern's apparitions belonged to a secular reality and bore no magic in any supernatural sense.

Defoe's take on optical projection coincided with his view on finance economy as an ambiguous and illusory perceptual realm: Both the magic lantern's light-borne images and speculative projections were a matter of "phantasms and appearances" unfixed from the yoke of the empirical. A salient point here was how Defoe, in an attempt to emphasize the paradoxical nature of projection in both optical and financial senses, quite likely unintentionally embraced the experiments on "parastatic magic" carried out by Jesuit scholars a few decades earlier. Kircher, we recall, deemed in the 1670s that the magic lantern's projections, which were populated by all sorts of devils, were "rare, curious, paradoxical and prodigious."[89] Among this list of attributes, as Stuart Clark points out (drawing on Rosalie Colie's work), the notion of "paradoxical" signified an indeterminate visual realm of optical effects designed to explore how certainty and uncertainty, truth and fiction, verisimilitude and dissemblance, were not mutually exclusive but compatible and even indistinguishable.[90] Here Kircher was indebted to a tradition of thought from the late Renaissance where the deceits of optical artifice were not divorced from logical and rhetorical paradox. "Deceits of the senses that are two things at once, two-or-more-in-one, are the parallel in natural philosophy of the verbal paradox of contradiction, since they raise and illustrate the same puzzles about the nature of perceived reality," Rosalie Colie notes.[91] Tautological, circular, self-contradictory, and regressive, both verbal and visual paradoxes eschew distinctions between being and non-being, the real and the virtual, or cause and effect.

Defoe fell back on a series of such paradoxical thought figures ("the essential Shadow of Something that is not," "gives Motion, yet it self cannot be said to Exist") in which the virtual and the real—what is a product of the imagination, and what bears some perceived substantiality—oscillated endlessly.[92] Defoe indeed invoked the powers of the paradox to declare something "to be what it manifestly is not," as Colie puts it.[93] Here, one could argue, Kircher's concept of projection haunted the fathoming of the ambiguous abstractions brought about by new speculative economic practices. For Kircher, the magic lantern was a technology of the imagination that externalized endogenous apparitions and invoked a realm of transformations—blurring cause and effect, inside and outside—the ambiguity of which, according to the Jesuit father,

imitated the work of God and therefore triggered divine presence in fearful souls. Defoe reiterated Kircher's notion of projected images—divested nonetheless of its religious underpinnings—as suggestive psychic forces when facing the enigmatic epistemological and ontological puzzles presented by the rise of finance. Simultaneously, Defoe's prose suggested a significant cognitive repositioning of the concept of projection: What previously appeared as God's prodigious workings were now considered as the process of the actualization of fantasies driving the speculative economy. In both instances, "projection" was a process that defied rationalization—but in the case of the latter, it had lost its heavenly supports. The perceptual as well as ontological ambiguity of projections ("Species of meer Air and Shadow") no longer (re)instated a providential economy of government, yet it alluded to an invisible and insoluble agency (which "gives Motion, yet it self cannot be said to Exist") behind appearances and occurrences.

The techno-aesthetic form of projection came to bear on Defoe's intuition of finance as a new kind of mental domain. In *The Great Mirror of Folly,* the magic lantern similarly functioned as a cognitive relay allowing one to tackle processes lacking a tangible shape (financial projection) through a perceptual phenomenon (optical projection). These fledgling parallels between the new medium of the magic lantern and the cognitive reality of finance were made more definite in an "Italian comedy" written by Denis Carolet from 1723, entitled "The Magic Lantern, or the Devil's Mississippi" (*La lanterne magique, ou le Mississippi du diable*). Set at the Butter Market in Amsterdam but commenting on the situation in France after the financial crash of 1720, the piece presents an allegorical parody of speculation, one that is conceptually close to Defoe's imagery. Credit, for instance, is characterized in the script as a deceitful agent producing visions, as a "kind of sorcerer who makes one see Treasures where they do not exist."[94]

The magic lantern plays a central figurative part in the parody. In the scene where Plutus and Fortune plot taking vengeance on humanity, there is a mysterious box brought by John Law (referred to as the "Scottish devil") to the god of wealth and passions. As the box is opened, "thick smoke" comes out of it, and "one sees emerge dreams and illusions, seductive charms and imposture who make up a dance," soon "interrupted by fraud, disorder, fright and despair."[95] The allusion in this passage to the use of a magic lantern is tangible: smoke rising from the top of the device and images streaming out of

the tube, resulting in a dance of apparitions. In the final scene of the play, the key character Harlequin imitates "the Savoyards with their Magic Lanterns" and projects a series of views, which everyone rushes to buy:

> Here's a Vessel charged with every imaginable Zero of which one can easily make millions by means of a piece of paper and enchanted ink; for two *liards*, two *liards*.
>
> Here's a bottle of the fountain of forgetting, which several people will be severely needing to drink in order to forget who they were; for two *liards*.
>
> Here are King Midas's hands, which still have the power to turn everything they touch into gold; for two *liards*. . . .
>
> Here's the Devil's master key to move money from one coffer to another; for two *liards*.
>
> Here are Letters of impunity, sent out to those who wish to file bankruptcy with honor; for two *liards*. . . .
>
> Here is a Bag of Algebra, or the art of withdrawing millions.[96]

The magic lantern's role in the play was primarily to lend a degree of intelligibility to processes that otherwise escaped comprehension: An observable realm of sensible shapes and forms was employed to tackle phenomena involving a high degree of abstraction. Financial innovations associated with Law—shares and fiat money—were explained (away) as "dreams and illusions" cast by the devil's black box. The Savoyards' lantern was given the task of exposing the financial market's modus operandi as the illusory conjuring of something out of nothing: The one who knew the secret of the optical artifice could also ideally see through the promises and prospects produced by financial projectors as misplaced materiality and deluded phantasy. The apparatus was ambiguously situated between obscurity and revelation, embodying and symbolizing an epistemological dilemma of enchantment and artifice within Law's "System" in which money, as Thomas Kavanagh puts it, became "a demiurgic force thriving on its own movement"[97]—like the seemingly self-propelling images emerging out of the magic lantern's tube of lenses.

It is relevant to point out here that in France Law's introduction of paper money and stock shares to revitalize the country's finances was received within a specific Catholic, sacramental framework. Charly Coleman shows how in the French context, the power of financial instruments to generate wealth seemingly miraculously was understood through the Eucharist where

simple bread became elevated into the real presence of Christ. At the same time, the Eucharist was associated with the alchemical notion of transmutation (referring, most simply, to the transformation of base metals into gold), due to how the doctrine of transubstantiation and alchemical science had informed one another since the Middle Ages. Banknotes and shares could become intelligible within a symbolic order where signs were thought to be capable of bringing about what they represented.[98]

The Cartesian philosopher and advocate of Law's methods, Abbé Terrasson, for example, wrote about the mystery of the Eucharist: "the mouth and the stomach really receive the true body and the true blood of Jesus Christ, and the soul is only truly satisfied and nourished when imitating it."[99] The real presence of Jesus Christ emanated from the host, and was incorporated into the body of the believer, filling the believer's soul with divine grace. The host was an "exceptional sign," as Coleman calls it, capable of storing and spreading the divine as well as effecting transformations. There was no requirement of iconic resemblance; rather, transubstantiation, as Coleman points out, "posited a total disjuncture between the appearance of these materials and their actual, divine nature."[100] Hence, the host could serve as a mysterious analogue for paper notes divorced from gold and silver and capable of transmitting as well as "transubstantiating" value. With banknotes, Terrasson put it plainly, one could "generate money."[101] Wealth was potentially infinite and appeared from nowhere like God's glory and power. The Dutch satirists in *The Great Mirror of Folly* did not dare to put Law in the place of God but portrayed him on more than one occasion as an alchemist overseeing the fires of transmutation where speculators throw their monies. "All or nothing," the banner in one illustration translates loosely ("shit or king," literally), suggesting, as Coleman notes, "a radical transformation of minds and bodies, through which 'Nothing' could give rise to 'All.'"[102]

Carolet's play dealt with this transformation by introducing further shape shifting: Law the alchemist became a devil operating an image projection device. An enigmatic apparatus conjuring magnified images from its interior stood for the invisible agency animating Law's "system." Projected images paralleled with paper notes, embodying the mystery of transformation in a palpable visual form. "Transmutation" was in fact one of the semantic aspects of the word "projection" (both in English and in French) during the period: projection meant the "moment of transmutation," we read in Johnson's

dictionary, or more precisely, as Denis Diderot and Jean le Rond D'Alembert's *Encyclopédie* describes it, the act of throwing a powdered substance, by means of a spoon equipped with a long handle, into a vessel on a fire containing other substances.[103] We recall how Carolet's Jesuit predecessors in Rome and elsewhere had attributed similar qualities of miraculous transformation to the magic lantern. For them, the optical apparatus participated in the providential effusion of divine light, which was not far removed from the sacramental symbolic order where exceptional and prodigious signs could be considered emanations of divine power.

Yet the magic lantern simultaneously held an ambiguous place in the Jesuit imaginary: The device could be employed to trick perception and machinate the imagination—to perceive devils, for example—and to generate *simulacra* and phantasms potentially devoid of contact with the holy. It was indeed in this latter sense that Carolet's magic lantern performed in his play. The apparatus's projections suggested a surface of contact between the finite and the infinite, the natural and the supernatural, but ultimately their role was to perform an act of sacrilege whereby transubstantiation was revealed to fall flat on the materiality of the "host," and the miraculous powers attributed to paper money or shares were exposed as bunk. The apparatus, in other words, mirrored the realization that the new economy was far from a providential realm of infinitely expanding wealth; instead, it was perhaps more akin to *simulacra* of the imagination put into endless circulation, which gilded (to paraphrase Hume) things and beings with its anticipatory designs but was fundamentally lacking a pre-established (rational) plan or the provenance of divine grace.

Coda: "Ducts and Modes"

"There is a hand much busier in human affairs than what we vainly calculate; which, though the projectors of this world overlook,—or at least make no allowance for in the formation of their plans, they generally find in the execution of them," Laurence Sterne asserted in a sermon of his, pitting the calculations for economic gain devised by human "projectors" against God's benevolent providential rule over the universe.[104] Assumptions that one's pursuits might be subjected to the blind forces of "time and chance" were, in Sterne's estimation, fundamentally unfounded. Although unbeknownst to us mortals, God's governing hand directed every fortune and loss, and every happiness and misery in this world (including unequal distributions of

wealth, according to Sterne) and made sense when placed within "the whole plan of [God's] infinite wisdom and goodness."[105] Sterne's was a late voice among those arising after the 1720 financial crisis that sought to reconcile the disorder of economic behavior with divine providence. During the crisis, as Sheehan and Wahrman point out, belief in divine guidance was losing its powers of explanation and assurance.[106]

Compare Sterne's vindication of how the concept of providence could explain away anxieties about the accidental and the irregular with the observations made in a short-lived satirical journal *The Director,* which was published in response to the South Sea Bubble: "The Laws of Nature . . . are govern'd by a most exact Sovereignty, and a regular Hand," the anonymous author of the journal announced, "that Consequences are obedient to their Causes and that the same Causes are, *generally speaking,* directly tending to the same Consequences." The workings of divine providence (God's sovereignty) could in other words be witnessed in the "steady and masterly" course of nature. Yet the same could not, *The Director* emphasized, be argued about the speculative economic and social sphere where "the Springs and Motions seem to be acted by Principles differing from these which we call Natural." Events within the financial realm were lacking legibility; "the secret *primum Mobile* of the Unaccountables" was yet to be "accounted for."[107] The way things happened remained impenetrable and unknown, owing to the lack of an established cognitive and conceptual frame. Both Sterne and the anonymous author of *The Director* grappled with the epistemic opacity of the new economic reality, voicing how things and processes resisted interpretation and conceptual grasp, but with sharply opposing conclusions. Whereas the former subsumed eventualities within a rational and graceful (even if indefinite) whole, the latter emphasized variability associated with the accidental and the uncertain ("the unaccountable"). For the latter, the link between causes and effects appeared as broken, or at least as undetermined and arbitrary. Events and affairs were not anchored to anything purportedly durable and solid, and therefore they had lost bearings and proportion.

As we have seen, if there was an optical impetus to the development of speculative economy as such a cognitive realm, it partly sprang from the magic lantern's system of lenses, mirrors, slides, and screens. While the speculative economy was operationalized primarily through the screening practices of numerical data collection and probabilistic and predictive calculation, the

magic lantern's projections (infused with movement, variation, and transformation) provided a key visual form for the disorientation faced by those witnessing the rise of finance: a paradoxical regime of shifting shapes where credulous spectators could not tell the actual origins of appearances, which seemed to arrive irregularly and inexplicably.

Through satirical responses (in both pictures and text) to the burst of financial bubbles in 1720, to Daniel Defoe's economic analyses, we saw how the magic lantern's problematization of appearance and agency spoke intimately to the new economy of credit and speculation, where it was not easy to tell the difference between the imaginary and the real, cause and effect, or even the natural and the supernatural. Here is one more example: The satirical treatise *Observations on the Spleen and Vapours* (1721), written under the pseudonym John Midriff, evoked the magic lantern's aesthetics in describing the South Sea Bubble as "a Monster like the Shadow magnify'd on the Wall by the Light of a Candle, which was no ways proportionable to its Object."[108] The anonymous author's point of reference here, when ridiculing the speculative economy's "distemper'd Imaginations," might have been all sorts of shadow plays prone to expanding and twisting (see Figure 7). However, the emphasis on disproportion and magnification of illusion strongly suggests contemporary accounts and illustrations of the magic lantern's projections where human profiles turned into demonic shapes when drawn into the apparatus's diabolical dramas (see Figure 34).

Thus, the magic lantern figured in early eighteenth-century thought and imaginaries tackling the rise of finance—anecdotal, ephemeral, and difficult to pin down, yet a potent metaphoric frame to make sense of a changing world. If, since its inception, the device was contrived to conjure illusions of "wand'ring Spirits and Phantoms" (to quote Charles Patin's description of Johannes Franz Griendel's show from the 1670s), these projections now also could be analogues to account for fledgling modern economic experiences. Crucially, the lantern's projections of spirits came to mark a cognitive disconnect, whereby the equivalence between signs and their origins, previously ensured by divine providence, was challenged. If indeed some could entertain the magic lantern's projections as allusions of divine presence in worldly affairs—like Kircher's evocations of purgatory implementing a theology of fear, Wagner's concept of projection as the path to salvation, or Ehrenberger's simulation of God's governing hand brought into motion by means of

invisible cogwheels and rods—for others the apparatus's tricky visuals suggested disequilibrium and disproportion, unhinged from a transcendent design. The magic lantern's aesthetics of invisible agency embodied perceptual and epistemic disorientation and uncertainty (akin to *The Director's* evocation of "the secret *primum Mobile* of the Unaccountables"): The cause of things coming and going, surging and disappearing suddenly, seemed as obscure as the hidden manipulations of the artifice, and distinctions between true and false were as ephemeral and chimeric as the fleeting shadows projected on the screen.

At issue here was what kind of a hidden rationality, if any at all, one could attribute to sudden and capricious movements and excessive effects; what kinds of invisible powers were driving volatile and disorderly pursuits of wealth and happiness, and how they could be known. Suffice to note that new kinds of understandings of order, rationality, and organization—even if speculative and vague—started to emerge around the 1720 financial crisis, ones that challenged the old providence concept but at the same time surpassed initial critical assessments (such as Defoe's) of finance as merely driven by unruly and tumultuous imaginations akin to devilish projected images. Sheehan and Wahrman analyze how during the 1720s a diverse group of thinkers emerged—from Bernard Mandeville to Montesquieu and to even John Law himself—who no longer regarded chance effects and accidents as necessarily opposed to stability, and who entertained the fledgling idea that unpredictable and random behavior could itself serve as a basis for aggregate order. From the aftermath of the financial crisis, a concept of self-organization started to develop as an alternative to the binary between unfathomable disorder and pre-established providential plan, according to which temporary design could immanently emerge from seemingly random occurrences. The 1720s, Sheehan and Wahrman argue, was an early "historical juncture in Western Europe in which self-organization emerged as a recognizable cultural phenomenon; that is to say, the scene of a significant cluster of speculative ruminations about the emergence of aggregate high-level self-organizing order from lower-level disorder."[109]

Here, let us focus briefly on only one example: Isaac Gervaise, a Huguenot businessman based in England, who implied a nascent concept of self-organization in his economic theory of credit published anonymously in 1721. Gervaise, who had discussed the self-regulatory mechanisms of

international trade in his 1720 book *The System or Theory of the Trade of the World*, was concerned with how the circulation of credit could be restored on more secure and healthy foundations after the loss of investor confidence brought about by the South Sea Bubble. Credit, according to Gervaise, "may be led, but cannot be drove."[110] The merchant's sentiment was that top-down legislative or administrative attempts at managing the credit economy's ups and downs were fundamentally futile. "Credit, however it is sunk," Gervaise wrote, "can, from its Nature, only rise, with a general Care and Industry, by its own Ducts and Modes."[111] Therefore, the development of credit could only be "encouraged," rather than forced, by "setting it in a flourishing Condition."[112] To this effect, Gervaise's main proposal was to establish a public land registry of legally certified titles, which would enable the securitization of potentially volatile "Paper-Credit" on "Tracts of Land." But apart from this "Foundation Stone" laid by legislature, Gervaise envisioned, "the rest will be perfected by a Machine, which will move it self," and the credit economy's "Superstructure will not want any other Assistance in raising."[113]

Noteworthy in Gervaise's account is how it didn't resort to the common tropes of the supernatural or the phantasmatic in explaining the sudden rises and falls in the value of intangible possessions, but suggested, as Sheehan and Wahrman point out, "a remarkably clear economic vision" about "the self-organizing emergence of aggregate order, tending without external intervention to the public good."[114] In contrast to Defoe's bafflement about the speculative economy's "Species of meer Air and Shadow," Gervaise was able to maintain some cognitive distance and insist on the epistemic accessibility of finance, by asserting the naturalness of what he perceived as credit's self-movement occurring according to its "own Ducts and Modes." In Gervaise's treatment, the expectations and speculations fueling this economy—which were materialized in "all Sorts of Bankers, or Goldsmiths Notes, as well as Bank-Notes, all Sorts of Promissory-Notes, and Bills of Exchange"[115]—were not relegated to artificial and deceptive (and therefore devilish) "Visions and Apparitions" (to borrow Defoe's words), but expected to settle themselves spontaneously into cohesive arrangements that were no less tangible than anything else in this world. To this effect, however, Gervaise felt the need to anchor credit to something empirically verifiable—that is, to "Land Securities" inscribed in public registries. Here, Gervaise's gesture was in a sense to reassert perceptual points of reference based on distinctions between figure

and ground—movements and fluctuations juxtaposed against a durable background—that the financial revolution had uprooted, but with a new kind of understanding of intelligible patterns emerging immanently out of movements and fluctuations themselves. This was an alternative kind of perceptual regime based on the conviction that order and design would arise from what initially appeared as merely random and whimsical.

In concluding, it is tempting to draw a rough but potentially telling comparison between Gervaise's theory of credit written after the burst of the South Sea Bubble and Joseph Addison's experiences inside the Greenwich camera obscura from about ten years earlier. On the camera obscura's screen, we recall, Addison experienced the world miniaturized into its own moving image, which provided a new kind of perceptual grasp of nature's complex, spontaneous unfolding. This colorful animated surface full of detail and variation presented neither a world degenerated into (private or collective) phantasms nor one ordered and governed by higher supernatural powers, but one where, according to Addison, "Effects of Design" grew naturally from "what we call the Works of Chance." On the Greenwich camera obscura's screen, fleeting figures didn't suddenly emerge from nowhere, blurring one's spatial points of reference, but were discernible from their grounding, enabling cognitive grasp of things and processes outside the artifice. Yet what is more, on this screen, fluctuation and order, variety and structure, were not mutually exclusive. Complex movements ("Green Shadows of Trees, waving to and fro with the Wind"), when combined with a degree of perceptual detachment inside the apparatus's dark surroundings, enabled one to enjoy the internal coherence and intelligibility of what appeared as fleeting and ephemeral. Like the "ducts and modes" of credit, movements projected inside the dark room followed their own nature—a second nature perhaps. Common to both Addison's and Gervaise's appreciations, however different in purpose, was an intuition of the world as coming about of its own accord—an intuition that, ever since Kepler's initial experiments since the early 1600s, could be primarily located on the camera obscura's projective surface where the world seemed to arrange itself spontaneously into sensible, transitory shapes.

EPILOGUE

The turn of the seventeenth century signaled a particular historical junc-
ture where the institution of divine harmony in the world and God's care of
human history gradually shifted into a reality of contingencies, which pre-
sented unforeseeable risks as well as unprecedented opportunities: where the
divine plan gave way to a spontaneous but fundamentally insecure organiza-
tion, and the privilege of knowing the future was wrested from God by pro-
jecting minds that turned the world into its speculative image.

The previous chapters sought to demonstrate the place and meaning of the
period's dominant optical media—camera obscuras and magic lanterns—in
this process. "Projection" as both a techno-aesthetic practice and a concur-
rent cognitive form marked a particular threshold of modernity expressed
by changing relations between contingency and organization. On one side,
this involved a transition with which we are familiar: from theological models
of interpretation and influence, based on the divine manufacture of miracles
and sensory deceits, to modern science's claims for objectivity and the fac-
tual and its program for the domination and "improvement" of things and
beings. Images cast inside the camera obscura, in particular, shifted from
natural executors of divine rule to mechanical (and, therefore, purportedly
objective) informants about the aleatory empirical world. On the other side,
however, the history of optical media does not lend itself to a straightforward
narrative of disenchantment. The spirits conjured by the Jesuits by means of

their apparatuses of parastatic magic reappeared in attempts at grappling with the cognitive and socioeconomic disorder brought about by new capitalist ventures premised on speculation and credit. What appears as a program of rationalization from one angle, comes across, from another angle, as a rewriting of the providence-problematic in relation to the unfathomably contingent and spontaneous processes of speculative capitalism, seemingly beyond the reach of human control and comprehension.

Although it coincided with the rise of modern science as well as economic relations, the history of camera obscuras and magic lanterns outlined above was thus not simply a purposeful progression from a world of superstition and belief to a world of rationality and knowledge. It did not simply spell the discovery of the "real" but rather different, even if concurrent and mutually implicated, modes of virtualization. Otherwise put, the techno-aesthetic form of optical projection provided an important intellectual frame of reference for a series of abstractions, each equally (ir)rational in its own way. At the turn of the seventeenth century, "projection" symbolized, at a minimum: (1) the theocratic abstraction of the world under divine light and providential care; (2) the epistemic abstraction of things and beings into "data" and objects of appropriation ("property"); and (3) the economic abstraction of things and relations into speculative mental designs in the processes of financialization. In each of these instances, optical projection afforded shadowy and virtualizing frames within which the world could be referenced with respect to the not (yet) realized. Optical projection, in other words, instantiated the critical visual economy of these dissimilar yet equally expansive and colonizing frames, which yoked visible effects with invisible powers. The Jesuits' planetary mission of converting souls, the English project of expanding networks of knowledge and trade, and the rise of speculative capitalism all involved, and even necessitated, a centrifugal visual system where distributions of light and shadow provided cognitive relays to virtualize physical and mental realities within an ideally growing system of government and/or profitability.

Although each of these historical processes of abstraction would merit a more detailed genealogy of its own, let's briefly highlight the one with the most contemporary repercussions, concerning the rise of finance and the colonization of time as an (imaginary) source of potentially infinite wealth. We

have seen how the magic lantern's artificial realities helped in coming to terms with the early development of today's massive and triumphant form of capitalism that crunches basically anything into bits and pieces within its system of evaluation and accumulation, contributing to making sense of the "ghostification" of economic relations brought about by finance in its early days. Here, importantly, were laid the conceptual foundations for later attempts at understanding the operations of financial economy. Consider how Karl Marx drew on the ideas of optical projection and virtualization in a series of notes and remarks published in 1894 as part of the third volume of *Capital*, which focused on the development of bank credit, public debt, and shares.[1] Marx outlined a process of abstraction whereby the value of securities became more and more speculative the more the securities circulated in the market. For instance, shares in shipping companies, Marx noted, initially represented real capital (the capital invested in these companies), but through the process of being sold from one investor to another and yet to another, and so on, the value ascribed to the shares lost its connection with the original investment and became instead determined based on the investors' predictions about future revenues (on those shares themselves). What, in other words, according to Marx gave rise to speculative capital was valorization detached from productive activity per se and based instead on the anticipation of future accumulation. Crucially, Marx observed how "everything in this [financial] system appears in duplicate and triplicate, and is transformed into a mere phantom of the mind."[2] What Marx (following Charles Jenkinson) deemed "fictitious capital" was but the mind's projection, a product of desire and fantasy, a mere mirage transposed onto real relations.

The implicit media reference in Marx's characterization of speculative capital—"brain phantoms" (*Hirngespinst*, in the original German[3])—was the art of magic lantern projections that the philosopher famously also evoked when discussing the nature of commodities. The commodity, Marx wrote, "is nothing but the definite social relation between men themselves which assumes here, for them the fantastic [*phantasmagorische*] form of a relation between things."[4] With his choice of terminology, Marx evoked the phantasmagoria shows popularized by a Belgian physicist and magician Étienne-Gaspard Robert (or Robertson, which was his stage name), from the 1780s onward in France. In an abandoned Capuchin convent in Paris—which was, ironically perhaps, located near the residence that John Law

owned for a brief period of time on the Place Vendôme in the late 1710s—
Robertson "call[ed] forth phantoms" and "command[ed] ghosts" by means
of optical media.[5] With a range of visual effects—dark surroundings, mir-
rors, movable magic lanterns, black backgrounds of magic lantern slides, back
projections, projections on hidden screens, smoke, and so on—Robertson
staged spirit-shows that had a powerful emotional grip on their beholders,
exploiting in particular, as he expounded, involuntary fears and "religious
terror."[6] The screen was not lowered until the audience was seated and the
lights were dimmed; in this way, the spectators were lacking a spatial frame
for the projections, which seemed to be hanging in air indeed like supernatu-
ral "bubbles." Phantasmagoria shows were first and foremost meant to trigger
and exploit the "strange effects of the imagination," as Robertson put it.[7]

Phantasmagoric magic lantern projections, as Stefan Andriopoulos
shows, enjoyed a specific place and meaning in late eighteenth-century
epistemological discussions about sensory perception and the limits of
knowledge, particularly in Immanuel Kant's description of a subject "that
projects its forms of intuition onto the external world and that is inclined to
mistake subjective ideas for objectively given substances."[8] The magic lantern
embodied the mind's tendency to confound subjective ideas and imagina-
tions with material objects, the endogenous with the exogenous. This is also
the key idea behind Marx's analysis of the accumulation and circulation of
financial capital. The *Hirngespinste*—"brain phantoms," loosely translated—
that Marx used to characterize the logic of speculation echoed Kant, who
was tackling how the ghostly visions of spirit-seers were formed, how indeed
the soul transposes "such an image, which it ought, after all, to represent as
contained within itself, into quite a different relation, locating it, namely, in
a place *external* to itself."[9] In Marx's analysis, financial "projectors" equated
with spirit-seers—seers whose visions Kant explained with reference to opti-
cal effects.[10] Optical tricks with mirrors and magic lanterns, in other words,
served to make sense of perceptual and epistemic distortions, which in turn
became symbolic of the workings of finance capitalism.

Marx's understanding of speculative capitalism was indebted to two hun-
dred years of development, not only in economics and philosophy, but also
in optical media. Robertson's phantasmagoria shows took their inspiration
from Athanasius Kircher and his fellow Jesuit scholars.[11] The very notion
of finance as optical illusion was first formulated by Defoe and others with

reference to the magic lantern during the early eighteenth century. To be sure, such conceptual displacements from the past may seem irrelevant to present-day speculative economic practices, which appear to have become altogether divorced from the slow pace of human cognition, being driven instead by algorithms that crunch and manipulate numerical data circulating in optical fiber networks at infinitesimal speeds. Yet, if Marx was right, a certain process of perceptual and cognitive abstraction by which forms of property could dissolve into flows of capital was needed for such processes to function in the first instance. To arrive there, some optical adjustments were needed that could reinforce (if not realize) one's more-than-human dreams of infinite accumulation—adjustments that took place at the turn of the seventeenth century, when the world projected by camera obscuras and magic lanterns ceased to appear as a visual emanation of God's sovereignty and care and became instead a place of profitable knowing and speculating.

Notes

Preface

1. See, e.g., the treatise on "dioptrical vision" by the Capuchin friar and optical instrument maker Chérubin D'Orléans, *Dioptrique Oculaire, ou la Théorique, la positive, et la méchanique de l'oculaire dioptrique en toutes ses espèces* (Paris, 1671), 22–23.

2. Siegfried Zielinski, "Designing and Revealing: Some Aspects of a Genealogy of Projection," trans. Gloria Custance, in *Variations on Media Thinking* (Minneapolis: University of Minnesota Press, 2019), 339–376, see especially 342–345.

3. Hans Blumenberg, *The Legitimacy of the Modern Age*, trans. Robert M. Wallace (Cambridge, MA: MIT Press, 1983), 373.

4. Francesco Algarotti, *An Essay on Painting* (London, 1764), 66.

5. See, respectively, Martin Kemp, *The Science of Art: Optical Themes in Western Art from Brunelleschi to Seurat* (New Haven: Yale University Press, 1990), 188–217; Svetlana Alpers, *The Art of Describing: Dutch Art in the Seventeenth Century* (Chicago: University of Chicago Press, 1983), see especially 1–25; Jonathan Crary, *Techniques of the Observer: On Vision and Modernity in the Nineteenth Century* (Cambridge, MA: MIT Press, 1990), 25–66; Jill H. Casid, *Scenes of Projection: Recasting the Enlightenment Subject* (Minneapolis: University of Minnesota Press, 2015), 35–87.

6. See, e.g., Raz Chen-Morris, *Measuring Shadows: Kepler's Optics of Invisibility* (University Park: Pennsylvania State University Press, 2016); Stuart Clark, *Vanities of the Eye: Vision in Early Modern European Culture* (Oxford: Oxford University Press, 2007); Ofer Gal and Raz Chen-Morris, "Baroque Optics and the Disappearance of the Observer: From Kepler's *Optics* to Descartes' *Doubt*," *Journal of the History of Ideas* 71, no. 2 (2010): 191–217; Wolfgang Lefèvre, ed., *Inside the Camera Obscura: Optics and Art Under the Spell of the Projected Image* (Berlin: Max Planck Institute for

the History of Science, 2007); Eileen Reeves, *Evening News: Optics, Astronomy, and Journalism in Early Modern Europe* (Philadelphia: University of Pennsylvania Press, 2014), 135–205; Koen Vermeir, "Athanasius Kircher's Magical Instruments: An Essay on 'Science,' 'Religion,' and Applied Metaphysics," *Studies in History and Philosophy of Science* 38, no. 2 (2007): 363–400; Koen Vermeir, "The Magic of the Magic Lantern (1660–1700): On Analogical Demonstration and the Visualisation of the Invisible," *British Journal for the History of Science* 38, no. 2 (2007): 127–159.

7. See, e.g., Laurent Mannoni, *The Great Art of Light and Shadow: Archaeology of the Cinema*, trans. and ed. Richard Crangle (Exeter: University of Exeter Press, 2000); Charles Musser, *The Emergence of Cinema: The American Screen to 1907*, vol. 1 (Berkeley: University of California Press, 1990), 15–24; Deac Rossell, *Laterna Magica / Magic Lantern*, vol. 1 (Stuttgart: Füsslin, 2008). See also Friedrich Kittler, *Optical Media: Berlin Lectures 1999*, trans. Anthony Enns (Cambridge: Polity Press, 2010).

8. See Stefan Andriopoulos, *Ghostly Apparitions: German Idealism, the Gothic Novel, and Optical Media* (New York: Zone Books, 2013); Terry Castle, "Phantasmagoria: Spectral Technology and the Metaphorics of Modern Reverie," *Critical Inquiry* 15, no. 1 (1988): 26–61.

9. Sean Silver, *The Mind Is a Collection: Case-Studies in Eighteenth-Century Thought* (Philadelphia: University of Pennsylvania Press, 2015), 269.

10. "Projecting," for Defoe, as Kimberly Latta puts it, "was an act of throwing forward into the future for the sake of moving forward and taking risks, rather than for the sake of returning to a teleological origin—God the Father, truth, the state, the common good—that tradition constructed as the proper end (telos) of all human activity." Kimberly Latta, "'Wandring Ghosts of Trade Whymsies': Projects, Gender, Commerce, and Imagination in the Mind of Daniel Defoe," in *The Age of Projects*, ed. Maximillian E. Novak (Toronto: University of Toronto Press, 2008), 141–165, quotation on 142.

11. Thomas Aquinas, *On the Truth of the Catholic Faith (Summa Contra Gentiles)*, vol. 3: *Providence*, part 2, trans. Vernon J. Bourke (New York: Image Books, 1956), 42 (3.92.2).

12. See Kittler, *Optical Media*, 70.

13. Marie-José Mondzain, *Image, Icon, Economy: The Byzantine Origins of the Contemporary Imaginary*, trans. Rico Franses (Stanford: Stanford University Press, 2005).

14. See Giorgio Agamben, *The Kingdom and the Glory: For a Theological Genealogy of Economy and Government*, trans. Lorenzo Chiesa (Stanford: Stanford University Press, 2011), 17–52.

15. Mondzain, *Image, Icon, Economy*, 2–3.

16. See Michael Birch, *Establishing the New Science: The Experience of the Early Royal Society* (Woodbridge: Boydell Press, 1989), 1.

17. Devin Singh, *Divine Currency: The Theological Power of Money in the West* (Stanford: Stanford University Press, 2018), see especially 27–56.

18. See, among others, Jean-Louis Baudry, "Ideological Effects of the Basic Cinematographic Apparatus," trans. Alan Williams, *Film Quarterly* 28, no. 2 (1974–1975): 39–47; and Stephen Heath, "Narrative Space," *Screen* 17, no. 3 (1968): 68–112. For a recent reassessment of the notion of projection in cinema and beyond, see Virginia Crisp and Gabriel Menotti, ed., *Practices of Projection: Histories and Technologies* (Oxford: Oxford University Press, 2020).

19. Karl Marx and Friedrich Engels, *The German Ideology* (New York: Prometheus Books, 1998), 42. On the metaphor of the camera obscura in nineteenth-century thought, from Marx to Sigmund Freud and Friedrich Nietzsche, see Sarah Kofman, *Camera Obscura of Ideology*, trans. Will Straw (Ithaca: Cornell University Press, 1998).

20. Jean Laplanche and Jean-Bertrand Pontalis, *The Language of Psycho-analysis*, trans. Donald Nicholson-Smith (London: Karnac Books, 1988), 354.

21. Ibid., 352. For a thorough psychoanalytically oriented analysis of early optical media, see Casid, *Scenes of Projection*, 35–87.

22. Castle, "Phantasmagoria."

Chapter 1

1. Peter Fuhring, Louis Marchesano, Rémi Mathis, and Vanessa Selbach, ed., *A Kingdom of Images: French Prints in the Age of Louis XIV, 1660–1715* (Los Angeles: Getty Research Institute, 2015), 144. On Leclerc and the Academy, see E. C. Watson, "The Early Days of the Académie des Sciences as Portrayed in the Engravings of Sébastien Le Clerc," *Osiris* 7 (1939): 556–587.

2. Perrault's plan is reproduced in Jean-Baptiste Colbert, *Lettres, instructions et mémoires de Colbert*, vol. 5: *Fortifications, sciences, lettres, beaux-arts, bâtiments*, ed. Pierre Clément (Paris, 1868), 512–514.

3. For an analysis of the different scholarly disciplines represented in Leclerc's illustration, see Fuhring et al., *A Kingdom of Images*, 144.

4. See Anita Guerrini, "Counterfeit Bodies: Sébastien Leclerc, Anatomy, and the Art of Copying at the Paris Academy of Sciences," *Word & Image* 35, no. 3 (2019): 277–295, see especially 279.

5. Blaise Pascal, "De l'esprit géométrique et de l'art de persuader," in *Oeuvres complètes*, vol. 3 (Paris: Hachette, 1871), 164.

6. John Bender and Michael Marrinan, *The Culture of Diagram* (Stanford: Stanford University Press, 2010), 23.

7. René Descartes, *Discours de la méthode, pour bien conduire sa raison, & chercher la verité dans les sciences; plus La dioptrique, Les météores, et La Géométrie* (Leiden, 1637), 46–50.

8. Sébastian Leclerc, *Discours touchant le point de vue* (Paris, 1719), 39–53, quotation on 53 (my translation).

9. Sébastien Leclerc, *Système de la vision, fondé sur de nouveaux principes* (Paris, 1712), 2 (my translation).

10. Leclerc, *Discours touchant le point de vue*, 78 (my translation).

11. See Hans Belting, *Florence and Baghdad: Renaissance Art and Arab Science*, trans. Deborah Lucas Schneider (Cambridge, MA: Harvard University Press, 2011), 90–128. Belting points out how Abu Ali al-Hasan Ibn al-Haytham's (known in the West as Alhazen) theory of perception, embedded in its cultural milieu, did not include a concept of picture as a figurative reproduction of bodies between the eye and the object—appearances, insofar as they weren't purely mental products and therefore non-existent and imaginary, were rather considered just as abstract and geometrical as the operations of light.

12. Daniele Barbaro, *La pratica della perspettiva* (Venice, 1569), 192–193.

13. Entry "obscura, camera" in John Harris, *Lexicon technicum; or, an Universal English Dictionary of Arts and Sciences*, vol. 1, 2nd ed. (London, 1708), n.p.

14. Algarotti, *An Essay on Painting*, 61–63. Compare Martin Kemp's account of how the camera obscura "produces condensed enhancement of tone and color, providing subtle intensification without harshness or glare. Nuances of light and shade which seem too diffuse or slight to register in the original scene are somehow clarified, and tonal effects gain a new degree of coherence. The shapes of forms, miniaturized in such a way that they seem to be condensed to their very essence, acquire a crystalline clarity. Striking juxtapositions of scale at different planes, which we remain largely unconscious in the actual scene, become compellingly apparent." Martin Kemp, *The Science of Art: Optical Themes in Western Art from Brunelleschi to Seurat* (New Haven: Yale University Press, 1990), 193.

15. "A veil loosely woven of fine thread, dyed whatever color you please," Alberti famously described the structure, "divided up by thicker threads into as many parallel square sections as you like, and stretched on a frame. I set this up between the eye and the object to be represented, so that the visual pyramid passes through the loose weave of the veil." Leon Battista Alberti, *On Painting and On Sculpture*, trans. and ed. Cecil Grayson (London: Phaidon Press, 1972), 69.

16. Albrecht Dürer, *Unterweysung der Messung, mit dem Zirckel und Richtscheyt, in Linien, Ebnen und Gantzen Corporen* (Nuremberg, 1538); Jean Dubreuil, *Perspective Practical, or, A Plain and Easie Method of True and Lively Representing All Things* (London, 1672), 121.

17. Erwin Panofsky, "Dürer as a Mathematician," in *The World of Mathematics*, ed. James Newman, vol. 1 (London: George Allen and Unwin, 1956), 603–619, quotation on 610.

18. Abraham Bosse, *Le Peintre converty aux précises et universelles règles de son art* (Paris, 1667), 10–11. See also Hubert Damisch, *The Origin of Perspective*, trans. John Goodman (Cambridge, MA: MIT Press, 1994), 150.

19. Bosse, *Le Peintre converty*, 51.

20. William M. Ivins, Jr., *Art and Geometry: A Study in Space Intuitions* (New York: Dover, 1964), 69.

21. George L. Hersey, *Architecture and Geometry in the Age of the Baroque* (Chicago: The University of Chicago Press, 2000), 157.

22. See Girard Desargues, "The *Perspective* (1636)," in J. V. Field and J. J. Gray, *The Geometrical Work of Girard Desargues* (New York: Springer, 1987), 144–160. The original title of Desargues's treatise reads: "Exemple de l'une des manieres universelles du S. G. D. L. touchant la pratique de la perspective sans emploier aucun tiers point, de distance ny d'autre nature, qui soit hors du champ de l'ouvrage." On Desargues, see also Damisch, *The Origin of Perspective*, 50; Hersey, *Architecture and Geometry in the Age of the Baroque*, 168–171.

23. Hersey, *Architecture and Geometry in the Age of the Baroque*, 170–171.

24. See Girard Desargues, "The *Rough Draft on Conics* (1639)," in J. V. Field and J. J. Gray, *The Geometrical Work of Girard Desargues*, 69–143.

25. See Gilles Deleuze, *The Fold: Leibniz and the Baroque*, trans. Tom Conley (London: Continuum, 2006), 22.

26. Michel Serres, *Le système de Leibniz et ses modèles mathématiques* (Paris: P.U.F., 1968), 693 (my translation).

27. On Bosse and the controversy about the application of rules of perspective at l'Académie Royale de Peinture et de Sculpture, see Paul Duro, *The Academy and the Limits of Painting in Seventeenth-Century France* (Cambridge: Cambridge University Press, 1997), 174–180.

28. On Leclerc's collection of instruments and machines, see Maxime Préaud, "Le cabinet de Sébastien Leclerc," *Nouvelles de l'Estampe*, no. 249 (2014): 19–49.

29. For a history of anamorphic images, see Jurgis Baltrušaitis, *Anamorphic Art*, trans. W. J. Strachan (New York: Harry N. Abrams, 1977); Hanneke Grootenboer, *The Rhetoric of Perspective: Realism and Illusionism in Seventeenth-Century Dutch Still Life Painting* (Chicago: University of Chicago Press, 2005), 100–110; Fred Leeman, *Hidden Images: Games of Perception, Anamorphic Art, Illusion, from the Renaissance to the Present*, trans. Ellyn Childs Allison and Margaret L. Kaplan (New York: Harry N. Abrams, 1976), see especially 10–15; Lyle Massey, *Picturing Space, Displacing Bodies: Anamorphosis in Early Modern Theories of Perspective* (University Park: Pennsylvania State University Press, 2007).

30. Jean-François Niceron, *La perspective curieuse* (Paris, 1651), 89.

31. Massey, *Picturing Space*, 56.

32. Ibid., 66, 68.

33. On Huygens as the inventor of the magic lantern, see Laurent Mannoni, *The Great Art of Light and Shadow: Archaeology of the Cinema*, trans. and ed. Richard Crangle (Exeter: University of Exeter Press, 2000), 38–45.

34. Christiaan Huygens to Lodewijk Huygens (5 April 1662), in Huygens, *Oeuvres complètes*, vol. 4: *Correspondance 1662–1663* (The Hague: Martinus Nijhoff, 1891), 102. On Huygens's attitude toward his invention, see Jill H. Casid, *Scenes of Projection: Recasting the Enlightenment Subject* (Minneapolis: University of Minnesota Press, 2015), 55–56.

35. William Molyneux, *Dioptrica Nova: A Treatise in Dioptricks* (London, 1692), 183.

36. Charles Patin, *Travels thro' Germany, Swisserland, Bohemia, Holland, and Other Parts of Europe* (London, 1697), 233.

37. Jean Pierquin, "Reflexions philosophiques de M. Pierquin, sur l'évocation des morts," in Nicolas Lenglet Dufresnoy, *Recueil des dissertations anciennes et nouvelles, sur les apparitions, les visions et les songes*, 2 vols. (Avignon, 1752), 2.1: 144–150, quotation on 147. See also Stuart Clark, *Vanities of the Eye: Vision in Early Modern European Culture* (Oxford: Oxford University Press, 2007), 220.

38. Hersey, *Architecture and Geometry in the Age of the Baroque*, 60–62, 158, 170–171.

39. Serres, *Le système de Leibniz*, 655.

40. Ibid., 244 (my translation).

41. See Deleuze, *The Fold*, 20.

42. W. J. T. Mitchell, *Image Science: Iconology, Visual Culture, and Media Aesthetics* (Chicago: University of Chicago Press, 2015), 18–19.

43. "[Deus] omnia dirigit, conservat, et movet summa providentia." Roger de la Rochefoucauld, *Deo adjuvante: Theses philosophicae* (Paris, 1707), 7.

44. Sébastien Leclerc, *Nouveau système du monde, conforme à l'écriture sainte*, revised ed. (Paris: Pierre Emery, 1708), 6–7. On Leclerc's system, see Rémi Matthis, Jacques Gapaillard, and Colette Le Lay, "Quand un graveur veut se faire savant: *Le Nouveau système du monde* de Sébastien Leclerc," *Nouvelles d'estampe*, no. 257 (2016): 29–41; Oded Rabinovich, "Learned Artisan Debates the System of the World: Le Clerc Versus Mallemant de Messange," *British Journal for the History of Science* 50, no. 4 (2017): 603–636.

45. Gottfried Wilhelm Leibniz, "Drole de pensée," in *Sämtliche Schriften und Briefe*, vol. 4: *Politische Schriften*, part 1: 1667–1676, 3rd ed. (Berlin: Akademie Verlag, 1983), 562–568 (no. 49).

46. Deac Rossell, "Leibniz and the Lantern," *New Magic Lantern Journal* 9, no. 2 (2002): 25–26, quotation on 26.

47. Leibniz, "Drole de pensée," 564. On Leibniz and Griendel, see Deac Rossell,

"The Origins of the Magic Lantern in Germany: An Example of the Use and Misuse of Technological Argument in Media History," in *Die Medien und ihre Technik: Theories-Modelle-Geschichte*, ed. Harro Segeberg (Marburg: Schüren Verlag, 2004), 221–234.

48. Leibniz, "Drole de pensée," 567–568.

49. Horst Bredekamp, *Die Fenster der Monade: Gottfried Wilhelm Leibniz' Theater der Natur und Kunst*, 2nd ed. (Berlin: Akademie Verlag, 2008), 71–73.

50. See the French translation, Samuel van Hoogstraten, *Introduction à la haute école de l'art de peinture*, trans. Jan Blanc (Geneva: Librairie Droz, 2006), 399–400. Dutch original in Samuel van Hoogstraten, *Inleyding tot de hooge schoole der schilderkonst: Anders de zichtbaere werelt* (Rotterdam, 1678), 259–260.

51. Van Hoogstraten, *Introduction à la haute école de l'art de peinture*, 404; van Hoogstraten, *Inleyding*, 264.

52. Gilles Deleuze, *Cinema 2: The Time-Image*, trans. Hugh Tomlinson and Robert Galeta (Minneapolis: University of Minnesota Press, 1997), 126.

53. Bredekamp, *Die Fenster der Monade*, 79.

54. Gottfried Wilhelm Leibniz, *Theodicy: Essays on the Goodness of God, the Freedom of Man and the Origin of Evil*, trans. E. M. Huggard (La Salle: Open Court, 1985), 357.

55. Gottfried Wilhelm Leibniz, *Monadology: A New Translation and Guide*, trans. and ed. Lloyd Strickland (Edinburgh: Edinburgh University Press, 2014), 18 (§21), 26 (§60). For Leibniz, the study of optical mutations and movements in projective geometry facilitated the comprehension of higher properties of the universe. On this point, see Pierre Costabel, "Traduction française de notes de Leibniz sur les 'Coniques' de Pascal," *Revue d'histoire des sciences et de leurs applications* 15, no. 3–4 (1962): 253–268, see especially 265. See also Valérie Debuiche, "L'invention d'une géométrie pure au 17e siècle: Pascal et son lecteur Leibniz," *Studia Leibnitiana* 48, no. 1 (2016): 42–67.

56. Leibniz, *Monadology*, 25 (§57).

57. See Bredekamp, *Die Fenster der Monade*, 81–84. Cf. Leibniz's discussion of anamorphosis in Leibniz, *New Essays on Human Understanding*, trans. and ed. Peter Remnant and Jonathan Bennett (Cambridge: Cambridge University Press, 1996), 258 (bk. 2, chap. 29, §8).

58. Gottfried Wilhelm Leibniz, "Précepts pour avancer les sciences," in *Die Philosophischen Schriften*, 7 vols., ed. Karl Immanuel Gerhardt (Berlin: Weidmann, 1890), 7:157–173, quotation on 170. See also Deleuze, *The Fold*, 36.

59. Leibniz, *New Essays on Human Understanding*, 144 (bk. 2, chap. 11, §17).

60. Ibid., 177–178 (bk. 2, chap. xxi, §12).

61. Leibniz, *Theodicy*, 127.

62. Gottfried Wilhelm Leibniz, *De Summa Rerum: Metaphysical Papers, 1675–1676*, trans. G. H. R. Parkinson (New Haven: Yale University Press, 1992), 5 (463).

63. Bredekamp, *Die Fenster der Monade*, 108. "Every body," Leibniz wrote, "is affected by everything that happens in the universe, so much so that the one who sees all could read in each body what is happening everywhere, or even what has happened or will happen, by observing in the present that which is remote both in time and space." Leibniz, *Monadology*, 26 (§61).

64. Leibniz, *Theodicy*, 124, 128, 387.

65. Gottfried Wilhelm Leibniz, "*Discourse on Metaphysics*," in *Discourse on Metaphysics, Correspondence with Arnauld, and Monadology*, 2nd ed., trans. George R. Montgomery (Chicago: Open Court, 1918), 24 (§14).

66. Ibid., 23–24 (§14); Leibniz to Joachim Bouvet, S.J. (15 February 1701), in Gottfried Wilhelm Leibniz, *Der Briefwechsel mit den Jesuiten in China (1689–1714)*, ed. Rita Widmaier (Hamburg: Meiner, 2006), 310–312.

67. See Deleuze, *The Fold*, 169fn10.

68. Entry "projection" in *Le Dictionnaire de l'Académie françoise dedié au Roy*, 2 vols. (Paris, 1694), 1:584.

69. Entry "projection" in Antoine Furetière, *Dictionnaire universel*, vol. 3 (The Hague, 1690), n.p.

70. Entry "projection" in Samuel Johnson, *A Dictionary of English Language*, vol. 2 (London, 1756), n.p.

71. See Siegfried Zielinski, "Designing and Revealing: Some Aspects of a Genealogy of Projection," trans. Gloria Custance, in *Variations on Media Thinking* (Minneapolis: University of Minnesota Press, 2019), 339–376.

72. See Ansgar Lyssy, "Nature and Grace: On the Concept of Divine Economy in Leibniz's Philosophy," *Studia Leibnitiana* 48, no. 2 (2016): 151–177.

73. Thomas Aquinas, *On the Truth of the Catholic Faith (Summa Contra Gentiles)*, vol. 3: *Providence*, part 2, trans. Vernon J. Bourke (New York: Image Books, 1956), 66 (3.97.2).

74. See Giorgio Agamben, *The Kingdom and the Glory: For a Theological Genealogy of Economy and Government*, trans. Lorenzo Chiesa (Stanford: Stanford University Press, 2011), 133.

75. Jonathan Sheehan and Dror Wahrman, *Invisible Hands: Self-Organization and the Eighteenth Century* (Chicago: University of Chicago Press, 2015), 13.

76. On debates about providence in the social and economic thought of the seventeenth and eighteenth centuries, see also Jacob Viner, *The Role of Providence in the Social Order: An Essay in Intellectual History* (Princeton: Princeton University Press, 1972). Viner stresses the central role that the concept of providence played in the cognitive universe of the period, across Catholic and Protestant thinkers: "In the

seventeenth and eighteenth centuries, . . . it was for many men psychologically impossible to believe that God did not constantly have man in his providential care, and that the physical order of the cosmos was not one of the tools he had designed to serve that purpose" (ibid., 19).

77. Laurence Sterne, *The Works of Laurence Sterne*, vol. 3: *Sermons* (London, 1823), 79–80.

78. Pierre Bayle, *Various Thoughts on the Occasion of a Comet*, trans. Robert C. Bartlett (Albany: SUNY Press, 2000), 272 (§230), 276 (§234), 255 (§209).

79. John Locke, *An Essay Concerning Human Understanding*, 12th ed., 2 vols. (London, 1741), 2:272, 274–275 (bk. IV, chap. XIV, §§2–3).

80. Nicolas Malebranche, *De la recherche de la vérité*, in *Oeuvres complètes de Malebranche*, vol. 1 (Paris: De Sapia, 1837), 108–112, 324–329.

81. Jacques-Bénigne Bossuet, "Sermon sur la providence," in *Oeuvres complètes de Bossuet*, ed. F. Lachat, vol. 9 (Paris: Librairie de Louis Vivès, 1862), 161–177, see especially 163–165.

82. See Olivier Leplatre, "Spiritualité de l'anamorphose: *Le Carême du Louvre*, Bossuet," *L'information littéraire* 54, no. 4 (2002): 38–46, see especially 38–39.

83. Bossuet, "Sermon sur la providence," 164.

84. Leibniz, *Theodicy*, 216.

85. Athanasius Kircher, *Ars magna lucis et umbrae* (Rome: Hermann Scheus, 1646), 912.

86. [Joseph Addison and Richard Steele], *The Spectator*, no. 428 (11 July 1712), 8 vols. (London, 1744), 6:130.

87. Joseph Jackson, *A Discourse Concerning God's Foreknowledge and Man's Free Agency*, 4th ed. (London, 1713), 66, 57, 4, 42.

88. *The Spectator*, no. 191 (9 October 1711), 3:91.

89. On these two types of projection, see Sean Cubitt, *The Practice of Light: A Genealogy of Visual Technologies from Prints to Pixels* (Cambridge, MA: MIT Press, 2014), 202–217.

90. Christian Jacob, *The Sovereign Map: Theoretical Approaches in Cartography Throughout History*, trans. Tom Conley, ed. Edward H. Dahl (Chicago: University of Chicago Press, 2006), 2; on the cartographic grid, see 120–123.

91. Cubitt, *The Practice of Light*, 214. See, on this point, also Samuel Y. Edgerton, Jr., *The Renaissance Rediscovery of Linear Perspective* (New York: Harper & Row, 1975), 106–123.

92. Erwin Panofsky, *Perspective as Symbolic Form*, trans. Christopher S. Wood (New York: Zone Books, 1997), see especially 67–71. On linear perspective and cartography, see Edgerton, *The Renaissance Rediscovery of Linear Perspective*, 91–123. On painting and mapping, see also Svetlana Alpers, *The Art of Describing: Dutch Art in the Seventeenth Century* (Chicago: University of Chicago Press, 1983), 119–167.

93. Bernard Lamy, *A Treatise of Perspective; or, the Art of Representing All Manner of Objects as They Appear to the Eye in All Situations* (London, 1702), 25.

94. Belting, *Florence and Baghdad*, 244.

95. Brian Rotman, *Signifying Nothing: The Semiotics of Zero* (Stanford: Stanford University Press, 1987), 19. On Alberti's window as a screen, see also Anne Friedberg, *The Virtual Window: From Alberti to Microsoft* (Cambridge, MA: MIT Press, 2006), 26–48.

96. Panofsky, *Perspective as Symbolic Form*, 67.

97. Roger de Piles, *Cours de peinture par principes* (Paris: Jacques Estienne, 1708), 34.

98. On Alberti's notion of *historia*, see Belting, *Florence and Baghdad*, 245–246.

99. On the difference between Alberti's window metaphor for perspective and the camera obscura, see Friedberg, *Virtual Window*, 60–61.

100. de Piles, *Cours de peinture par principes*, 381–383.

101. Leonardo da Vinci quoted in Cubitt, *The Practice of Light*, 171.

102. Michael Baxandall, *Shadows and Enlightenment* (New Haven: Yale University Press, 1995), 84–88.

103. The quote is from Baxandall, *Shadows and Enlightenment*, 2. On the "modernization" of shadow, see also Cubitt, *The Practice of Light*, 168–178.

104. Victor Stoichita, *A Short History of the Shadow*, trans. Anne-Marie Glasheen (London: Reaktion Books, 1997), see especially 11–41. Stoichita extends this tradition back to Pliny's myth of image-making that regards images as substitutes for those who have passed the threshold between this world and the hereafter, capable of "capturing" their model by reduplicating it (ibid., 27).

105. "Doemonum spectra ab inferis revocata oculis spectantium." Kircher, *Ars magna lucis et umbrae*, 129.

106. Daniel Defoe, *A Review of the State of the British Nation*, ed. John McVeagh, vol. 7, part 2: October 1710–March 1711 (London: Pickering & Chatto, 2009), 652 (emphasis added).

107. Daniel Defoe, *The Chimera, or The French Way of Paying National Debts, Laid Open* (London, 1720), 6.

Chapter 2

1. Favián, on his own account, was spending his "life alone and retired, entertained by books" written by the "Reverend Father." Alexandro Favián to Athanasius Kircher (December 1665/January 1666), in Ignacio Osorio Romaro, *La Luz imaginaria: Epistolario de Atanasio Kircher con los novohispanos* (Mexico City: Universidad Nacional Autónoma de México, 1993), 65. On the relationship between Favián and

Kircher, see Stephanie Merrim, *The Spectacular City, Mexico, and Colonial Hispanic Literary Culture* (Austin: University of Texas Press, 2010), 209–212.

2. On Kircher's correspondence, see John Fletcher, *A Study of the Life and Works of Athanasius Kircher, "Germanus Incredibilis,"* ed. Elizabeth Fletcher (Leiden: Brill, 2011), 195–458.

3. Octavio Paz, *Sor Juana, or, The Traps of Faith* (Cambridge, MA: Harvard University Press, 1988), 39.

4. On Kircher's influence on Mexican scholarship in the later seventeenth century, see Jorge Cañizares-Esguerra, *Nature, Empire, and Nation: Explorations of the History of Science in the Iberian World* (Stanford: Stanford University Press, 2006), 49; Paula Findlen, "A Jesuit's Books in the New World: Athanasius Kircher and His American Readers," in *Athanasius Kircher: The Last Man Who Knew Everything*, ed. Paula Findlen (New York: Routledge, 2004), 329–364; Elías Trabulse, "El Tránsito del Hermetismo a la Ciencia Moderna: Alejandro Fabián, Sor Juana Inés de la Cruz y Carlos de Sigüenza y Góngora," *Calíope: Journal of the Society for Renaissance and Baroque Hispanic Poetry* 4, nos. 1–2 (1998): 56–69.

5. Findlen, "A Jesuit's Books," 342; Osorio Romaro's introduction to *La Luz imaginaria*, xxv–xxvi.

6. Favián to Kircher (23 August 1664), in Osorio Romaro, *La Luz imaginaria*, 47.

7. On the museum's collections, see Georgius de Sepibus, *Romani collegii Societatis Jesu musaeum celeberrimum* (Amsterdam, 1678). See also the illustrated catalogue of Kircher's collection by Francisco Ruspolo, *Musaeum Kircherianum* (Rome, 1709); on catoptric machines (including the magic lantern), see 310–312.

8. See Favián to Kircher (23 August 1664), in Osorio Romaro, *La Luz imaginaria*, 46.

9. Favián to Kircher (9 May 1663), in Osorio Romaro, *La Luz imaginaria*, 23–24.

10. See Favián to Kircher (9 May 1663), and Favián to Kircher (23 August 1664), in Osorio Romaro, *La Luz imaginaria*, 28, 46.

11. Favián to Kircher (9 May 1663), in Osorio Romaro, *La Luz imaginaria*, 27.

12. See Eileen Reeves and Albert Van Helden, introduction to *On Sunspots*, by Galileo Galilei and Christoph Scheiner (Chicago: University of Chicago Press, 2010), 1–6; Mario Biagioli, *Galileo's Instruments of Credit: Telescopes, Imagery, Secrecy* (Chicago: University of Chicago Press, 2006), 135–217.

13. See Favián to Kircher (December 1665/January 1666) and (14 November 1667), in Osorio Romaro, *La Luz imaginaria*, 59, 141.

14. Favián to Kircher (December 1665/January 1666), in Osorio Romaro, *La Luz imaginaria*, 60.

15. Favián to Kircher (14 November 1667), in Osorio Romaro, *La Luz imaginaria*, 147.

16. See Favián to Kircher (9 May 1663), in Osorio Romaro, *La Luz imaginaria*, 28. Some historians argue that Favián was referring to a magic lantern of sorts. See José Antonio Rodriquez, *El Arte de las Ilusiones: Espetáculos precinematográficos en México* (Mexico City: Testimonios del Archivo, 2009), 27–28.

17. See Findlen, "A Jesuit's Books," 336.

18. The concept of "steganography" was used already in the early 1600s by the French writer Béroalde de Verville, who called his 1610 novel *Le Voyage de princes fortunez* "a steganographic work," referring to the nesting of hidden meanings beneath the surface of writing, which plays with the apparent and the concealed, the known and the unknown. On Verville, see Tom Conley, "Eros stéganographique: Béroalde de Verville, *Le Voyage des princes fortunez* (1610)," in *Théories critiques et littérature de la Renaissance: Mélanges offerts à Lawrence Kritzman*, ed. Todd Reeser and David LaGuardia (Paris: Classiques Garnier, 2020), 75–90.

19. On Fontana, see Laurent Mannoni, *The Great Art of Light and Shadow: Archaeology of the Cinema*, trans. and ed. Richard Crangle (Exeter: University of Exeter Press, 2000), 30–32.

20. Kircher, *Ars magna lucis et umbrae*, 915. Gaspar Schott also gives a description of this type of lantern in *Magia universalis naturae et artis*, 4 vols. (Bamberg: Johann Martin Schönwetter, 1677), 1:332.

21. William Ashworth, "Light of Reason, Light of Nature: Catholic and Protestant Metaphors of Scientific Knowledge," *Science in Context* 3, no. 1 (1989): 89–107. Scheiner's divisions of knowledge derived from St. Bonaventure's four-fold differentiation of divine light from the thirteenth century. "Even though every illumination of knowledge is internal," Bonaventure proposed, "still we can reasonably distinguish what may be called an exterior light, or the light of mechanical art; an inferior light, or the light of sense perception; an interior light, or the light of philosophical knowledge; and a superior light, or the light of grace and of Sacred Scripture." Bonaventure, *Works of St. Bonaventure*, vol. 1: *On the Reduction of the Arts to Theology*, trans. Zachary Hayes (St. Bonaventure, NY: Franciscan Institute, St. Bonaventure University, 1996), 37.

22. "nihil insit in intellectu, quod in sensu non prius fuerit." Kircher, *Ars magna lucis et umbrae*, 834. See also Ashworth, "Light of Reason, Light of Nature," 96–97.

23. "Tanta est sensum nostrorum fallacia, ut αδυνατον ferè sit ad perfecta rerum naturaliu notitia pervenire, nisi aliquo fulcirentur, quo latentus rerum recessus in lucem eruerentur. . . . [H]aec autem est divina illa Opticae scientia, quae quod abditum est è profundissimis tenebris in admirabile lumen educit." Kircher, *Ars magna lucis et umbrae*, 834. See also Mark A. Waddell, *Jesuit Science and the End of Nature's Secrets* (Burlington: Ashgate, 2015), 138–141.

24. Galileo Galilei, *Sidereus Nuncius, or, the Sidereal Messenger*, trans. Albert van

Helden (Chicago: University of Chicago Press, 1989), 36. On the ambiguous re-sponse by the Jesuit scholars to Galileo's discoveries, see, e.g., Roberto Buonanno, *The Stars of Galileo Galilei and the Universal Knowledge of Athanasius Kircher*, trans. Roberto Buonanno and Giuliana Giobbi (Cham: Springer, 2014), 23–60.

25. One should note that the model of the universe encapsulated in the frontis-piece was indebted to a long tradition of neo-Platonic metaphysical thought. In the third century BCE, Plotinus gave it a decisive design based on the notion of emana-tion according to which the divine radiated its powers throughout the cosmos. The multiplicity of earthly creatures proceeded from the life and power of the heavenly One, the virtual principle of creation, just like all light—as the metaphor often used by Plotinus goes—originated from the sun (see Plotinus, *The Enneads*, trans. George Boys-Stones et al., ed. Lloyd P. Gerson [Cambridge: Cambridge University Press, 2018], 1.7.1. and 5.1.7.). Kircher's Plotinian influences were likely mediated by someone like Marsilio Ficino, a Renaissance Florentine scholar, who, in his treatise on the sun, *Liber de sole* (1493), praised sunlight as a pure emanation from the heavenly spheres. "The ray shining forth from the eye is itself the image of vision," Ficino wrote, "So too perhaps is light itself the vision of the heavenly soul, or the action of vision reaching out to exterior things—acting from a distance, yet not leaving the heavens, but ever continuing there unmixed with external things, acting at once by seeing and by touch-ing." (Marsilio Ficino, *The Book of the Sun*, trans. Geoffrey Cornelius et al., in *Marsilio Ficino*, ed. Angela Voss [Berkeley: North Atlantic Books, 2006], 189–213, quotation on 191). On the metaphor of light in neo-Platonic thought, see the classic essay by Hans Blumenberg, "Light as a Metaphor for Truth: At the Preliminary Stage of Philosophi-cal Concept Formation," trans. Joel Anderson, in *Modernity and the Hegemony of Vi-sion*, ed. David Michael Levin (Berkeley: University of California Press, 1993), 30–62.

26. Thomas Leinkauf, *Mundus combinatus: Studien zur Struktur der barocken Uni-versalwissenschaft am Beispiel Athanasius Kirchers SJ* (Berlin: De Gruyter, 2012), 203; Waddell, *Jesuit Science*, 131–133.

27. Kircher, *Ars magna lucis et umbrae*, 924–925. The hierarchy drew on the Italian Renaissance scholar Francesco Patrizi's neo-Platonic light metaphysics based on dif-ferentiations of divine light (*lux*) into lesser types of light. In Patrizi's epistemology, the study of light would eventually allow creatures to return to God, the "Father of lights." On Patrizi, see David C. Lindberg, "The Genesis of Kepler's Theory of Light," *Osiris* 2 (1986): 28–29.

28. "Deus sons lucis est, et Angelus primae lucis speculum; secundum speculum, homo." Kircher, *Ars magna lucis et umbrae,* 924.

29. See Koen Vermeir, "The Magic of the Magic Lantern (1660–1700): On Ana-logical Demonstration and the Visualization of the Invisible," *British Journal for the History of Science* 38, no. 2 (2005): 138–140.

30. Kircher, *Ars magna lucis et umbrae*, 924.

31. Koen Vermeir, "Kircher's Magical Instruments: An Essay on 'Science,' 'Religion,' and Applied Metaphysics," *Studies in History and Philosophy of Science*, vol. 38 (2007): 363–400, see especially 393.

32. Plotinus, *Enneads*, 3.2.1.

33. Christoph Scheiner, *Oculus, hoc est: Fundamentum opticum* (Freiburg, 1621), 32–33.

34. Athanasius Kircher, *Mundus subterraneus* (Amsterdam: Jansson and Weyerstrat, 1665), 2:327. On Kircher's ideas about *panspermia* and creation, see Hiro Hirai, "Kircher's Chymical Interpretation of the Creation and Spontaneous Generation," in *Chymists and Chymistry: Studies in the History of Alchemy and Early Modern Chemistry*, ed. Lawrence Principe (Sagamore Beach: Science History Publications, 2007), 77–87, see especially 78–81; Hirai, "Interprétation chymique de la création et origine corpusculaire de la vie chez Athanasius Kircher," *Annals of Science* 64, no. 2 (2007): 217–234; Leinkauf, *Mundus combinatus*, 92–110; Karin Leonhard, *Bildfelder: Stillleben und Naturstücke des 17. Jahrhunderts* (Berlin: Akademie Verlag 2013), 60–66; Ingrid Rowland, "Athanasius Kircher, Giordano Bruno, and the *Panspermia* of the Infinite Universe," in *Athanasius Kircher: The Last Man Who Knew Everything*, ed. Paula Findlen (New York: Routledge, 2004), 191–205.

35. Kircher, *Mundus subterraneus*, 2:330; translation from Rowland, "Athanasius Kircher, Giordano Bruno, and the *Panspermia* of the Infinite Universe," 199.

36. Ingrid Rowland, "'Th' United Sense of th' Universe': Athanasius Kircher in Piazza Novonna," *Memoirs of the American Academy in Rome* 46 (2001): 153–181, quotation on 174.

37. Kircher, *Mundus subterraneus*, 2:335. See also Kircher, *Ars magna lucis et umbrae*, 150. On Kircher's use of the camera obscura model in *Mundus subterraneus*, see Hirai, "Interprétation chymique," 227; Hirai, "Kircher's Chymical Interpretation," 82–83.

38. On perspectivist optical theories, see David C. Lindberg, *Theories of Vision from Al-Kindi to Kepler* (Chicago: University of Chicago Press, 1976), 104–146. On the concept of *species*, see also Katherine H. Tachau, *Vision and Certitude in the Age of Ockham: Optics, Epistemology, and the Foundations of Semantics 1250–1345* (Leiden: Brill, 1988), 3–16.

39. Hirai, "Kircher's Chymical Interpretation," 83.

40. Benito Daza de Valdés, *The Use of Eyeglasses*, ed. Paul E. Runge (Oostende, Belgium: J. P. Wayenborgh, 2004), 176.

41. "Toute peinture est morte au prix, car c'est icy la vie mesme, ou quelque chose de plus relevé, si la parole n'y manquoit." Contantijn Huygens to family (13 April 1622), in *Briefwisseling*, vol. 1: 1608–1634, ed. J. A. Worp (The Hague: Martinus

Nijhoff, 1911), 94 (my translation). On Drebbel and his camera obscura, see Mannoni, *The Great Art of Light and Shadow*, 34–35.

42. On the seventeenth-century reception of the camera obscura, see Arthur K. Wheelock, Jr., "Constantijn Huygens and Early Attitudes Towards the Camera Obscura," *History of Photography* 1, no. 2 (1977): 93–103.

43. Samuel van Hoogstraten, *Introduction à la haute école de l'art de peinture*, trans. Jan Blanc (Geneva: Librairie Droz, 2006), 403. Dutch original in Samuel van Hoogstraten, *Inleyding tot de hooge schoole der schilderkonst: anders de zichtbaere werelt* (Rotterdam, 1678), 263. See also Pierre le Lorrain de Vallemont, *Physique occulte, ou Traité de la baguette divinatoire* (Paris, 1693), 409.

44. Willem Jacob 's Gravesande, "Usage de la chambre obscure pour le dessein," in *Essai de perspective* (The Hague: Veuve d'Abraham Troyel, 1711), I6.

45. Lorraine Daston and Peter Galison, *Objectivity* (New York: Zone Books, 2007), 17.

46. Kircher, *Ars magna lucis et umbrae*, 812–813.

47. Kircher, *Mundus subterraneus*, 2:27–45.

48. Paula Findlen, "Jokes of Nature and Jokes of Knowledge," *Renaissance Quarterly* 43, no. 2 (1990): 292–331, quotation on 300.

49. Athanasius Kircher, *Diatribe de prodigiosis crucibus* (Rome, 1661), 60; Kircher, *Mundus subterraneus*, 2:335–336. See also Findlen, "Jokes of Nature and Jokes of Knowledge," 300.

50. Lorraine Daston, "Nature Paints," in *Iconoclash: Beyond the Image Wars in Science, Religion, and Art*, ed. Bruno Latour and Peter Weibel (Cambridge, MA: MIT Press, 2002), 136–138, quotation on 138.

51. Martin Kemp, *The Science of Art: Optical Themes in Western Art from Brunelleschi to Seurat* (New Haven: Yale University Press, 1990), 191.

52. Kircher, *Ars magna lucis et umbrae*, 808:

[N]am maximis paulatim prodigiis ita clarere coepit, ut iam toto illo orbe locus vix celebrior habeatur atque adeo Deus Optimus Maximus subindex occasione huius imagines insolita quadam ratione sub oculos cadentis ad nominis sui gloriam Matrisque cultum propagandum hunc sibi locum elegisse videatur, ut vel hinc quoque appareat nihil in rerum natura tam causale ac fortuitum apparere posse, quod sub occulta divinae providentiae dispositione, omnium moderatrice, non lateat.

53. Gaspar Schott, *Physica Curiosa, sive Mirabilia Naturae et Artis Libris XII* (Herbipoli, 1667), 1:27, quoted in Zakiya Hanafi, *The Monster in the Machine: Magic, Medicine, and the Marvelous in the Time of the Scientific Revolution* (Durham: Duke University Press, 2000), 65.

54. Kircher, *Mundus subterraneus*, 2:44 (my emphasis). See also Kircher, *Diatribe*,

24–27. See Stephen Jay Gould, "Father Athanasius on the Isthmus of a Middle State: Understanding Kircher's Paleontology," in *Athanasius Kircher: The Last Man Who Knew Everything*, ed. Paula Findlen (New York: Routledge, 2007), 207–237, see especially 233.

55. We should distinguish the general concept of providence from *providentia specialis*, which signified the government of the church and the faithful, as well as *providentia extraordinaris*, the God's government in the form of the supernatural. On the different senses of providence, see Karl Barth, *Church Dogmatics*, vol. 3: *The Doctrine of Creation 3*, trans. G. W. Bromiley and R. J. Ehrlich, ed. G. W. Bromiley and T. F. Torrance (London: T&T Clark, 1960), 184–185.

56. Kircher, *Ars magna lucis et umbrae*, 805–807.

57. Kircher, *Mundus subterraneus*, 2:43–44.

58. According to Kircher's reasoning, as Stephen Jay Gould explains, "the final cause (or purpose) of the picture may well reside in God's intended design as a portent or signal, but God may still superintend the actual production of the object by efficient causes." Gould, "Father Athanasius on the Isthmus of a Middle State," 233.

59. The fifth General Congregation of the Society concluded in 1593, which devised the educational policy of Jesuit colleges proliferating across Europe (culminating in the *ratio studiorum* from 1599): "By all means, Ours should consider St. Thomas as their special teacher, and they should be obliged to follow him in scholastic theology. . . . St. Thomas is deservedly regarded by all as the prince of theologians." Quoted in Louis Caruana, "The Jesuits and the Quiet Side of the Scientific Revolution," in *The Cambridge Companion to the Jesuits*, ed. Thomas Worcester (Cambridge: Cambridge University Press, 2008), 243–260, quotation on 246. However, Jesuit theology, as Rivka Feldhay notes, "indeed was rooted in Thomism, but reoriented Thomist thinking in new directions." (Rivka Feldhay, "Knowledge and Salvation in Jesuit Culture," *Science in Context* 1, no. 2 [1987]: 195–213, quotation on 204.) Most notably Luis Molina and Francisco Suarez challenged Thomist views on God's omnipotence, predetermination, and human free will at the turn of the sixteenth century, arguing that the effects of the will are not brought about by the first cause itself. Essentially, they wanted to grant the human will more liberty to determine its own actions. On Aquinas, Molina, and Suarez, see William Lane Craig, *The Problem of Divine Foreknowledge and Future Contingents from Aristotle to Suarez* (Leiden: Brill, 1988), 99–126, 169–232. On Molina and Aquinas, see Juan Cruz, "Predestination as Transcendent Teleology: Molina and the First Molinism," in *A Companion to Luis de Molina*, ed. Matthias Kaufmann and Alexander Aichele (Leiden: Brill, 2014), 89–121. On the ambiguous place of Thomism in Jesuit thought, see Roger Ariew, "Descartes and the Jesuits: Doubt, Novelty, and the Eucharist," in *Jesuit Science and the Republic of Letters*, ed. Mordechai Feingold (Cambridge, MA: MIT Press, 2003), 157–194, see especially 162–169.

60. Thomas Aquinas, *On Kingship*, bk. 2, chap. II, 55–56, quoted in Giorgio Agamben, *The Kingdom and the Glory: For a Theological Genealogy of Economy and Government*, trans. Lorenzo Chiesa (Stanford: Stanford University Press, 2011), 92.

61. Thomas Aquinas, *Commentary on the Book of Causes*, trans. Vincent Guagliardo, Charles Hess, and Richard Taylor (Washington, DC: Catholic University of America Press, 1996), 6, 45.

62. Ibid., 9.

63. Agamben, *The Kingdom and the Glory*, 126, 134.

64. Thomas Aquinas, *On the Truth of the Catholic Faith (Summa Contra Gentiles)*, vol. 3: *Providence*, part 2, trans. Vernon J. Bourke (New York: Image Books, 1956), 74 (3.98.3).

65. On providence and first and second causes in Aquinas, see Ignacio Silva, "Thomas Aquinas on Natural Contingency and Providence," in *Abraham's Dice: Chance and Providence in the Monotheistic Traditions*, ed. Karl Giberson (Oxford: Oxford University Press, 2016), 158–174.

66. Aquinas, *On the Truth of the Catholic Faith (Summa Contra Gentiles)*, 3.2:78–79 (3.99.9).

67. As Agamben puts it, "insofar as it is considered in its connection with the first cause, the order of the world is unchangeable and coincides with divine prescience and goodness. On the other hand, insofar as it entails an articulation of second causes, it makes room for divine intervention 'praeter ordinem rerum.'" Agamben, *The Kingdom and the Glory*, 97.

68. Lorraine Daston and Katharine Park, *Wonders and the Order of Nature, 1150–1750* (New York: Zone Books, 1998), 121–123.

69. Thomas Aquinas, *Summa theologica*, part 1, trans. Fathers of the English Dominican Province, 2nd ed. (London: Burns Oates & Washbourne Ltd., 1920), 208 (Q. 14, Art. 13)

70. Kircher, *Ars magna lucis et umbrae*, 934. On this passage, see Vermeir, "Athanasius Kircher's Magical Instruments," 387–390. Kircher's reference here is to the First Epistle of St. Paul to the Corinthians, where we read: "And when all things shall be subdued unto him, then the Son also himself shall be subject unto him that put all things under him, that God may be all in all." (1 Cor. 15:28 [Douay Rheims version].) Thanks to Siiri Toiviainen for pointing this out.

71. Agamben, *The Kingdom and the Glory*, 109–166. See also Joseph Vogl, *The Ascendancy of Finance*, trans. Simon Garnett (Cambridge: Polity, 2017), 41–42.

72. Agamben, *The Kingdom and the Glory*, 154.

73. On God as infinite light, see Kircher, *Ars magna lucis et umbrae*, 917–918. The notion of infinite light derives from the Gospel of John: "I am the light of the world. He that followeth me walketh not in darkness, but shall have the light of life." (John

8:12 [Douay Rheims version].) On Kircher's metaphysics of light (alongside magnetism and musical harmony), see Leinkauf, *Mundus combinatus*, 324–348.

74. Wilhelm Gumppenberg, *Atlas Marianus* (Munich, 1672). See also the bilingual German and French edition: Gumppenberg, *L'Atlas Marianus*, ed. Laurent Auberson, Naïma Ghermani, and Anton Serdeczny (Neuchatel: Editions Alphil-Presses universitaires suisses, 2015). On Gumppenberg's *Atlas*, see Jane Garnett and Gervase Rosser, *Spectacular Miracles: Transforming Images from the Renaissance to the Present* (London: Reaktion Books, 2013), 11–12.

75. Gumppenberg, *L'Atlas Marianus*, 53 (my translation).

76. See Ralph Dekoninck, "*Propagatio Imaginum*: The Translated Images of Our Lady of Foy," in *The Nomadic Object: The Challenge of World for Early Modern Religious Art*, ed. Christine Göttler and Mia Mochizuki (Leiden: Brill, 2018), 241–267, see especially 244–245.

77. Olivier Christin and Fabrice Flückiger, "Rendre visible la frontière confessionnelle: l'*Atlas Marianus* de Wilhelm Gumppenberg," in *Les Affrontements religieux en Europe: Du début du XVIe au milieu du XVIIe siècle*, ed. Véronique Castagnet, Olivier Christin, and Naïma Ghermani (Villeneuve d'Ascq: Presses Universitaires du Septentrion, 2008), 33–44.

78. Marie-José Mondzain, *Image, Icon, Economy: The Byzantine Origins of the Contemporary Imaginary*, trans. Rico Franses (Stanford: Stanford University Press, 2005), 18–117, 151–170.

79. Ibid., 102.

80. Nicephorus, *Antirrhetics*, 277A, in Mondzain, *Image, Icon, Economy*, 236.

81. Mondzain, *Image, Icon, Economy*, 159, 158, 162, 167.

82. Andrea Pozzo, *Rules and Examples of Perspective Proper for Painters and Architects, etc.*, trans. John James of Greenwich (London, 1693), A7v. On Pozzo and Kircher, see Filippo Camerota, "Exactitude and Extravagance: Andrea Pozzo's 'Viewpoint,'" in *Imagine Math: Between Culture and Mathematics*, ed. Michele Emmeror (Milan: Springer, 2012), 23–41, see especially 25.

83. Felix Burda Stengel, *Andrea Pozzo et l'art video: Déplacement et point de vue de spectateur dans l'art baroque et l'art contemporain*, trans. Heinke Wagner (Paris: Isthme Éditions, 2006), 81–101; Yves Bonnefoy, *Rome, 1630: L'horizon du premier baroque* (Paris: Flammarion, 2000), 36, 42.

84. Giovanni Paolo Oliva, *Sermoni domestici detti privatamente nelle Casa Romane della Compagnia di Giesù da Gio: Paolo Oliva Generale della Stessa Compagnia* (Venice, 1679–1681), 1:260ff., quoted in Francis Haskell, "The Role of Patrons: Baroque Style Changes," in *Baroque Art: The Jesuit Contribution*, ed. Rudolf Wittkower and Irma B. Jaffe (New York: Fordham University Press, 1972), 51–62, quotation on 60.

85. See Evonne Levy, *Propaganda and the Jesuit Baroque* (Berkeley: University of California Press, 2004), 151.

86. On the frontispiece and its connection with Kircher, see Findlen, "A Jesuit's Books," 359.

87. Gregorio Rosignoli, *Meraviglie di Dio ne' Suoi santi*, vol. 3 (Venice, 1772), 352–354.

88. See the posthumous work by Francisco de Florencia, revised and augmented by Juan Antonio de Oveido, *Zodiaco Mariano* (Mexico, 1755).

89. Augustine de Vetancurt, *Chronica de la Provincia del Santo Evangelio de Mexico*, vol. 4 of *Teatro Mexicano* (Mexico, 1697), 127 (my translation).

90. Mondzain, *Image, Icon, Economy*, 32.

91. Vetancurt, *Chronica*, 127–128. Several versions of the legend exist. In the following, I draw from the Mexican priest Luis Laso de la Vega's account from 1649; see Luis Laso de la Vega, *The Story of Guadalupe: Luis Laso de la Vega's "Huei tlamahuiçoltica" of 1649*, ed. and trans. Lisa Sousa, Stafford Poole, and James Lockhart (Stanford: Stanford University Press, 1998), 48–127. For a comprehensive account of the development of the legend and different interpretations, see David A. Brading, *Mexican Phoenix: Our Lady of Guadalupe: Image and Tradition Across Five Centuries* (Cambridge: Cambridge University Press, 2001).

92. See Serge Gruzinski, *Images at War: Mexico from Columbus to Blade Runner (1492–2019)*, trans. Heather MacLean (Durham: Duke University Press, 2001), 142.

93. Laso de la Vega, *The Story of Guadalupe*, 85.

94. Vetancurt, *Chronica*, 127 (my translation).

95. Ernesto de la Torre Vilar and Ramiro Navarro de Anda, *Testimonios históricos guadalupanos: Complicación, prólogo, notas bibliograficas y indices* (Mexico City: FCE, 1982), 259, quoted in Gruzinski, *Images at War*, 130.

96. Gruzinski, *Images at War*, 127, 142.

97. Brading, *Mexican Phoenix*, 80–81, 88–89.

98. Luis Becerra Tanco, *Felicidad de México en el principio, y milagroso origen, que tubo el Santuario de la Virgen María N. Señora de Guadalupe* (Mexico, 1675), 21v.

99. About the probable date of composition of *Perspectiva communis*, see David C. Lindberg, introduction to *John Pecham and the Science of Optics: Perspectiva communis*, trans. and ed. David C. Lindberg (Madison: University of Wisconsin Press, 1970), 18. On Pecham's and other medieval optical theories, see Lindberg, *Theories of Vision*, 104–121.

100. John Pecham, *Perspectiva communis* (Cologne: Apud Haeredes Arnoldi Birckmanni, 1580), 185 (proposition II.32); Becerra Tanco, *Felicidad de México*, 23v.

101. Pecham, *Perspectiva communis*, 189 (proposition II.34); Becerra Tanco, *Felicidad de México*, 24v.

102. See Arnold Lebeuf, "Cave of the Astronomers at Xochicalco," in *Handbook of Archaeoastronomy and Ethnoastronomy*, ed. Clive Ruggles (New York: Springer, 2015), 749–758.

103. Pecham, *Perspectiva communis*, A3v.

104. On this point, see Linda Báez Rubí, "Vislumbrar y admirar: 'La maravilla americana' en los modelos de visión y procesos icónicos de la cultura jesuítica," in *XXXVI Coloquio Internacional de Historia del Arte: Los estatutos de la imagen, creación-manifestación-percepción*, ed. Linda Báez Rubí and Emilie Carreón Blaine (México: Universidad Nacional Autónoma de México / Instituto de Investigaciones Estéticas, 2014), 67–86, see especially 72–73. Eileen Reeves points out that "pinhole and dark room projections, moreover, were routinely said to be 'inscribed' or 'engraved' or 'printed' in the early seventeenth century, as if to emphasize the smoothness of the transition to mechanically produced and legible images." Eileen Reeves, *Evening News: Optics, Astronomy, and Journalism in Early Modern Europe* (Philadelphia: University of Pennsylvania Press, 2014), 157.

105. Becerra Tanco, *Felicidad de México*, 25.

106. See Merrim, *The Spectacular City*, 209.

107. Becerra Tanco, *Felicidad de México*, 22r, 23v.

108. See Lindberg, introduction to *John Pecham and the Science of Optics*, 35–36.

109. Pecham, *Perspectiva communis*, 109 (I.27).

110. Roger Bacon, *Opus maius*, part 4, dist. 2, chap.1, quoted in Lindberg, *Theories of Vision*, 113.

111. Kircher, *Mundus subterraneus*, 2:44.

112. Apart from China and Mexico, some early sources relate to Japan. We know that it was Dutch merchants who introduced camera obscuras and magic lanterns into Japan by the second half of the eighteenth century at the latest. The Jesuits' contributions to the spreading of optical media in Japan, however, remain obscure. On the introduction of camera obscuras and magic lanterns to Japan, see Timon Screech, *The Lens Within the Heart: The Western Scientific Gaze and Popular Imagery in Later Edo Japan* (Honolulu: University of Hawai'i Press, 2002), 56–57, 106–112.

113. See Craig Clunas, *Pictures and Visuality in Early Modern China* (London: Reaktion Books, 1997), 172–183; Nicolas Standaert, "Jesuits in China," in *The Cambridge Companion to the Jesuits*, ed. Thomas Worcester (Cambridge: Cambridge University Press, 2008), 172–173.

114. Ferdinand Verbiest, *Astronomia Europaea* (Dillingen, 1687), 77–78. On Verbiest, see Thijs Weststeijn, "'Sinarum gentes . . . omnium sollertissimae': Encounters Between the Middle Kingdom and the Low Countries, 1602–92," in *Reshaping the Boundaries: The Christian Intersection of China and the West in the Modern Era*, ed. Song Gang (Hong Kong: Hong Kong University Press, 2016), 9–34.

115. Jean-Baptiste Du Halde, *A Description of the Empire of China and Chinese-Tartary* (London, 1741), 2:126–127. On Grimaldi, see Mannoni, *The Great Art of Light and Shadow*, 71–73.

116. Du Halde, *A Description of the Empire of China*, 2:127.

117. See Franklin Perkins, *Leibniz and China: A Commerce of Light* (Cambridge: Cambridge University Press, 2004), 118–121.

118. Johann Christoph Wagner, *Das mächtige Kayser-Reich Sina und die Asiatische Tartaren* (Augsburg, 1688), xxx2r. For an important analysis of the frontispiece, see Koen Vermeir, "Optical Instruments in the Service of God: Light Metaphors for the Circulation of Jesuit Knowledge in China," in *The Circulation of Science and Technology: Proceedings of the 4th International Congress of ESHS, Barcelona, 18–20 November 2010*, ed. Antoni Roca-Rosell (Barcelona: Societat Catalana d'Història de la Ciència i de la Tècnica, 2010), 333–337, see especially 334–336.

119. See Sturm's discussion of portable camera obscuras and magic lanterns in *Collegium Experimentale, sive Curiosum* (Nuremberg: Endteri & Haeredum, 1676), 161–168.

120. On the replications of Griendel's magic lantern design in scientific publications from the turn of the seventeenth century, see Deac Rossell, "Early Magic Lantern Illustrations: What Can They Tell Us About Magic Lantern History?" *Magic Lantern Gazette* 21, no. 1 (2009): 15–23, see especially 15–17. On Wagner, see also Rossell, *Laterna Magica / Magic Lantern*, vol. 1 (Stuttgart: Füsslin, 2008), 49–51.

121. See Vermeir, "Optical Instruments in the Service of God," 335–336.

122. Wagner, *Das mächtige Kayser-Reich Sina*, xxx2r.

123. Wu Li, "A Western Lantern," in Jonathan Chaves, *Singing of the Source: Nature and God in the Poetry of the Chinese Painter Wu Li* (Honolulu: University of Hawai'i Press, 1993), 134.

124. See Joseph Needham, *Science and Civilization in China*, vol. 4: *Physics and Physical Technology*, part 1: *Physics* (Cambridge: Cambridge University Press, 1962), 78–124; Jennifer Purtle, "Double Take: Chinese Optics and Their Media in Postglobal Perspective," *Ars Orientalis*, no. 48 (2018): 71–117; Jennifer Purtle, "Scopic Frames: Devices for Seeing China c. 1640," *Art History* 33, no. 1 (2010): 54–73.

125. The description of the pacing horse lantern is from a fourteenth-century poem by Deng Ya (entitled "Pacing Horse Lantern"), quoted in Purtle, "Scopic Frames," 65.

126. Gabriel de Magalães, *A New History of China, Containing a Description of the Most Considerable Particulars of that Vast Empire*, trans. John Ogilby (London, 1688), 105–106.

127. Purtle, "Scopic Frames," quotation on 70.

128. For the following, I'm drawing on the essay on Sun's *A History of Lenses* by

S. E. Kile and Kristina Kleutghen, "Seeing Through Pictures and Poetry: *A History of Lenses* (1681)," *Late Imperial China* 38, no. 1 (2017): 47–112; on the camera obscura, see especially 84–87.

129. Sun Yunqiu, *A History of Lenses* (1681), quoted in ibid., 84.

130. Quoted in ibid., 85.

131. Quoted in ibid., 86–87.

Chapter 3

1. Jean Loret, *La Muze historique, ou recueil des lettres en vers*, vol. 2: 1655–1658 (Paris: P. Daffis, 1877), 192–193.

2. Entry "Hôtel de Liancourt, Paris," in Lilian H. Zirpolo, *Historical Dictionary of Baroque Art and Architecture*, 2nd ed. (Lanham: Rowman & Littlefield, 2018), n.p.

3. Loret, *La Muze historique*, 2:192 (my translation).

4. Thomas Hobbes, *Leviathan*, ed. J. C. A. Gaskin (Oxford: Oxford University Press, 1998), 13 (chap. 2, §6).

5. On Loret's description of the optical show at Liancourt, see Richard Crangle, "'A Quite Rare Entertainment': An Optical Show in Paris in 1656," *New Magic Lantern Journal* 9, no. 5 (2003): 76–78; Koen Vermeir, "The Magic of the Magic Lantern (1660–1700): On Analogical Demonstration and the Visualisation of the Invisible," *British Journal for the History of Science* 38, no. 2 (2007): 129–130n7.

6. Giambattista Della Porta, *Natural Magick* (London, 1669), 364–365.

7. Daniel Schwenter, *Deliciae Physco-Mathematicae, oder Mathemat: Und Philosophische Erquickstunden* (Nuremberg, 1636), 263. On Schwenter, see Jörg Jochen Berns, "Der Zauber der technischen Medien: Fernohr, Hörrohr, Camera obscura, Laterna magica," *Simpliciana: Schriften der Grimmelshausen-Gesellschaft* 26 (2004): 245–266, see especially 255–256.

8. Robert Burton, *The Anatomy of Melancholy*, ed. A. R. Shilleto, vol. 1 (London: George Bell & Sons, 1903), 491.

9. Ibid., 182, 491.

10. Della Porta, *Natural Magick*, 355, 370.

11. François Lemée, *Traité des statues* (Paris: Arnould Seneuze, 1688), 11–12, 354–385, 430–434. On Lemée's ideas about idolatry and animism, see Caroline van Eck, *Art, Agency, and Living Presence: From the Animated Image to the Excessive Object* (Leiden: Leiden University Press / De Gruyter, 2015), 92–108.

12. Lemée, *Traité des statues*, 11, 426.

13. Lemée's ideas exemplified what Horst Bredekamp conceptualizes as "substitutive images acts," referring to practices of image making and reception in which "bodies are treated as images and images as bodies." Horst Bredekamp, *Image Acts:*

A Systematic Approach to Visual Agency, trans. Elizabeth Clegg (Berlin: De Gruyter, 2018), 137–192, quotation on 137.

14. Loret, *La Muze historique*, 2:193.

15. Pierre le Lorrain de Vallemont, *Physique occulte, ou Traité de la baguette divinatoire* (Paris, 1693), 405, 408.

16. See Gaspar Schott, *Magia universalis naturae et artis*, 4 vols. (Bamberg: Johan Martin Schönwetter, 1677), 1:170–217; on Della Porta, see 206–217.

17. Athanasius Kircher, *Ars magna lucis et umbrae* (Rome: Hermann Scheus, 1646), 799.

18. Prov. 8:30–31 (Douay Rheims version). Thank you to Siiri Toiviainen for pointing out this reference.

19. Schott, *Magia universalis*, 1:170–171.

20. Georg Philipp Harsdörffer, *Delitiae philosophicae et mathematicae*, vol. 3 (Nuremberg, 1653), 229–231. On Kircher's correspondence with Harsdörffer, see John Fletcher, *A Study of the Life and Works of Athanasius Kircher, "Germanus Incredibilis,"* ed. Elizabeth Fletcher (Leiden: Brill, 2011), 358–366.

21. Gaspar Schott, *Magia Optica* (Frankfurt am Main: Johan Martin Schönwetter, 1677), 181–182; English translation from Angela Mayer-Deutsch, "The Ideal *Musaeum Kircherianum* and the Ignatian *Exercitia spiritualia*," in *Instruments in Art and Science: On the Architectonics of Cultural Boundaries in the 17th Century*, ed. Helmar Schramm, Ludger Schwarte, and Jan Lazardzig (Berlin: Walter de Gruyter, 2008), 235–256, quotation on 247.

22. See Jill H. Casid, *Scenes of Projection: Recasting the Enlightenment Subject* (Minneapolis: University of Minnesota Press, 2015), 47–48. On Aguilón's account, see Hermann Hecht, "The History of Projecting Phantoms, Ghosts, and Apparitions," *New Magic Lantern Journal* 3, no. 2 (1984): 2–6, see especially 5.

23. "Rebus ita callide comparatis, silentium severius indicitur, quasi quispiam proditurus fit è machina Deus. Hic pallere alij, alij sudare metu rei eventurae." Kircher, *Ars magna lucis et umbrae*, 129.

24. Schott, *Magia universalis*, 1:199. One of the definitions of "simulacrum" in *The Dictionary of Medieval Latin from British Sources* is: "outward appearance of a person or thing, as imagined in the mind or seen in a dream."

25. See Schott, *Magia Optica*, 31; Schott, *Magia universalis*, 1:38.

26. See Mayer-Deutsch, "The Ideal *Musaeum Kircherianum*," 246–247.

27. "causa efficientem esse radiationem phantasiae materialem res extrinsecas vehementi imaginatione apprehendentem." Kircher, *Ars magna lucis et umbrae*, 152–153.

28. Marina Warner, *Phantasmagoria: Spirit Visions, Metaphors, and Media into the Twenty-First Century* (Oxford: Oxford University Press, 2006), 141.

29. See the analysis of early responses to the magic lantern by Laurent Mannoni, *The Great Art of Light and Shadow: Archaeology of the Cinema*, trans. and ed. Richard Crangle (Exeter: University of Exeter Press, 2000), 47–49.

30. Entry "lanterne magique" in Antoine Furetière, *Dictionnaire universel*, vol. 2 (The Hague, 1690), n.p.

31. Robert Hooke, "A Contrivance to Make the Picture of Any Thing Appear on a Wall, Cub-Board, or Within a Picture-Frame," *Philosophical Transactions* 3, no. 38 (1668): 741–743, quotation on 742.

32. Charles Patin, *Travels thro' Germany, Swisserland, Bohemia, Holland, and Other Parts of Europe* (London, 1697), 233–235. On Patin and Griendel, see Deac Rossell, *Laterna Magica / Magic Lantern*, vol. 1 (Stuttgart: Füsslin, 2008), 30–33. On the magic lantern spectator response, according to Patin, see Casid, *Scenes of Projection*, 72–73.

33. See, e.g., Thomas Hankins and Robert Silverman, *Instruments and the Imagination* (Princeton: Princeton University Press, 1995), 43–44; Mannoni, *The Great Art of Light and Shadow*, 58; Willem Wagenaar, "The Origins of the Lantern: The True Inventor of the Magic Lantern—Kircher, Walgenstein, or Huygens?," *New Magic Lantern Journal* 1, no. 3 (1980): 10–12. For an alternative interpretation, see Vermeir, "The Magic of the Magic Lantern," 127–159.

34. John Bargrave, *Pope Alexander the Seventh and the College of Cardinals*, ed. James Craigie Robertson (London, 1867), 134.

35. Athanasius Kircher, *Ars magna lucis et umbrae*, 2nd ed. (Amsterdam: Jansson and Weyerstrat, 1671), 768–769. On Walgenstein, see Mannoni, *The Great Art of Light and Shadow*, 47–52; Rossell, *Laterna Magica / Magic Lantern*, 21–22.

36. "laterna, quam dicunt magicam." Francesco Eschinardi, *Centuria problema tum opticorum, in qua praecipuae difficultates catoptricae, et dioptricae, demonstrative solvuntur*, 2 vols. (Rome, 1666–1668), 2:221. Note that the second volume (1668) has a different title page: *Centuriae opticae pars altera, seu Dialogi optici pars tertia.* . . .

37. Riccardo G. Villoslada, *Storia del Collegio Romano dal suo inizio (1551) alla soppressione della Compagnia di Gesù*, Analecta Gregoriana vol. LXVI (Rome: Apud Aedes Universitatis Gregorianae, 1954), 278.

38. Siegfried Zielinski, *Deep Time of the Media: Toward an Archaeology of Hearing and Seeing by Technical Means*, trans. Gloria Custance (Cambridge, MA: MIT Press, 2006), 138.

39. Schott, *Magia universalis*, 1:18.

40. Kircher, *Ars magna lucis et umbrae*, 2nd ed., 770; Johann Zahn, *Oculo artificiali teledioptrico, sive telescopio*, 3 vols. (Würzburg, 1685–1686), 3:255–256.

41. See Tom Gunning, "The Transforming Image: The Roots of Animation in Metamorphosis and Motion," in *Pervasive Animation*, ed. Suzanne Buchan (New York: Routledge, 2013), 52–67.

42. Kircher, *Ars magna lucis et umbrae*, 2nd ed., 673.

43. Zacharius Traber, *Nervus opticus sive tractatus theoricus in tres libros* (Vienna, 1675), 71. For a technical account, see Zahn, *Oculo artificiali*, 2:234–260.

44. Kircher, *Ars magna lucis et umbrae*, 2nd ed., 775, 782. See also Joscelyn Godwin, *Athanasius Kircher's Theatre of the World: His Life, Work, and the Search for Universal Knowledge* (London: Thames & Hudson, 2009), 213.

45. Barbara Maria Stafford and Frances Terpak, *Devices of Wonder: From the World in a Box to Images on a Screen* (Los Angeles: The Getty Research Institute, 2001), 27–28.

46. Kircher, *Ars magna lucis et umbrae*, 2nd ed., 770, 781.

47. Ignatius de Loyola, *Powers of Imagining* (Albany: SUNY Press, 1986), 105.

48. Ibid., quotations on 138, 121, 117, 116, 127.

49. Roland Barthes, *Sade / Fourier / Loyola*, trans. Richard Miller (Berkeley: University of California Press, 1989), 51.

50. Pierre-Antoine Fabre, *Ignace de Loyola, le lieu de l'image: Le problème de la composition du lieu dans les pratique spirituelles et artistiques jésuites de la seconde moitié XVIe siècle* (Paris: Vrin, 1992), 85–88.

51. Barthes, *Sade / Fourier / Loyola*, 54.

52. Michel Foucault, *Security, Territory, Population: Lectures at the Collège de France, 1977–1978*, ed. Michel Senellart, trans. Graham Burchell (Basingstoke: Palgrave Macmillan, 2009), 192–193.

53. Ibid., 167.

54. *Catechismus ex decreto concilii Tridentini ad Parochos Pii V Pont. Max. iussu editus* (Rome, 1566), 173, quoted in Wietse de Boer, *The Conquest of the Soul: Confession, Discipline, and Public Order in Counter-Reformation Milan* (Leiden: Brill, 2001), 137.

55. de Boer, *The Conquest of the Soul*, 112.

56. Ibid., 114.

57. Mark A. Waddell, *Jesuit Science and the End of Nature's Secrets* (Burlington: Ashgate, 2015), 14.

58. Samuel Y. Edgerton, *The Heritage of Giotto's Geometry: Art and Science on the Eve of the Scientific Revolution* (Ithaca: Cornell University Press, 1991), 254.

59. Friedrich Kittler, *Optical Media: Berlin Lectures 1999*, trans. Anthony Enns (Cambridge: Polity, 2010), 79–80. See also Mayer-Deutsch, "The Ideal *Musaeum Kircherianum*," 249–255.

60. Kircher, *Ars magna lucis et umbrae*, 152.

61. Ignatius de Loyola, *Powers of Imagining*, 119.

62. The similarity between the two illustrations is pointed out by Trent Pomplun, *Jesuit on the Roof of the World: Ippolito Desideri's Mission to Eighteenth-Century Tibet* (Oxford: Oxford University Press, 2010), 38–39.

63. Ignatius de Loyola, *Powers of Imagining*, 139–140. See Mayer-Deutsch, "The Ideal *Musaeum Kircherianum*," 252.

64. Barthes, *Sade / Fourier / Loyola*, 69.

65. Kircher, *Ars magna lucis et umbrae*, 2nd ed., 770.

66. Andreas Bähr, *Furcht und Furchtlosigkeit: Göttliche Gewalt und Selbstkonstitution im 17. Jahrhundert* (Göttingen: V&R Unipress, 2013), 55–183; on Kircher, see 171–183.

67. See Kircher, *Ars magna lucis et umbrae*, 2nd ed., 809.

68. [Abbé Jean Olivier?], *Memoirs of the Life and Adventures of Signor Rozelli, at the Hague* (London, 1709), 263.

69. The etching was published as a cover illustration for a satirical text about King Charles II's testament, entitled *De toverlantaaren: Volgens de Romeinse Copy* (1701). About the print, see [Frederick George Stephens], *Catalogue of Prints and Drawings in the British Museum, Division I, Political and Personal Satires*, vol. 2: June 1689 to 1733 (London: Chiswick Press, 1873), 100–101 (entry 1346).

70. Hauke Lange-Fuchs, "On the Origin of Moving Slides," *New Magic Lantern Journal* 7, no. 3 (1995): 10–14, see especially 12.

71. See ibid., 14.

72. Translation from Lange-Fuchs, "On the Origin of Moving Slides," 13. Original in Bonifacius Heinrich Ehrenberger (or Samuel Johannes Rhanaeus), *Novum et curiosum laternae magicae augmentum* (Jena, 1713), 8–9.

73. Lange-Fuchs, "On the Origin of Moving Slides," 13.

74. Pierre van Musschenbroek, *Essai de physique*, vol. 2, trans. Pierre Massuet (Leiden, 1751), 607–609, and plate 21. On the themes of magic lantern slides produced at the Musschenbroek workshop, see Tristan Mostert, "The Collection of Musschenbroek Slides in the Stedelijk Museum De Lakenhal, Leiden, the Netherlands," *New Magic Lantern Journal* 11, no. 1 (2012): 9–11.

75. Carlos Eire, *War Against the Idols: The Reformation of Worship from Erasmus to Calvin* (Cambridge: Cambridge University Press, 1986), 226.

76. Bridget Heal, *A Magnificent Faith: Art and Identity in Lutheran Germany* (Oxford: Oxford University Press, 2017), 1–2.

77. See, e.g., Bonifacius Heinrich Ehrenberger (or Georg Balthasaris Sand), *De deceptionibus catoptricis programma II* (Coburg, 1744).

78. Psalms 20:6 (1611 King James Version).

79. Peter 5:7 (1611 King James Version).

80. *Heidelberg Catechism*, question no. 27.

81. Ehrenberger (or Rhanaeus), *Novum et curiosum laternae magicae*, 20–22.

82. Hans Belting, *Florence and Baghdad: Renaissance Art and Arab Science*, trans. Deborah Lucas Schneider (Cambridge, MA: Harvard University Press, 2011), 127.

83. See Ignacio Osorio Romaro, *La Luz imaginaria: Epistolario de Atanasio Kircher con los novohispanos* (Mexico City: Universidad Nacional Autónoma de México, 1993), xxx.

84. On the collection, see Octavio Paz, *Sor Juana, or, The Traps of Faith* (Cambridge, MA: Harvard University Press, 1988), 246–247.

85. Sor Juana Inés de la Cruz, "First I Dream," in *Poems, Protest, and a Dream*, trans. Margaret Sayers Peden (New York: Penguin Books, 1997), 123–126 (lines 868–886).

86. Sor Inés de la Cruz, "First I Dream," 93 (266–287).

87. Sor Juana Inés de la Cruz, "Response to the Most Illustrious Poetess Sor Filotea de la Cruz," in *Poems, Protest, and a Dream*, 43.

88. Sor Juana Inés de la Cruz, quoted in Paula Findlen, "A Jesuit's Books in the New World: Athanasius Kircher and His American Readers," in *Athanasius Kircher: The Last Man Who Knew Everything*, ed. Paula Findlen (New York: Routledge, 2004), 357.

89. Sor Inés de la Cruz, "Response," 23.

90. Sor Inés de la Cruz, "First I Dream," 113, 115 (671–672, 698–699).

91. Ibid., 540–559, 597–598 (107, 109). On Sor Juana Inés de la Cruz's skepticism about the power of the intellect, see Paz, *Sor Juana*, 378–383.

Chapter 4

1. Samuel Pepys, *The Diary of Samuel Pepys*, ed. Henry B. Wheatley (London: George Bell & Sons, 1894–1895), 5:406 (19 August 1666).

2. Pepys, *The Diary*, 4:215–216 (13 August 1664); Pepys, *The Diary*, 5:229 (21 February 1666). Nonetheless, Pepys ordered a copy of Christopher Wren's "perspectograph" to be made for him. On Wren's design, see the account by Henri Oldenburg in "The Description of an Instrument Invented Divers Years Ago by Dr. Christopher Wren," *Philosophical Transactions of the Royal Society* 4, no. 45 (25 March 1669): 898–899.

3. Pepys, *The Diary*, 5:409 (22 August 1666).

4. Pepys, *The Diary*, 4:216 (13 August 1664).

5. John Evelyn, *The Diary of John Evelyn*, ed. Guy de la Bédoyère (Woodbridge: Boydell Press, 2004), 175.

6. See Thomas Birch, *The History of the Royal Society of London*, vol. 2 (London, 1756), 436–440. On Hooke's camera obscura designs, see Matthew C. Hunter, "'Mr. Hooke's Reflecting Box': Modeling the Projected Image in the Early Royal Society," *Huntington Library Quarterly* 78, no. 2 (2015): 301–328.

7. Entry "intromit" in Samuel Johnson, *A Dictionary of English Language*, vol. 1 (London, 1756), n.p.

8. Entry "species" in Johnson, *A Dictionary of English Language*, vol. 2, n.p.

9. Richard Waller, "The Life of Dr. Robert Hooke," in *The Posthumous Works of Robert Hooke*, ed. Richard Waller (London, 1705), xiv.

10. Roger Bacon explained *species* as follows:

> The species is not a body, nor is it changed as regards itself as a whole from one place to another, but that which is produced in the first part of the air is not separated from that part, since form cannot be separated from the matter in which it is, unless it be soul, but the species forms a likeness to itself in the second position of the air, and so on. Therefore it is not a motion as regards place, but is a propagation multiplied through the different parts of the medium; nor is it a body, which is there generated, but a corporeal form, without, however, dimensions per se. . . .

Roger Bacon, *Opus majus*, trans. Robert Belle Burke, vol. 2 (New York: Russell & Russell, 1962), 489–490. On medieval theories of vision, see David C. Lindberg, *Theories of Vision from Al-Kindi to Kepler* (Chicago: University of Chicago Press, 1976), 104–146.

11. Bacon, *Opus majus*, vol. 2, 426. On the concept of *species* and its assimilation with *intentione* in Roger Bacon, see Katherine H. Tachau, *Vision and Certitude in the Age of Ockham: Optics, Epistemology, and the Foundations of Semantics 1250–1345* (Leiden: Brill, 1988), 3–26.

12. René Descartes, *Discourse on Method, Optics, Geometry, and Meteorology*, trans. Paul J. Olscamp, revised ed. (Indianapolis: Hackett, 2001), 68.

13. On Kepler and Descartes, see Ofer Gal and Raz Chen-Morris, "Baroque Optics and the Disappearance of the Observer: From Kepler's *Optics* to Descartes' Doubt," *Journal of the History of Ideas* 71, no. 2 (2010): 191–217. On Kepler's redefinition of ocular experience in relation to medieval and Renaissance theories of vision, see Raz Chen-Morris, *Measuring Shadows: Kepler's Optics of Invisibility* (University Park: Pennsylvania State University Press, 2016), 98–122.

14. Witelo (or Vitello) was a medieval philosopher and mathematician working in the perspectivist tradition.

15. Johannes Kepler, *Optics: Paralipomena to Witelo & Optical Part of Astronomy*, trans. William H. Donahue (Santa Fe: Green Lion Press, 2000), 194. On the Dresden *Kunstkammer* and the camera obscura experiment described by Kepler, see Sven Dupré and Michael Korey, "Inside the *Kunstkammer*: The Circulation of Optical Knowledge and Instruments at the Dresden Court," *Studies in History and Philosophy of Science* 40 (2009): 405–420, see especially 406–415.

16. Kepler, *Optics*, 194.

17. Sven Dupré, "Inside the 'Camera Obscura': Kepler's Experiment and Theory of Optical Imagery," *Early Science and Medicine* 13, no. 3 (2008): 219–244, quotation on 236.

18. See Isabelle Pantin, "*Simulachrum, species, forma, imago*: What Was Transported by Light into the Camera Obscura," *Early Science and the Medicine* 13, no. 3 (2008): 245–269; Alan E. Shapiro, "Images: Real and Virtual, Projected and Perceived, from Kepler to Dechales," *Early Science and Medicine* 13, no. 3 (2008): 270–312; A. Mark Smith, *From Sight to Light: The Passage from Ancient to Modern Optics* (Chicago: University of Chicago Press, 2015), 322–372.

19. Christoph Scheiner, *Oculus, hoc est: Fundamentum opticum* (Freiburg, 1621), 32–34.

20. Kepler, *Optics*, 210, 77, 180.

21. Svetlana Alpers, *The Art of Describing: Dutch Art in the Seventeenth Century* (Chicago: University of Chicago Press, 1983), 36.

22. Lindberg, *Theories of Vision*, 202.

23. Gal and Chen-Morris, "Baroque Optics and the Disappearance of the Observer," 191.

24. Ibid., 212–217. On Kepler and Descartes, see also Alpers, *The Art of Describing*, 33–38; Hans Belting, *Florence and Baghdad: Renaissance Art and Arab Science*, trans. Deborah Lucas Schneider (Cambridge, MA: Harvard University Press, 2011), 124–128; Jonathan Crary, *Techniques of the Observer: On Vision and Modernity in the Nineteenth Century* (Cambridge, MA: MIT Press, 1990), 43–50; Alan E. Shapiro, ed., "Kepler, Optical Imagery, and the Camera Obscura," special issue of *Early Science and Medicine* 13, no. 3 (2008): 217–312. See also Michael J. Olson, "The Camera Obscura and the Nature of the Soul: On a Tension Between the Mechanics of Sensation and the Metaphysics of the Soul," *Intellectual History Review* 25, no. 3 (2015): 279–291.

25. Chen-Morris, *Measuring Shadows*, 168.

26. Henri Wotton, "Sir Henry Wotton to Lord Bacon," in *Reliquiae Wottonianae, or, a Collection of Lives, Letters, Poems* (London, 1685), 298–302, quotation on 300. On Wotton's letter, see Alpers, *Art of Describing*, 50–51; Eileen Reeves, *Evening News: Optics, Astronomy, and Journalism in Early Modern Europe* (Philadelphia: University of Pennsylvania Press, 2014), 138–164.

27. Chen-Morris, *Measuring Shadows*, 20.

28. Wotton, "Sir Henry Wotton to Lord Bacon," 299.

29. Lorraine Daston, "Baconian Facts, Academic Civility, and the Prehistory of Objectivity," in *Rethinking Objectivity*, ed. Allan Megill (Durham: Duke University Press, 1994), 37–63.

30. Francis Bacon, *Novum Organum*, ed. Joseph Devey (New York: P. F. Collier, 1902), 88 (§CXII), 83 (§CV), 86 (§CIX).

31. Thomas Sprat, *The History of the Royal Society of London, for the Improving of Natural Knowledge*, 4th ed. (London, 1734), 252, 26.

32. William Molyneux, *Dioptrica Nova: A Treatise in Dioptricks* (London, 1692), 39.

33. However, in a description of an "optical experiment" from 1668, Hooke envisioned somewhat different uses for a room-sized camera obscura he had constructed. Various "apparitions and disappearances" and "very delightful" effects, Hooke proposed, could be presented to credulous spectators inside the dark room, so as to incite their "passions of love, fear, reverence, honour, and astonishment." What Hooke contrived was an arrangement of visual spectacles in which actors and objects were placed outside the apparatus, and simultaneously outside the observer's awareness; things both real and imaginary could thus be animated in an unprecedentedly vivid manner: "the prospect of contryes, cities, houses, navies, armies; the actions and motions of men, beasts, birds, &c." Here, the dark chamber was to become a stage for artificial realities—a machine of what the Jesuits called "parastatic magic." Very little, it seems, of Hooke's 1668 experiments on optical trickery remains in his later designs of the device. Robert Hooke, "A Contrivance to Make the Picture of Any Thing Appear on a Wall, Cub-Board, or Within a Picture-Frame," *Philosophical Transactions* 3, no. 38 (1668): 741–743. On Hooke's experiment, see also Jill H. Casid, *Scenes of Projection: Recasting the Enlightenment Subject* (Minneapolis: University of Minnesota Press, 2015), 50–54.

34. Sprat, *The History of the Royal Society of London*, 395.

35. Robert Hooke, "An Instrument of Use to Take the Draught, or Picture of Any Thing," in *Philosophical Experiments and Observations*, ed. William Derham (London, 1726), 292–296.

36. Robert Boyle, *Tracts About the Cosmical Qualities of Things, Cosmical Suspicions, the Temperature of the Subterraneal Regions, the Temperature of the Submarine Regions, the Bottom of the Sea* (Oxford, 1671), 18–19 (chap. VI).

37. Hooke, "An Instrument of Use," 292–293.

38. Ibid., 295.

39. We can consider Hooke's picture box as an early visual device for the gathering and processing of information—a device that values the perceived image "only as a source of convertible data, not an end in itself," as Steve Anderson observes about the grid-based tracing processes enabled by portable camera obscuras. Steve F. Anderson, *Technologies of Vision: The War Between Data and Images* (Cambridge, MA: MIT Press, 2017), 24.

40. Hooke, "An Instrument of Use," 294.

41. According to Matthew Hunter, the print is "reconcilable with no surviving plans" by Hooke. Hunter, "'Mr. Hooke's Reflecting Box,'" 314.

42. Wotton, "Sir Henry Wotton to Lord Bacon," 300.

43. Hooke, "An Instrument of Use," 293.

44. See in particular Alpers, *The Art of Describing*, 26–71.

45. On Constanijn Huygens, Jr.'s *View of the Ijssel* (5 June 1672), see Michael Collins, "The Ground Glass: Landscape Art, the Camera Obscura and Photography," Picturing Places, British Library, accessed April 20, 2021, https://www.bl.uk/picturing-places/articles/the-ground-glass-landscape-art-the-camera-obscura-and-photography-coll-items-missing.

46. Alpers, *The Art of Describing*, 135.

47. William Cheselden, *Osteographia, or, the Anatomy of the Bones* (London, 1733), n.p.

48. See Daniel Carey, "Compiling Nature's History: Travellers and Travel Narratives in the Early Royal Society," *Annals of Science* 54, no. 3 (1997): 269–292; John Gascoigne, "The Royal Society, Natural History and the Peoples of the 'New World(s),' 1660–1800," *British Journal for the History of Science* 42, no. 4 (2009): 539–562; Sarah Irving, *Natural Science and the Origins of British Empire* (London: Pickering & Chatto, 2008), 3; Mary Poovey, *A History of the Modern Fact: Problems of Knowledge in the Sciences of Wealth and Society* (Chicago: University of Chicago Press, 1998), 110–120; Barbara J. Shapiro, *A Culture of Fact: England, 1550–1720* (Ithaca: Cornell University Press, 2000), 72–76.

49. As Matthew Hunter points out, "among the networks of Royal Society informants moving through Turkey, Egypt, South Asia, the American colonies, and numerous points in between, . . . few correspondents made images themselves or actually knew how to draw." Matthew C. Hunter, *Wicked Intelligence: Visual Art and the Science of Experiment in Restoration London* (Chicago: University of Chicago Press, 2013), 18.

50. See Hunter, *Wicked Intelligence*, 125–158.

51. Hooke, *The Posthumous Works*, 338.

52. Irving, *Natural Science and the Origins of British Empire*; see, e.g., 22.

53. Joseph Glanvill, *Scepsis Scientifica: Or, Contest Ignorance, the Way to Science; in an Essay of the Vanity of Dogmatizing* (London, 1665), 131–132.

54. See Anna Winterbottom, *Hybrid Knowledge in the Early East India Company World* (Basingstoke: Palgrave Macmillan, 2016), 13.

55. Irving, *Natural Science and the Origins of British Empire*, 1.

56. On the East India Company, see Nick Robins, *The Corporation That Changed the World: How the East India Company Shaped the Modern Multinational* (London: Pluto Press, 2006).

57. Robert Boyle, "Experimenta et Observationes Physicae," in *The Works of the Honourable Robert Boyle* (London, 1772), 5:575; Boyle, *The Works of the Honourable Robert Boyle*, 1:cviii.

58. Robert Boyle, "A Disquisition About the Final Causes of Natural Things," in

The Works of the Honourable Robert Boyle, 5:411. See also Irving, *Natural Science and the Origins of British Empire*, 73.

59. Bacon, *Novum Organum*, 38 (§LXV), 34 (§LXII). Bacon famously wrote that "four species of idols beset the human mind, to which (for distinction's sake) we have assigned names, calling the first Idols of the Tribe, the second Idols of the Den, the third Idols of the Market, the fourth Idols of the Theatre," the latter including religion and theology (ibid., 19–20 [§XXXIX]).

60. Hooke, *Philosophical Experiments and Observations*, 240.

61. Michel Foucault, *Security, Territory, Population: Lectures at the Collège de France, 1977–1978*, ed. Michel Senellart, trans. Graham Burchell (Basingstoke: Palgrave Macmillan, 2009), 236.

62. Genesis 1:26 (1611 King James Version).

63. Robert Hooke, lecture (18 December 1697), quoted in Michael Hunter, *Boyle Studies: Aspects of the Life and Thought of Robert Boyle (1627–91)* (London: Routledge, 2016), 211.

64. Carey, "Compiling Nature's History," 271–273.

65. Lawrence Rooke, "Directions for Sea-men, Bound for Far Voyages," *Philosophical Transactions of the Royal Society* 1, no. 8 (May 1665): 140–143. In the early 1660s, a general set of questions for overseas countries was produced by the Royal Society. See Michael Hunter, "Robert Boyle and the Early Royal Society: A Reciprocal Exchange in the Making of Baconian Science," *British Journal for the History of Science* 40, no. 1 (2007): 1–23, see especially 16.

66. Robert Boyle, "General Heads for a Natural History of a Countrey, Great or Small," *Philosophical Transactions* 1 (1665–1666): 186–189.

67. On the production of Knox's *Historical Relation*, see Anna Winterbottom, "Producing and Using the *Historical Relation of Ceylon*: Robert Knox, the East India Company and the Royal Society," *British Journal for the History of Science* 42, no. 4 (2009): 515–538, especially 521–527.

68. Robert Hooke, preface to Robert Knox, *An Historical Relation of the Island of Ceylon* (London: Richard Chiswell, 1681), A2r.

69. Hooke, "An Instrument of Use," 293–294.

70. See Hunter, *Wicked Intelligence*, 120.

71. On the illustrations in Knox's *Historical Relation*, see Winterbottom, "Producing and Using the *Historical Relation of Ceylon*," 522. Ogilby's *America* was a translation of *De nieuwe en onbekende weereld* (1671), written by Arnoldus Montanus who never actually visited the New World. Hooke had a copy of *America* in his library, and it is included in the list of books with inaccurate illustrations that Hooke mentions: "Such are all the Pictures in the Books of *Theodore de Brie*, concerning the *East* and *West-Indies*: Such are also the greatest Part of the Pictures in Sir *Thomas Herbert's* Travels; and those of *Mr. Ogilby's*

Asia, Africa, and *America;* which are Copies of the *Dutch* Originals, and are, originally, nothing but Mr. Engraver's fancy." (Hooke, "An Instrument of Use," 293–294.)

72. Hooke, "An Instrument of Use," 294.

73. See Hooke, *The Posthumous Works,* 126–127.

74. Hunter, *Wicked Intelligence,* 43–49. In Hooke's times, the usefulness of illustration for empirical science was enhanced by the use of lead for drawing. Lead provided "a flexible medium which could give a sharp or soft line, infinite gradations of tone, and which could be erased," as Ann Bermingham describes it. Ann Bermingham, *Learning to Draw: Studies in the Cultural History of a Polite and Useful Art* (New Haven: Yale University Press, 2000), 70–71.

75. Robert Hooke, *Micrographia: Or Some Physiological Descriptions of Minute Bodies Made by Magnifying Glasses with Observations and Inquiries Thereupon* (London, 1665), A2r & A2v.

76. British Library, the Sloane Manuscripts, MS Sloane 1039 f. 156. See Winterbottom, *Hybrid Knowledge,* 155; Winterbottom, "Producing and Using the *Historical Relation of Ceylon,*" 520.

77. See Birch, *The History of the Royal Society of London,* 2:436–442. On Hooke's involvement in different camera obscura designs throughout his career, see Hunter, "'Mr. Hooke's Reflecting Box,'" 308–315.

78. Birch, *The History of the Royal Society of London,* 2:442.

79. Hooke, "An Instrument of Use," 294.

80. Lorraine Daston and Peter Galison, *Objectivity* (New York: Zone Books, 2007), 17.

81. Hooke, "A Contrivance," 742.

82. See Michael J. Gorman, "Projecting Nature in Early-Modern Europe," in *Inside the Camera Obscura: Optics and Art Under the Spell of the Projected Image,* ed. Wolfgang Lefèvre (Berlin: Max Planck Institute for the History of Science, 2007), 31–50, see especially 36.

83. See Carsten Wirth, "The Camera Obscura as a Model for a New Concept of Mimesis in Seventeenth-Century Painting," in *Inside the Camera Obscura: Optics and Art Under the Spell of the Projected Image,* ed. Wolfgang Lefèvre (Berlin: Max Planck Institute for the History of Science, 2007), 149–193, see especially 152.

84. Sean Silver, *The Mind Is a Collection: Case-Studies in Eighteenth-Century Thought* (Philadelphia: University of Pennsylvania Press, 2015), 65–66.

85. See Bernhard Siegert, *Cultural Techniques: Grids, Filters, Doors, and Other Articulations of the Real,* trans. Geoffrey Winthrop-Young (New York: Fordham University Press, 2015), 129–146.

86. Christian Jacob, *The Sovereign Map: Theoretical Approaches in Cartography Throughout History,* trans. Tom Conley, ed. Edward H. Dahl (Chicago: University of

Chicago Press, 2006), 325. See also J. B. Harley, "Maps, Knowledge and Power," in *The Iconography of Landscape: Essays on the Symbolic Representation, Design, and Use of Past Environments*, ed. Denis Cosgrove and Stephen Daniels (Cambridge: Cambridge University Press, 1988), 277–312.

87. British Library, MS Sloane 1039 f. 156. On Hooke's camera obscura models as prototypes for modern surveying techniques, see M. A. R. Cooper, "Robert Hooke (1635–1703): Proto-Photogrammetrist," *Photogrammetric Record* 15 (1996): 403–417, see especially 409–411. On Hooke's involvement in various cartographic projects, see E. G. R. Taylor, "Robert Hooke and the Cartographic Projects of the Late Seventeenth Century (1666–1696)," *Geographical Journal* 90, no. 6 (1937): 529–540.

88. "'I see, I draw, I conquer' is the etching's implied caption," Kaja Silverman notes about the illustration of the picture box. Kaja Silverman, *The Miracle of Analogy, or, The History of Photography, Part 1* (Stanford: Stanford University Press, 2015), 70.

89. John Locke, *An Essay Concerning Human Understanding*, 2 vols., 12th ed. (London, 1741), 2:274–275 (bk. IV, chap. XV, §2–3).

90. See Winterbottom, *Hybrid Knowledge*. Winterbottom demonstrates that the production of knowledge of the natural world was imperative to European expansion and the beginnings of colonialism. See also Kapil Raj, *Relocating Modern Science: Circulation and the Construction of Knowledge in South Asia and Europe, 1650–1900* (Basingstoke: Palgrave Macmillan, 2007), 15–18.

91. British Museum, the Harleian Manuscripts, MS 4959, Minutes of the Union Commissioners 1702–1703, f. 21 (16 December 1702), quoted in P. G. M. Dickson, *The Financial Revolution in England: A Study in the Development of Public Credit 1688–1756* (London: Macmillan, 1967), 8.

92. Locke, *An Essay Concerning Human Understanding*, 2:265 (bk. IV, chap. XII, §10).

93. Irving, *Natural Science and the Origins of British Empire*, 117–119.

94. See Irving, *Natural Science and the Origins of British Empire*, 113.

95. John Locke, *Two Treatises of Government*, ed. Peter Laslett (Cambridge: Cambridge University Press, 1988), bk. II, §§32, 27, 34.

96. Ibid., bk. II, §26.

97. C. B. Macpherson, *The Political Theory of Possessive Individualism: Hobbes to Locke* (Oxford: Oxford University Press, 1992), 197–221.

98. Locke, *Two Treatises of Government*, bk. II, §§85, 50.

99. Ibid., bk. II, §48.

100. Bernard Mandeville, *The Fable of the Bees; or, Private Vices Public Benefits* (London: T. Ostell, 1806), 514.

101. Locke, *Two Treatises of Government*, bk. II, §27. The term "possessive

individualism" was first coined by Macpherson in *The Political Theory of Possessive Individualism*.

102. Macpherson, *The Political Theory of Possessive Individualism*, 255–256.

103. Locke, *An Essay Concerning Human Understanding*, 1:82 (bk. II, chap. II, §2).

104. Ibid., 1:123 (bk. II chap. XI, §17). On Locke and the camera obscura, see, e.g., Crary, *Techniques of the Observer*, 41–43; Silver, *The Mind Is a Collection*, 31–32.

105. Ibid.

106. As Sean Silver argues about the picture box, "seeking and taking is after all the very purpose of Hooke's object." Silver, *The Mind Is a Collection*, 64.

107. On outlining (by means of Hooke's picture box and other drawing devices) in terms of "spatial enclosure," see Hunter, *Wicked Intelligence*, 45–49.

108. Locke, *Two Treatises of Government*, bk. 2, §49.

109. [Joseph Addison and Richard Steele], *The Spectator*, no. 416 (27 July 1712), 8 vols. (London, 1744), 6:81–83.

110. *The Spectator*, no. 411 (21 June 1712), 6:63, 64.

111. *The Spectator*, no. 414 (25 June 1712), 6:74–75.

112. See Silver, *The Mind Is a Collection*, 88. On camera obscuras at the Greenwich Observatory, see Pip Brennan, *The Camera Obscura and Greenwich* (London: National Maritime Museum, 1994), 15–20.

113. W. H. Quarrel and M. Mare, *London in 1710, from the Travels of Zacharias Conrad von Uffenbach* (London, 1934), 21, quoted in Brennan, *The Camera Obscura and Greenwich*, 17.

114. *The Spectator*, no. 412 (23 June 1712), 6:90–91.

115. Alexander Pope to Martha Blount (2 June 1725), in *The Works of Alexander Pope*, vol. 6 (London: John Murray, 1871), 383.

116. Locke, *An Essay Concerning Human Understanding*, 1:121 (bk. II, chap. II, §2).

117. *The Spectator*, no. 414 (25 June 1712), 6:73, 75–76.

118. *The Spectator*, no. 411 (21 June 1712), 6:64.

119. Ibid., 6:63.

Chapter 5

1. Jonathan Swift, "The South Sea Project," in *The Works of the Rev. Jonathan Swift, D.D.* (London, 1801), 7:189–196, quotation on 194.

2. *Plain Dealing: In a Dialogue Between Mr. Johnson and Mr. Wary* (London, 1691), 3.

3. Ibid., 5, 8.

4. Swift, "The South Sea Project," in *The Works of the Rev. Jonathan Swift*, 7:194.

5. Daniel Defoe, *Considerations on the Present State of the Nation* (London, 1720), 2.

6. Laurence Sterne, *The Works of Laurence Sterne*, vol. 3: *Sermons* (London, 1823), 82 (emphasis in original).

7. On the early history of probability theory, lotteries, gambling, and insurance, see Lorraine Daston, *Classical Probability in the Enlightenment* (Princeton: Princeton University Press, 1988), 112–182.

8. John Arbuthnot, preface to *Of the Laws of Chance, or, A Method of Calculation of the Hazards of Game* (London, 1692), n.p.

9. John Arbuthnot, "An Argument for Divine Providence, Taken from the Constant Regularity Observ'd in the Births of Both Sexes," *Philosophical Transactions* 27, no. 328 (1710): 186–190.

10. Francis Hutcheson, *An Inquiry into the Original of Our Ideas of Beauty and Virtue*, 2nd ed. (London, 1726), 55–56. Hutcheson asserted:

> When we see then such a *multitude* of *Individuals of* a Species, *similar* to each other in a vast number of Parts; and when we see in *each Individual*, the corresponding Members so exactly like each other, what possible room is there left for questioning *Design* in the *Universe? None* but the barest *Possibility* against an inconceivably great *Probability.* (Ibid., 59)

11. See Daston, *Classical Probability*, 131–132, 250–253.

12. William N. Goetzmann, *Money Changes Everything: How Finance Made Civilization Possible* (Princeton: Princeton University Press, 2016), 258.

13. John Houghton, *A Collection for the Improvement of Husbandry and Trade*, vol. 1 (London, 1727), 265 (22 May 1694).

14. David Hume, *A Treatise of Human Nature*, ed. L. A. Selby-Bigge (Oxford: Clarendon Press, 1960), 444.

15. David Hume, *An Enquiry Concerning Human Understanding, and Selections from A Treatise of Human Nature* (Chicago: Open Court, 1921), 146, 72.

16. Ibid., 145, 73, 76.

17. Ibid., 77.

18. Hume, *A Treatise of Human Nature*, 8–9.

19. Gilles Deleuze, *Difference and Repetition*, trans. Paul Patton (New York: Columbia University Press, 1994), 70.

20. Hume cautioned that "were ideas entirely loose and unconnected, chance alone wou'd join them; and 'tis impossible the same simple ideas should fall regularly into complex ones (as they commonly do) without some bond of union among them, some associating quality, by which one idea naturally introduced another." Hume, *A Treatise of Human Nature*, 10.

21. Ibid. On Hume's concept of the imagination, see also Timothy Costelloe, *Imagination in Hume's Philosophy: The Canvas of the Mind* (Edinburgh: Edinburgh University Press, 2018), chap. 1.

22. David Hume, *An Enquiry Concerning the Principles of Morals* (Chicago: Open Court, 1912), 135.

23. Hume, *A Treatise of Human Nature*, 253.

24. Barry Stroud, "'Gilding and Staining' the World with 'Sentiments' and 'Phantasms,'" *Hume Studies* 19, no. 2 (1993): 253–272, quotation on 260.

25. [Joseph Addison and Richard Steele], *The Spectator*, no. 3 (3 March 1711), 1:19–20.

26. David Hume, "Of Public Credit," in *Essays and Treatises on Several Subjects*, vol. 1 (London, 1764), 383–400, quotation on 386.

27. Ibid., 400.

28. Hume, *A Treatise of Human Nature*, 534.

29. See Anne L. Murphy, *The Origins of English Financial Markets: Investment and Speculation Before the South Sea Bubble* (Cambridge: Cambridge University Press, 2009), 89–113.

30. Houghton, *A Collection*, 2 (30 March 1692).

31. Miles Ogborn, *Indian Ink: Script and Print in the Making of the East India Company* (Chicago: University of Chicago Press, 2007), 171–188.

32. Ibid., 193.

33. Catherine Ingrassia, *Authorship, Commerce, and Gender in Early Eighteenth-Century England: A Culture of Paper Credit* (Cambridge: Cambridge University Press, 1998), 6.

34. Jonathan Swift, "The Run upon the Bankers" [1720], in *The Works of the Rev. Jonathan Swift*, 7:177–179, quotation on 178.

35. J. G. A. Pocock, *Virtue, Commerce and History: Essays on Political Thought and History, Chiefly in the Eighteenth Century* (Cambridge: Cambridge University Press, 1985), 113.

36. Charles Jenkinson, *A Treatise on the Coins of the Realm; in a Letter to the King* (Oxford: Oxford University Press, 1805), 228.

37. Entry "bubble" in Malachy Postlethwayt, *The Universal Dictionary of Trade and Commerce*, vol. 1, 4th ed. (London, 1774), n.p. These words were in fact merely a slight modification of two lines from Samuel Butler's satirical poem *Hudibras* from 1660–70s. "For what is worth in anything, / But so much money as 'twill bring?" Samuel Butler, *Hudibras*, vol. 1 (London: Henry G. Bohn, 1859), Part II, Canto I, lines 465–466 (p. 153).

38. See Ian Baucom, *Specters of the Atlantic: Finance Capital, Slavery, and the Philosophy of History* (Durham: Duke University Press, 2005), 95–96.

39. See Joseph Vogl, *The Specter of Capital*, trans. Joachim Redner and Robert Savage (Stanford: Stanford University Press, 2015), 36–42.

40. Jonathan Swift, *The Examiner*, no. 34 (29 March 1711), in *The Works of the Rev. Jonathan Swift*, 3:175.

41. Daniel Defoe, *A Review of the State of the English Nation* (London, 1706), 3:502–503 (22 October 1706).

42. Colin Nicholson, *Writing and the Rise of Finance: Capital Satires of the Early Eighteenth Century* (Cambridge: Cambridge University Press, 1994), 46.

43. Charles Davenant, "Discourses on the Public Revenues, and on Trade," in *The Political and Commercial Works*, vol. 1 (London, 1771), 162, 151.

44. Ibid., 1:128.

45. William Petty, "Political Arithmetick" [1676], in *The Economic Writings of Sir William Petty*, vol. 1, ed. Charles Henry Hull (Cambridge: University Press, 1899), 244.

46. Mary Poovey, *A History of the Modern Fact: Problems of Knowledge in the Sciences of Wealth and Society* (Chicago: University of Chicago Press, 1998), 123–138.

47. William Petty, "The Political Anatomy of Ireland," in *The Economic Writings of Sir William Petty*, 1:152. On individuals as forms of money in the context of slave trade specifically, see Baucom, *Specters of the Atlantic*, 60–61. On this kind of economic rationality, see also Jonathan Swift's grim parody from 1729, about a seemingly well-intentioned gentleman, a "projector," who comes up with the infamous scheme to alleviate and at once capitalize on the famine in Ireland by turning children into livestock. Jonathan Swift, "A Modest Proposal for Preventing the Children of Poor People in Ireland from Being a Burden to Their Parents or Country, and for Making Them Beneficial to the Publick," in *The Works of the Rev. Jonathan Swift*, 9: 287–299.

48. Jonathan Sheehan and Dror Wahrman, *Invisible Hands: Self-Organization and the Eighteenth Century* (Chicago: University of Chicago Press, 2015), 59–61.

49. Gilles Deleuze, *The Fold: Leibniz and the Baroque*, trans. Tom Conley (London: Continuum, 2006), 27.

50. Davenant, "Discourses on the Public Revenues," in *The Political and Commercial Works*, 1:145, 134.

51. William Deringer, *Calculated Values: Finance, Politics, and the Quantitative Age* (Cambridge, MA: Harvard University Press, 2018), 74–75.

52. Daniel Defoe, "An Essay upon Projects," in *The Earlier Life and Works of Daniel Defoe*, ed. Henry Morley (London: George Routledge and Sons, 1889), 23–164, see especially 88–89.

53. Edmund Halley, "An Estimate of the Degrees of the Mortality of Mankind, Drawn from Curious Tables of the Births and Funerals at the City of Breslaw," *Philosophical Transactions of the Royal Society* 17, no. 196 (1693): 596–610, quotation on 602.

54. See Emily Nacol, *An Age of Risk: Politics and Economy in Modern Britain* (Princeton: Princeton University Press, 2016), 2.

55. Deringer, *Calculated Values*, 227–262.

56. Edward M. Jennings, "The Consequences of Prediction," *Studies on Voltaire and the Eighteenth Century* 153 (1976): 1131–1151, quotation on 1131.

57. Douglas Patey, *Probability and Literary Form: Philosophic Theory and Literary Practice in the Augustan Age* (Cambridge: Cambridge University Press, 1984), 73.

58. Pocock, *Virtue, Commerce and History*, 100.

59. Defoe, "An Essay upon Projects," 77, 80.

60. Defoe, *Considerations on the Present State of the Nation*, 23–24.

61. Defoe, "An Essay upon Projects," 82.

62. François Ewald, "Insurance and Risk," in *The Foucault Effect: Studies in Governmentality*, ed. Graham Burchell, Colin Gordon, and Peter Miller (Chicago: University of Chicago Press, 1991), 197–210, quotation on 207.

63. Defoe, "An Essay upon Projects," 42–43.

64. See David Alff, *The Wreckage of Intentions: Projects in British Culture, 1660–1730* (Philadelphia: University of Pennsylvania Press, 2017), 3.

65. Defoe, "An Essay upon Projects," 45.

66. Aaron Hill, *Account of the Rise and Progress of the Beech-Oil Invention* (London, 1715), 8, quoted in Alff, *The Wreckage of Intentions*, 70.

67. Defoe, "An Essay upon Projects," 31–32.

68. Ibid., 34.

69. The original prints for the folio (an "ideal" version of it) are reproduced in *The Great Mirror of Folly: Finance, Culture, and the Crash of 1720*, ed. William N. Goetzmann, Catherine Labio, K. Geert Rouwenhorst, and Timothy G. Young (New Haven: Yale University Press, 2013). As the editors explain in their introduction to the volume, no two existent copies of *Great Mirror* are exactly alike. The folio was originally compiled by an anonymous consortium of publishers based in Amsterdam who gathered a selection of visual and textual documents on the financial crash of 1720 that circulated in the Dutch republic. See William N. Goetzmann et al., "Introduction," in *The Great Mirror of Folly*, 3–17, see especially 3–4. See also Arthur Cole, *The Great Mirror of Folly: An Economic-Bibliographical Study* (Boston: Baker Library / Harvard Graduate School of Business Administration, 1949).

70. For the following account, see P. G. M. Dickson, *The Financial Revolution in England: A Study in the Development of Public Credit 1688–1756* (London: Macmillan, 1967), 90–156.

71. See Larry Neal, *The Rise of Financial Capitalism: International Capital Markets in the Age of Reason* (Cambridge: Cambridge University Press, 1990), 234–235.

72. See Violet Barbour, *Capitalism in Amsterdam in the Seventeenth Century*, The Johns Hopkins University Studies in Historical and Political Science, vol. 67 (Baltimore: Johns Hopkins Press, 1950), 74–84. See also Oscar Gelderblom and Joost Jonker, "Amsterdam as the Cradle of Modern Futures Trading and Options Trading, 1550–1650," in *The Origins of Value: The Financial Innovations That Created Modern*

Capital Markets, ed. William N. Goetzmann and K. Geert Rouwenhorst (Oxford: Oxford University Press, 2005), 189–206.

73. Francois d'Usson de Bonrepaus, "Mémoire touchant le négoce and la navigation des Hollandois," *Bijdragen en Mededeelingen van het Historisch Genootschap* 24 (1903): 238–318, quotation on 294 (my translation).

74. The pamphlet "Kermis wind-kraamer en grossier" ("The Wholesale Wind-Peddler's Fair"), plate 7 (p. 272) in Goetzmann et al., ed., *The Great Mirror of Folly* (my translation). The original French reads: "Le vent est mon tresor, coussin, et fondement / Suis je maitre du vent, je le suis de la vie / Monopole des vents se rend presentement / L'adorable sujet de riche idolatrie."

75. Montesquieu, *Persian Letters*, trans. John Davidson (London: George Routledge & Sons, 1923), 319 (letter 142).

76. Jean Terrasson, *Lettres sur le nouveau système des finances* (1720), 2 (1st letter). On Law's system, see e.g., Thomas Kavanagh, *Enlightenment and the Shadows of Chance: The Novel and the Culture of Gambling in Eighteenth-Century France* (Baltimore: Johns Hopkins University Press, 1993), 67–104.

77. The dwarfish showman from *The Great Mirror of Folly* made in fact his first appearance in the book *Il Callotto resuscitato, oder, Neu eingerichtes Zwerchen Cabinet* from circa 1715, a collection of caricatures of dwarfs in various roles and professions inspired by the French draughtsman Jacques Callot's "Grotesque Dwarves." This time he is identified as "Nicolo Cantabella, Savoyardischer Würmschneider," a trickster (to translate the description freely) from Savoy. And this time he is carrying a neatly decorated peep show box instead of a magic lantern. "Oh, pretty rarities" ("oh sena rarite"), he cries in Savoyard-accented German, referring to the perceptual pleasures afforded by the media device on his back. For an analysis of the illustration, see Deirdre Loughridge, *Haydn's Sunrise, Beethoven's Shadow: Audiovisual Culture and the Emergence of Musical Romanticism* (Chicago: University of Chicago Press, 2016), 72.

78. Deac Rossell, *Laterna Magica / Magic Lantern*, vol. 1 (Stuttgart: Füsslin, 2008), 107.

79. As one of the rare contemporaneous narrative accounts describes an indoor "magic lanthorn" show. Tobias Smollett, *The Adventures of Ferdinand Fathom*, part 2, in *The Works of Tobias Smollett*, 12 vols. (New York: The Jenson Society, 1907), 9:186.

80. Joseph Monteyne points this out succinctly in his analysis of Ouvrier's engraving. See Joseph Monteyne, *From Still Life to the Screen: Print Culture, Display, and the Materiality of the Image in Eighteenth-Century London* (New Haven: Yale University Press, 2013), 205–207.

81. Anthony Ashley Cooper, Third Earl of Shaftesbury, *Characteristicks of Men, Manners, Opinions, Times*, vol. 1 (Indianapolis: Liberty Fund, 2001), 73.

82. Fortune, we should note, was widely taken to symbolize credit and the secular

temporality of credit economy, standing, as Pocock suggests, "for that future which can only be sought passionately and inconstantly, and for the hysterical fluctuations of the urge toward it." Pocock, *Virtue, Commerce and History*, 99.

83. Daniel Defoe, *An Essay upon Publick Credit* (London, 1710), 6.

84. For a critique of the allegory, see Marieke de Goede, "Mastering 'Lady Credit': Discourses of Financial Crisis in Historical Perspective," *International Feminist Journal of Politics* 2, no. 1 (2000): 58–81.

85. Daniel Defoe, *A Review of the State of the British Nation*, vol. 6 (London, 1709), 122 (14 June 1709).

86. Daniel Defoe, *The Chimera, or The French Way of Paying National Debts, Laid Open* (London, 1720), 5–6.

87. Daniel Defoe, *The Political History of the Devil* (Oxford: D. A. Talboys, 1840), 200.

88. Ibid., 352.

89. Athanasius Kircher, *Ars magna lucis et umbrae*, 2nd ed. (Amsterdam: Jansson and Weyerstrat, 1671), 673.

90. Stuart Clark, *Vanities of the Eye: Vision in Early Modern European Culture* (Oxford: Oxford University Press, 2007), 106–110.

91. Rosalie Colie, *Paradoxia Epidemica: The Renaissance Tradition of Paradox* (Princeton: Princeton University Press, 1966), 312.

92. Defoe, *An Essay upon Publick Credit*, 6.

93. Colie, *Paradoxia Epidemica*, 516.

94. [Denis Carolet], *La lanterne magique, ou le Mississippi du diable* (The Hague: Mathieu Roguet, 1723), 10 (my translation).

95. Ibid., 17, 19–20 (my translation).

96. Ibid., 61–62 (my translation).

97. Kavanagh, *Enlightenment and the Shadows of Chance*, 87.

98. Charly Coleman, "The Spirit of Speculation: John Law and Economic Theology in the Age of Lights," *French Historical Studies* 42, no. 2 (2019): 203–237. To be sure, associations between alchemy and finance were not unique to the French Catholic world. Carl Wennerlind discusses how in England the alchemical experiments by Samuel Hartlib and his followers from the early part of the seventeenth century contributed to the emergence of credit currency and influenced the development of the Bank of England. (Carl Wennerlind, *Casualties of Credit: The English Financial Revolution, 1620–1720* [Cambridge, MA: Harvard University Press, 2011], 44–79.) The science of messy combinations and conversions was not foreign to new calculative economic practices either. Petty, who was a member of the Hartlib Circle and an advocate of credit money, argued that the ultimate goal of his political arithmetic (by reckoning the effects of population exchanges, intermarriage, and so on) was to

achieve the "natural Transmutation" of the Irish into English, his "data screens" thus contributing to colonial government and social engineering. See Petty, "The Political Anatomy of Ireland, in *The Economic Writings*, 1:158.

99. Jean Terrasson, "Traité de la communion," in *Traité de l'infini créé, avec l'explication de la possibilité de la transsubtantiation* (Amsterdam, 1769), 197–198 (my translation).

100. Coleman, "The Spirit of Speculation," 210, 212.

101. Terrasson, *Lettres sur le nouveau systême des finances*, 25 (3rd letter).

102. Coleman, "The Spirit of Speculation," 226. The illustration is entitled "Le véritable portrait du très fameux seigneur de messire Quinquenpoix."

103. Entry "projection" in Samuel Johnson, *A Dictionary of English Language*, vol. 1 (London, 1756), n.p.; entry "projection" in Denis Diderot and Jean le Rond D'Alembert, ed., *Encyclopédie, ou Dictionnaire raisonné des arts et des métiers* (Neufchastel: Samuel Faulche, 1765), 13:440–441.

104. Sermon on "Time and Chance" in Laurence Sterne, *The Works of Laurence Sterne*, vol. 3: *Sermons* (London, 1823), 76–83, quotation on 82.

105. Sermon on "The Ways of Providence Justified to Man" in Laurence Sterne, *The Works of Laurence Sterne*, vol. 3: *Sermons*, 415–423, quotation on 423.

106. Sheehan and Wahrman, *Invisible Hands*, 110–113.

107. *The Director*, nos. I, II, III, IV (London, 1720?), 16–17 (no. III).

108. John Midriff, *Observations on the Spleen and Vapours* (London, 1721), 61.

109. Sheehan and Wahrman, *Invisible Hands*, 118–133, quotation on 127–128.

110. [Isaac Gervaise], *A True State of Publick Credit* (London, 1721), 13.

111. Ibid., n.p. ("Declaration").

112. Ibid., 13, 31.

113. Ibid., n.p. ("Declaration").

114. Sheehan and Wahrman, *Invisible Hands*, 130.

115. [Gervaise], *A True State of Publick Credit*, 5.

Epilogue

1. Karl Marx, *Capital: A Critique of Political Economy*, vol. 3, trans. David Fernbach (London: Penguin, 1991), 525–542, 594–606.

2. Marx, *Capital*, vol. 3, 603.

3. The original German reads: "Alles in diesem Kreditsystem sich verdoppelt und verdreifacht und in bloßes Hirngespinnst sich verwandelt." Karl Marx, *Das Kapital: Kritik der Politischen Ökonomie*, Dritter Band, in *Gesamtausgabe*, vol. 15 (Berlin: Akademie Verlag, 2004), 470.

4. Karl Marx, *Capital: A Critique of Political Economy*, vol. 1, trans. Ben Fowkes (Harmondsworth: Penguin, 1976), 165. Original German in Karl Marx, *Das Kapital:*

Kritik der Politischen Ökonomie, Erster Band, in *Gesamtausgabe*, vol. 10 (Berlin: Dietz Verlag, 1991), 72.

5. Etienne-Gaspard Robertson, *Mémoires récréatifs, scientifiques et anecdotiques*, 2 vols. (Paris, 1831), 1:215–216.

6. Ibid., 1:276.

7. Ibid., 1:278.

8. Stefan Andriopoulos, *Ghostly Apparitions: German Idealism, the Gothic Novel, and Optical Media* (New York: Zone Books, 2013), 14.

9. Immanuel Kant, "Dreams of a Spirit-Seer Elucidated by Dreams of Metaphysics," in *Theoretical Philosophy, 1755–1770*, trans. and ed. David Walford (Cambridge: Cambridge University Press, 1992), 331 (emphasis in original). On Marx and Kant, see Andriopoulos, *Ghostly Apparitions*, 18, 44–45.

10. Kant, "Dreams of a Spirit-Seer," 332.

11. Robertson, *Mémoires récréatifs*, 1:197.

Bibliography

Primary Sources

[Les Academiciens de l'Académie françoise]. *Le Dictionnaire de l'Académie françoise dedié au Roy.* 2 vols. Paris, 1694.

[Addison, Joseph, and Richard Steele.] *The Spectator.* 8 vols. London, 1744.

Aquinas, Thomas. *Commentary on the Book of Causes.* Translated by Vincent Guagliardo, Charles Hess, and Richard Taylor. Washington, DC: Catholic University of America Press, 1996.

———. *On the Truth of the Catholic Faith (Summa Contra Gentiles).* Translated by Vernon J. Bourke. New York: Image Books, 1956.

———. *Summa theologica.* Translated by Fathers of the English Dominican Province. 2nd ed. London: Burns Oates & Washbourne Ltd., 1920.

Alberti, Leon Battista. *On Painting and On Sculpture.* Translated and edited by Cecil Grayson. London: Phaidon Press, 1972.

Algarotti, Francesco. *An Essay on Painting.* London, 1764.

Arbuthnot, John. "An Argument for Divine Providence, Taken from the Constant Regularity Observ'd in the Births of Both Sexes." *Philosophical Transactions* 27, no. 328 (1710): 186–190.

———. *Of the Laws of Chance, or, A Method of Calculation of the Hazards of Game.* London, 1692.

Bacon, Francis. *Novum Organum.* Edited by Joseph Devey. New York: P. F. Collier, 1902.

Bacon, Roger. *Opus majus.* Translated by Robert Belle Burke. New York: Russell & Russell, 1962.

Barbaro, Daniele. *La pratica della perspettiva.* Venice, 1569.

Bargrave, John. *Pope Alexander the Seventh and the College of Cardinals.* Edited by James Craigie Robertson. London, 1867.

Bayle, Pierre. *Various Thoughts on the Occasion of a Comet.* Translated by Robert C. Bartlett. Albany: SUNY Press, 2000.

Becerra Tanco, Luis. *Felicidad de México en el principio, y milagroso origen, que tubo el Santuario de la Virgen María N. Señora de Guadalupe.* Mexico, 1675.

Birch, Thomas. *The History of the Royal Society of London.* London, 1756.

Bonaventure. *Works of St. Bonaventure,* vol. 1: *On the Reduction of the Arts to Theology.* Translated by Zachary Hayes. St. Bonaventure, NY: Franciscan Institute, St. Bonaventure University, 1996.

Bosse, Abraham. *Le Peintre converty aux précises et universelles règles de son art.* Paris, 1667.

Bossuet, Jacques-Bénigne. *Oeuvres complètes de Bossuet.* Edited by F. Lachat. Paris: Librairie de Louis Vivès, 1862.

Boyle, Robert. "General Heads for a Natural History of a Countrey, Great or Small." *Philosophical Transactions* 1 (1665–1666): 186–189.

———. *Tracts About the Cosmical Qualities of Things, Cosmical Suspicions, the Temperature of the Subterraneal Regions, the Temperature of the Submarine Regions, the Bottom of the Sea.* Oxford, 1671.

———. *The Works of the Honourable Robert Boyle.* London, 1772.

Burton, Robert. *The Anatomy of Melancholy.* Edited by A. R. Shilleto. 3 vols. London: George Bell & Sons, 1903.

Butler, Samuel. *Hudibras.* London: Henry G. Bohn, 1859.

[Carolet, Denis]. *La lanterne magique, ou le Mississippi du diable.* The Hague: Mathieu Roguet, 1723.

Cheselden, William. *Osteographia, or, the Anatomy of the Bones.* London, 1733.

Colbert, Jean-Baptiste. *Lettres, instructions et mémoires de Colbert.* Vol. 5: *Fortifications, sciences, lettres, beaux-arts, bâtiments.* Edited by Pierre Clément. Paris, 1868.

Cooper, Anthony Ashley. *Characteristicks of Men, Manners, Opinions, Times.* Vol. 1. Indianapolis: Liberty Fund, 2001.

Davenant, Charles. *The Political and Commercial Works.* London, 1771.

Daza de Valdés, Benito. *The Use of Eyeglasses.* Edited by Paul E. Runge. Ostende: J. P. Wayenborgh, 2004.

Defoe, Daniel. *The Chimera, or The French Way of Paying National Debts, Laid Open.* London, 1720.

———. *Considerations on the Present State of the Nation.* London, 1720.

———. *An Essay upon Publick Credit.* London, 1710.

———. "An Essay upon Projects." In *The Earlier Life and Works of Daniel Defoe,* edited by Henry Morley, 23–164. London: George Routledge and Sons, 1889.

———. *The Political History of the Devil*. Oxford: D. A. Talboys, 1840.

———. *A Review of the State of the British Nation*. Edited by John McVeagh. Vol. 7. London: Pickering & Chatto, 2009.

———. *A Review of the State of the English Nation*. Vol. 3. London, 1706.

Desargues, Girard. "The *Perspective* (1636)." In J. V. Field and J. J. Gray, *The Geometrical Work of Girard Desargues*, 144–160. New York: Springer, 1987.

———. "The *Rough Draft on Conics* (1639)." In J. V. Field and J. J. Gray, *The Geometrical Work of Girard Desargues*, 69–143. New York: Springer, 1987.

Descartes, René. *Discours de la méthode, pour bien conduire sa raison, & chercher la verité dans les sciences; plus La dioptrique, Les météores, et La Géométrie*. Leiden, 1637.

———. *Discourse on Method, Optics, Geometry, and Meteorology*. Translated by Paul J. Olscamp. Revised edition. Indianapolis: Hackett, 2001.

Diderot, Denis, and Jean le Rond D'Alembert, ed. *Encyclopédie, ou Dictionnaire raisonné des arts et des métiers*. Vol. 13. Neufchastel: Samuel Faulche, 1765.

The Director. Nos. I, II, III, IV. London, 1720(?).

D'Orléans, Chérubin. *Dioptrique Oculaire, ou la Théorique, la positive, et la méchanique de l'oculaire dioptrique en toutes ses espèces*. Paris, 1671.

Dubreuil, Jean. *Perspective Practical, or, A Plain and Easie Method of True and Lively Representing All Things*. London, 1672.

Dürer, Albrecht. *Unterweysung der Messung, mit dem Zirckel und Richtscheyt, in Linien, Ebnen und Gantzen Corporen*. Nuremberg, 1538.

[Ehrenberger, Bonifacius Heinrich (or Georg Balthasaris Sand)?]. *De deceptionibus catoptricis programma II*. Coburg, 1744.

[Ehrenberger, Bonifacius Heinrich (or Samuel Johannes Rhanaeus)?]. *Novum et curiosum laternae magicae augmentum*. Jena, 1713.

Eschinardi, Francesco. *Centuria problema tum opticorum, in qua praecipuae difficultates catoptricae, et dioptricae, demonstrative solvuntur*. 2 vols. Rome, 1666–1668.

Evelyn, John. *The Diary of John Evelyn*. Edited by Guy de la Bédoyère. Woodbridge: Boydell Press, 2004.

Ficino, Marsilio. *The Book of the Sun*. Translated by Geoffrey Cornelius et al. In *Marsilio Ficino*, edited by Angela Voss. Berkeley: North Atlantic Books, 2006.

Florencia, Francisco de. *Zodiaco Mariano*. Revised and augmented by Juan Antonio de Oveido. Mexico, 1755.

Furetière, Antoine. *Dictionnaire universel*. 3 vols. The Hague, 1690.

Galilei, Galileo. *Sidereus Nuncius, or, the Sidereal Messenger*. Translated by Albert van Helden. Chicago: University of Chicago Press, 1989.

[Gervaise, Isaac]. *A True State of Publick Credit*. London, 1721.

Glanvill, Joseph. *Scepsis Scientifica: Or, Contest Ignorance, the Way to Science; in an Essay of the Vanity of Dogmatizing*. London, 1665.

's Gravesande, Willem Jacob. *Essai de perspective*. The Hague: Veuve d'Abraham Troyel, 1711.

The Great Mirror of Folly: Finance, Culture, and the Crash of 1720. Edited by William N. Goetzmann, Catherine Labio, K. Geert Rouwenhorst, and Timothy G. Young. New Haven: Yale University Press, 2013.

Gumppenberg, Wilhelm. *Atlas Marianus*. Munich, 1672.

———. *L'Atlas Marianus*. Translated by Laurent Auberson, Naïma Ghermani, and Anton Serdeczny. Neuchatel: Editions Alphil-Presses universitaires suisses, 2015.

Du Halde, Jean-Baptiste. *A Description of the Empire of China and Chinese-Tartary*. London, 1741.

Halley, Edmund. "An Estimate of the Degrees of the Mortality of Mankind, Drawn from Curious Tables of the Births and Funerals at the City of Breslaw." *Philosophical Transactions of the Royal Society* 17, no. 196 (1693): 596–610.

Harris, John. *Lexicon technicum; or, an Universal English Dictionary of Arts and Sciences*. Vol. 1, 2nd ed. London, 1708.

Harsdörffer, Georg Philipp. *Delitiae philosophicae et mathematicae*. Nuremberg, 1653.

Hobbes, Thomas. *Leviathan*. Edited by J. C. A. Gaskin. Oxford: Oxford University Press, 1998.

Hoogstraten, Samuel van. *Inleyding tot de hooge schoole der schilderkonst: Anders de zichtbaere werelt*. Rotterdam, 1678.

———. *Introduction à la haute école de l'art de peinture*. Translated by Jan Blanc. Geneva: Librairie Droz, 2006.

Hooke, Robert. "A Contrivance to Make the Picture of Any Thing Appear on a Wall, Cub-Board, or Within a Picture-Frame." *Philosophical Transactions* 3, no. 38 (1668): 741–743.

———. *Micrographia: Or Some Physiological Descriptions of Minute Bodies Made by Magnifying Glasses with Observations and Inquiries Thereupon*. London, 1665.

———. *Philosophical Experiments and Observations*. Edited by William Derham. London, 1726.

———. *The Posthumous Works of Robert Hooke*. Edited by Richard Waller. London, 1705.

Houghton, John. *A Collection for the Improvement of Husbandry and Trade*. Vol. 1. London, 1727.

Hume, David. *An Enquiry Concerning Human Understanding, and Selections from A Treatise of Human Nature*. Chicago: Open Court, 1921.

———. *An Enquiry Concerning the Principles of Morals*. Chicago: Open Court, 1912.

———. *Essays and Treatises on Several Subjects*. Vol. 1. London, 1764.

———. *A Treatise of Human Nature*. Edited by L. A. Selby-Bigge. Oxford: Clarendon Press, 1960.

Hutcheson, Francis. *An Inquiry into the Original of Our Ideas of Beauty and Virtue.* 2nd ed. London, 1726.

Huygens, Christiaan. *Briefwisseling.* Vol. 1: 1608–1634. Edited by J. A. Worp. The Hague: Martinus Nijhoff, 1911.

———. *Oeuvres complètes.* Vol. 4: *Correspondance 1662–1663.* The Hague: Martinus Nijhoff, 1891.

Ignatius de Loyola. *Powers of Imagining.* Albany: SUNY Press, 1986.

Inés de la Cruz, Juana. *Poems, Protest, and a Dream.* Translated by Margaret Sayers Peden. New York: Penguin Books, 1997.

Jackson, Joseph. *A Discourse Concerning God's Foreknowledge and Man's Free Agency.* 4th and revised ed. London, 1713.

Jenkinson, Charles. *A Treatise on the Coins of the Realm; in a Letter to the King.* Oxford: Oxford University Press, 1805.

Johnson, Samuel. *A Dictionary of English Language.* 2 vols. London, 1756.

Kant, Immanuel. "Dreams of a Spirit-Seer Elucidated by Dreams of Metaphysics." In *Theoretical Philosophy, 1755–1770.* Translated and edited by David Walford. Cambridge: Cambridge University Press, 1992.

Kepler, Johannes. *Optics: Paralipomena to Witelo & Optical Part of Astronomy.* Translated by William H. Donahue. Santa Fe: Green Lion Press, 2000.

Kircher, Athanasius. *Ars magna lucis et umbrae.* Rome: Hermann Scheus, 1646.

———. *Ars magna lucis et umbrae.* 2nd ed. Amsterdam: Jansson and Weyerstrat, 1671.

———. *Diatribe de prodigiosis crucibus.* Rome, 1661.

———. *Mundus subterraneus.* Amsterdam: Jansson and Weyerstrat, 1665.

Knox, Robert. *An Historical Relation of the Island of Ceylon.* London: Richard Chiswell, 1681.

Lamy, Bernard. *A Treatise of Perspective; or, the Art of Representing All Manner of Objects as They Appear to the Eye in All Situations.* London, 1702.

Leclerc, Sébastien. *Discours touchant le point de vue.* Paris, 1719.

———. *Nouveau système du monde, conforme à l'écriture sainte.* Paris, 1708.

———. *Système de la vision, fondé sur de nouveaux principes.* Paris, 1712.

Leibniz, G. W. *Der Briefwechsel mit den Jesuiten in China (1689–1714).* Edited by Rita Widmaier. Hamburg: Meiner, 2006.

———. *De Summa Rerum: Metaphysical Papers, 1675–1676.* Translated by G. H. R. Parkinson. New Haven: Yale University Press, 1992.

———. *Discourse on Metaphysics, Correspondence with Arnauld, and Monadology.* 2nd ed. Translated by George R. Montgomery. Chicago: Open Court, 1918.

———. *Monadology: A New Translation and Guide.* Translated and edited by Lloyd Strickland. Edinburgh: Edinburgh University Press, 2014.

———. *New Essays on Human Understanding*. Translated and edited by Peter Remnant and Jonathan Bennett. Cambridge: Cambridge University Press, 1996.

———. *Die Philosophische Schriften*. Edited by Karl Immanuel Gerhardt. 7 vols. Berlin: Weidmann, 1890.

———. *Sämtliche Schriften und Briefe*. Vol. 4: *Politische Schriften*, part 1: 1667–1676. 3rd ed. Berlin: Akademie Verlag, 1983.

———. *Theodicy: Essays on the Goodness of God, the Freedom of Man and the Origin of Evil*. Translated by E. M. Huggard. La Salle: Open Court, 1985.

Lemée, François. *Traité des statues*. Paris: Arnould Seneuze, 1688.

Locke, John. *An Essay Concerning Human Understanding*. 12th ed. 2 vols. London, 1741.

———. *Two Treatises of Government*. Edited by Peter Laslett. Cambridge: Cambridge University Press, 1988.

Loret, Jean. *La Muze historique, ou recueil des lettres en vers*. Vol. 2, 1655–1658. Paris: P. Daffis, 1877.

de Magalães, Gabriel. *A New History of China, Containing a Description of the Most Considerable Particulars of that Vast Empire*. Translated by John Ogilby. London, 1688.

Malebranche, Nicolas. *De la recherche de la vérité*. In *Oeuvres complètes de Malebranche*. Vol. 1. Paris: De Sapia, 1837.

Mandeville, Bernard. *The Fable of the Bees; or, Private Vices Public Benefits*. London: T. Ostell, 1806.

Marx, Karl. *Capital: A Critique of Political Economy*. Vol. 1. Translated by Ben Fowkes. Harmondsworth: Penguin, 1976.

———. *Capital: A Critique of Political Economy*. Vol. 3. Translated by David Fernbach. London: Penguin, 1991.

———. *Das Kapital: Kritik der Politischen Ökonomie*. Vol. 1. In *Gesamtausgabe*. Vol. 10. Berlin: Dietz Verlag, 1991.

———. *Das Kapital: Kritik der Politischen Ökonomie*. Vol. 3. In *Gesamtausgabe*. Vol. 15. Berlin: Akademie Verlag, 2004.

Marx, Karl, and Friedrich Engels. *The German Ideology*. New York: Prometheus Books, 1998.

Midriff, John. *Observations on the Spleen and Vapours*. London, 1721.

Molyneux, William. *Dioptrica Nova: A Treatise in Dioptricks*. London, 1692.

Montesquieu. *Persian Letters*. Translated by John Davidson. London: George Routledge & Sons, 1923.

Musschenbroek, Pierre van. *Essai de physique*. Translated by Pierre Massuet. Leiden, 1751.

Niceron, Jean-François. *La perspective curieuse*. Paris, 1651.

Oldenburg, Henri. "The Description of an Instrument Invented Divers Years Ago by Dr. Christopher Wren." *Philosophical Transactions of the Royal Society* 4, no. 45 (25 March 1669): 898–899.

[Olivier, Abbé Jean?]. *Memoirs of the Life and Adventures of Signor Rozelli, at the Hague.* London, 1709.

Osorio Romaro, Ignacio. *La Luz imaginaria: Epistolario de Atanasio Kircher con los novohispanos.* Mexico City: Universidad Nacional Autónoma de México, 1993.

Pascal, Blaise. "De l'esprit géométrique et de l'art de persuader." In *Oeuvres complètes.* Vol. 3. Paris: Hachette, 1871.

Patin, Charles. *Travels thro' Germany, Swisserland, Bohemia, Holland, and Other Parts of Europe.* London, 1697.

Pecham, John. *John Pecham and the Science of Optics: Perspectiva communis.* Translated and edited by David C. Lindberg. Madison: University of Wisconsin Press, 1970.

———. *Perspectiva communis.* Cologne: Apud Haeredes Arnoldi Birckmanni, 1580.

Pepys, Samuel. *The Diary of Samuel Pepys.* Edited by Henry B. Wheatley. London: George Bell & Sons, 1894–95.

Petty, William. *The Economic Writings of Sir William Petty.* Edited by Charles Henry Hull. Cambridge: Cambridge University Press, 1899.

Pierquin, Jean. "Reflexions philosophiques de M. Pierquin, sur l'évocation des morts." In Nicolas Lenglet Dufresnoy, *Recueil des dissertations anciennes et nouvelles, sur les apparitions, les visions et les songes.* 2 vols. Avignon, 1752.

de Piles, Roger. *Cours de peinture par principes.* Paris: Jacques Estienne, 1708.

Plain Dealing: In a Dialogue Between Mr. Johnson and Mr. Wary. London, 1691.

Plotinus. *The Enneads.* Translated by George Boys-Stones et al. Edited by Lloyd P. Gerson. Cambridge: Cambridge University Press, 2018.

Pope, Alexander. *The Works of Alexander Pope.* Vol. 6. London: John Murray, 1871.

Porta, Giambattista Della. *Natural Magick.* London, 1669.

Postlethwayt, Malachy. *The Universal Dictionary of Trade and Commerce.* 4th ed. London, 1774.

Pozzo, Andrea. *Rules and Examples of Perspective Proper for Painters and Architects, etc.* Translated by John James of Greenwich. London, 1693.

Robertson, Etienne-Gaspard. *Mémoires récréatifs, scientifiques et anecdotiques.* 2 vols. Paris, 1831.

de la Rochefoucauld, Roger. *Deo adjuvante: Theses philosophicae.* Paris, 1707.

Rooke, Lawrence. "Directions for Sea-men, Bound for Far Voyages." *Philosophical Transactions of the Royal Society* 1, no. 8 (May 1665): 140–143.

Rosignoli, Gregorio. *Meraviglie di Dio ne' Suoi santi.* Venice, 1772.

Ruspolo, Francisco. *Musaeum Kircherianum.* Rome, 1709.

Scheiner, Christoph. *Oculus, hoc est: Fundamentum opticum*. Freiburg, 1621.

———. *Rosa ursina sive sol*. Bracciano, 1626–1630.

Schott, Gaspar. *Magia Optica*. Frankfurt am Main: Johan Martin Schönwetter, 1677.

———. *Magia universalis naturae et artis*. 4 vols. Bamberg: Johann Martin Schönwetter, 1677.

Schwenter, Daniel. *Deliciae Physico-Mathematicae, oder Mathemat: Und Philosophische Erquickstunden*. Nuremberg, 1636.

Sepibus, Georgius de. *Romani collegii Societatis Jesu musaeum celeberrimum*. Amsterdam, 1678.

Smollett, Tobias. *The Adventures of Ferdinand Fathom*. In *The Works of Tobias Smollett*. Vol. 9. New York: The Jenson Society, 1907.

Sprat, Thomas. *The History of the Royal Society of London, for the Improving of Natural Knowledge*. 4th ed. London, 1734.

[Stephens, Frederick George]. *Catalogue of Prints and Drawings in the British Museum, Division I, Political and Personal Satires*. Vol. 2: June 1689 to 1733. London: Chiswick Press, 1873.

Sterne, Laurence. *The Works of Laurence Sterne*. Vol. 3: *Sermons*. London, 1823.

Sturm, Johann Christian. *Collegium Experimentale, sive Curiosum*. Nuremberg: Endteri & Haeredum, 1676.

Swift, Jonathan. *The Works of the Rev. Jonathan Swift, D. D.* 19 vols. London, 1801.

Terrasson, Jean. *Lettres sur le nouveau systême des finances*. 1720.

———. *Traité de l'infini créé, avec l'explication de la possibilité de la transubstantiation*. Amsterdam, 1769.

Traber, Zacharius. *Nervus opticus sive tractatus theoricus in tres libros*. Vienna, 1675.

d'Usson de Bonrepaus, Francois. "Mémoire touchant le négoce and la navigation des Hollandois." *Bijdragen en Mededeelingen van het Historisch Genootschap* 24 (1903): 238–318.

Vallemont, Pierre le Lorrain. *Physique occulte, ou Traité de la baguette divinatoire*. Paris, 1693.

de la Vega, Luis Laso. *The Story of Guadalupe: Luis Laso de la Vega's "Huei tlamahuiçoltica" of 1649*. Edited and translated by Lisa Sousa, Stafford Poole, and James Lockhart. UCLA Latin American Studies 84. Stanford: Stanford University Press, 1998.

Verbiest, Ferdinand. *Astronomia Europaea*. Dillingen, 1687.

de Vetancurt, Augustine. *Chronica de la Provincia del Santo Evangelio de Mexico*. Vol. 4 of *Teatro Mexicano*. Mexico, 1697.

Wagner, Johann Christoph. *Das mächtige Kayser-Reich Sina und die Asiatische Tartaren*. Augsburg, 1688.

Waller, Richard. "The Life of Dr. Robert Hooke." In *The Posthumous Works of Robert Hooke*, edited by Richard Waller. London, 1705.

Wotton, Henri. *Reliquiae Wottonianae, or, a Collection of Lives, Letters, Poems.* London, 1685.

Zahn, Johann. *Oculus artificialis teledioptricus sive telescopium.* 3 vols. Herbipolis [Würzburg], 1685–1686.

Secondary Sources

Agamben, Giorgio. *The Kingdom and the Glory: For a Theological Genealogy of Economy and Government.* Translated by Lorenzo Chiesa. Stanford: Stanford University Press, 2011.

Alff, David. *The Wreckage of Intentions: Projects in British Culture, 1660–1730.* Philadelphia: University of Pennsylvania Press, 2017.

Alpers, Svetlana. *The Art of Describing: Dutch Art in the Seventeenth Century.* Chicago: University of Chicago Press, 1983.

Anderson, Steve. *Technologies of Vision: The War Between Data and Images.* Cambridge, MA: MIT Press, 2017.

Andriopoulos, Stefan. *Ghostly Apparitions: German Idealism, the Gothic Novel, and Optical Media.* New York: Zone Books, 2013.

Ariew, Roger. "Descartes and the Jesuits: Doubt, Novelty, and the Eucharist." In *Jesuit Science and the Republic of Letters*, edited by Mordechai Feingold, 157–194. Cambridge, MA: MIT Press, 2003.

Ashworth, William. "Light of Reason, Light of Nature: Catholic and Protestant Metaphors of Scientific Knowledge." *Science in Context* 3, no. 1 (1989): 89–107.

Báez Rubí, Linda. "Vislumbrar y admirar: 'La maravilla americana' en los modelos de visión y procesos icónicos de la cultura jesuítica." In *XXXVI Coloquio Internacional de Historia del Arte: Los estatutos de la imagen, creación-manifestación-percepción*, edited by Linda Báez Rubí and Emilie Carreón Blaine, 67–86. México: Universidad Nacional Autónoma de México / Instituto de Investigaciones Estéticas, 2014.

Bähr, Andreas. *Furcht und Furchtlosigkeit: Göttliche Gewalt und Selbstkonstitution im 17. Jahrhundert.* Göttingen: V&R Unipress, 2013.

Baltrušaitis, Jurgis. *Anamorphic Art.* Translated by W. J. Strachan. New York: Harry N. Abrams, 1977.

Barbour, Violet. *Capitalism in Amsterdam in the Seventeenth Century.* Johns Hopkins University Studies in Historical and Political Science. Vol. 67. Baltimore: Johns Hopkins Press, 1950.

Barth, Karl. *Church Dogmatics.* Vol. 3: *The Doctrine of Creation 3.* Translated by G. W.

Bromiley and R. J. Ehrlich. Edited by G. W. Bromiley and T. F. Torrance. London: T&T Clark, 1960.

Barthes, Roland. *Sade / Fourier / Loyola*. Translated by Richard Miller. Berkeley: University of California Press, 1989.

Baucom, Ian. *Specters of the Atlantic: Finance Capital, Slavery, and the Philosophy of History*. Durham: Duke University Press, 2005.

Baudry, Jean-Louis. "Ideological Effects of the Basic Cinematographic Apparatus." Translated by Alan Williams. *Film Quarterly* 28, no. 2 (1974–1975): 39–47.

Baxandall, Michael. *Shadows and Enlightenment*. New Haven: Yale University Press, 1995.

Belting, Hans. *Florence and Baghdad: Renaissance Art and Arab Science*. Translated by Deborah Lucas Schneider. Cambridge, MA: Harvard University Press, 2011.

Bender, John, and Michael Marrinan. *The Culture of Diagram*. Stanford: Stanford University Press, 2010.

Bermingham, Ann. *Learning to Draw: Studies in the Cultural History of a Polite and Useful Art*. New Haven: Yale University Press, 2000.

Berns, Jörg Jochen. "Der Zauber der technischen Medien: Fernohr, Hörrohr, Camera obscura, Laterna magica." *Simpliciana: Schriften der Grimmelshausen-Gesellschaft* 26 (2004): 245–266.

Biagioli, Mario. *Galileo's Instruments of Credit: Telescopes, Imagery, Secrecy*. Chicago: University of Chicago Press, 2006.

Birch, Michael. *Establishing the New Science: The Experience of the Early Royal Society*. Woodbridge: Boydell Press, 1989.

Blumenberg, Hans. *The Legitimacy of the Modern Age*. Translated by Robert M. Wallace. Cambridge, MA: MIT Press, 1983.

———. "Light as a Metaphor for Truth: At the Preliminary Stage of Philosophical Concept Formation." Translated by Joel Anderson. In *Modernity and the Hegemony of Vision*, edited by David Michael Levin, 30–62. Berkeley: University of California Press, 1993.

de Boer, Wietse. *The Conquest of the Soul: Confession, Discipline, and Public Order in Counter-Reformation Milan*. Leiden: Brill, 2001.

Bonnefoy, Yves. *Rome, 1630: L'horizon du premier baroque*. Paris: Flammarion, 2000.

Brading, David A. *Mexican Phoenix: Our Lady of Guadalupe: Image and Tradition Across Five Centuries*. Cambridge: Cambridge University Press, 2001.

Bredekamp, Horst. *Die Fenster der Monade: Gottfried Wilhelm Leibniz' Theater der Natur und Kunst*. 2nd ed. Berlin: Akademie Verlag, 2008.

———. *Image Acts: A Systematic Approach to Visual Agency*. Translated by Elizabeth Clegg. Berlin: De Gruyter, 2018.

Brennan, Pip. *The Camera Obscura and Greenwich*. London: National Maritime Museum, 1994.

Buonanno, Roberto. *The Stars of Galileo Galilei and the Universal Knowledge of Athanasius Kircher*. Translated by Roberto Buonanno and Giuliana Giobbi. Cham: Springer, 2014.

Camerota, Filippo. "Exactitude and Extravagance: Andrea Pozzo's 'Viewpoint.'" In *Imagine Math: Between Culture and Mathematics*, edited by Michele Emmeror, 23–41. Milan: Springer, 2012.

Cañizares-Esguerra, Jorge. *Nature, Empire, and Nation: Explorations of the History of Science in the Iberian World*. Stanford: Stanford University Press, 2006.

Carey, Daniel. "Compiling Nature's History: Travellers and Travel Narratives in the Early Royal Society." *Annals of Science* 54, no. 3 (1997): 269–292.

Caruana, Louis. "The Jesuits and the Quiet Side of the Scientific Revolution." In *The Cambridge Companion to the Jesuits*, edited by Thomas Worcester, 243–260. Cambridge: Cambridge University Press, 2008.

Casid, Jill H. *Scenes of Projection: Recasting the Enlightenment Subject*. Minneapolis: University of Minnesota Press, 2015.

Castle, Terry. "Phantasmagoria: Spectral Technology and the Metaphorics of Modern Reverie." *Critical Inquiry* 15, no. 1 (1988): 26–61.

Chaves, Jonathan. *Singing of the Source: Nature and God in the Poetry of the Chinese Painter Wu Li*. Honolulu: University of Hawai'i Press, 1993.

Chen-Morris, Raz. *Measuring Shadows: Kepler's Optics of Invisibility*. University Park: Pennsylvania State University Press, 2016.

Christin, Olivier, and Fabrice Flückiger. "Rendre visible la frontière confessionnelle: l'*Atlas Marianus* de Wilhelm Gumppenberg." In *Les Affrontements religieux en Europe: Du début du XVIe au milieu du XVIIe siècle*, edited by Véronique Castagnet, Olivier Christin, and Naïma Ghermani, 33–44. Villeneuve d'Ascq: Presses Universitaires du Septentrion, 2008.

Clark, Stuart. *Vanities of the Eye: Vision in Early Modern European Culture*. Oxford: Oxford University Press, 2007.

Clunas, Craig. *Pictures and Visuality in Early Modern China*. London: Reaktion Books, 1997.

Cole, Arthur. *The Great Mirror of Folly: An Economic-Bibliographical Study*. Boston: Baker Library / Harvard Graduate School of Business Administration, 1949.

Coleman, Charly. "The Spirit of Speculation: John Law and Economic Theology in the Age of Lights." *French Historical Studies* 42, no. 2 (2019): 203–237.

Colie, Rosalie. *Paradoxia Epidemica: The Renaissance Tradition of Paradox*. Princeton: Princeton University Press, 1966.

Collins, Michael. "The Ground Glass: Landscape Art, the Camera Obscura, and Photography." Picturing Places, British Library. Accessed April 20, 2021. https://www.bl.uk/picturing-places/articles/the-ground-glass-landscape-art-the-camera-obscura-and-photography-coll-items-missing

Conley, Tom. "Eros stéganographique: Béroalde de Verville, *Le Voyage des princes fortunez* (1610)." In *Théories critiques et littérature de la Renaissance: Mélanges offerts à Lawrence Kritzman,* edited by Todd Reeser and David LaGuardia, 75–90. Paris: Classiques Garnier, 2020.

Cooper, M. A. R. "Robert Hooke (1635–1703): Proto-Photogrammetrist." *Photogrammetric Record* 15 (1996): 403–417.

Costabel, Pierre. "Traduction française de notes de Leibniz sur les 'Coniques' de Pascal." *Revue d'histoire des sciences et de leurs applications* 15, nos. 3–4 (1962): 253–268.

Costelloe, Timothy. *Imagination in Hume's Philosophy: The Canvas of the Mind.* Edinburgh: Edinburgh University Press, 2018.

Craig, William Lane. *The Problem of Divine Foreknowledge and Future Contingents from Aristotle to Suarez.* Leiden: Brill, 1988.

Crangle, Richard. "'A Quite Rare Entertainment': An Optical Show in Paris in 1656." *New Magic Lantern Journal* 9, no. 5 (2003): 76–78.

Crary, Jonathan. *Techniques of the Observer: On Vision and Modernity in the Nineteenth Century.* Cambridge, MA: MIT Press, 1990.

Crisp, Virginia, and Gabriel Menotti, ed. *Practices of Projection: Histories and Technologies.* Oxford: Oxford University Press, 2020.

Cruz, Juan. "Predestination as Transcendent Teleology: Molina and the First Molinism." In *A Companion to Luis de Molina,* edited by Matthias Kaufmann and Alexander Aichele, 89–121. Leiden: Brill, 2014.

Cubitt, Sean. *The Practice of Light: A Genealogy of Visual Technologies from Prints to Pixels.* Cambridge, MA: MIT Press, 2014.

Damisch, Hubert. *The Origin of Perspective.* Translated by John Goodman. Cambridge, MA: MIT Press, 1994.

Daston, Lorraine. "Baconian Facts, Academic Civility, and the Prehistory of Objectivity." In *Rethinking Objectivity,* edited by Allan Megill, 37–63. Durham: Duke University Press, 1994.

———. *Classical Probability in the Enlightenment.* Princeton: Princeton University Press, 1988.

———. "Nature Paints." In *Iconoclash: Beyond the Image Wars in Science, Religion, and Art,* edited by Bruno Latour and Peter Weibel, 136–138. Cambridge, MA: MIT Press, 2002.

Daston, Lorraine, and Peter Galison. *Objectivity.* New York: Zone Books, 2007.

Daston, Lorraine, and Katharine Park. *Wonders and the Order of Nature, 1150–1750.* New York: Zone Books, 1998.

Debuiche, Valérie. "L'invention d'une géométrie pure au 17e siècle: Pascal et son lecteur Leibniz." *Studia Leibnitiana* 48, no. 1 (2016): 42–67.

Dekoninck, Ralph. "*Propagatio Imaginum:* The Translated Images of Our Lady of Foy." In *The Nomadic Object: The Challenge of World for Early Modern Religious Art*, edited by Christine Göttler and Mia Mochizuki, 241–267. Leiden: Brill, 2018.

Deleuze, Gilles. *Cinema 2: The Time-Image.* Translated by Hugh Tomlinson and Robert Galeta. Minneapolis: University of Minnesota Press, 1997.

———. *Difference and Repetition.* Translated by Paul Patton. New York: Columbia University Press, 1994.

———. *The Fold: Leibniz and the Baroque.* Translated by Tom Conley. London: Continuum, 2006.

Deringer, William. *Calculated Values: Finance, Politics, and the Quantitative Age.* Cambridge, MA: Harvard University Press, 2018.

Dickson, P. G. M. *The Financial Revolution in England: A Study in the Development of Public Credit 1688–1756.* London: Macmillan, 1967.

Dupré, Sven. "Inside the 'Camera Obscura': Kepler's Experiment and Theory of Optical Imagery." *Early Science and Medicine* 13, no. 3 (2008): 219–244.

Dupré, Sven, and Michael Korey. "Inside the *Kunstkammer*: The Circulation of Optical Knowledge and Instruments at the Dresden Court." *Studies in History and Philosophy of Science* 40 (2009): 405–420.

Duro, Paul. *The Academy and the Limits of Painting in Seventeenth-Century France.* Cambridge: Cambridge University Press, 1997.

Eck, Caroline van. *Art, Agency, and Living Presence: From the Animated Image to the Excessive Object.* Leiden: Leiden University Press / De Gruyter, 2015.

Edgerton, Jr., Samuel Y. *The Heritage of Giotto's Geometry: Art and Science on the Eve of the Scientific Revolution.* Ithaca: Cornell University Press, 1991.

———. *The Renaissance Rediscovery of Linear Perspective.* New York: Harper & Row, 1975.

Eire, Carlos. *War Against the Idols: The Reformation of Worship from Erasmus to Calvin.* Cambridge: Cambridge University Press, 1986.

Ewald, François. "Insurance and Risk." In *The Foucault Effect: Studies in Governmentality*, edited by Graham Burchell, Colin Gordon, and Peter Miller, 197–210. Chicago: University of Chicago Press, 1991.

Fabre, Pierre-Antoine. *Ignace de Loyola, le lieu de l'image: Le problème de la composition du lieu dans les pratique spirituelles et artistiques jésuites de la seconde moitié XVIe siècle.* Paris: Vrin, 1992.

Feldhay, Rivka. "Knowledge and Salvation in Jesuit Culture." *Science in Context* 1, no. 2 (1987): 195–213.

Findlen, Paula. "A Jesuit's Books in the New World: Athanasius Kircher and His American Readers." In *Athanasius Kircher: The Last Man Who Knew Everything*, edited by Paula Findlen, 329–364. New York: Routledge, 2004.

———. "Jokes of Nature and Jokes of Knowledge." *Renaissance Quarterly* 43, no. 2 (1990): 292–331.

Fletcher, John. *A Study of the Life and Works of Athanasius Kircher, "Germanus Incredibilis."* Edited by Elizabeth Fletcher. Leiden: Brill, 2011.

Foucault, Michel. *Security, Territory, Population: Lectures at the Collège de France, 1977–1978.* Edited by Michel Senellart. Translated by Graham Burchell. Basingstoke: Palgrave Macmillan, 2009.

Friedberg, Anne. *The Virtual Window: From Alberti to Microsoft.* Cambridge, MA: MIT Press, 2006.

Fuhring, Peter, Louis Marchesano, Rémi Mathis, and Vanessa Selbach, ed. *A Kingdom of Images: French Prints in the Age of Louis XIV, 1660–1715.* Los Angeles: Getty Research Institute, 2015.

Gal, Ofer, and Raz Chen-Morris. "Baroque Optics and the Disappearance of the Observer: From Kepler's *Optics* to Descartes' *Doubt*." *Journal of the History of Ideas* 71, no. 2 (2010): 191–217.

Garnett, Jane, and Gervase Rosser. *Spectacular Miracles: Transforming Images from the Renaissance to the Present.* London: Reaktion Books, 2013.

Gascoigne, John. "The Royal Society, Natural History and the Peoples of the 'New World(s),' 1660–1800." *British Journal for the History of Science* 42, no. 4 (2009): 539–562.

Gelderblom Oscar, and Joost Jonker. "Amsterdam as the Cradle of Modern Futures Trading and Options Trading, 1550–1650." In *The Origins of Value: The Financial Innovations That Created Modern Capital Markets*, edited by William N. Goetzmann and K. Geert Rouwenhorst, 189–206. Oxford: Oxford University Press, 2005.

Godwin, Joscelyn. *Athanasius Kircher's Theatre of the World: His Life, Work, and the Search for Universal Knowledge.* London: Thames & Hudson, 2009.

de Goede, Marieke. "Mastering 'Lady Credit': Discourses of Financial Crisis in Historical Perspective." *International Feminist Journal of Politics* 2, no. 1 (2000): 58–81.

Goetzmann, William N. *Money Changes Everything: How Finance Made Civilization Possible.* Princeton: Princeton University Press, 2016.

Gorman, Michael J. "Projecting Nature in Early-Modern Europe." In *Inside the Camera Obscura: Optics and Art Under the Spell of the Projected Image*, edited

by Wolfgang Lefèvre, 31–50. Berlin: Max Planck Institute for the History of Science, 2007.

Gould, Stephen Jay. "Father Athanasius on the Isthmus of a Middle State: Understanding Kircher's Paleontology." In *Athanasius Kircher: The Last Man Who Knew Everything*, edited by Paula Findlen, 207–237. New York: Routledge, 2007.

Grootenboer, Hanneke. *The Rhetoric of Perspective: Realism and Illusionism in Seventeenth-Century Dutch Still Life Painting*. Chicago: University of Chicago Press, 2005.

Gruzinski, Serge. *Images at War: Mexico from Columbus to* Blade Runner *(1492–2019)*. Translated by Heather MacLean. Durham: Duke University Press, 2001.

Guerrini, Anita. "Counterfeit Bodies: Sébastien Leclerc, Anatomy, and the Art of Copying at the Paris Academy of Sciences." *Word & Image* 35, no. 3 (2019): 277–295.

Gunning, Tom. "The Transforming Image: The Roots of Animation in Metamorphosis and Motion." In *Pervasive Animation*, edited by Suzanne Buchan, 52–67. New York: Routledge, 2013.

Hanafi, Zakiya. *The Monster in the Machine: Magic, Medicine, and the Marvelous in the Time of the Scientific Revolution*. Durham: Duke University Press, 2000.

Hankins, Thomas, and Robert Silverman. *Instruments and the Imagination*. Princeton: Princeton University Press, 1995.

Harley, J. B. "Maps, Knowledge and Power." In *The Iconography of Landscape: Essays on the Symbolic Representation, Deigns and Use of Past Environments*, edited by Denis Cosgrove and Stephen Daniels, 277–312. Cambridge: Cambridge University Press, 1988.

Haskell, Francis. "The Role of Patrons: Baroque Style Changes." In *Baroque Art: The Jesuit Contribution*, edited by Rudolf Wittkower and Irma B. Jaffe, 51–62. New York: Fordham University Press, 1972.

Heal, Bridget. *A Magnificent Faith: Art and Identity in Lutheran Germany*. Oxford: Oxford University Press, 2017.

Heath, Stephen. "Narrative Space." *Screen* 17, no. 3 (1968): 68–112.

Hecht, Hermann. "The History of Projecting Phantoms, Ghosts, and Apparitions." *New Magic Lantern Journal* 3, no. 2 (1984): 2–6.

Hersey, George L. *Architecture and Geometry in the Age of the Baroque*. Chicago: University of Chicago Press, 2000.

Hirai, Hiro. "Interprétation chymique de la création et origine corpusculaire de la vie chez Athanasius Kircher." *Annals of Science* 64, no. 2 (2007): 217–234.

———. "Kircher's Chymical Interpretation of the Creation and Spontaneous Generation." In *Chymists and Chymistry: Studies in the History of Alchemy and Early*

Modern Chemistry, edited by Lawrence Principe, 77–87. Sagamore Beach: Science History Publications, 2007.

Hunter, Matthew C. "'Mr. Hooke's Reflecting Box': Modeling the Projected Image in the Early Royal Society." *Huntington Library Quarterly* 78, no. 2 (2015): 301–328.

———. *Wicked Intelligence: Visual Art and the Science of Experiment in Restoration London*. Chicago: University of Chicago Press, 2013.

Hunter, Michael. *Boyle Studies: Aspects of the Life and Thought of Robert Boyle (1627–91)*. London: Routledge, 2016.

———. "Robert Boyle and the Early Royal Society: A Reciprocal Exchange in the Making of Baconian Science." *British Journal for the History of Science* 40, no. 1 (2007): 1–23.

Ingrassia, Catherine. *Authorship, Commerce, and Gender in Early Eighteenth-Century England: A Culture of Paper Credit*. Cambridge: Cambridge University Press, 1998.

Irving, Sarah. *Natural Science and the Origins of British Empire*. London: Pickering & Chatto, 2008.

Ivins, Jr., William M. *Art and Geometry: A Study in Space Intuitions*. New York: Dover, 1964.

Jacob, Christian. *The Sovereign Map: Theoretical Approaches in Cartography Throughout History*. Translated by Tom Conley. Edited by Edward H. Dahl. Chicago: University of Chicago Press, 2006.

Jennings, Edward M. "The Consequences of Prediction." *Studies on Voltaire and the Eighteenth Century* 153 (1976): 1131–1151.

Kavanagh, Thomas. *Enlightenment and the Shadows of Chance: The Novel and the Culture of Gambling in Eighteenth-Century France*. Baltimore: Johns Hopkins University Press, 1993.

Kemp, Martin. *The Science of Art: Optical Themes in Western Art from Brunelleschi to Seurat*. New Haven: Yale University Press, 1990.

Kile, S. E., and Kristina Kleutghen. "Seeing Through Pictures and Poetry: A History of Lenses (1681)." *Late Imperial China* 38, no. 1 (2017): 47–112.

Kittler, Friedrich. *Optical Media: Berlin Lectures 1999*. Translated by Athony Enns. Cambridge: Polity, 2010.

Kofman, Sarah. *Camera Obscura of Ideology*. Translated by Will Straw. Ithaca: Cornell University Press, 1998.

Lange-Fuchs, Hauke. "On the Origin of Moving Slides." *New Magic Lantern Journal* 7, no. 3 (1995): 10–14.

Laplanche, Jean, and Jean-Bertrand Pontalis. *The Language of Psycho-analysis*. Translated by Donald Nicholson-Smith. London: Karnac Books 1988.

Latta, Kimberly. "'Wandring Ghosts of Trade Whymsies': Projects, Gender, Commerce, and Imagination in the Mind of Daniel Defoe." In *The Age of Projects*, edited by Maximillian E. Novak, 141–165. Toronto: University of Toronto Press, 2008.

Lebeuf, Arnold. "Cave of the Astronomers at Xochicalco." In *Handbook of Archaeoastronomy and Ethnoastronomy*, edited by Clive Ruggles, 749–758. New York: Springer, 2015.

Leeman, Fred. *Hidden Images: Games of Perception, Anamorphic Art, Illusion, from the Renaissance to the Present*. Translated by Ellyn Childs Allison and Margaret L. Kaplan. New York: Harry N. Abrams, 1976.

Lefèvre, Wolfgang, ed. *Inside the Camera Obscura: Optics and Art Under the Spell of the Projected Image*. Berlin: Max Planck Institute for the History of Science, 2007.

Leinkauf, Thomas. *Mundus combinatus: Studien zur Struktur der barocken Universalwissenschaft am Beispiel Athanasius Kirchers SJ*. Berlin: De Gruyter, 2012.

Leonhard, Karin. *Bildfelder: Stillleben und Naturstücke des 17. Jahrhunderts*. Berlin: Akademie Verlag 2013.

Leplatre, Olivier. "Spiritualité de l'anamorphose: *Le Carême du Louvre*, Bossuet." *L'information littéraire* 54, no. 4 (2002): 38–46.

Levy, Evonne. *Propaganda and the Jesuit Baroque*. Berkeley: University of California Press, 2004.

Lindberg, David C. "The Genesis of Kepler's Theory of Light: Light Metaphysics from Plotinus to Kepler." *Osiris* 2 (1986): 4–42.

———. Introduction to *John Pecham and the Science of Optics: Perspectiva communis*. Translated and edited by David C. Lindberg Madison: University of Wisconsin Press, 1970.

———. *Theories of Vision from Al-Kindi to Kepler*. Chicago: University of Chicago Press, 1976.

Loughridge, Deirdre. *Haydn's Sunrise, Beethoven's Shadow: Audiovisual Culture and the Emergence of Musical Romanticism*. Chicago: University of Chicago Press, 2016.

Lyssy, Ansgar. "Nature and Grace: On the Concept of Divine Economy in Leibniz's Philosophy." *Studia Leibnitiana* 48, no. 2 (2016): 151–177.

Macpherson, C. B. *The Political Theory of Possessive Individualism: Hobbes to Locke*. Oxford: Oxford University Press, 1992.

Mannoni, Laurent. *The Great Art of Light and Shadow: Archaeology of the Cinema*. Translated and edited by Richard Crangle. Exeter: University of Exeter Press, 2000.

Massey, Lyle. *Picturing Space, Displacing Bodies: Anamorphosis in Early Modern*

Theories of Perspective. University Park: Pennsylvania State University Press, 2007.

Matthis, Rémi, Jacques Gapaillard, and Colette Le Lay. "Quand un graveur veut se faire savant: *Le Nouveau système du monde* de Sébastien Leclerc." *Nouvelles d'estampe*, no. 257 (2016): 29–41.

Mayer-Deutsch, Angela. "The Ideal *Musaeum Kircherianum* and the Ignatian *Exercitia spiritualia*." In *Instruments in Art and Science: On the Architectonics of Cultural Boundaries in the 17th Century*, edited by Helmar Schramm, Ludger Schwarte, and Jan Lazardzig, 235–256. Berlin: Walter de Gruyter, 2008.

Merrim, Stephanie. *The Spectacular City, Mexico, and Colonial Hispanic Literary Culture*. Austin: University of Texas Press, 2010.

Mitchell, W. J. T. *Image Science: Iconology, Visual Culture, and Media Aesthetics*. Chicago: University of Chicago Press, 2015.

Mondzain, Marie-José. *Image, Icon, Economy: The Byzantine Origins of the Contemporary Imaginary*. Translated by Rico Franses. Stanford: Stanford University Press, 2005.

Monteyne, Joseph. *From Still Life to the Screen: Print Culture, Display, and the Materiality of the Image in Eighteenth-Century London*. New Haven: Yale University Press, 2013.

Mostert, Tristan. "The Collection of Musschenbroek Slides in the Stedelijk Museum De Lakenhal, Leiden, the Netherlands." *New Magic Lantern Journal* 11, no. 1 (2012): 9–11.

Murphy, Anne L. *The Origins of English Financial Markets: Investment and Speculation Before the South Sea Bubble*. Cambridge: Cambridge University Press, 2009.

Musser, Charles. *The Emergence of Cinema: The American Screen to 1907*. Vol. 1. Berkeley: University of California Press, 1990.

Nacol, Emily. *An Age of Risk: Politics and Economy in Modern Britain*. Princeton: Princeton University Press, 2016.

Neal, Larry. *The Rise of Financial Capitalism: International Capital Markets in the Age of Reason*. Cambridge: Cambridge University Press, 1990.

Needham, Joseph. *Science and Civilization in China*. Vol. 4: *Physics and Physical Technology*. Cambridge: Cambridge University Press, 1962.

Nicholson, Colin. *Writing and the Rise of Finance: Capital Satires of the Early Eighteenth Century*. Cambridge: Cambridge University Press, 1994.

Ogborn, Miles. *Indian Ink: Script and Print in the Making of the East India Company*. Chicago: University of Chicago Press, 2007.

Olson, Michael J. "The Camera Obscura and the Nature of the Soul: On a Tension Between the Mechanics of Sensation and the Metaphysics of the Soul." *Intellectual History Review* 25, no. 3 (2015): 279–291.

Panofsky, Erwin. "Dürer as a Mathematician." In *The World of Mathematics*, edited by James Newman. Vol. 1, 603–619. London: George Allen and Unwin, 1956.

———. *Perspective as Symbolic Form*. Translated by Christopher S. Wood. New York: Zone Books, 1997.

Pantin, Isabelle. "*Simulachrum, species, forma, imago*: What Was Transported by Light into the Camera Obscura." *Early Science and the Medicine* 13, no. 3 (2008): 245–269.

Patey, Douglas. *Probability and Literary Form: Philosophic Theory and Literary Practice in the Augustan Age*. Cambridge: Cambridge University Press, 1984.

Paz, Octavio. *Sor Juana, or, The Traps of Faith*. Cambridge, MA: Harvard University Press, 1988.

Perkins, Franklin. *Leibniz and China: A Commerce of Light*. Cambridge: Cambridge University Press, 2004.

Pocock, J. G. A. *Virtue, Commerce and History: Essays on Political Thought and History, Chiefly in the Eighteenth Century*. Cambridge: Cambridge University Press, 1985.

Pomplun, Trent. *Jesuit on the Roof of the World: Ippolito Desideri's Mission to Eighteenth-Century Tibet*. Oxford: Oxford University Press, 2010.

Poovey, Mary. *A History of the Modern Fact: Problems of Knowledge in the Sciences of Wealth and Society*. Chicago: University of Chicago Press, 1998.

Préaud, Maxime. "Le cabinet de Sébastien Leclerc." *Nouvelles de l'Estampe*, no. 249 (2014): 19–49.

Purtle, Jennifer. "Double Take: Chinese Optics and Their Media in Postglobal Perspective." *Ars Orientalis*, no. 48 (2018): 71–117

———. "Scopic Frames: Devices for Seeing China c. 1640." *Art History* 33, no. 1 (2010): 54–73.

Rabinovich, Oded. "Learned Artisan Debates the System of the World: Le Clerc Versus Mallemant de Messange." *British Journal for the History of Science* 50, no. 4 (2017): 603–636.

Raj, Kapil. *Relocating Modern Science: Circulation and the Construction of Knowledge in South Asia and Europe, 1650–1900*. Basingstoke: Palgrave Macmillan, 2007.

Reeves, Eileen. *Evening News: Optics, Astronomy, and Journalism in Early Modern Europe*. Philadelphia: University of Pennsylvania Press, 2014.

Reeves, Eileen, and Albert Van Helden. Introduction to *On Sunspots*, by Galileo Galilei and Christoph Scheiner. Chicago: University of Chicago Press, 2010.

Robins, Nick. *The Corporation That Changed the World: How the East India Company Shaped the Modern Multinational*. London: Pluto Press, 2006.

Rodriquez, José Antonio. *El Arte de las Ilusiones: Espetáculos precinematográficos en México*. Mexico City: Testimonios del Archivo, 2009.

Rossell, Deac. "Early Magic Lantern Illustrations: What Can They Tell Us About Magic Lantern History?" *Magic Lantern Gazette* 21, no. 1 (2009): 15–23.

———. *Laterna Magica / Magic Lantern*. Vol. 1. Stuttgart: Füsslin, 2008.

———. "Leibniz and the Lantern." *New Magic Lantern Journal* 9, no. 2 (2002): 25–26.

———. "The Origins of the Magic Lantern in Germany: An Example of the Use and Mis-use of Technological Argument in Media History." In *Die Medien und ihre Technik: Theories-Modelle-Geschichte*, edited by Harro Segeberg, 221–234. Marburg: Schüren Verlag, 2004.

Rotman, Brian. *Signifying Nothing: The Semiotics of Zero*. Stanford: Stanford University Press, 1987.

Rowland, Ingrid. "Athanasius Kircher, Giordano Bruno, and the *Panspermia* of the Infinite Universe." In *Athanasius Kircher: The Last Man Who Knew Everything*, edited by Paula Findlen, 191–205. New York: Routledge, 2004.

———. "'Th' United Sense of th' Universe': Athanasius Kircher in Piazza Novonna." *Memoirs of the American Academy in Rome* 46 (2001): 153–181.

Screech, Timon. *The Lens Within the Heart: The Western Scientific Gaze and Popular Imagery in Later Edo Japan*. Honolulu: University of Hawai'i Press, 2002.

Serres, Michel. *Le système de Leibniz et ses modèles mathématiques*. Paris: P.U.F., 1968.

Shapiro, Alan E. "Images: Real and Virtual, Projected and Perceived, from Kepler to Dechales." *Early Science and Medicine* 13, no. 3 (2008): 270–312.

———, ed. "Kepler, Optical Imagery, and the Camera Obscura." Special issue of *Early Science and Medicine* 13, no. 3 (2008): 217–312.

Shapiro, Barbara J. *A Culture of Fact: England, 1550–1720*. Ithaca: Cornell University Press, 2000.

Sheehan, Jonathan, and Dror Wahrman. *Invisible Hands: Self-Organization and the Eighteenth Century*. Chicago: University of Chicago Press, 2015.

Siegert, Bernhard. *Cultural Techniques: Grids, Filters, Doors, and Other Articulations of the Real*. Translated by Geoffrey Winthrop-Young. New York: Fordham University Press, 2015.

Silva, Ignacio. "Thomas Aquinas on Natural Contingency and Providence." In *Abraham's Dice: Chance and Providence in the Monotheistic Traditions*, edited by Karl Giberson, 158–174. Oxford: Oxford University Press, 2016.

Silver, Sean. *The Mind Is a Collection: Case-Studies in Eighteenth-Century Thought*. Philadelphia: University of Pennsylvania Press, 2015.

Silverman, Kaja. *The Miracle of Analogy, or, The History of Photography, Part 1*. Stanford: Stanford University Press, 2015.

Singh, Devin. *Divine Currency: The Theological Power of Money in the West*. Stanford: Stanford University Press, 2018.

Smith, A. Mark. *From Sight to Light: The Passage from Ancient to Modern Optics*. Chicago: University of Chicago Press, 2015.

Stafford, Barbara Maria, and Frances Terpak. *Devices of Wonder: From the World in a Box to Images on a Screen*. Los Angeles: Getty Research Institute, 2001.

Standaert, Nicolas. "Jesuits in China." In *The Cambridge Companion to the Jesuits*, edited by Thomas Worcester, 169–185. Cambridge: Cambridge University Press, 2008.

Stengel, Felix Burda. *Andrea Pozzo et l'art video: Déplacement et point de vue de spectateur dans l'art baroque et l'art contemporain*. Translated by Heinke Wagner. Paris: Isthme éditions, 2006.

Stoichita, Victor. *A Short History of the Shadow*. Translated by Anne-Marie Glasheen. London: Reaktion Books, 1997.

Stroud, Barry. "'Gilding and Staining' the World with 'Sentiments' and 'Phantasms.'" *Hume Studies* 19, no. 2 (1993): 253–272.

Tachau, Katherine H. *Vision and Certitude in the Age of Ockham: Optics, Epistemology, and the Foundations of Semantics 1250–1345*. Leiden: Brill, 1988.

Taylor, E. G. R. "Robert Hooke and the Cartographic Projects of the Late Seventeenth Century (1666–1696)." *Geographical Journal* 90, no. 6 (1937): 529–540.

Trabulse, Elías. "El Tránsito del Hermetismo a la Ciencia Moderna: Alejandro Fabián, sor Juana Inés de la Cruz y Carlos de Sigüenza y Góngora." *Calíope: Journal of the Society for Renaissance and Baroque Hispanic Poetry* 4, nos. 1–2 (1998): 56–69.

Vermeir, Koen. "Athanasius Kircher's Magical Instruments: An Essay on 'Science,' 'Religion,' and Applied Metaphysics." *Studies in History and Philosophy of Science* 38 (2007): 363–400.

———. "The Magic of the Magic Lantern (1660–1700): On Analogical Demonstration and the Visualization of the Invisible." *British Journal for the History of Science* 38, no. 2 (2005): 127–159.

———. "Optical Instruments in the Service of God: Light Metaphors for the Circulation of Jesuit Knowledge in China." In *The Circulation of Science and Technology: Proceedings of the 4th International Congress of ESHS, Barcelona, 18–20 November 2010*, edited by Antoni Roca-Rosell, 333–337. Barcelona: Societat Catalana d'Història de la Ciència i de la Tècnica, 2010.

Villoslada, Riccardo G. *Storia del Collegio Romano dal suo inizio (1551) alla soppressione della Compagnia di Gesù*. Analecta Gregoriana LXVI. Rome: Apud Aedes Universitatis Gregorianae, 1954.

Viner, Jacob. *The Role of Providence in the Social Order: An Essay in Intellectual History*. Princeton: Princeton University Press, 1972.

Vogl, Joseph. *The Ascendancy of Finance*. Translated by Simon Garnett. Cambridge: Polity, 2017.

———. *The Specter of Capital*. Translated by Joachim Redner and Robert Savage. Stanford: Stanford University Press, 2015.

Waddell, Mark A. *Jesuit Science and the End of Nature's Secrets*. Burlington: Ashgate, 2015.

Wagenaar, Willem. "The Origins of the Lantern: The True Inventor of the Magic Lantern—Kircher, Walgenstein, or Huygens?" *New Magic Lantern Journal* 1, no. 3 (1980): 10–12.

Warner, Marina. *Phantasmagoria: Spirit Visions, Metaphors, and Media into the Twenty-First Century*. Oxford: Oxford University Press, 2006.

Watson, E. C. "The Early Days of the Académie des Sciences as Portrayed in the Engravings of Sébastien Le Clerc." *Osiris* 7 (1939): 556–587.

Wennerlind, Carl. *Casualties of Credit: The English Financial Revolution, 1620–1720*. Cambridge, MA: Harvard University Press, 2011.

Weststeijn, Thijs. "'Sinarum gentes . . . omnium sollertissimae': Encounters Between the Middle Kingdom and the Low Countries, 1602–92." In *Reshaping the Boundaries: The Christian Intersection of China and the West in the Modern Era*, edited by Song Gang, 9–34. Hong Kong: Hong Kong University Press, 2016.

Wheelock, Jr., Arthur K. "Constantijn Huygens and Early Attitudes Towards the Camera Obscura." *History of Photography* 1, no. 2 (1977): 93–103.

Winterbottom, Anna. *Hybrid Knowledge in the Early East India Company World*. Basingstoke: Palgrave Macmillan, 2016.

———. "Producing and Using the *Historical Relation of Ceylon*: Robert Knox, the East India Company and the Royal Society." *British Journal for the History of Science* 42, no. 4 (2009): 515–538.

Wirth, Carsten. "The Camera Obscura as a Model for a New Concept of Mimesis in Seventeenth-Century Painting." In *Inside the Camera Obscura: Optics and Art Under the Spell of the Projected Image*, edited by Wolfgang Lefèvre, 149–193. Preprint 333. Berlin: Max Planck Institute for the History of Science, 2007.

Zielinski, Siegfried. *Deep Time of the Media: Toward an Archaeology of Hearing and Seeing by Technical Means*. Translated by Gloria Custance. Cambridge, MA: MIT Press, 2006.

———. *Variations on Media Thinking*. Translated by Gloria Custance. Minneapolis: University of Minnesota Press, 2019.

Zirpolo, Lilian H. *Historical Dictionary of Baroque Art and Architecture*. 2nd ed. Lanham: Rowman & Littlefield, 2018.

Index

Page numbers in italics refer to figures.

CPSIA information can be obtained
at www.ICGtesting.com
Printed in the USA
JSHW050532140522
25778JS00004B/3